michelangelo

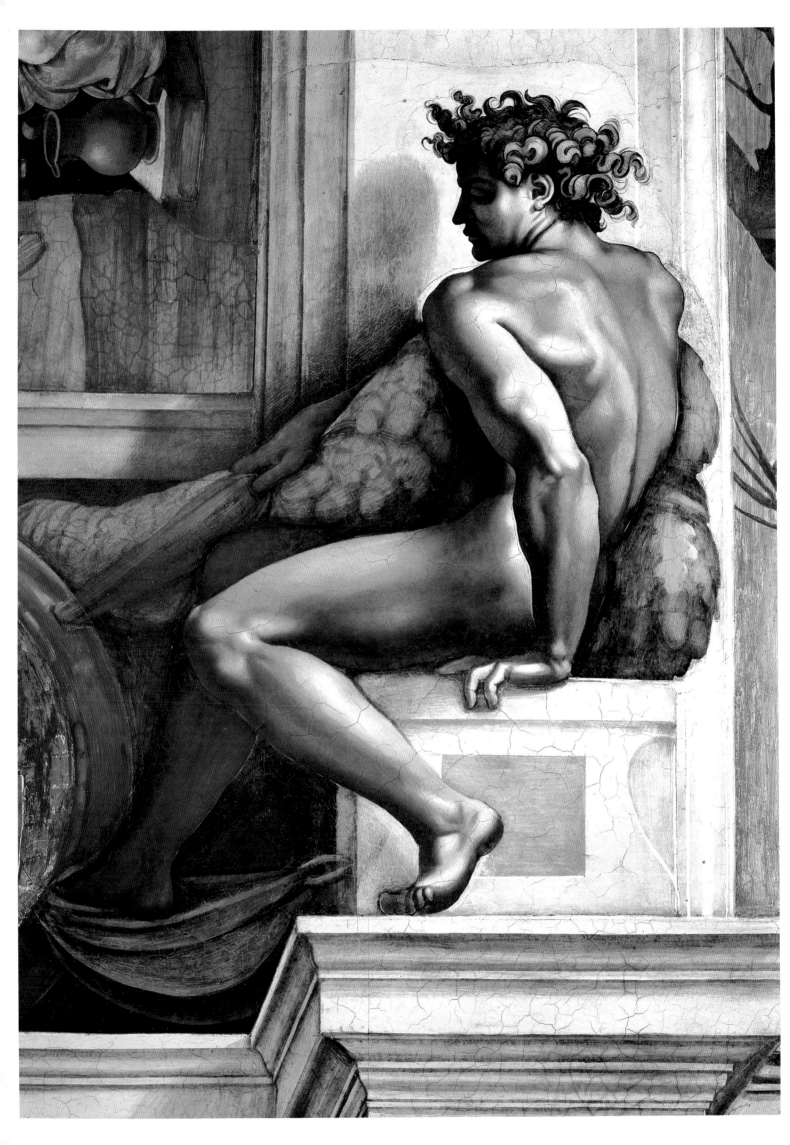

michelangelo

paintings · sculpture · architecture complete edition · ludwig goldscheider

Φ

Phaidon Press Limited
Regent's Wharf
All Saints Street
London N1 9PA

Phaidon Press Inc.
180 Varick Street
New York, NY 10014

www.phaidon.com

First published 1953
Sixth edition 1996
Reprinted 1997, 1998, 1999,
2000, 2001, 2003, 2004, 2005,
2006, 2007
© 1953, 1996 Phaidon Press
Limited

ISBN 978 0 7148 3296 8

A CIP catalogue record for
this book is available from
the British Library.

Printed in Hong Kong

Frontispiece
NUDE YOUTH, 1508–1509,
Sistine Chapel Ceiling

The publishers would like to
thank the following museums
and organizations for
supplying the photographs
on the pages listed, and for
permission to reproduce them:
Scala, Florence (10), Vatican
Museums (2, 14– 15, 18, 19,
22, 23, 26, 27, 30, 31),
© Nippon Television
Network Corporation,
Tokyo 1995 (30, 31)

FOREWORD

IN the course of the last thirty years the Michelangelo literature has increased to a formidable extent. Nevertheless, there has been no new concise work containing reproductions of all Michelangelo's paintings, sculptures and architectural works—no unpretentious yet comprehensive volume to replace the one which was published long ago in the 'Klassiker der Kunst' series and which has rendered good service to several generations of students, but has now become unusable.

In the meantime the quantity of photographic and illustrative material available has greatly increased and the conception underlying it has changed. There exist to-day special publications reproducing all the frescoes in the Sistine and Pauline chapels, with an almost unlimited abundance of details, there are new works on the Medici chapel and the tomb of Julius, with hundreds of illustrations. For the two volumes in large format, published by the Phaidon Press during the second world war, new photographs were taken of all the sculptures and of numerous details from the frescoes. All these photographs have been used in the present comprehensive volume, yet almost a third of the reproductions are from entirely new photographs, some of them of details never published before.

As regards the reproductions of architecture and the remarks thereon, the reader must not expect to find what he would be justified in expecting in a specialized work. He will, however, find reproductions corresponding to those in the volume of the 'Klassiker der Kunst', though of better quality. Virtually all the illustrations in this volume show the buildings as they are today.

The textual portions of the present volume are quite straightforward and consist solely of concentrated material from which the reader may construct his own Michelangelo book. For this reason I have refrained from writing an introduction in the form of an essay expounding my own views and experience and offer the reader in its place an easily readable chronological table, which he can consult from time to time if he wishes to refresh his memory of Michelangelo's life and works or of the background to some period of his career. The conception underlying the whole volume is that it should serve the reader as a constant companion to the Michelangelo literature, or, in the case of less patient readers, give them, with the choice and arrangement of the illustrations, a coherent idea of the work of one of the most prolific masters of all time.

NOTE ON THE FOURTH EDITION (1962)

Since the appearance of the third edition of the present volume (in Spring 1959) a number of important books and articles on Michelangelo have been published, of which the following may be mentioned.

Michelangelo by Herbert von Einem is at present the only monograph on the artist which incorporates all the research of the last twenty years. It is rather a slender volume, very readable, and an excellent first introduction to the Sculpture and Painting of Michelangelo.—A very short and very charming first chapter of an English monograph on the master can be found in *The Horizon Book of the Renaissance* (New York 1961, pp. 105-111), 'The Young Michelangelo' by Kenneth Clark, the only perfect seven pages in the whole volume.—In André Chastel's *Art et Humanisme à Florence* (Paris 1959) there are many paragraphs that throw a bright light on the spiritual background of Michelangelo's life (e.g. pp. 505-21, *La tragédie de Michel Ange : le triomphe de Saturne*).—Luitpold Dussler's *Die Zeichnungen des Michelangelo* (Berlin 1959) contains more than a discussion of the drawings; and so does Professor Johannes Wilde's valuable article *'Cartonetti' by Michelangelo* (Burlington Magazine, Nov. 1959, pp. 370-81).—The fifth volume of Tolnay's monumental work on Michelangelo (*The Final Period*, Princeton 1960) deals with the late frescoes and the last Pietàs.—The three last Pietàs are also discussed at length by Alexander Perrig in *Michelangelo Buonarrotis letzte Pietà-Idee*, Berne 1960.—Chapter VIII of Armando Schiavo's *San Pietro in Vaticano* (Rome, Istituto di Studi Romani, 1960) discusses the alterations which Michelangelo's model for the cupola of St. Peter's has suffered.—The *Journal of the Society of Architectural Historians*, vol. XIX (1960, pp. 97-108) contains an article by Elizabeth MacDougall on 'Michelangelo and the Porta Pia'.—Professor James S. Ackerman's *The Architecture of Michelangelo* (two volumes, London 1961) is the long expected standard work in this field.—A complete one-volume edition of *"Michelangelo"* and his work (Sculptor, Painter, Architect, Poet), with essays by Charles de Tolnay, Roberto Salvini, Mario Salmi, a.o., was published in 1966 by Istituto Geografico De Agostini, Novara. (A German translation from the Italian, same year, Wiesbaden, Vollmer Verlag.)

I have read these books and articles with great profit; but on the whole I have left the text of my book almost exactly as it was in the first edition. A few illustrations have been added. *The Vase with the Medici arms*, our pl. IV-a, was first published by Professor Charles de Tolnay in his 'Michelagniolo', Firenze, 1951, pl. 148; the *Fibula of Brutus* (p. 279), in the same author's 'Michelangelo IV': *The Tomb of Julius II*, Princeton, 1954, pl. 92. Our reproductions of these two details are based on original photographs and not on the illustrations in Tolnay's books.

NOTE ON THE SIXTH EDITION

Since the last edition of this book was published, Michelangelo's frescoes in the Sistine Chapel have been cleaned. The colour plates have all been replaced to reflect this change, while the other illustrations provide an invaluable record of the condition of the Sistine ceiling and *Last Judgement* before restoration. They, and the incomparable series of photographs of Michelangelo's sculpture and architecture, have been entirely reoriginated.

BIOGRAPHICAL CONSPECTUS

I. CHILDHOOD · APPRENTICESHIP · BEGINNINGS

1474. The Florentine Republic, during the rule of Lorenzo de' Medici, appoints Lodovico di Lionardo Buonarroti Simoni (1446–1531) of Florence 'Podestà' (i.e. mayor and local magistrate) of Caprese and Chiusi for the period of six months. Lodovico's wife was Francesca di Neri (1455–81). Caprese is in Tuscany, about 40 miles from Florence in the district known as the Casentino, in the upper valley of the Arno.

1475–84. Michelangelo born on 6 March 1475 at Caprese, the second son of Lodovico Buonarroti. (In Florence, the name was spelled Michelangiolo; but Vasari calls him Michelagnolo, and thus the name is sometimes written in the documents. Michelangiolo di Lodovico Buonarroti-Simoni is the correct full form of the artist's name.) When Michelangelo is not yet a month old, his father's term of office expires and the family returns to Florence. Michelangelo is placed in the care of a foster-mother at Settignano (five miles east of Florence), but it is not known how long he remained there. His mother dies when he is six years old.

1485–87. In 1485 Michelangelo's father marries his second wife, Lucrezia Ubaldini (who dies in 1497). About this time Michelangelo returns to Florence to live with his father, stepmother, four brothers and an uncle in a gloomy house in the Via de' Bentaccordi, near Santa Croce. He attends a school kept by Francesco da Urbino.

1488. Michelangelo makes friends with a young painter named Francesco Granacci, who works with the brothers Ghirlandaio and on 1 April Michelangelo becomes an apprentice in Domenico and David Ghirlandaio's workshop. He makes sketches after frescoes by Giotto and Masaccio and copies drawings of the old masters and Schongauer's engraving 'The Temptation of St Anthony'.

1489. Michelangelo leaves the Ghirlandaio workshop (probably in the early part of the year) and enters Bertoldo's 'school for sculptors'. He makes clay figures and a free copy in marble, after an antique sculpture, the head of a Faun (since lost).

1490–91. The attention of Lorenzo de' Medici is drawn to Michelangelo's talent and he invites him to reside as a guest in his palace, where Michelangelo remains until Lorenzo's death on 8 April 1492. There Michelangelo comes into contact with several leading humanists, among them Angelo Poliziano, who inspires him to carve the relief of the Battle of Centaurs (Plate 2), Marsilio Ficino, the interpreter of Plato, and Cristoforo Landino, the commentator of Dante. Michelangelo creates his relief of the 'Madonna of the Stairs' (Plate 1). Lorenzo de' Medici appoints Michelangelo's father an excise officer.

1492–95. Lorenzo's successor, Piero de' Medici, invites Michelangelo to live in the palace again, but gives him only one commission – to make a statue of snow (January 1494). The spiritual ruler of Florence at the time is Savonarola, whose sermons Michelangelo hears. In the meantime he finishes an over-lifesize marble statue of Hercules and a wooden crucifix (both lost). Florence is threatened by the advance of the French army (entry of Charles VIII into the city, 17 November 1494) and in October 1494 Michelangelo flees to Bologna and thence to Venice; there his money runs out and he returns to Bologna. (Dürer, four years older than Michelangelo, in Venice. Death of Ghirlandaio and Memling.) Michelangelo's father loses his post. Piero de' Medici and his brother Giuliano go into exile. Florence becomes a republic. In Bologna Michelangelo sees the works of Jacopo della Quercia and himself makes three statuettes for the shrine of San Domenico (Plates 4–6). At the end of 1495 Michelangelo returns to Florence, where Lorenzo di Pierfrancesco de' Medici commissions him to carve a marble statue of the youthful St John (lost).

1496. Michelangelo makes a marble statue, in antique style, of a recumbent Cupid (lost). This statue comes into the hands of the art dealer Baldassare del Milanese in Rome, who offers it for sale as a genuine antique. Michelangelo tries in vain to regain possession of the statue, which is eventually sold to Cesare Borgia, and was later in the collection of Isabella d'Este. In June 1496 Michelangelo arrives in Rome.

II. THE YOUNG MASTER

1496–1501. Michelangelo in Rome. He makes a lifesize marble statue of Cupid (or Apollo?), which he sells to Jacopo Galli (since lost); Galli also purchases his 'Bacchus' (Plate 7) and obtains for Michelangelo from Cardinal Jean de Villiers de la Groslaye the commission for a Pietà (Plate 13), which is completed in the spring of 1499. Two years later Michelangelo returns to Florence, where the situation has meanwhile become quieter. (Savonarola burned at the stake on 23 May 1498; the Republic survives until 1512.)

1501–5. Michelangelo in Florence. Contract for fifteen figures for the Piccolomini altar in Siena (5 June 1501), of which only a few were executed (Plates 28–31); contract for the marble 'David' (16 August 1501), which was not completed until 1504 (Plate 19). Contract (August 1502) for a bronze 'David', which was sent to France and has since been lost. Contract for twelve figures of Apostles for the Duomo in Florence (April 1503), of which only the 'Matthew' was begun (Plate 47). A 'Madonna with the Christ Child', begun at the same time as the statues for the Siena altar, was not delivered in Bruges until 1506 (Plate 34). During these years Michelangelo executes three tondi of the Madonna,

two of them sculptures and one a painting (Plates 43, 45, 44). Leonardo da Vinci obtains the commission for a mural painting of the 'Battle of Anghiari' in the Palazzo Vecchio, Florence, the left half of the wall being reserved for a 'Battle of Cascina' by Michelangelo, who gets no further than the cartoon; this, too, has been lost and is known to us only through copies (Plate XXIV). Raphael in Florence.

1505–8. Pope Julius II summons Michelangelo to Rome. First design for the 'Tomb of Julius'. (1506: Laocoön found in Rome.) Michelangelo feels that he is neglected in Rome and flees to Florence (17 April 1506). There he resumes work on his cartoon for the 'Battle of Cascina', on the 'Matthew' and perhaps also on designs for the Pope's tomb. In November 1506 he goes to Bologna to meet Julius (who occupies the city in the course of his war against Perugia and Bologna). Michelangelo makes a large bronze statue of the Pope, which is installed in February 1508 on the façade of San Petronio. (This bronze portrait was destroyed in 1511.) (1506: Death of Mantegna and Columbus.)

III. CEILING FRESCOES IN THE SISTINE CHAPEL · TOMB OF JULIUS

1508–12. In the spring of 1508 Michelangelo is summoned to Rome by Pope Julius to paint the ceiling of the Sistine Chapel. The first half of the ceiling is finished by September 1510. In December 1510 Michelangelo visits the Pope in Bologna, to protest against intrigues. After his return he resumes his work in the Sistine Chapel and finishes it in October 1512. One month earlier the Medici had been reinstalled in Florence by Spanish troops (12 September 1512); Giovanni de' Medici (destined to become Pope in the following year under the name of Leo X) and his brother Giuliano de' Medici (Duke of Nemours) become masters of the city. (1510: Death of Botticelli and Giorgione.)

1513–16. Julius II dies in February 1513. Michelangelo concludes a new contract with the Pope's heirs for the tomb of Julius. Two statues of 'Captives' are begun (Plates 145, 148) and work on the tomb continues until 1516. (At this time Raphael paints his last Vatican frescoes and Grünewald finishes the Isenheim Altar.)

IV. IN THE SERVICE OF THE MEDICI

1516–20. Michelangelo in Florence, in June 1516 and then again from August on, after spending the month of July in Rome, where he makes a third contract for the tomb of Julius. He becomes the patron of Sebastiano del Piombo, and helps him with drawings for the 'Raising of Lazarus' and other paintings. At this time (1516–19) the head of the Medici family in Florence is Lorenzo, Duke of Urbino, who is succeeded by Giulio de' Medici (later Pope Clement VII). Commissions to artists for the embellishment of Florence, however, are awarded by another member of the Medici family, Pope Leo X. From 1516 on Michelangelo discusses with him the improvement of the façade of San Lorenzo. Baccio

d'Agnolo makes a wooden model after Michelangelo's design, but Michelangelo rejects it and makes his own model (spring 1517–winter 1517–18; cf. Plate 155). He spends most of his time in the quarries at Carrara and Pietrasanta, with occasional visits to Rome. On 19 January 1518 the contract for the façade of San Lorenzo is signed, but Michelangelo continues working in Florence on the tomb of Julius. To Leo X he offers to execute a Tomb of Dante without payment (1518, Document in the Archivio di Stato, Florence). He gives up his house in Rome and many of his cartoons are burned. In November 1518 Michelangelo begins building a house for himself and his workshop in the Via Mozza, Florence. In the summer of 1519 he begins the 'Statue of Christ' (Plate 151), commissioned as long ago as 1514, work on a first version having soon been suspended because the block of marble proved to be defective. The second version is completed in spring 1520. On 10 March the contract for the façade of San Lorenzo is cancelled. Work on the tomb of Julius continues during this year. (Leonardo dies in 1519, Raphael in 1520.)

1521–33. In 1521 Luther (who in 1517 nailed his theses to the door of the church in Wittenberg) is declared a heretic by the Diet of Worms, retires to the Wartburg and begins translating the Bible. The Reformation. (Holbein paints his 'Dead Christ', now at the Basle Museum.) In the spring of the same year Michelangelo begins work in the Medici Chapel. In November 1523 Giulio de' Medici is elected Pope (Clement VII). Alessandro de' Medici becomes ruler of Florence. In 1524 Michelangelo is still working on the models for the sculptures in the Medici Chapel. Work begun on the Biblioteca Laurenziana. In 1525 new agreement for the tomb of Julius, which is now to be executed as a wall tomb, and not standing free. The 'Allegories of the Phases of the Day' for the Medici Chapel are still not quite finished. In October 1526 Michelangelo sends a new design for the tomb of Julius to Rome. In the following year Rome is occupied by imperial troops under the Connétable de Bourbon, and the Pope, a Medici, is besieged in Castel Sant'Angelo. In consequence, the Medici are driven out of Florence again. Two years later the Emperor Charles V and Pope Clement VII agree to restore Alessandro. In 1529 Michelangelo is employed mainly as a military engineer, fortifying Florence against attacks by the Medici in their attempts to return. Michelangelo lends the city a thousand scudi. He goes to Ferrara to ask the Duke for advice concerning fortifications, promises him a picture and paints 'Leda and the Swan'. The picture (afterwards lost in France) is not delivered, but presented to Mini, Michelangelo's favourite pupil. In September 1529 Michelangelo returns to Florence, but in the same month flees to Ferrara and thence to Venice. He is declared a traitor and threatened with confiscation of his property, whereupon he returns to Florence while

the city is besieged. On 12 August 1530 Florence capitulates and the imperial troops enter the city, which is handed over to Clement VII, who appoints Baccio Valori his plenipotentiary. Michelangelo remains in hiding, but is promised immunity by the Pope if he will continue his work on the Medici Chapel. In the autumn of the same year he resumes work in the Chapel and presents Baccio Valori with an 'Apollo' (Plate 206). During this disturbed period Michelangelo's father dies (not in 1534, as was at one time supposed). The reliquary loggia in San Lorenzo completed in 1532 (Plate 164). On 29 April 1532, fourth contract for the tomb of Julius. From August 1532, Michelangelo in Rome.

V. TRANSITIONS

1533–34. Michelangelo spends the winter 1532–33 in Rome. He forms a lifelong friendship with Tommaso de' Cavalieri, to whom he dedicates many poems and drawings. He decides to settle in Rome. In June 1533 he returns for four months to Florence. At that time the 'Allegories of the Phases of the Day' still reposed on the floor of the Medici Chapel, but shortly before Michelangelo's final move to Rome at least the statues of the two Medici Dukes had been installed in their niches. From November 1533 to June 1534 Michelangelo is in Rome, where he receives from the Pope the commission for the 'Last Judgement' and works once more on the tomb of Julius. After this he again spends three months in Florence; the benches and the wooden ceiling of the Biblioteca Laurenziana, designed as long ago as 1526, are now completed (Plates VIII and IX). Assistants carry on the work on the Laurenziana and after many interruptions it is at last finished in 1559, when Ammanati and Vasari execute the staircase after drawings and a model by Michelangelo (Plate 162). The Medici Chapel is also left unfinished after Michelangelo's departure and the remaining work is entrusted to assistants (see, e.g., Plate IV).

In September 1534 Michelangelo moves to Rome. He never returns to Florence during the remaining thirty years of his life. The Medici remain rulers of the city; first Alessandro, and after his murder (1537), Cosimo I, both of whom are disliked by Michelangelo, who refuses all the flattering offers of Duke Cosimo.

VI. THE 'LAST JUDGEMENT'

1534–41. Two days after Michelangelo's arrival in Rome, on 25 September 1534, Pope Clement VII dies. He is succeeded by Alessandro Farnese (Paul III). Michelangelo, who wants to continue work on the tomb of Julius, is ordered by the new Pope to begin the altarpiece for the Sistine Chapel, the 'Last Judgement' (Plate 224). The preparatory work lasts until 1536 and the fresco is completed in 1541. Friendship with Vittoria Colonna, for whom Michelangelo makes a 'Christ on the Cross' and other religious drawings. He comes into contact with Cardinal Pole and the religious circle of the 'spirituali'. In 1538 Ignatius Loyola comes to Rome.

Michelangelo's conversations with Francisco de Hollanda. (Vesalius works on his 'Anatomia'. Death of Paracelsus.)

VII. RELIGIOUS THEMES

1542–45. First fresco in the Cappella Paolina, the 'Conversion of St Paul', commissioned by Pope Paul III (Plate 239). At the same time, after forty years' work, the tomb of Julius is completed (Plate 234). On 8 January 1544 (according to the Florentine calendar, = 1545), death at the age of fifteen of Cecchino Bracci, nephew and favourite of Luigi del Riccio, one of Michelangelo's friends. Michelangelo composes fifty poetic inscriptions and makes a drawing for the boy's tomb (Plate XX–a). Titian in Rome, visits Michelangelo. In November 1545 Pietro Aretino attacks Michelangelo in an open letter for his 'godlessness' and blames him for the unseemliness of the many nudes in the 'Last Judgement'. The Council of Trent begins its sittings. The Counter-Reformation.

1546. Vasari in Rome. Antonio da Sangallo dies and Michelangelo takes over the construction of the Palazzo Farnese, at the same time making the first designs for the rebuilding of the Capitol and beginning his share in the work of building St Peter's (Plates 246–50; XVIII).

1546–53. Second fresco in the Cappella Paolina, the 'Crucifixion of St Peter' (Plate 240). Work begins on the 'Florentine Pietà' (Plate 256) and on the Nicchione del Belvedere (Plate 255, about 1550). First plans for the reconstruction of San Giovanni dei Fiorentini in Rome (on which Michelangelo works until 1560). The first edition of Vasari's 'Vite' is published, including the biography of Michelangelo (1550). In the same year appear Benedetto Varchi's 'Due Lezioni' on Michelangelo as a poet. (1547: Death of Sebastiano del Piombo and of Vittoria Colonna.) In February 1550 Vasari comes to Rome and stays until the end of 1553. He sees Michelangelo working on his Florentine Pietà. Later on, after 1555, he is told that Michelangelo has smashed the Pietà to pieces.

VIII. THE LAST PHASE

1553–64. In 1553: Execution of the floor of the Biblioteca Laurenziana (Plate 158), an imitation of the carved ceiling; publication of Ascanio Condivi's 'Vita di Michelangelo'; Pieter Bruegel in Rome. At the end of 1555, death of Michelangelo's servant and assistant, Francesco Urbino, who had served him for twenty-five years. Shortly after this, Michelangelo with blows of his hammer damages the 'Florentine Pietà' (Plate 256), which Tiberio Calcagni subsequently restores. Michelangelo begins the 'Palestrina Pietà' (Plate 262), which is completed by another hand. He also begins the 'Rondanini Pietà' (Plate 260), on which he himself works until his death. Production of important religious drawings, especially 'Crucifixions'. In 1558 Michelangelo makes a model for the staircase of the Laurenziana

(Plates 159, 162), and begins his model for the dome of St Peter's, which he finishes in 1561 (Plate 266). About the same time Michelangelo works on the project for the transformation of the Thermae of Diocletian into the church of Santa Maria degli Angeli (Plate XVII), the designs for the outer side of the Porta Pia (Plate 264) and for the Sforza Chapel in Santa Maria Maggiore (Plate XX–b). By order of Pope Paul IV, some nudities in the 'Last Judgement' are painted over by Daniele da Volterra (1559–60). On 12 February 1564 Daniele da Volterra watches the master working all day long on a 'Pietà'. Two days later Michelangelo falls ill and, though feverish, wanders about in the open air, telling his assistant Calcagni that he can find no rest. The following day, still more feverish, he remains by the fireside. After only two days in bed, he dies on 18 February 1564, in the presence of Tommaso de' Cavalieri, Daniele da Volterra and a number of doctors and friends. The body is taken to the church of the Santi Apostoli and the Pope wishes it to be buried in St Peter's, but Michelangelo's nephew and heir, Leonardo Buonarroti, removes the body to Florence. The dead master arrives there on 10 March and is buried in Santa Croce, but the solemn commemoration is not held until 14 July, in San Lorenzo. More than a hundred artists are present, but not Duke Cosimo de' Medici, and the funeral oration is spoken by Benedetto Varchi. (Shakespeare was born a few weeks after Michelangelo's death.)

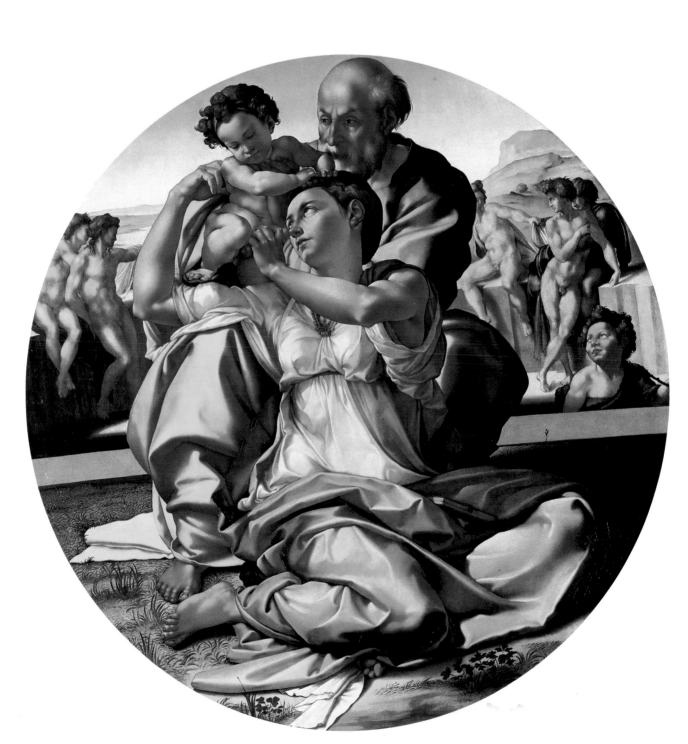

MADONNA DONI. About 1504. Florence, Uffizi

CATALOGUE

MADONNA OF THE STAIRS. Plate 1. Marble relief, 22 × 15¾ in. Executed c. 1491, when the artist was about sixteen years old. First mentioned by Vasari in the second edition of his *Lives* (1568) and described by him as being not quite one (Florentine) ell[1] in height (see Paola Barocchi, *Vasari: Michelangelo*, 1962, vol. II, notes 92–94). According to Vasari, it then belonged to Leonardo Buonarroti, Michelangelo's nephew. It subsequently came into the possession of the Medici, who in 1617 presented it to the Casa Buonarroti. Since Vasari's day its relationship to reliefs by Donatello has often been stressed, notably by Bode. The attribution to Michelangelo has, without adequate reason, been doubted by Charles Holroyd (1903) and Ernst Benkard (1933). H. Brinckmann (in *Barockskulptur*, Berlin, 1919, p. 18) suggested that the relief ought to be dated 1494; R. Longhi (in *Paragone*, 1958, No. 101, p. 61 f.) dated it after the Pietà of S. Pietro; this idea of a late dating was adopted by J. Pope-Hennessy (in *Italian High Renaissance and Baroque Sculpture*, Catalogue, p. 1, London, 1963; 2nd ed. 1970, p. 299).

BATTLE OF CENTAURS. Plate 2 (3). Marble relief, 33¼ × 35⅝ in. Vasari (1568) calls it 'a battle between Hercules and the Centaurs', while Condivi (1553) describes it as 'the Rape of Dejanira and the battle of Centaurs'. According to Condivi, the idea of this relief was suggested to Michelangelo by Poliziano (died 1494), the tutor of Lorenzo il Magnifico's sons. The poet and humanist Poliziano may have derived his knowledge of the subject from Boccaccio's *Genealogia* or from the collection of legends attributed to Hyginus. The details in this relief are not very clear; it has neither been agreed which of the figures are Centaurs and which are human, nor which are the men and which the women. Wölfflin maintained that there was not a single female figure in the relief, whereas Symonds believed that the central figure was female. According to Justi, however, this central figure is the Centaur Eurytion, while Knapp thinks it is either Hercules or Theseus.[2] The representation is modelled on sarcophagus fronts of the Roman Imperial period, and Bertoldo's equestrian relief has rightly been compared with it. Michelangelo seems to have been very fond of his Centaur relief, which he executed when he was seventeen (his fondness for it is confirmed by Condivi); in any case he kept it all his life, and it then passed into the possession of his family.

THE THREE BOLOGNA STATUETTES. Plates 4–6. Marble; Proculus, 22 in.; Petronius, 25 in.; the Angel, 20¼ in. high, with base. Condivi mentions only the *Petronius* and the *Angel holding a candlestick* and says that Michelangelo received 18 ducats for the Saint and 12 for the angel. According to C. Gnudi (1942) and Bertini (1945), the *Petronius* was begun by Niccolò dell' Arca and finished by Michelangelo, who left the back of the statue as he found it. This opinion is based on a statement by Lodovico da Prelormo (1572), but Tolnay declared the statuette to be 'entirely by the hand of the Master'. The *Proculus*, 'the most interesting of the three figures' (Johannes Wilde), is first mentioned, together with the other two, by Leandro Alberti in his '*De divi Dominici obitu et sepultura*' (1535). 'Foratti questions the authenticity of the Proculus, which it is true one would not be sorry to see eliminated from Michelangelo's œuvre, but on the other hand it is too well authenticated by Fra Lodovico da Prelormo and Leandro Alberti to justify its arbitrary rejection' (Panofsky). In addition to Foratti, Wölfflin and Frey have declared themselves against the attribution of the Proculus to Michelangelo; Thode, Mackowsky and Bode have given excellent reasons in favour of its authenticity. According to contemporary reports, the statue was knocked down and broken in 1572 while it was being cleaned; the shanks were broken off and it is still easy to see where they were stuck on again. Thode thought: 'In my opinion there can be no doubt that in the Proculus we have a self-portrait of the nineteen-year-old artist.' – Michelangelo's angel is the male counterpart of the delicate female angel by Niccolò dell' Arca, who executed the rest of the decoration over the shrine of St Dominic. Justi summed up the figures: 'The three Bologna statuettes – the fruits of one year's sojourn in the city – are probably the most insignificant and least satisfactory works which have been handed down to us under Michelangelo's name, but it must be admitted that they are only too well authenticated.' On the other hand, Stendhal says in their favour: 'These figures are remarkable, one sees quite clearly that this great artist began by imitating nature in the most painstaking way and that he knew how to render all her charm and *morbidezza*.'

BACCHUS. Plate 7 (8–12). Marble, 80 in. high, including base. According to Condivi, executed for the Roman banker Jacopo Galli in his house. Commissioned in 1496; intended for erection in a garden. The Bacchus and Satyr are hewn out of one block. Vasari was the first to notice the hermaphroditic element in the figure: 'A marvellous blending of both sexes – combining the slenderness of a youth with the round fullness of a woman'; to which Condivi adds: 'The eyes are dim and lewd.' The pathological character of the figure has often repelled critics. Brinckmann calls it 'the coarsest work by Michelangelo which we possess'; Mackowsky describes the 'vice in a beaming youthful countenance' as an aesthetic error. Stendhal remarks: 'Michelangelo divined the antique, in so far as it expresses strength, but the face is coarse and without charm.' Shelley wrote: 'The countenance of this figure is the most revolting mistake of the spirit and meaning of Bacchus. It looks drunken, brutal and narrow-minded, and has an expression of dissoluteness the most revolting.' He finds fault with the stiffness of the legs; quite wrongly, for they are naturalistic rendering of the semi-paralysed movements of the drunken god. About

[1] A Florentine ell = 23 in.
[2] There is a detailed study of the subject-matter in Tolnay, I 133. Wickhoff suggested that the correct title should be: 'The Marriage of Deidameia and Battle between Centaurs and Lapithae'. When I examined the relief, I counted six Centaurs: the central figure (horse's legs just visible); top left, a figure holding a woman by the hair; the figure in the right corner of the front row; the fallen figure in the centre foreground; the figure above, with his arms round a woman's waist; towards the right, a strangler.

MICHAEL·AG͡LVS·BONAR͡TVS·FL®ENT·FAC͡EBAT

Michelangelo's signature on the Pietà at St Peter's

the restoration of the right hand, holding the cup, see Edgar Wind, *Pagan Mysteries in the Renaissance*, London 1958, pp. 147 f.

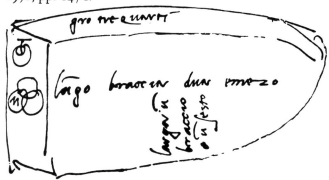

Michelangelo's sketch of a marble block with measurements and his stone-masons's mark.
(Pen and ink drawing. Formerly Collection Stefan Zweig.)

PIETÀ (Madonna della Febbre). Plate 13 (14–18). Marble, 69 in. high. The only work by Michelangelo bearing his genuine signature. The group was commissioned by Cardinal Jean de Villiers de la Groslaye (died 1499), French Ambassador to the Holy See. The contract was made on 27 August 1498, the price agreed upon being 450 ducats. The chief work of Michelangelo's youthful period. The subject was a complete novelty for Italy – at least as far as sculpture is concerned,[3] and many of Michelangelo's contemporaries considered it heretical; an orthodox writer in 1549 describes it as a 'Lutheran notion'. Michelangelo's Pietà originally stood in the Petronilla chapel, the so-called French chapel of the old church of St Peter's; after the demolition of the latter about 1535, it was installed in the new St Peter's, at first in the Cappella della Febbre, the 'fever chapel'. Since 1749 it has been in the Cappella del Crocifisso (Cappella della Pietà). Four fingers of the Madonna's left hand were broken off and replaced in 1736. [The sculpture was struck and badly damaged by a mentally disturbed tourist in May 1972 and has since been painstakingly restored.]

DAVID ('The Giant'). Plate 19 (20–26). Marble, 16 ft. 10½ in. high, including base. The contract between the Operai of the Cathedral and Michelangelo is dated 16 August 1501, with a term of delivery of two years and a fee which was subsequently raised to 400 ducats. On 25 January 1504 a conference of artists was held, to decide where the David should be erected; among the participants were Leonardo da Vinci, Botticelli, Filippino Lippi, Perugino and Piero di Cosimo. It was resolved that Donatello's Judith should be removed from the entrance to the Palazzo Vecchio, in order to make room for Michelangelo's David. On 8 September 1504 the erection in front of the Palazzo Vecchio was completed. In 1873 the statue was removed to the Accademia and in 1910 a

marble replica was placed in front of the Palazzo Vecchio. Michelangelo was given a block of marble out of which Agostino di Duccio, or perhaps Baccellino, had attempted to hew a David. 'So Michelangelo made a wax model of a youthful David holding the sling, which might serve as the emblem of the palace' (Vasari). When the Medici were driven out of Florence on 26 April 1527, the statue was damaged by a bench thrown out of one of the palace windows and the left arm was shattered. The three pieces were found by Salviati and Vasari and in 1543, by order of Duke Cosimo, they were replaced. Burckhardt finds fault with the 'preoccupation with the model' seen in this statue and with the 'mistake' of trying to represent the figure of an adolescent in colossal proportions. 'Only grown persons can be conveniently enlarged. . . . When seen through a diminishing glass, the David gains uncommonly in beauty and life; to be sure with exception of the head, which seems to have been designed for quite a different mood.' On the other hand Justi writes: 'His most perfect statue of a nude man, considered from a purely technical and plastic standpoint as life in marble.'

FIVE STATUES OF THE PICCOLOMINI ALTAR, SIENA CATHEDRAL. Plates 27–33. Marble, each about 50 in. high. Cardinal Francesco Piccolomini, later Pope Pius III, ordered the altar from the Lombard sculptor Andrea Bregno, who erected it in 1481–5. Sixteen statues were to decorate this altar, and in 1501 (when Bregno was eighty), the Cardinal approached Pietro Torrigiano, who began the figure of St Francis (Plate 28), but did not finish it. In the same year the commission was offered to Michelangelo, who first finished Torrigiano's St Francis, and then, between June 1501 and October 1504, delivered four more statues (Plates 29, 30, 31, 32). The contract was renewed in 1504. Valentiner believes that the Bruges Madonna (Plate 34, was originally intended for the upper central niche of this altar. St Peter and St Paul were of course meant as counterpieces, and in 1944 they were placed accordingly: St Peter in the lower right niche, St Paul in the lower left niche. St Francis, previously in the place of St Paul, was moved to the upper left niche. St Gregory and St Pius, also counterpieces, have always rightly been placed in the middle niches. Burckhardt (1891). Thode (1908), J. Wilde (1932), Toesca (1934), F. Kriegbaum (1941), Valentiner (1942), and A. Bertini (1945) have accepted the statues as Michelangelo's own work. Tolnay (1947 and 1951) insists that the execution is due mainly to Baccio da Montelupo.[4] According to Kriegbaum, the St Paul (Plate 27) is a self-portrait of Michelangelo (who at that time was about twenty-seven).

[3] There is a clear relationship, not confined merely to the choice of subject, to the Lamentation of Christ by Jacopo del Sellaio (1442–93), now in the Berlin Museum (Cat. No. 1055), especially as regards the pathetic opening of the Madonna's hand and the pendent right arm of the Christ.

[4] On plates 26 and 27 the heads of *David* and *St Paul* have been juxtaposed in order to show that there are indeed technical differences in these two sculptures, which are generally dated from the same period. This is particularly obvious in the treatment of the pupils and the corners of the mouths: the drill has been used to a great extent in the statue of St Paul, with a similar result as in late Roman statues, leaving the holes made by the drill undisguised.

THE BRUGES MADONNA. Plate 34 (35–42). Marble, 50½ in. high, including base. The earliest mention of this work occurs in Albrecht Dürer's diary of his journey to the Netherlands, on 7 April 1521: 'I saw the alabaster Madonna in Our Lady's Church that Michelangelo of Rome made.' (Alabaster here means white marble, and 'Our Lady's Church' means Notre-Dame.) Condivi, who never saw the work, which Francesco del Pugliese brought to Bruges in 1506, describes it as a bronze,[5] and says that the Bruges merchant Mouscron[6] paid 100 ducats for it.[7] The French sculptor David d'Angers claimed to have discerned the hand of an assistant; Wölfflin was of the same opinion. Pieraccini, in his guide to the Tribuna del David (Prato, 1883) includes it among the 'doubtful works'. The back and side views (Plates 36–39) show that an assistant, perhaps Baccio da Montelupo, did some work, at least on the drapery and the socle of rough stones on which the Virgin is seated. Apparently the group is designed to be placed rather high. In the present position the head of the Child seems too large.[8]

THE ROUND MADONNA RELIEF IN LONDON. Plate 43. Marble, 46¼ in. Also known as the Taddei Madonna, after its first owner, Taddeo Taddei. Thode and Wölfflin think that the Pitti Madonna is the older, but Knapp, Kriegbaum and others consider the Taddei tondo to be the older. The relief is held to be unfinished and a number of opinions concerning its sketchiness were collected by Justi (II, p. 190). Walter Pater wrote of it: 'Michelangelo secures that ideality of expression which in Greek sculpture depends on a delicate system of abstraction, and in early Italian sculpture on lowness of relief, by an incompleteness, which is surely not always undesigned, and which trusts to the spectator to complete the half-emergent form.' Within Michelangelo's œuvre these two round reliefs represent his 'small sculptures'. Justi stresses the 'genre-like' treatment of the Taddei Madonna and the fact that it was 'intended for a room in a bourgeois home'. The boy on the left is characterized as the Baptist by the christening bowl at his hip; the bird

in his hands which startles the Christ Child is a goldfinch, a symbol of the Passion. (The goldfinch is supposed to be fond of feeding on thorns and thus recalls Christ's Crown of Thorns. Cf. Herbert Friedmann, *The Symbolic Goldfinch*, New York, 1946.) The Taddei Madonna was bought in 1823 by Sir George Beaumont in Rome, and after his death, and the death of his wife, it was presented to the Royal Academy (1830).[9]

THE HOLY FAMILY. Plate 44. Wood, resin and tempera.[10] Diameter 47¼ in. Known as the 'Doni Madonna', after Angelo Doni, who commissioned the work. The only certain easel painting by Michelangelo, but at the same time the least esteemed of his paintings. Even Doni seems to have been dissatisfied with it, for Vasari tells us of a long dispute about the fee. The picture was subsequently taken out of its original frame and a tondo by Lorenzo di Credi was put in its place.[11] Stendhal thought that the task was unworthy of Michelangelo: 'A Hercules at the spinning wheel'. Critics of the late nineteenth century were unanimous in their disapproval of the Doni Madonna. 'With sentiments of this kind nobody ought to paint a Holy Family', was Burckhardt's opinion, and he also discovered 'deliberate difficulties' in it. Justi did not hestitate to say: 'The play of the arrangement of the limbs ruins the impression; the idyll of parental felicity becomes a gymnastic exercise.' Nevertheless, the picture is a miracle of draughtsmanship and powerful composition, merits which perhaps only painters are capable of appreciating. The colours would have aroused the enthusiasm of Ingres. The work contains the germ of everything which makes the ceiling of the Sistine Chapel unique, even the superabundance of muscles. This Madonna is a sister of the Delphic Sibyl; the youth half concealed by Joseph's shoulder is a forerunner of one of the nudes of the Sistine ceiling.

THE ROUND MADONNA RELIEF IN FLORENCE. Plate 45 (46). Marble, 33½ in. Also known as the Pitti Madonna, after Bartolommeo Pitti, who commissioned it. Executed at about the same time as the other two round Madonnas, the *Taddei Madonna* in London (Plate 43) and the tempera painting, the *Doni Madonna* in Florence (Plate 44). Justi stresses the intimate character of the work and the fact that it was intended 'for the home' and

[5] Vasari calls it a 'bronze tondo'. Considering that Condivi wrote under Michelangelo's eyes, one cannot simply assume that he also made a mistake. Valentiner (*Art Quarterly*, 1942) showed the possibility that the Bruges Madonna was originally intended for the Piccolomini altar, and therefore it is not impossible that Mouscron bought from Michelangelo also a bronze tondo, perhaps similar in style to the two marble tondi, Plates 43 and 45. Benedetto Varchi, in his funeral oration for Michelangelo (which he spoke in front of all the academicians of Florence) counted up the master's works in bronze and also mentioned 'una vergine Maria col Bambino in collo maravigliosissima, mandata in Fiandra da alcuni mercatanti de' Mascheroni'.
[6] Alexander Mouscron had warehouses in Florence and Rome. He dealt in English clothing materials.
[7] A fee of 100 ducats would have been rather little for an almost life-size marble group. Michelangelo received 450 ducats for the Pietà ordered in 1498 by Cardinal de la Groslaye, and 400 for his David in 1502, which did not include the cost of the marble. A few years later, when Michelangelo was working on the Sistine ceiling frescoes, living very economically and having no travelling expenses, he mentioned in a letter to his father that he was spending 20 ducats a month.
[8] In Rembrandt's atelier there was a cast of the Child Jesus of the Bruges group (in the inventory of 1656 it figures as 'a child, by Michelangelo'). This cast of Rembrandt's is reproduced in a painting by Jan Lievens (Hans Schneider, *Lievens*, Haarlem 1932, Plate 14; Louvre). Another cast of the Child appears in Wallerant Vaillant's painting *The Young Artist*, of about 1670 (London, National Gallery, No. 3591).
During the second world war Hitler took the *Bruges Madonna* to Alt-Aussee in Austria, with the intention to present it to the Linz museum.

[9] When the auctioneer Claridge of Curzon Street, London, exhibited the relief (not for sale) in 1829, he stated in his advertisement that the sculpture was 'bearing the date 1504'. This date, perhaps written on the back, has now disappeared. (W. T. Whitley, *Art in England 1821–37*, London 1930, p. 202.) Our Plate 43 shows the correct position of the relief, which differs from the position in which it is now placed at the R.A. The engraving by William Young Ottley, 1828, already shows the correct position and Knapp and Kriegbaum have also pointed out that the exergue should be horizontal.
[10] Heath Wilson, Ricci and Carl Justi maintain that the picture is painted in oil, but technically this is incorrect. We have here the usual Italian mixed technique of the period, with powerful outline drawing on a plaster ground, a thin layer of green earth, in covering resin, and a graduated heightening in white with tempera; the over-painting is done with transparent resin, except in the flesh parts, which are painted in pure tempera.
[11] The painting and frame were not brought together again until 1905 (Poggi, *Kunstchronik* XVIII, p. 299 f., and E. Bock, *Florentinische und Venezianische Bilderrahmen*, Munich, 1902, p. 78). The frame bears the arms of Angelo Doni and Maddalena Strozzi. It is supposed that the painting was commissioned on the occasion of their wedding, about 1503–4. Cf. Appendix, Plate XV.

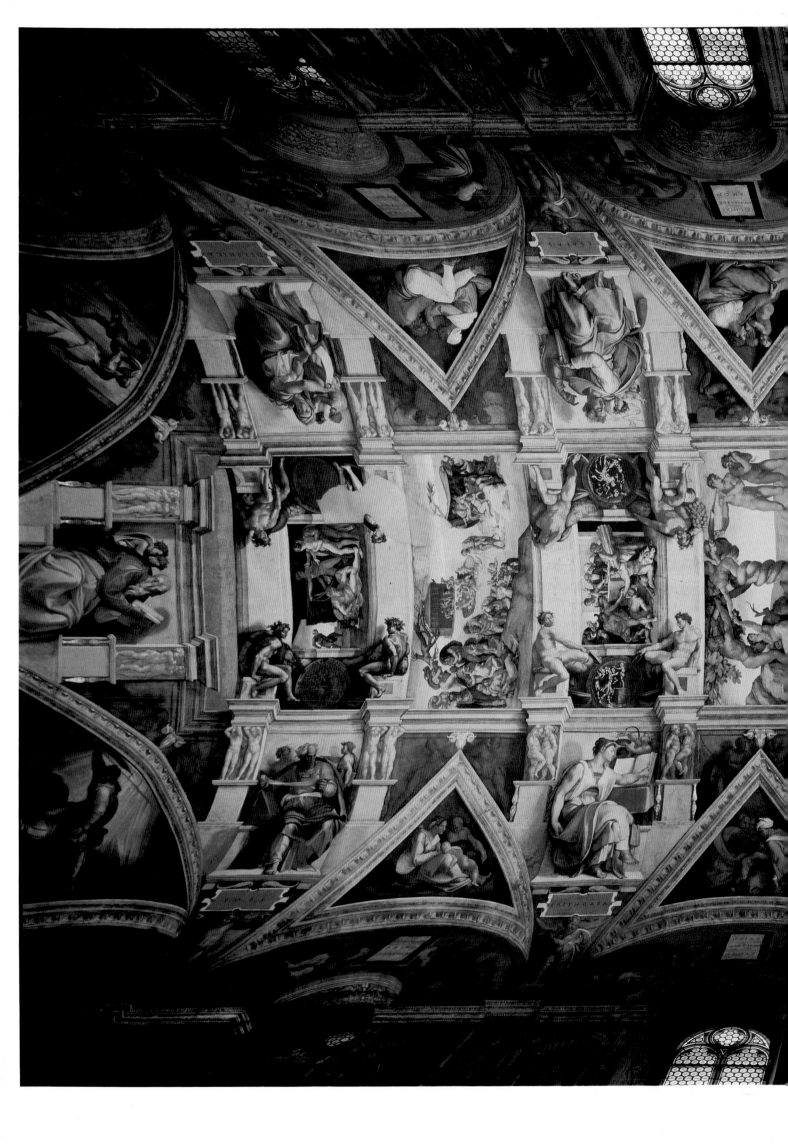

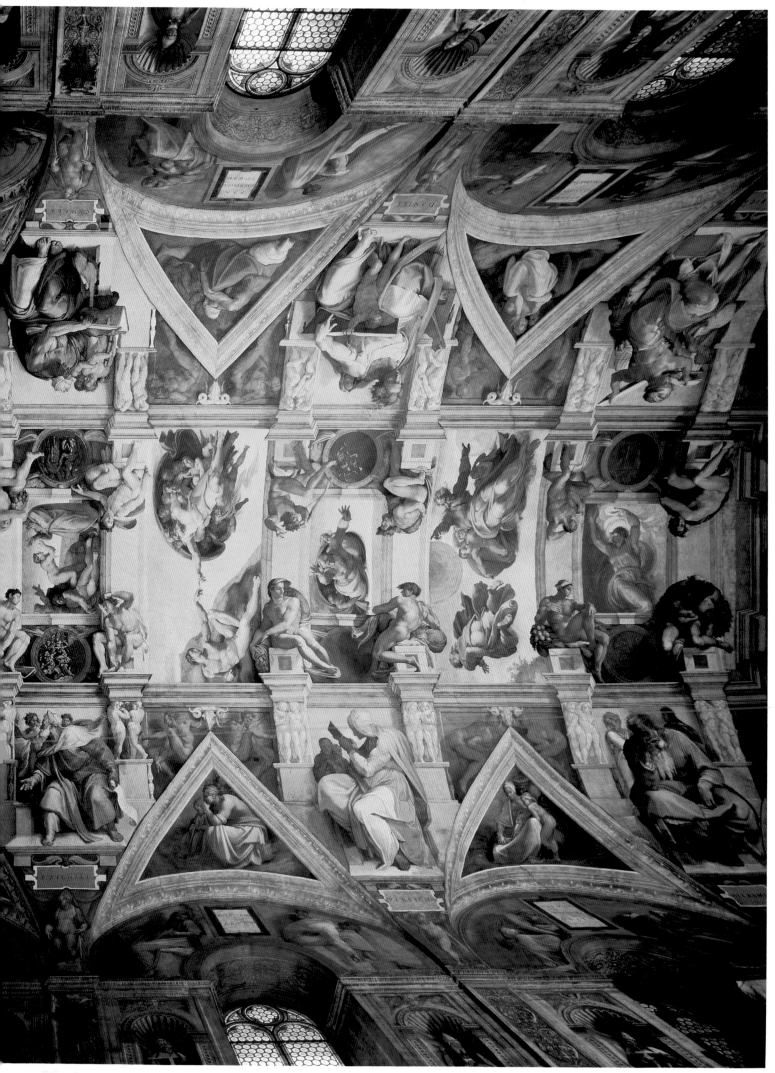

THE FRESCOES ON THE CEILING OF THE SISTINE CHAPEL. 1508–1512

'not for oratories or tombs'. At one time the relief was considered to be 'unfinished', but to modern eyes this does not seem to be the case.

ST MATTHEW. Plate 47 (48). Marble, 8 ft. 11 in. Unfinished. Begun immediately after the David, a contract having been signed on 24 April 1503 with the Arte della Lana in Florence for twelve Apostles for the Cathedral. In the winter of 1504-5 Michelangelo was working mainly on his battle cartoon; in March 1505 he was summoned to Rome by Julius II, with whom he made a five-year contract for the tomb. After this, on 18 December 1505, the contract for the Apostles was cancelled. Four months later, when Michelangelo fled from Rome to Florence, he appears to have resumed work on the St Matthew (April–November 1506). At the end of November 1506 he joined the Pope in Bologna and began work on the large bronze portrait (since lost). The St Matthew thus remained unfinished.[12] It was kept in the Opera del Duomo until 1834, when it was removed to the Accademia in Florence. Wölfflin and Justi think that most of the work on the statue was done about 1504; Thode and Mackowsky, about 1506. Ollendorf has drawn attention to a certain influence of the Laocoön, which was discovered in 1506, especially in the expression and poise of the head. Grünwald has established that the antique 'Pasquino' was used as a model.

THE CEILING FRESCOES IN THE SISTINE CHAPEL. Plates 49-140. The ceiling painting, as reproduced in Plate 49a,b, measures 45 × 128 ft.

Fresco-painting (fresco buono) is painting on damp lime wash. In this process the lime serves to bind together the pigments and also to provide the white colouring. Only a limited number of colours can be used and these become lighter when dry. The painter applies as much of the plaster as will serve for one day's work; if the plaster were allowed to stand for more than a day, a film of lime would be formed on which the painting would appear patchy. In Michelangelo's frescoes the edges of each application can be clearly discerned and we can thus determine how much he painted every day. In his time the ground was composed of two parts marble sand to one part plaster. To this ground of sand and plaster, which was dampened the night before, and applied in several layers, was added a damp covering of marble dust and plaster. The previously prepared drawing, or cartoon, was cut into pieces, each of which represented a day's work. The section of the drawing was then fastened on to the fresco ground and

the outlines were traced with an iron stylus. (These traced contours, which were not always followed exactly in the execution of the painting, can be clearly discerned in some of our reproductions, e.g. Plate 62.) The fresco took about six weeks to dry. After drying, the ceiling paintings of the Sistine Chapel were partly gone over a secco in size-colour. The colouring does not greatly differ from that of the 'Doni Madonna', but in the course of the four years' work Michelangelo tended more and more towards the use of subdued grey, grisaille-like tones. The modelling, especially that of the flesh parts, is lead-grey; the high lights have the full strength of the white lime. Grey, grey-violet, grey-brown, grey-green, olive-green, yellow, cerise, orange-red and even pure black are used; the colours achieve their strongest effects in the shadows, in the half light they are broken with grey and in the full light with yellow.

The project of re-painting the ceiling of the Sistine Chapel was conceived by Pope Julius II in 1506. The contract with Michelangelo was concluded on 10 May 1508. Scaffolding was erected a month later and on 27 July the ceiling was covered with plaster as a ground for the frescoes. Numerous assistants took part in the work, among them Francesco Granacci, but they seem to have carried out only labourer's work. According to Biagetti and Redig de Campos, the work of assistants can be seen not only in the ornamental parts, but also in single figures of the Flood, the earliest of the frescoes. The standing mother with her children is quoted as an example of where the sharp outlines are said to show the hand of a helper who slavishly followed the master's cartoon. This assumption, however, is not easy to prove. Giuliano da Sangallo gave Michelangelo technical advice, especially as to the means of avoiding 'efflorescence' – the formation of mould on the damp plaster. Before Michelangelo overpainted it, the face of the vaulting of the chapel had been painted to form a blue sky with gold stars. According to his original plan, the central portion was to be filled with grotesques and the twelve Apostles were to be painted between the empty spandrels.[13] Gradually the plan was extended until it became the final version, including the spandrels and lunettes, with Prophets and Sibyls instead of the Apostles; three hundred figures were executed, as against the twelve of the first project. Between the autumn of 1508 and September 1510 the eastern half of the ceiling was completed. This is the part beginning at the entrance and running from Noah's Drunkenness to the Creation of Eve, with the nude figures of youths, Prophets and Sibyls as far as Ezekiel and the Cumaean Sibyl. Between January and August 1511 the western half of the ceiling was painted.[14] On 14 August 1511 the ceiling frescoes were unveiled and on 31 October 1512 the first Mass was celebrated in the chapel.

[12] In his life of Andrea Ferruci da Fiesole, Vasari says: 'Andrea was employed by the wardens of Santa Maria del Fiore to make the statue of an Apostle, four ells high [about 7 ft. 10 in.]. This was at the time when Cardinal Giulio de' Medici was ruling in Florence. At the same time [1512-15] four similar figures were allotted to four different masters: one to Benedetto [Rovezzano, 1512], one to Jacopo Sansovino [c. 1513], a third to Baccio Bandinelli [1514-15] and a fourth to Michelangelo Buonarroti.' The contract with Andrea Ferrucci for a statue of St Andrew the Apostle is extant, dated 13 October 1512. Was there a second contract with Michelangelo for an Apostle statue at about the same date? (Cf. Vasari, ed. Milanesi, 1879, vol. IV, pp. 478, 479 – note 2, and 532.) I accept the usual dating 1504-06, but only with some doubt, as the St Matthew agrees in style much more with the statue of Moses and could therefore be connected with a hypothetical second commission for Apostle statues in about 1512. Moreover, the only extant drawing by Michelangelo for the statue of an Apostle (BB.1521r.) shows a figure which recalls rather the statues of the Piccolomini altar and is quite different from the St Matthew in the Florence Academy.

[13] The simple decoration of a starry sky was painted (twenty-five years before Michelangelo came to the Sistine Chapel) by Pier-Matteo Serdenti d'Amelia. This decoration was destroyed when Michelangelo began his work. In a letter to Giovanni Francesco Fattucci, of December 1523, Michelangelo says: 'My first design included the twelve Apostles between the lunettes, and for the rest a certain arrangement of compartments filled with ornaments, such as is customary.'

[14] The Ancestors of Christ, in the lunettes and the spandrels above them (Plates 103-124), were painted after the finishing of the last Histories and the unveiling, i.e. between October 1511 and October 1512; the cartoons had been finished by the beginning of 1511.

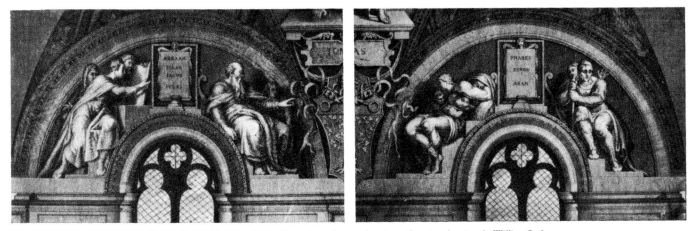

The two destroyed lunette paintings. Engravings, after now lost sixteenth-century drawings, by William Ottley

The impression produced on Michelangelo's contemporaries by these frescoes was enormous and it has been maintained through four centuries. Goethe wrote in 1786: 'No one who has not seen the Sistine Chapel can have a clear idea of what a human being can achieve. . . . The master's inner security and strength, his greatness is beyond all description. . . . At the moment I am so engrossed by Michelangelo that even Nature makes no appeal to me, for my vision is so small compared with his. If there were only some means of fixing such pictures in one's soul! But at least I shall bring with me all the engravings and drawings after his works that I can find.' In England the fame of Michelangelo had already been exalted in the Academy lectures given by Reynolds (1769–91) and Henry Fuseli (1801). Reynolds called his style 'the language of the gods', while Fuseli said: 'A beggar rose from his hand the patriarch of poverty; his women are moulds of generation; his infants teem with the man; his men are a race of giants.' Another painter, Benjamin Haydon, objected to this exaggeration (*Encyclopædia Britannica*, 7th edition, 1838): 'His women may be moulds of generation, but certainly not of love.' And he attacked vigorously Michelangelo's monumental style: 'When you see an outline like iron, that is the grand style. When hands are twisted, heads distorted, one leg up, the other so far removed from the body, that you may question if it will return, that is the grand style. . . . Every figure of his looks as if he was insulted and preparing to return a blow. If they sleep they seem as if they would kick; if they move when they are awake, they seem as if all their muscles are cracking.'

The general view of the ceiling (Plate 49a–b) shows the whole of the paintings except for the lunettes, which extend downwards on the walls. The three triple central portions contain the actual narrative (Plates 51–59). Stendhal already recognized that 'spiritually we must separate these compartments from everything that surrounds them and consider them as separate paintings'. They narrate the three origins of the world and mankind: the first Trinity, the origin of the World: the division of light from darkness, the creation of the stars, the separation of water from land and with the latter the creation of animals and plants (Plates 51–53).[15] The second Trinity, the origin of mankind: the creation of man and woman, the Fall, the expulsion from the Garden of Eden into the wilderness of this world (Plates 54–56).[16] The third Trinity, the origin of Sin: the Flood, Noah's sacrifice and his covenant with God, the drunkenness of Noah and the continuing of Sin (Plates 58, 57, 59).[17] This ends the narrative of the middle compartments – the tale of mankind living in sin and awaiting redemption. Round these nine pictures are the twenty youths bearing garlands, who with their vigorous movements emphasize the same idea as the captives on the tomb of Julius, namely the vain efforts of mankind while still unsaved (Plates 72–91). The chorus of seers, Prophets and Sibyls, likewise points to salvation (Plates 127–140). The four subjects in the triangular spaces at the corners deal with temporal salvation, the deliverances from earthly distress, the miraculous deliverances of Israel (Plates 66–69). The victory of a boy and the victory of women are represented, the victory of weakness over strength and of the grace of God over violence. We see the triumphs of David, Judith and Esther; but the most significant of these pictures is the fourth, the 'Brazen Serpent'. 'And as Moses lifted up the

[15] Plate 53 reproduces what Vasari calls 'The Dividing of the Waters from the Land' and Condivi 'The Creation of the Denizens of the Waters'. Konrad Lange (*Rep. f. Kunstwissenschaft* XLII, 1919, p. 1 f.) and Adolfo Venturi (*L'Arte* XXII, 1919, p. 85 f.) accept in a way Vasari's interpretation, but Erwin Panofsky (1923) supports Condivi's theory. – Lange and Venturi, however, call the fresco 'The Separation of Sky and Water' because there is no earth to be seen in it. The Bible describes thus the third day of the Creation: 'Let the waters that are under the heaven be gathered together into one place, and let the dry land appear.' Which means that at the beginning of the third day the earth was not yet visible, just as on the second day.

[16] In Plate 60 the right arm of God is stretched out creating Adam, while his left arm is round the shoulders of a young woman and his left hand rests on a child. According to an ingenious explanation of J. P. Richter, the one figure is Eve, as she appears before her creation in God's mind, the other figure is the Christ child (*Thode*, II, p. 323; *Tolnay*, II, p. 35).

[17] The sequence of the narrative is altered in the ceiling paintings because Michelangelo wanted to use the large central compartment for the 'Flood' with its numerous figures. – Condivi, and following him Vasari in the second edition of his work, calls the first compartment not 'Noah's Sacrifice', but the 'Sacrifice of Cain and Abel'. This sacrifice was the cause of Abel's murder, the first sin upon earth; and if we are to assume that Condivi was right, then the sequence of the three pictures would be correct.

The theme of the Deluge was chosen by Savonarola for his Lenten sermon of 1494 on the Ark of Noah: 'Ecce ego abducam aquas super terram – behold, I, even I, do bring a flood of waters upon the earth'; in this sermon Savonarola foretold the divine wrath and the fall of Florence. Pico della Mirandola relates that he trembled in every limb and that his hair stood on end when he heard this stern warning; Michelangelo must have heard the sermon too, for he did not leave Florence until October of that year.

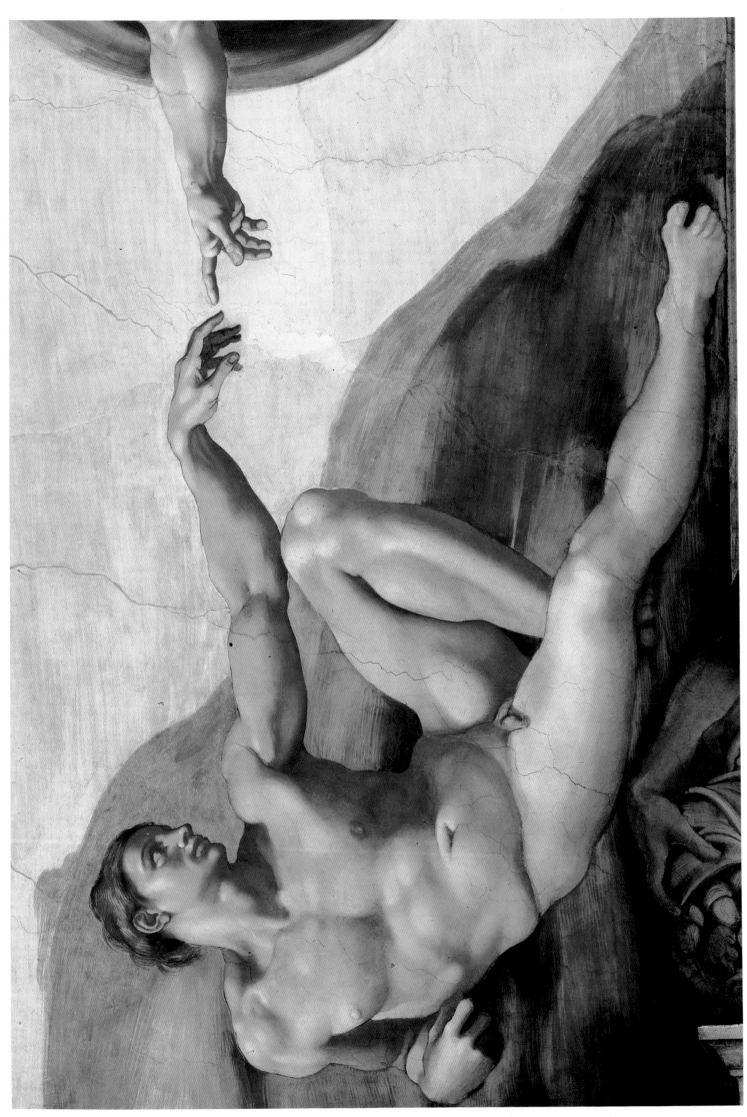

ADAM. Detail from *The Creation of Man* (Plate 54). 1511. Sistine Chapel Ceiling

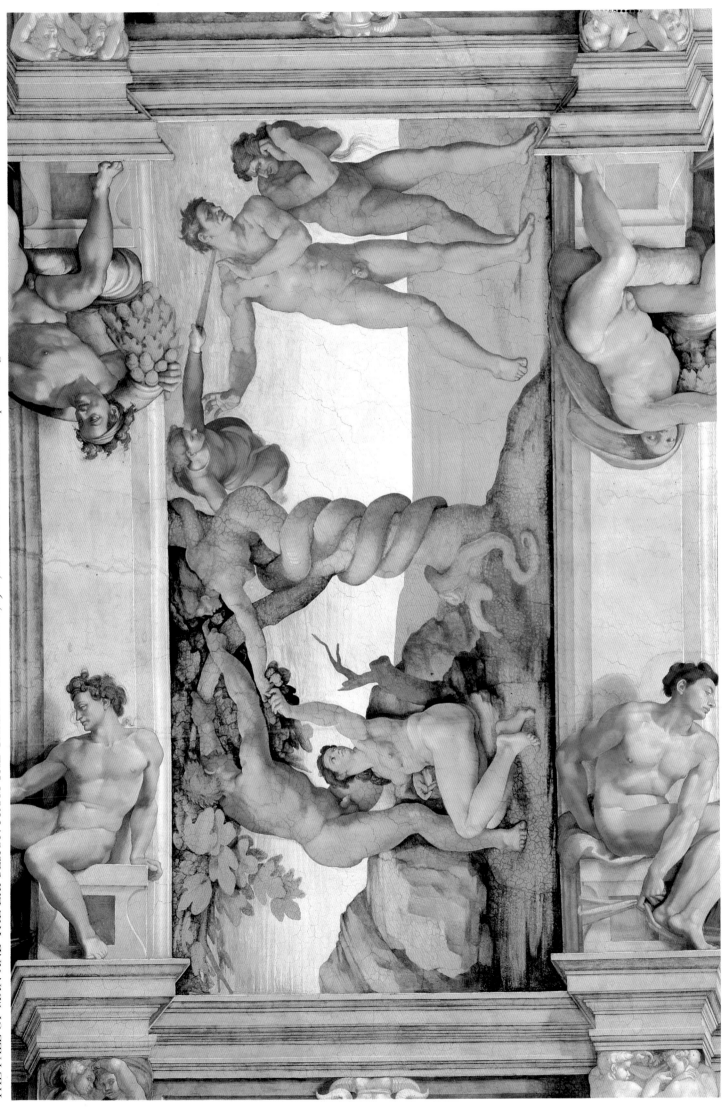

serpent in the wilderness, even so must the Son of man be lifted up: That whosoever believeth in him should not perish, but have eternal life' (Gospel according to St John, iii, 14, 15). This prefiguration of the Redeemer's coming is connected with the pictures of the Ancestors of Christ in the other spandrels and lunettes (Plates 103–126).

The first two lunettes, painted above the altar, were destroyed by Michelangelo himself, when he walled them up (1535) in order to paint the 'Last Judgement' on this wall. (See the illustrations on p. 17.)

The Sistine ceiling frescoes have of course suffered during the more than four hundred years of their existence. As early as 1547 they are mentioned as being in a poor state in a letter from Paolo Giovio to Vasari. About 1570 parts were restored, especially 'The Sacrifice of Noah', of which a piece had fallen off. The female figure in the left foreground was completely repainted by the restorer Domenico Carnevali. Further restorations were carried out in 1625 and 1712. On 28 June 1797 the blast of an explosion in the gun powder magazine of the nearby Castel Sant' Angelo damaged a part of the *Flood* and the decorative parts around it. Extensive restorations followed. A drawing at Windsor Castle (Plate 74), a copy by a pupil of Michelangelo, reproduces one Nude Youth almost completely destroyed by that explosion. The latest restorations were carried out in 1903–6, and 1935–8.

THE TOMB OF POPE JULIUS. Plates 141–150; 234–236; X, XI. First contract and first design, March 1505; it was stipulated that there should be forty statues, delivery within five years, against payment of 10,000 ducats. In April Michelangelo went to the quarries at Carrara; in December he returned to Rome and set up a workshop in Piazza San Pietro. 'If only my blocks of marble would arrive from Carrara!' he wrote to his father on 31 January 1506. 'In this matter I think I have the greatest ill-fortune. . . . A few days ago a vessel arrived which had been all but sunk owing to contrary winds, and when I had succeeded in unloading it there came a flood which swamped everything in such a way that I could not begin work.' The work thus began without the blessing of the stars and elements. Condivi called the story of its execution 'The Tragedy of the Tomb'. On 17 April 1506 Michelangelo fled from Rome, feeling that he was not properly appreciated by the Pope and that he had been grievously offended. From Florence he wrote on 2 May 1506 to Giuliano da Sangallo: 'If I had stayed in Rome any longer, it would have been indeed a question not of the Pope's tomb, but of my own. That was the reason for my sudden departure.' But a few days later Roselli wrote to Michelangelo that people in Rome were saying that Michelangelo was frightened by the idea of having to execute the frescoes in the Sistine Chapel and that this was the reason for his flight. In Florence Michelangelo may have resumed work on his battle cartoon; the tomb seems to have been forgotten. The Pope had important political plans; he was thinking of war and of reconquering for the Church her lost territories. On 23 August 1506 he left Rome and on 11 November he entered Bologna without encountering resistance. He at once summoned Michelangelo thither, in order that he might cast his statue in bronze for the reconquered city. Michelangelo went to Bologna 'with the rope round his neck', as he himself expressed it; but the tomb seems to have been forgotten again. From 1508 to 1512 Michelangelo worked in Rome on the frescoes for the ceiling of the Sistine Chapel. After finishing them, he wanted to resume work on the tomb, but no agreement could be reached. In October 1512 Michelangelo wrote to his father: 'I am still doing no work and am waiting for the Pope to tell me what to do.' On 21 February Julius II died and on 6 May a second contract was concluded with the executor of his will. Michelangelo undertook to complete the tomb in seven years and not to accept any other work in the meantime; he was to receive 1300 ducats in addition to the 3500 he had already had from Pope Julius. He submitted a revised design. Between 1513 and 1516 the *Moses* and the two *Captives* were executed (Plates 141–150). Michelangelo had a workshop at the Macello dei Corvi and employed Florentine stonemasons. In July 1516 a third contract was made and a modified design submitted, but there was a fresh interruption owing to work on the designs for the façade of San Lorenzo. The following years were spent in unproductive work in Florence and in journeys to the marble quarries of Carrara, Pietrasanta and Seravezza. In 1520 the contract for the façade of San Lorenzo was definitely cancelled, but work on the Medici tombs was begun. In 1525, while working on the Libreria, he first had the idea of completing the Julius monument as a wall-tomb. But no decision was reached, although Michelangelo submitted a new design in October 1526. He went on working on the Medici tombs. The year 1529 was spent in work as an architect of fortifications. On 29 April 1532, after prolonged negotiations, a fourth contract was drawn up, but then came the execution of the *Last Judgement* and after its completion in 1542 the work on the tomb of Julius, which had long been relegated to assistants, was entrusted entirely to Raffaello da Montelupo and Pietro Urbano. 'I wish I had learned in my youth to make matches,' wrote Michelangelo in this year, 'then I should not be in such a state of agitation. . . . I do not want to go on living under this burden. . . . Only death or the Pope can release me from it. I have wasted all my youth, chained to this tomb.' In the fifth contract (20 August 1542) everything was granted that Michelangelo had requested in his petition to Pope Paul III. 'Master Michelangelo Buonarroti,' begins this document, 'undertook a long time ago to execute a tomb for Pope Julius.' . . . 'Master Michelangelo,' it says later, 'shall be authorized to entrust three of the six statues destined for this tomb to a good and esteemed master . . . and the other three, among them the Moses, shall be by his own hand. But as Master Michelangelo has given the three statues which are already quite far advanced, namely the Madonna with Child on her arm in a standing posture, and a Prophet and a Sibyl, both seated, to the Florentine Raffaello da Montelupo . . . there remained for him to complete with his own hand only the other three statues, namely the Moses and the two Captives, which are all three almost finished. But as the two Captives mentioned were begun when the work was planned on a far larger scale [a much larger number of statues had been contemplated, but by the contract of April 1532 the number was reduced],

they are no longer suited to this project. . . . Wherefore Master Michelangelo began work on two other statues, which are to stand on either side of Moses, namely the Contemplative and the Active Life, which are fairly well advanced, so that they can easily be completed by other masters.' At that time Michelangelo had undertaken a work for Pope Paul III, the frescoes in 'his chapel', that is to say the Cappella Paolina, a work which, as he himself says, 'required a whole man free from care'. In February 1545 the monument was finally erected. 'It can now be seen in San Pietro in Vincoli',[18] wrote Condivi in 1553, 'not, as in the first design, with four façades, but with *one* front, this being one of the smaller ones, not standing free, but against the wall. But although the work had been patched up and reduced, it is still the worthiest monument to be found in Rome and perhaps in the whole world, on account of the three figures thereon which are by the master's own hand.' (Plates 141, 235, 236). The lower storey of the architecture is the work of Antonio del Pontasieve (1513-14). The four herms are by Jacomo del Duca (who, about twenty years later, helped Michelangelo with the Porta Pia). The upper storey of the architecture is the work of Urbino (Francisco di Bernardino d'Amadore), whose assistant Giovanni de' Marchesi is probably responsible for the four ugly heads underneath the candelabra. The contract between Michelangelo and Urbino is dated 21 August 1541. The Pope's coat-of-arms is by Donato Benti (1543). The four figures on the upper storey are the work of two independent assistants (see caption of Plate 234). About the Sibyl and the Prophet by Montelupo we may believe what Vasari says: 'Raffaello da Montelupo fell ill while engaged upon the work, he could not devote his usual care and diligence to it, so that he lost in reputation and Michelangelo was dissatisfied.' The Madonna was begun by Sandro Fancelli (called Scherano da Settignano), but also finished by Montelupo. Urbino had perhaps a share in Boscoli's statue of the Pope.
(See also Appendix, Plates X, XI and XIV-a.)

MOSES. Part of the tomb of Julius. Plate 141 (142-144). Marble, 100 in. high. According to Thode, it was begun in 1506, but Knapp maintains that a consignment of marble from Carrara of 24 June 1508[19] was intended for the Moses as well as for the two Captives now in the Louvre. Vasari, however, states explicitly: 'While Michelangelo was engaged on this work, the remaining blocks of marble destined for the tomb arrived from Carrara and were unloaded at the Ripa'; at that time the Pope had 'his head full of Bologna matters'; this must therefore have been in 1506. Between the beginning of this work and its completion came the execution of the figures of Prophets on the ceiling of the Sistine Chapel, Joel and Jeremiah. 'When Michelangelo had finished the Moses,' writes Vasari in 1568, 'there was no other work to be seen, whether ancient or modern, which could rival it.' He praises especially the painteresque treatment of the hair – 'one might almost believe that the chisel had become a brush'. Stendhal (1817) says: 'Those who have not seen this statue cannot realize the full power of sculpture,' but he also mentions the 'profound disparagement' which had been the statue's lot and quotes the sculptor Falconet, who declared that the Moses was more like a galley-slave than a divinely inspired lawgiver, and the painter Fuseli, who discovered in it a resemblance to a satyr or a 'goat's face'. About this time Goethe kept a small bronze copy of the Moses on his writing desk. The costume is imitated from antique statues of barbarians (an attempt at historical accuracy). 'The rest is entirely in the antique style,' says Condivi.

THE HEROIC AND THE DYING CAPTIVES. Belonging to the Julius tomb. Plates 145-150. Marble, 7 ft. 1 in. and 7 ft. 6½ in. These two statues were not used for the tomb of Julius, because, as we learn from Michelangelo himself, they could not be fitted into the reduced design. In 1544, while the tomb was being erected, the master was lying ill in the palace of Roberto Strozzi. The latter, a cousin of Caterina de' Medici and a great-grandson of Lorenzo il Magnifico, was the owner of banking houses in Rome and Lyons and had influence at the French court. He conspired against Grand-Duke Cosimo de' Medici and shared with Michelangelo the ambition of restoring Florence to its republican freedom. In 1544 Michelangelo presented him with the two statues, and six years later Strozzi gave them to King Henri II of France, who in turn presented them to the Connétable Anne de Montmorency for his castle of Écouen; in 1632 they belonged to Cardinal Richelieu; in 1794 they became state property and so passed to the Louvre. The Heroic Captive shows a deep crack, which goes across the face and down to the left shoulder (retouched in most reproductions). The antique prototypes of these Captives were not the statues of fettered barbarians, but the Hellenistic representations of Marsyas, which survived in mediaeval figures of St Sebastian. Ever since Condivi's time cautious attempts have been made to discover the allegorical significance of the Captives; almost every possible suggestion has been made, down to the 'personification of the mass for the dead'. Condivi writes (in 1553): 'Between the niches there should have been herms, to which, on cube-shaped projections, other statues were bound like captives. These represented the liberal arts and in the same way painting, sculpture and architecture, each statue with its attributes, making them easily recognizable. This was intended to signify that all the noble arts had died at the same time as Pope Julius.' Oscar Ollendorf has interpreted the Captives in the platonic sense, Werner Weisbach as triumphal symbols. A political interpretation, which has not found support, was given by Vasari: 'These Captives represent the provinces which the Pope subjugated and incorporated in the Papal State.' If we ignore all these conjectures, and also those of Justi, Thode, Brockhaus, Borinski and Laux, if we wish to see nothing except what the works themselves reveal to our eyes, these Captives become easily comprehensible, eternally human symbols: captives

[18] Instead of in St Peter's, as was originally planned.
[19] The accompanying letter to Michelangelo mentions 'the large statue', 'two statues' and the 'statue of His Holiness', in other words four blocks hewn in the rough. Laux (*Juliusmonument*, 1943, p. 158) assumes a much later date for the Moses: after 1515 or even after 1519. See the contract of 1542 (here p. 20) where the Moses statue is called 'almost finished'. This means that parts of the statue may have been retouched in the time from 1542 to 1545.

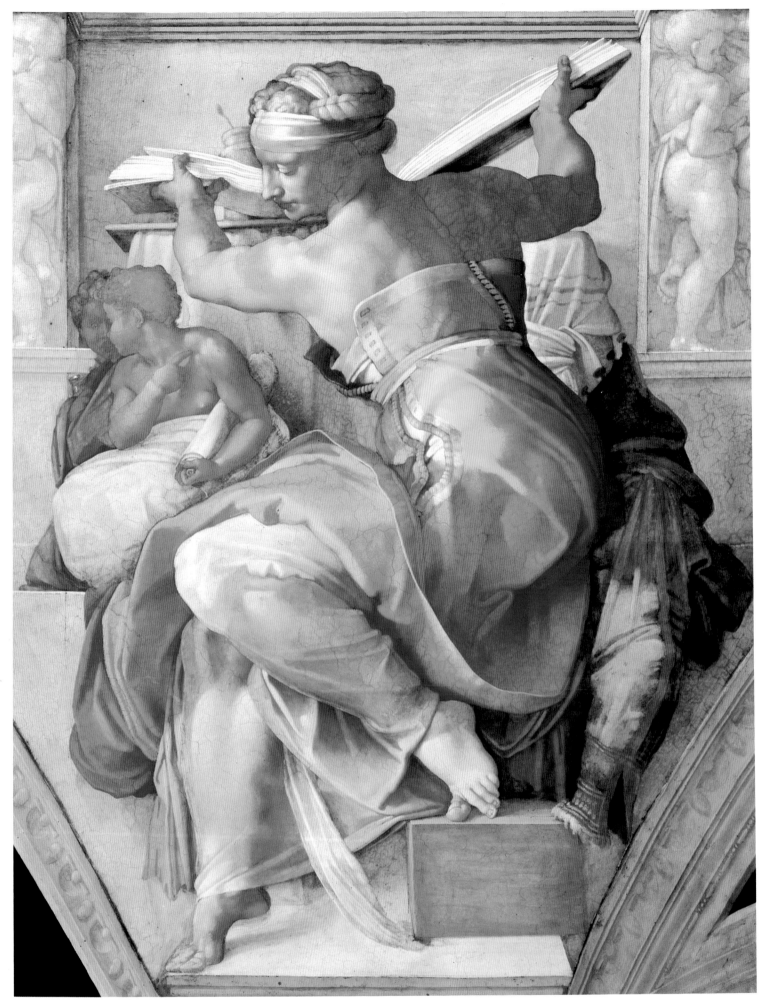

THE LIBYAN SIBYL. 1511. Sistine Chapel Ceiling

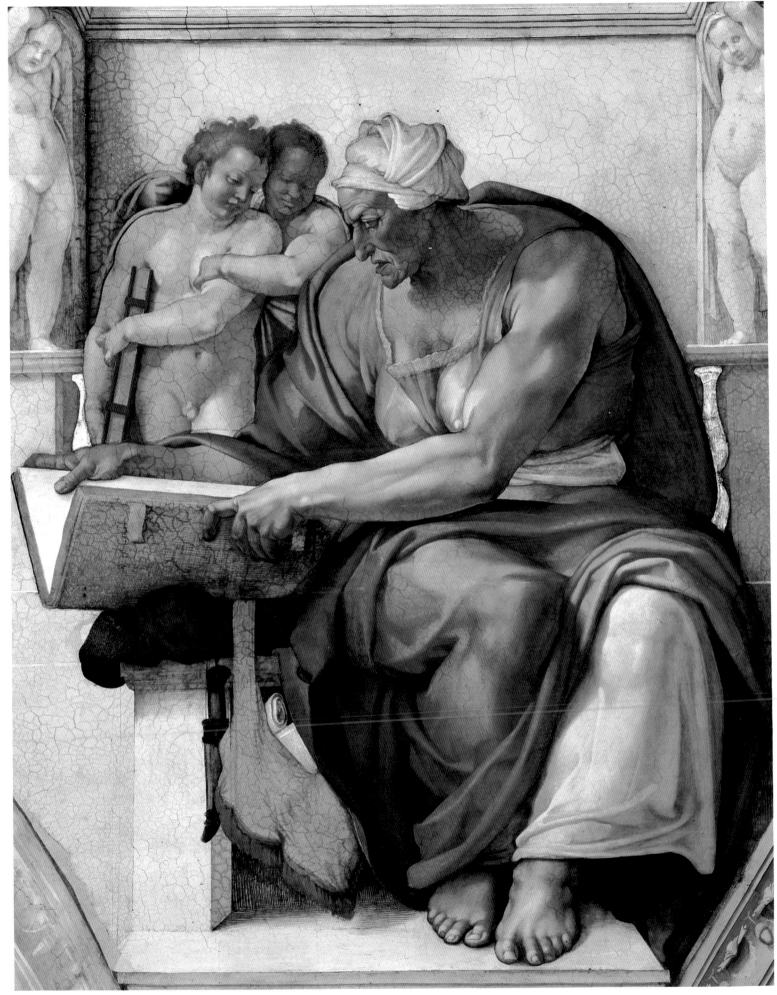

THE CUMAEAN SIBYL. 1510. Sistine Chapel Ceiling

of life, of dreams and of death, struggling against the bonds of fate and relentless nature, Titans who wrestle in vain or relapse into redeeming unconsciousness. In this sense these eternally vanquished beings become the counterparts of the temporal conquerors, the Victories (see Plate 203).

THE RISEN CHRIST. Plates 151–153. Marble, 6 ft. 10 in. high. Commissioned on 14 June 1514 by Metello Vari and two other Romans, in return for a fee of 200 ducats. A black vein was found in the marble, which disfigured the face, and Michelangelo had to begin again. This first version, since lost, was seen by Aldovrandi in 1556 in Vari's courtyard. Owing to this defect in the marble, work was broken off in 1516; on 21 December 1518 the new block of marble from Carrara had not yet arrived. At that time Michelangelo wrote to Lionardo Sellaio in Rome: 'I am also being pressed by Signor Metello Vari concerning his statue, which is in Pisa[20] and should arrive by one of the first vessels. I have never answered him and shall not write to you again until I have begun the work; for I am dying of grief and against my will appear to myself as a swindler.' The barges conveying marble from Carrara had been held up in Pisa owing to the drying-up of the Arno. The second version of the Christ was created in Florence between the beginning of 1519 and April 1520. Michelangelo's assistant Pietro Urbano was sent to Rome to erect the statue in Santa Maria sopra Minerva and to finish it there. On 6 September 1520, Sebastiano del Piombo wrote in a letter to Michelangelo: 'I must tell you that Pietro Urbano has ruined everything that he has worked upon. Especially the toes of the right, completely visible foot, which he has mutilated, also he has shortened the fingers of the hands, especially those of the right hand holding the Cross, so that Frizzi says that they look as if they had been made by a baker of cracknels. . . . Also one can see clearly what he has been up to with the beard; my apprentice could have done it more cleverly. . . . Then, too, he has knocked one of the nostrils about – a little more, and only God himself could have put this nose right! Pietro thinks he is a great master – poor man, he will never learn what it means to make such figures – for the knees of this statue are worth more than the whole of Rome.' Federigo Frizzi subsequently repaired and completed the statue. Nevertheless, Michelangelo proposed to his customer Vari that he should make a new statue, that is to say a third version, for he would hardly have made a replica. But Vari, who had been waiting for this work for six years, wanted no improvements: 'It shows the loftiness of your mind, that you wish to replace a work which could not be better by one that is better.' On 27 December 1521 the statue was unveiled; on 12 January Sebastiano del Piombo wrote to Michelangelo: 'The statue makes a very good impression. All the same, I have said and caused to be said, in all places where it seemed to me fitting, that the execution is not by your hand.'

A SMALL CHAPEL IN CASTEL SANT'ANGELO. Plate 154. This chapel, dedicated to Cosmas and Damian, the patron saints of the Medici, shows the Medici arms on the interior, while outside there is the coat-of-arms of Pope Leo X (1513–21). Erected before Michelangelo moved to Florence in 1516.

WOODEN MODEL FOR THE FAÇADE OF SAN LORENZO. Plate 155. 7 ft. high and 9 ft. 4 in. wide. In 1513 Giovanni de' Medici, a son of Lorenzo il Magnifico, became Pope (Leo X, died in 1521) and in 1523 Giulio de' Medici (Clement VII, died in 1534), a son of the Giovanni who had been murdered in the Pazzi conspiracy of 1478. Under these two Medici Popes Michelangelo received commissions for several works which were meant to do honour to the Medici family. These works were: the façade of San Lorenzo; the transformation of the loggia of the Medici palace; a small aedicula in Castel Sant'Angelo; the Biblioteca Laurenziana; and the Sepulchral Chapel of the Medici. On the designs for the Lorenzo façade Michelangelo worked from 1516 onwards; he even made a small terracotta model which has been lost; then he entrusted to Baccio d'Agnolo the task of making a wooden model after his designs (cf. Plate 155);[21] which did not satisfy him, however, and finally, from August to December 1517, he made another model (with the help of Pietro Urbano) which included wax sketches of the statues and probably also of the reliefs. This model has also been lost. (See Ackerman, *The Architecture of Michelangelo*, 1961, Catalogue, p. 9f. and fig. 5a.) The contract for the Lorenzo façade was concluded on 19 January 1518 and cancelled on 10 March 1520, a few months before the inception of the Medici tombs.

A WINDOW OF THE MEDICI PALACE IN FLORENCE. Plate 156. While Michelangelo was working on his models for the Lorenzo façade, or perhaps after this plan had been abandoned and before the work on the Medici tombs began, Pope Leo X decided to transform the ground-floor loggia of the Medici palace into a hall. 'Michelangelo,' says Vasari, 'made a model for two kneeling windows (finestre inginocchiate) of the Medici palace . . . and directed the making of perforated copper jalousies (gelosie di rame straforato), executed by the goldsmith Piloto.' Piloto worked with Michelangelo in 1520–4, when he made the polyhedric ball with the cross for the dome of the Sagrestia Nuova, the Medici Chapel. Piloto's 'copper jalousies' were later replaced by iron grills; or else, they have perhaps never been on those windows, as Vasari gives contradictory information in the Life of Giovanni da Udine: 'Cosimo il Vecchio had made on his palace a loggia for the citizens to meet. . . . This loggia was now closed, following a design by Michelangelo, and was made in the form of a chamber with *two kneeling windows with iron bars*, the first such erected outside palaces.'

THE BIBLIOTECA LAURENZIANA. Plates 157–163; Plates VIII, IX, XII-f. Commissioned by Pope Clement VII. Michelangelo made the first drawings for it in

[20] He means, of course, the block hewn in the rough.

[21] Plate 155 is identified by A. Schiavo and V. Mariani with d'Agnolo's work; but Tolnay (1951, p. 166) sees in it 'una riduzione del modello del contratto', which must mean a reduced version of Pietro Urbano's model, which he made in December 1517 under the eyes of Michelangelo and took to Rome to show it to the Pope. Prof. Wilde describes this wooden model as 'a free replica of the original' and suspects that it is the work of Giovanantonio Dosio.

January 1524. In the same year the design for the carved ceiling was also made, but this was finished only *ca.* ten years later by Battista del Tasso and Antonio Carota (see Plate IX–b). In 1559, when Ammanati finished the staircase of the Laurenziana (with Vasari's help), Duke Cosimo I de' Medici asked him whether it were not possible to acquire Michelangelo's original design for the carved ceiling. The floor, which repeats the design of the ceiling, was made by Tribolo (together with Sante Buglioni and others), the carved benches by Battista del Cinque and Ciappino, probably also from sketches by Michelangelo. (See Plates VIII and IX.)

THE 'PERGAMO' OF SAN LORENZO. Plate 164. This sacrarium was ordered by Pope Clement VII in order to store there the relics collected by Lorenzo de' Medici. Michelangelo made his first design for it in February 1526, but the work was not finished before the winter of 1532–3. It is erected over the main entrance to the church and faces the altar. Over the left pilaster appear the three Medici rings, while under the loggia – over the door of the church – there is the coat-of-arms of Clement VII, in the shape of a horse's skull, also designed by Michelangelo.

THE FUNERARY CHAPEL FOR THE MEDICI FAMILY. Plates 165–201; 209–211; III–VII, XIII–b, XIV–c. Commissioned by Cardinal Giulio de' Medici, afterwards Pope Clement VII. Originally, in 1520, planned as a free-standing edifice with four tombs, for Lorenzo il Magnifico, Giuliano the Elder, Giuliano Duke of Nemours (died 1516), son of Lorenzo il Magnifico, and Lorenzo Duke of Urbino (died 1519), grandson of Lorenzo il Magnifico; then as mural decoration with two sarcophagi on each wall; then with the addition of a double tomb for the two Medici Popes, Leo X and Clement VII; executed after 1524 in its final form, which underwent various modifications during the work. The figure of the Madonna (Plate 196), which had been projected from the first, was to have been placed on the tomb of Lorenzo il Magnifico and his brother. The final solution was that the papal tomb and those for the Magnifici were omitted, and the project was limited to two separate tombs for the Dukes. In March 1521 the construction of the chapel was begun and the cupola was in position by January 1524 (see Plates VII and XIII). The *Madonna* was begun in the same year and should have been ready by the winter of 1531–2, but was still unfinished in the autumn of 1534, when Michelangelo went to Rome to paint the *Last Judgement* in the Sistine Chapel. Of the four recumbent figures the first to be begun was the *Aurora* (Plate 176), the dates of execution being: *Aurora*, 1524–31; *Crepuscolo* (Plate 177), 1524–31; *Notte* (Plate 179), 1526–31; *Giorno* (Plate 180), 1526–34, unfinished; statue of *Lorenzo* (Plate 169), 1524–34; statue of *Giuliano* (Plate 170), 1526–34. In addition to these, four river-gods were planned, which were to have reclined by the sarcophagi; an over-lifesize clay model for one of these is now at the Accademia in Florence (Plate 200). Participation of assistants: Tribolo began the 'Earth' for the tomb of Lorenzo, but neither the model nor the abbozzo of the statue has been preserved; Montelupo carved, after Michelangelo's model, the *Damian* (holding a pill-box)

while Montorsoli, who also helped to finish the Giuliano, executed independently the *Cosmas* on the other side of the Madonna (Plates IV–c, d). The *Crouching Boy* (Plate 209) was, according to a hypothesis advanced by Popp, intended together with three similar, unexecuted pieces, to crown the entablature. Various attempts have been made to interpret the allegorical meaning of the monument: Borinski saw in it allusions to Dante; Steinmann, to a carnival song; Brockhaus, to Ambrosian hymns; all three of them thus suggest a literary derivation. Tolnay gives an elaborate explanation, according to which the whole chapel was a synthesized representation of the universe, divided into its three zones – Hell, Earth and the Heavenly Spheres. Jacob Burckhardt's opinion of the chapel (1855) was: 'Architecture and sculpture are conceived together in such a way, as if the master had previously modelled both out of one and the same clay.' On the other hand the French painter Henri Regnault declared (1867): 'The statues are in a bad setting. This architecture, which is attributed to Michelangelo, made me quite wild. It is common and without charm, and it reduces and destroys the figures. Those little mausoleums, those tiny pillars and windows which surround the divine figures of the Thinker and Giuliano, made me turn livid with rage.'

Michelangelo made use of marble of various colours. The body of the 'Notte' is almost white, that of 'Giorno' almost brown; the sarcophagus is yellowish, etc.

LORENZO AND GIULIANO DE' MEDICI. Belonging to the Medici tombs. Marble, 5 ft. 10 in. and 5 ft. 8 in. high. Plates 169–174; 186–188; 190–191. Vasari mentions the collaboration of Montorsoli in the execution of both statues; according to Steinmann, his participation was limited to the helmets, armour and other details. Michelangelo made no effort to achieve portrait-like fidelity in the statues of the two dukes; to the Florentines, who missed this lifelikeness and were puzzled by the purely idealistic conception, Michelangelo proudly answered that in a thousand years' time nobody would know what the two Medicis had really looked like. Lorenzo represents the vita contemplativa, Giuliano the vita activa, as already suggested by J. Richardson in 1722.

THE FOUR PHASES OF THE DAY. Belonging to the Medici tombs. Plates 165–166.
Crepuscolo, length of the marble block, 6 ft. 4¾ in.; Plate 175, *Aurora,* length of the marble block, 6 ft. 8 in.; Plate 176. *Notte,* length of the marble block, 6 ft. 4¾ in.; Plate 179. *Giorno,* length of the marble block, 6 ft. 8¾ in.; Plate 180. Stendhal (in *Histoire de la peinture en Italie,* 1817) says: 'The statues in San Lorenzo are partly unfinished. This deficiency is rather an advantage in view of Michelangelo's powerful style.' Stendhal was also the first to draw attention to the resemblances to the 'Belvedere Torso'. 'In both the male figures', he says while discussing the *Giorno* and the *Crepuscolo,* 'one finds striking reminiscences of the Belvedere Torso, but transformed by Michelangelo's genius.' Burckhardt writes: 'In these four statues the master has proclaimed his boldest ideas on the limits and aim of his art. . . . For his successors this was the straight road to ruin.' Vasari wrote: 'And what can I say of the

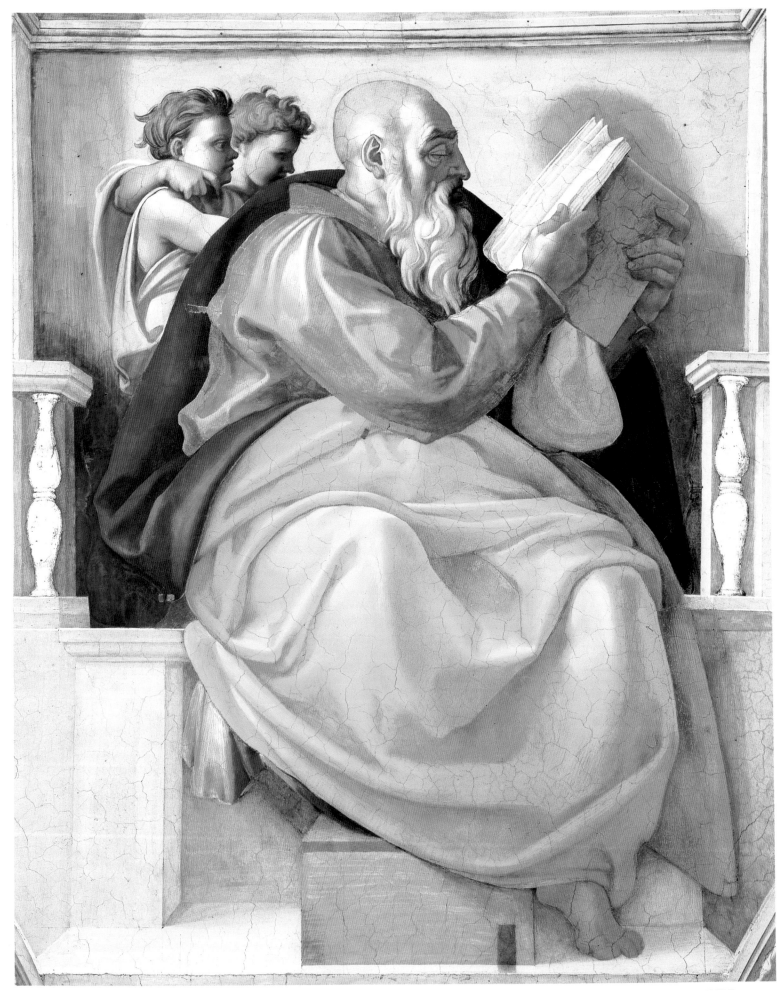

ZECHARIAH. 1509. Sistine Chapel Ceiling

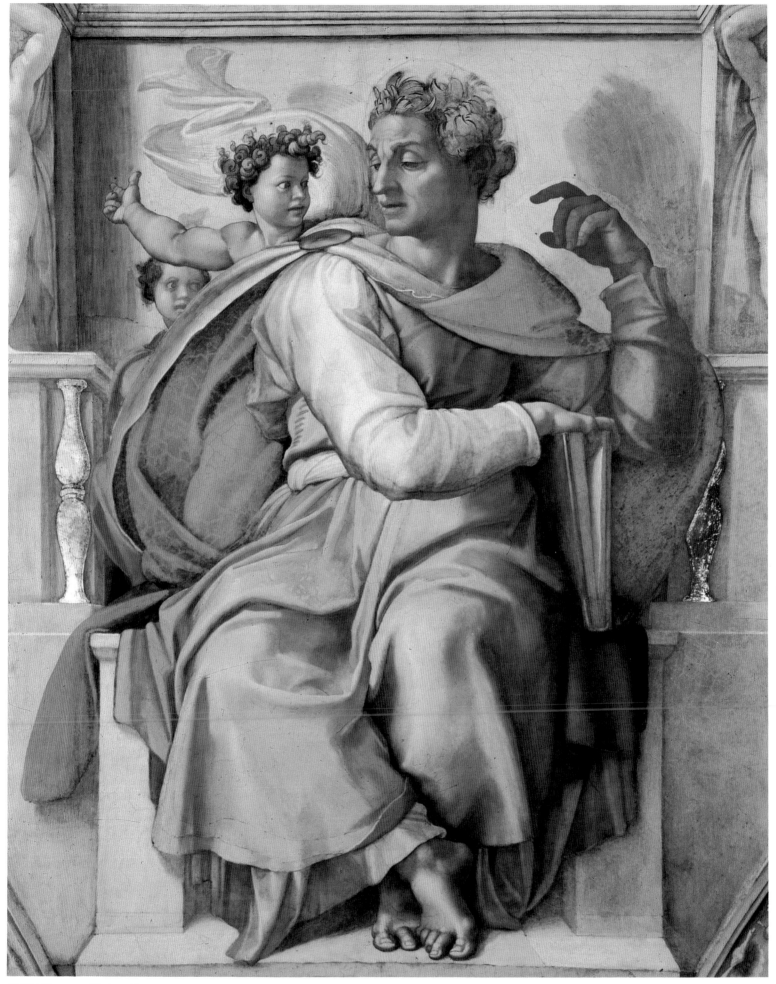

ISAIAH. 1509. Sistine Chapel Ceiling

Night, this statue which is not only a great and rare work of art, but is also unique? Who, in any period, has ever seen a statue, whether ancient or modern, of such a high degree of culture? One can well understand that it was this Night which completely obscured all those artists who for a time sought, not to surpass, but to equal Michelangelo.' Daniele da Volterra made copies of all the figures in the Medici Chapel, and Tintoretto, El Greco and Rubens, among others, drew inspiration from them.

MADONNA AND CHILD. Belonging to the Medici tombs. Plates 196–199. Marble, 7 ft. 5½ in. Burckhardt says of it: 'It is hardly more than hewn in the rough. . . . Owing to a fault in the marble or a slip on the part of the artist, the right arm did not turn out as it should have done and was therefore adjusted behind as we see it to-day. Probably this affected the rest of the statue, which for that reason was completed only schematically and inadequately.' But to this Carl Justi added: 'We live in an age of revision of all values, of a fundamental transformation of the world of culture: and thus it happens that the most criticized of Michelangelo's marble figures, which previously was almost ignored, is now the most praised, as the most powerful expression of his style.'

RIVER-GOD. Modelled in clay and oakum, over wood. 5 ft. 10 in. long. Plates 200–201. On 24 October 1525 Michelangelo wrote to Fattucci in Rome: 'The four rough-hewn statues[22] are not yet ready and there is still much work to do on them. The four others, representing rivers, have not yet been begun, as I have not yet got the marble blocks in my house, although they have arrived in Florence.' The four rivers were conceived as allegorical figures for the bases of the two sarcophagi in the Medici Chapel, but the work does not seem to have progressed further than clay models of the two river gods for the sarcophagus of Lorenzo, of which only one, much damaged, has been preserved (which would probably have been placed beneath the Aurora). Plate 200 shows approximately the correct position, Plate 201 the same figure in a wrong position, as exhibited now.

CLAY MODEL FOR A 'VICTORY' GROUP. Plate 202. 16½ in. high. It is often called 'Hercules and Cacus' or 'Samson slaying a Philistine', but according to Springer, Wilde and Laux (Michelangelos Juliusmonument, Berlin, 1943, pp. 54 and 411) it belongs, like the group in the Palazzo Vecchio (Plate 203), to the tomb of Julius and is a model for a group which was not executed. See also Appendix, Plate XXIII. (But cf. E. Panofsky, Studies in Iconology, New York, 1939, pp. 231 f.) The illustrations in Bode's Denkmäler der Renaissance-Sculptur in Toscana (pl. 531) and in Klassiker der Kunst (pl. 166) show this model without heads and without the right arm of the standing figure, which were only added in 1927, but not quite correctly. There is a copy in wax in the Victoria and Albert Museum, London, that ought to be compared.

THE VICTORY. Probably intended for the tomb of Julius.[23] Plate 203 (204, 205). Marble, 8 ft. 7½ in. high.

Knapp thinks the group was destined for the façade of San Lorenzo; Brinckmann, too, thinks that it was not intended for the tomb of Julius and sees in it an allegory of the platonic Eros; on the other hand, Schottmüller, Wilde and Panofsky, are against this theory. Justi gave it a political interpretation, as symbolizing the overthrowing of liberty in Florence; he describes the group as 'probably the most puzzling work which Michelangelo has bequeathed to posterity'. Mackowsky suspects the collaboration of assistants on account of the 'exaggerated modelling' and dates it about the same time as the Apollo, which was executed after 1530, thus assigning it to the same period as Justi.[24] A terminus post quem is given by the fact that the marble of this statue comes from the quarries of Serravezza which were not worked before the year 1518. A resemblance between the features of the vanquished figure and those of Michelangelo was noted by the older writers (Symonds, I, 89); by assuming that some young minion of Michelangelo was the model for the beautiful figure of the victor, it was easy to arrive at an erotic interpretation.[25] The group was left unfinished in Michelangelo's Florentine workshop. The head is now in parts polished, which may have been done by some assistant; the pupil is incised in the right eye, but not in the left, which is also probably due to the same assistant. After Michelangelo's death the statue was put in the hands of Daniele da Volterra, who proposed to put it, together with other sculptures, on the Master's tomb. R. Wittkower (in Burlington Magazine, 1941, p. 133) suggested that the head of the Victor is the work of Vincenzo Danti; Tolnay called this 'a not very convincing opinion'.

APOLLO. Plates 206 (207, 208). Marble, 4 ft. 10½ in. high, including base. In 1527 the Medici were driven out for the second time, but the Emperor Charles V joined forces with Pope Clement VII and laid siege to Florence. (Michelangelo was then responsible for the fortifications.) The city fell after eleven months (on 12 August 1530). Vasari relates: 'After the capitulation of Florence. Baccio Valori, as the Pope's plenipotentiary, was ordered to arrest some of the most prominent party leaders among the burghers. The court sent to Michelangelo's house to seek him, but, foreseeing this, he had taken refuge in the house of a friend near-by.' The Pope ordered that he should be found and promised him immunity from punishment if he would resume work on the chapel of the Medici family. 'When Michelangelo felt himself thus reassured, he sought first to win the favour of Baccio Valori. He made for him from a block of marble, three ells high [about five foot nine inches], a figure representing an Apollo, who is drawing an arrow from his quiver. This statue, which was not quite finished, now stands

[22] Presumably the Madonna, Lorenzo, Aurora and Crepuscolo.
[23] On this point see the detailed exposition by Karl August Laux, Michelangelos Juliusmonument, Berlin 1943, p. 46 f., and note 18 on p. 411.

[24] See Johannes Wilde, Michelangelo, The Group of Victory, Oxford, 1945.
[25] There is a late echo of this Victory group in the 'Apotheosis of Prince Eugen' by Balthasar Permoser, 1721, in which the 'Vanquished' is actually an authentic self-portrait of the artist (reproduced by Ludwig Goldscheider in 500 Self-portraits, 1936, Plate 295). Michelangelo's group is reminiscent in its composition of Donatello's 'Judith and Holofernes', to which it may also be akin in its meaning as representing the victory of innocence over the power of sin. Male figures of 'Victory' were to be placed on the Julius monument opposite female figures of identical meaning (cf. Plate I–a), representing the chosen few who, notwithstanding their weakness, have been vouchsafed great victories and triumphs over evil, whereas the 'Slaves' symbolize the common crowd overcome by sin.

in the chamber of the Duke of Florence.' Popp describes the statue as a niche figure for the Magnifici tomb and does not believe that it is the statue intended for Valori. She calls it 'David', which is in accordance with the Inventory of 1553, when the statue was in the collection of Duke Cosimo I de' Medici. The bulge beneath the right foot should not be interpreted as the head of Goliath, but might very well be the head of the python slain by Apollo, or just a stone.

THE CROUCHING BOY. According to Popp, intended for the Medici tombs. Plates 209–211. Marble, 22 in. high. Its authenticity is entirely unsupported and therefore doubtful.[26] Hewn out of a cubic block, with maximum utilization of the volume. (I have included this sculpture among the authentic works because I believe that it was begun by Michelangelo himself, although probably continued by Tribolo.[27] One could say what Sebastiano del Piombo said about the Minerva Christ: 'However, I am telling everybody that the execution is not by Michelangelo's hand.') The statue is not quite finished. L. Brown, an Englishman, bought the statue in 1787 from the Medici collection in Florence, and sold it to the Academy in St Petersburg; in 1851 it was transferred to the Hermitage.

THE FOUR UNFINISHED CAPTIVES. Intended for the tomb of Julius. Plates 212–221. Marble. Youthful Captive, 8 ft. 6¾ in.; Atlas, 9 ft. 1½ in.; Bearded Captive, 8 ft. 8¼ in.; Awakening Captive, 9 ft. Inserted by Grand Duke Cosimo de' Medici, who received them from Michelangelo's nephew, into artificial stalactites in a grotto at the entrance to the Boboli gardens in Florence, whence they were transferred to the Accademia in 1908. Mackowsky made a technical study of these four figures, for he believed them to be 'more suitable than any other work of the master's for deducing valuable conclusions as to Michelangelo's methods'. He declares that Michelangelo did not transfer a finished model to marble following the schematic method of point-setting, but that he hewed into the block from one side in the manner of relief. Justi arrived at the same conclusion, quoting the descriptions of Michelangelo's methods by Vasari and Cellini and referring to the five unfinished statues: the St Matthew and the four Captives from the Boboli gardens. Justi speaks of an 'extraction of the statue out of the block from the front. . . . Anyone who knew nothing of its genesis would think that the St Matthew was an unfinished relief. Here we have the front half of a figure, the parts seen in profile or frontally having been carried to different degrees of completion; the other, rear portion, is still hidden in the untouched, quadrilateral block. . . . But it was intended that this apparent half-relief should become a statue in the round.' Mackowsky speaks of the tools used: 'Nowhere can we find traces of the

drill;[28] the whole of the work was done with punch and claw-chisel. In consequence the surface shows parallel strokes which remind us of hatching in a drawing.' F. Baumgart, in *Bolletino d'arte*, XXVIII, 1934, pp. 353–5, compared the technique of the St Matthew with that of the 'Unfinished Captives' and pointed out that the block of Matthew was hewn from the front, while the block of the 'Awakening Giant' was begun to be carved at one of the four upright edges, in such a way that *two* sides of the block were used for the figure. The same method was used for the *Atlas*, both statues being intended as corner figures. (On Michelangelo's technique compared with that of the Greek sculptors, see: *Vasari on Technique*, ed. Baldwin Brown, London, 1907, p. 193; Stanley Casson, *The Technique of Early Greek Sculpture*, Oxford, 1933, pp. 128, 186.) The sculptor Adolf von Hildebrand denied that the four unfinished Captives in Florence were the work of Michelangelo's own hand (in *Michelangelos spätere Plastik*, in *Gesammelte Aufsätze*, Strasbourg, 1916). Kriegbaum was of the same opinion and assumed that one or several assistants worked here from large models by the master. Panofsky (in *Studies in Iconology*, New York, 1939, p. 218) thinks a date as late as 1532–4 possible for the execution of the 'Unfinished Captives'. Tolnay dated the 'Unfinished Captives' after 1534,[29] but Kriegbaum and Laux (*Juliusmonument*, p. 420, Note 59) again pleaded for the earlier date, namely about 1519, Wilde about 1520.

CLAY MODEL FOR A CAPTIVE. (Casa Buonarroti No. 524.) Terra secca, 8⅝ in. high. Plate 222.

CLAY MODEL FOR A CAPTIVE. (L. Fagan, *The Art of Michelangelo . . . in the British Museum*, London 1883, p. 163.) Terracotta, painted green by a later hand. 11⅝ in. high. Plate 223.
Until 1859 in the Casa Buonarroti in Florence.

THE LAST JUDGEMENT. Plates 224–233; XXX. The largest fresco in Rome, painted area 48 by 44 ft. Three frescoes by Perugino and two lunette paintings by Michelangelo were removed to make way for it. The windows in the altar wall were blocked up with bricks[30] and an inner wall of dried bricks was erected; between the wall of the chapel and this inner wall a space for ventilation was left. The wall for the fresco was built sloping, in such a way that it overhung at the top by about half a Florentine 'braccio' (about a foot), thus preventing the accumulation of dust. The ground for oil painting (mortar mixed with resin), which had been applied by Sebastiano del Piombo, was removed by Michelangelo, who painted in fresco on a ground of damp lime and mortar. He executed the whole work personally, being assisted only by an ordinary colour-

[26] Since these words were first printed (1939) two critics have doubted the authenticity of the statue: Kriegbaum (1940), who with good reasons attributes the execution to Tribolo, and Wittkower (1944), who suggests Pierino da Vinci.

[27] I reproduce the front view of the *Crouching Boy* intentionally facing the "Young Giant" in order to show the similarities of style, which are particularly striking in the joints (e.g. the knees). I suspect that Tribolo collaborated on both of these sculptures.

[28] The drill was used by Michelangelo in his early period, particularly in the 'Drunken Bacchus' and the 'Pietà of St Peter's' (see Plates 10–12 and 15), but also in the two earliest *Captives* (Plates 145, 148).

[29] *Michelangelo*, Florence 1951, p. 249: 'between September 1534 and April 1536'. In *The Tomb of Julius II* (*Michelangelo*, vol. IV, Princeton 1954, p. 113 f.) Tolnay corrected his dating to '1532–1534'. Michelangelo's move to Rome in 1534 may be regarded as a certain *terminus ante quem*, for he left these unfinished statues behind in his Florentine workshop.

[30] The preparations for the fresco lasted a year, from the spring of 1535 to the spring of 1536 (*Steinmann*, II, p. 766 f.). The cartoon was finished in September 1535.

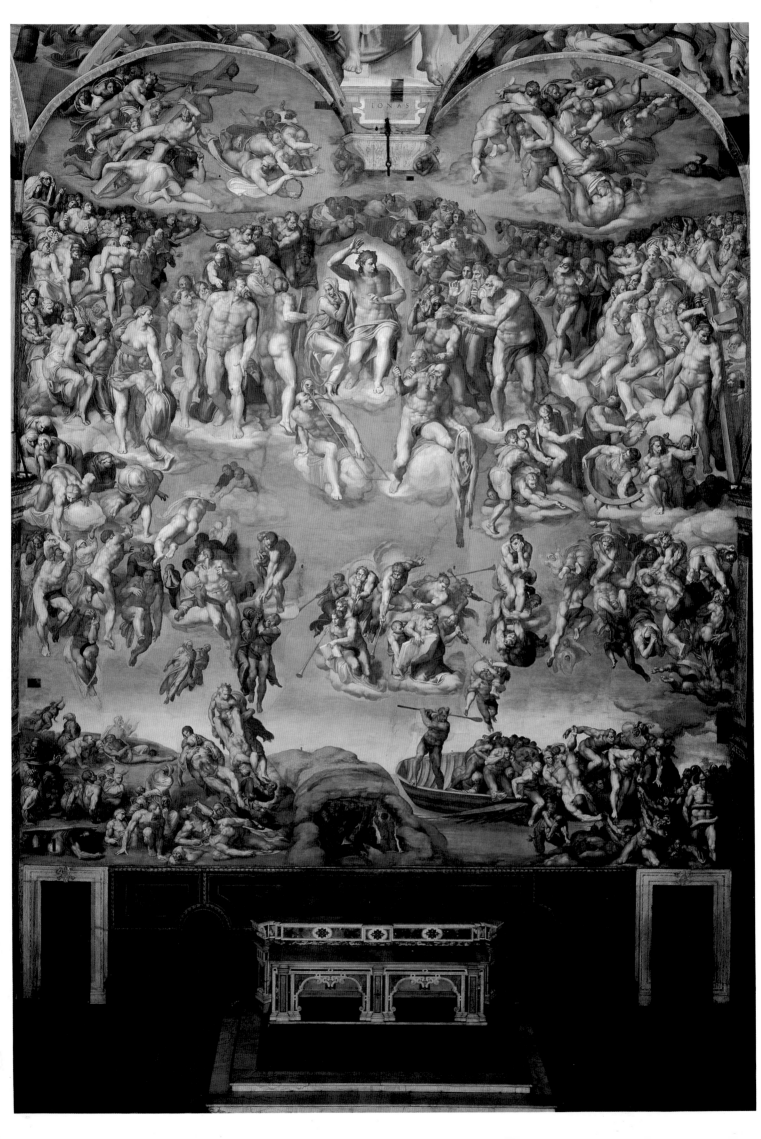

THE LAST JUDGEMENT. 1536–1541. Rome, Sistine Chapel

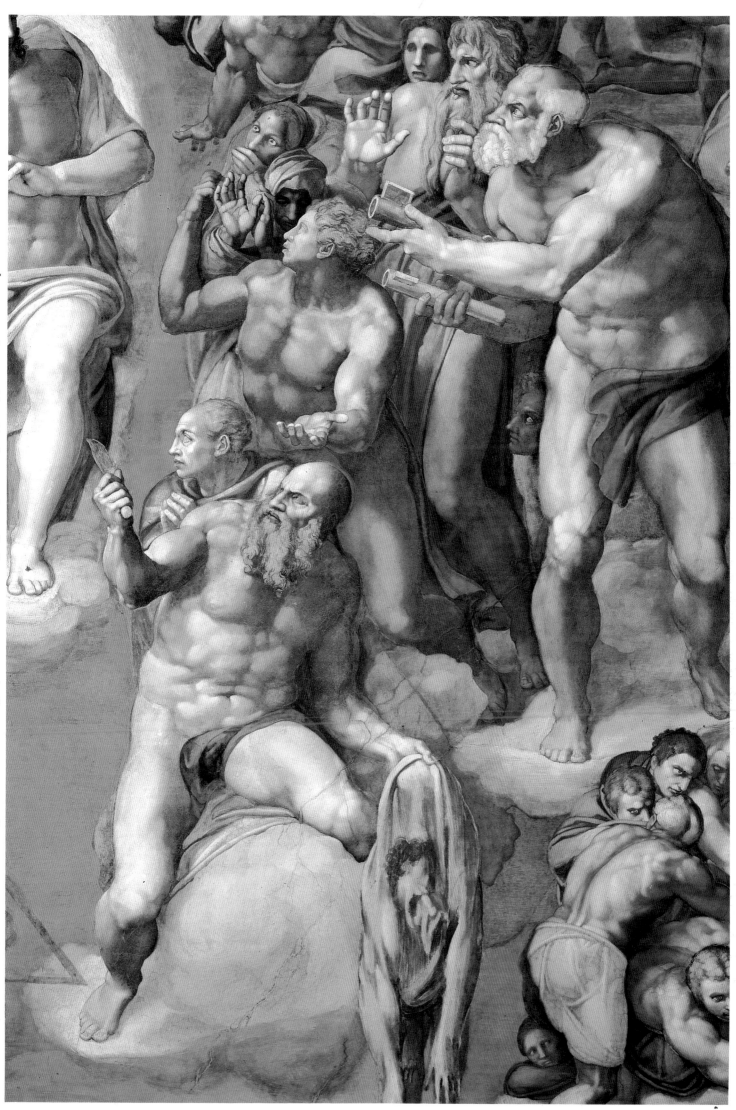

SAINT BARTHOLOMEW (Pietro Aretino holding the skin of Michelangelo). Detail from *The Last Judgement* (Plate 224). 1536–1541. Rome, Sistine Chapel

grinder. He began the work after 10 April 1536 (according to Biagetti towards the end of June or early in July), the upper portion being finished by 15 December 1540, and the complete painting was unveiled on 31 October 1541 (twenty-nine years after the unveiling of the ceiling paintings). We are told that Pope Paul III, overcome by the sight, broke into prayer with the words: 'Lord, charge me not with my sins when Thou shalt come on the Day of Judgement.' The fresco is arranged in three zones. The top one is the Kingdom of Heaven, with Christ as Judge of the World enthroned in the centre and the Virgin next to him; around him is an inner circle of Apostles in the right half of the arch, and Patriarchs in the left. Two Martyrs finish off the lower end of this circle. Above, in the lunettes, we see hosts of angels, with the instruments of Christ's Passion, the Cross, and the pillar at which He was scourged. In the other circle we have Prophets, Confessors and Martyrs on the right, and the Hebrew women, holy virgins and Sibyls on the left. – The middle zone is the realm of those who have been judged: on the left the ascent of the elect, on the right the fall of the damned, while in the centre the messengers of the Lord blow their trumpets. – The lowest zone is the realm of Charon and the demons; the Resurrection of the Dead and the arrival in Hell fill the portion immediately above the altar. – Justi described the 'Last Judgement' as 'Michelangelo's last word in formative art'. Weisbach saw in it the perfection of the 'heroic' style, while Dvořák recognized it as the 'source of a new style', and wrote: 'From the time of the *Last Judgement* the whole of Italian art becomes Michelangelesque, not only in its various forms, but in its entire trend of thought, which is filled with a new conception of ideal timelessness, of spatial universality, and with a hitherto unknown spiritual pathos. When we say that Michelangelo became the destiny of Italian art, this is true of none of his works so much as of the *Last Judgement*, and if we wished to give an exhaustive study of its influence we should have to enumerate all the works produced in Italy, and in part to the north of the Alps as well, from the day it was painted to the end of Baroque art.' In contrast to the enormous impression which it made on contemporary painters was the zealous hostility of theologians and men of letters, who were filled with the spirit of the Counter-Reformation. Two opinions have become popular and almost anecdotal, those of the papal master of ceremonies, Biagio da Cesena, and of Pietro Aretino. Biagio, who saw the upper portion of the fresco in 1540, called it a 'stufa d'ignudi', a bathing establishment. In 1537 Michelangelo wrote to Aretino: 'I regret that I cannot avail myself of your ideas, but the painting has already progressed too far. . . . As for your resolution not to come again to Rome, you should not break it for the sake of seeing my painting. That would be indeed too much. Adieu.' Eight years later came Aretino's attack, in the form of a long 'open' letter. He compared his courtesans' dialogue 'Nanna' with Michelangelo's 'Last Judgement', and claimed that he had displayed more modesty than Michelangelo: he accused the painter of being irreverent. 'Such things might be painted in a voluptuous bathroom, but not in the choir of the highest chapel. . . . Our souls are benefited little by art, but by piety.' Michelangelo is supposed to have

inserted the portraits of both of these critics in his 'Last Judgement', Aretino being represented as Bartholomew[31] with the skin of the flayed martyr, which itself bears a self-portrait of Michelangelo (Plate 229). According to Vasari, he caricatured Biagio in the figure of Minos, the supreme judge of hell (Plate 228); the ears resemble a donkey's. Biagio complained to the Pope, who answered him, as witty as Boccaccio, that to rescue him from hell was outside his province; if he had been in Purgatory, that would have been a different matter, but 'ibi nulla est redemptio'. Nevertheless Biagio's opinion finally prevailed, and at a session of the Council of Trent on 3 December 1563, the representation of unsuitable subjects in churches was forbidden. Under Popes Paul IV (1559) and Gregory XIII Michelangelo's fresco was in danger of being completely destroyed. Most of the nudities were painted over, firstly by Michelangelo's pupil Daniele da Volterra, who thereby won for himself the nickname of 'il brachettone' or the 'breeches-maker'. St Catherine and the Bad Thief show particularly heavy overpainting. Under Pius V (1572) further draperies were added and at that time El Greco offered to replace the whole painting by one of his own, which 'would be decent and pious and no less well painted than Michelangelo's'. Further overpaintings were undertaken in 1625, 1712 and 1762. 'The state in which the gigantic work has come down to us is of such mutilation that it is impossible to form an opinion as to its artistic qualities' (Thode). Copies by Marcello Venusti (1549, Appendix Plate XXX) and by Robert le Voyer (1570, Montpellier Museum), and a large engraving by Beatrizet (1562, in eleven parts) show the figures in the painting before the alterations.

THE CONTEMPLATIVE AND THE ACTIVE LIFE (Rachel and Leah). Belonging to the tomb of Julius. Plates 234–236. Marble, 6 ft. 7½ in. and 6 ft. 10 in. high. Mainly by Michelangelo's hand, but finished and polished by assistants. On 20 July 1542 Michelangelo proposed that these figures, which he had already begun, should be substituted for the Captives, as the latter no longer fitted the niches (see above, THE TOMB OF JULIUS, p. 20). According to Vasari, Michelangelo executed the statues in 'less than the span of a year'. Vasari also says that one of the figures is Leah, symbol of the active life, and the other Rachel, symbol of the contemplative life. Condivi does not mention Rachel and Leah, but calls the figures simply the Active and the Contemplative Life.[32] He adds: 'In this Michelangelo, always a zealous student of Dante, is following the latter, to whom in his Purgatorio the Countess Matilda appeared in a flowery meadow as the personification of the active life.' (Dante *Purgatorio*, XXVII, 94 f.; XXVIII, 37 f.; XXXIII, 118 f.)

[31] The *Last Judgement* was finished four years before Aretino wrote his aggressive letter. Therefore the tradition that Bartholomew is his portrait appears doubtful.
[32] Michelangelo himself, in his memorandum of 20 July 1542 to Pope Paul III, calls them the Contemplative and the Active Life, not Rachel and Leah. The Active and the Contemplative Life play a prominent part in the *Disputationes Camaldulenses* by Cristoforo Landino (written about 1468). The protagonists of these conversations are Leone Battista Alberti, Lorenzo il Magnifico, his brother Giuliano de' Medici and others. These conversations circulated in manuscript form in Florence and must certainly have been known to Michelangelo.

BRUTUS. Plate 237 (238). Marble, 29½ in. high without socle. On the pedestal the distich: *Dum Bruti effigiem sculptor de marmore ducit, In mentem sceleris venit et abstinuit.* (While the sculptor was hewing the effigy of Brutus out of the marble, he came upon the spirit of crime and desisted.) According to tradition this inscription was composed by the Venetian humanist Pietro Bembo (1470–1547). Vasari maintains that the inspiration came from Donato Giannotti and that the work was commissioned by Cardinal Ridolfi. In his *Dialogues*, written in 1545–6, Giannotti makes Michelangelo speak of Brutus: 'He who slays a tyrant does not kill a man, but a beast in human form. For since all tyrants are devoid of that love which all men must have for their neighbours, so too they are without human feelings and therefore no men, but beasts.' Knapp remains faithful to the old political interpretation and sees in the bust a reference to the murder of Duke Alessandro de' Medici by Lorenzino. According to Vasari, Michelangelo gave the bust of Brutus to Tiberio Calcagni, in order that he might finish it – 'he himself having only executed the features of the Brutus with fine strokes of the claw-chisel'. On this point Carl Justi wrote: 'The head of Brutus remained at the stage of a sketch; only the draperies were elaborated; this trite and insignificant work is neither by the hand nor in the style of the master.' Grünwald has investigated Calcagni's share; the retouching concerns mainly the robe and the neck, but in addition to this the chin and mouth and a part of the hair have been gone over roughly with a flat chisel, an instrument which Michelangelo used only in his very early work. Attention has frequently been drawn to the resemblance to busts of Roman emperors, but this resemblance is due to the toga and the shape of the bust, which were Calcagni's work. Calcagni (1532–65) first came to Michelangelo's studio in 1556; at that time the bust was still unfinished.

THE CONVERSION OF ST PAUL and THE CRUCIFIXION OF ST PETER. Plates 239–245; XXIX). Each fresco measures 20 ft. 6 in. by 21 ft. 8 in. Finished by Michelangelo when he was seventy-five years old. Badly preserved, restored and over-painted; Plate XXIX in the Appendix gives an indication of the state of preservation of the two frescoes, as the photos were taken while the paintings were stripped before the restorer retouched and over-painted them again. Most retouchings in the first fresco are, however, by Michelangelo himself.

Both frescoes were restored in 1933; the restorer's work shows mainly in the landscape. Further restorations were carried out in 1953 (see Tolnay, *Michelangelo: The Final Period*, Princeton 1960, p. 142).

Lomazzo (in his *Idea del tempio della pittura*, Milan, 1590, p. 53) was the first critic who had any appreciation for these two frescoes. He explains that they show Michelangelo's third and greatest style (the first style being that of the Prophets and Sibyls, and the second that of the Last Judgement). The Paolina frescoes had no appeal for the writers of the eighteenth and nineteenth centuries (although William Blake copied one of the figures), but in our time Dvořák, D. Frey, Neumeyer, Baumgart, Biagetti, Redig de Campos, and H. von Einem, have established a revaluation of Michelangelo's last paintings.

THE PIAZZA OF THE CAPITOL IN ROME. Plates 246–249. Michelangelo's original plan is known from du Pérac's etching (Plate 246). The outside staircase of the Palazzo Senatorio was begun in 1544, and at the same time the façade of the building was partially altered after designs by Tommaso Cavalieri, but in 1578–1583 the new bell tower was erected and in 1598–1612 the façade was completely rebuilt. Michelangelo was therefore responsible only for the outside stairway of the central building. The Palazzo dei Conservatori was finished in 1568 according to the Master's designs, but Jacomo del Duca, at a later date, enlarged the central window and transformed it into a balcony. The Museo Capitolino (on our left when we are facing the Senatorial Palace) is an exact copy of the Palazzo dei Conservatori and was erected under Pope Innocent X (1644–55). The elliptical pavement in the Capitol Square (exactly the same pattern as appears in Michelangelo's design of 1546, Plate 246) was finished only in 1940 (Plate XII-e). The chronology of the reconstruction of the Piazza of the Capitol is complicated and still in dispute. Cf. Herbert Siebenhüner, *Das Kapitol in Rom, Idee und Gestalt*, Munich 1954; and the review by Prof. James S. Ackerman in *The Art Bulletin*, March 1956 (Vol. 38–1), pp. 53–57.

PALAZZO FARNESE. Plates 250–254. Begun by Antonio da Sangallo the Younger, who died in 1546 and left the work unfinished. Michelangelo was appointed by Pope Paul III (Alessandro Farnese) to continue this work. He was responsible for the balcony and the large coat-of-arms, the windows of the upper storeys, the cornice, and the upper storey of the courtyard. The balustrade of the balcony was added by Antonio Cipolla about 1866; earlier engravings show the central window without balustrade. It can be proved, however, that this shape

The façade of the Palazzo Farnese in the eighteenth century. Engraving. 1765.

was intended by Michelangelo himself; the reverse of a Farnese medal, representing the Farnese Palace, shows the central window in the shape of a balcony. This medal was coined in 1548. An engraving by N. Beatrizet, dated 1548, gives an identical view.[33] The two smaller coats-of-arms are late additions (as can be seen from the engraving reproduced here). Vignola (who died 1573) and Giacomo della Porta finished the building in 1589.

[33] Both views are based on the model, or on drawings.

IL GRAN NICCHIONE DEL BELVEDERE (The Large Niche of the Belvedere in the Vatican). Plate 255. The lower storey was designed by Bramante (begun 1503) and had a stairway with semi-circular steps, the inside concave, the outside convex. Pope Julius III (1550–5) commissioned Michelangelo to replace Bramante's stairway by another one with a double flight of stairs, similar to that of the Palazzo dei Senatori (Plate 247). It has come down to us in an adulterated form; the balustrade and the fountain with the masks were added about 1700, whereas the antique peacocks and the pinecone were brought there as early as 1618.

Michelangelo conceived the idea of transforming the exedra into a large niche, which means that the two upper storeys were added according to his designs; but the work was carried out in the time of Pius IV by Pirro Ligorio (1562), who was responsible for the superstructure and the colonnade. A drawing in the Uffizi (see Plate XVI–a) shows the appearance of the Nicchione in Michelangelo's time; an engraving by Brambilla shows it soon after Michelangelo's death, before the outside stairs were altered (see Plate XVI–b).

THE FLORENTINE PIETÀ (Entombment). Plate 256 (257, 258). Marble 7 ft 8 in. Mentioned by Vasari in his first edition, it must have been begun before 1550. Probably in 1550, the French traveller Blaise de Vigenère saw Michelangelo working on it: 'I saw Michelangelo at work. He had passed his sixtieth year and although he was not very strong, yet in a quarter of an hour he caused more splinters to fall from a very hard block of marble than three young masons in three or four times as long. No one can believe it who has not seen it with his own eyes. And he attacked the work with such energy and fire that I thought it would fly into pieces. With one blow he brought down fragments three or four fingers in breadth, and so exactly at the point marked, that if only a little more marble had fallen, he would have risked spoiling the whole work.' From Condivi we learn that Michelangelo was still working on this group in 1553. In his second edition Vasari says: 'At this time (1556) Michelangelo worked on it almost every day as a pastime. At last he broke the stone, probably because it contained veins of emery and was so hard that the chisel struck sparks from it; perhaps also because his criticism of his own work was so severe that nothing he did satisfied him. For this reason, to tell the truth, there are few finished works by him from his later period, when he had reached the highest maturity of his artistic power of creation. His finished sculptures all date from his early period.' Vasari tells us later that Michelangelo gave the broken Pietà to Francesco Bandini, who wanted to have it finished by Tiberio Calcagni, but the latter died in 1565. When one sees what he did, one can only say that his death was a good thing for the Pietà. He is responsible for the highly polished and minutely chiselled Magdalen, which must have been very beautiful before; he was also responsible for the polishing of the trunk of the Christ and the sharp folds of the shroud. Note that Christ's left leg is missing. Vasari proposed that the Pietà should be placed on Michelangelo's tomb, as was the master's own intention, but this was not done. For a long time the group was left in the open air in a vineyard on Monte Cavallo, "nel giardino del Signore Cardinale Bandini". In 1664 it had already been transferred to Florence, first to San Lorenzo, and in 1722 it was placed behind the high altar of the cathedral. Finally, in 1933, it found its place in a chapel of the north choir. (Cf. Plate XXXII–a.)

THE RONDANINI PIETÀ. Plate 259 (260, 261). Marble, 6 ft. 3⅝ in. high (the elliptical base is 2 ft. 2 in. wide and 1 ft. 11 in. deep). On 12 February 1564, six days before his death, Michelangelo worked all day long standing in front of this group, as we learn from a letter of Daniele da Volterra to the nephew of the Master, Leonardo Buonarroti.

Michelangelo began the group probably by the end of 1556, when he abandoned the Florentine Pietà, and then revised it again – perhaps seven years later. The legs of the Christ and the free right arm are relics of the first version. The Rondanini Pietà was left as a legacy to Michelangelo's servant Antonio del Franzese. It is not known when the Pietà was brought to the Palazzo Rondanini. Goethe, who lived opposite the Palazzo Rondanini in Rome from November 1786 to April 1788, does not mention the work, although he knew the Rondanini collection well and had a cast made of a mask of Medusa which belonged to it. In 1952 the sculpture was bought from Conte Sanseverino by the City of Milan for 125 million Lire (about $180,000) and placed in the Castello Sforzesco.

THE PALESTRINA PIETÀ. Plate 262 (263). 8 ft. 2½ in. high. Burckhardt mentions it in the first edition of his *Cicerone* (1855), but refrains from giving his opinion on it. Wölfflin (1898), in his book *Die klassische Kunst* refers to the 'abbozzo in the castle of Palestrina', but this Pietà was first published by A. Grenier (in *Gazette des Beaux-Arts*, 1907). Wallerstein, Thode, Mackowsky, Davies, Toesca, d'Ancona and Redig de Campos maintained that it is authentic. On the other hand Schottmüller writes: 'The group is certainly close to Michelangelo's conception in his later period, but it has not the quality of the work executed by his own hand.' Anny Popp attributed the group to an 'imitator of Michelangelo', Ulrich Middeldorf thought of Pierino da Vinci. But the authenticity of the Palestrina Pietà has again been defended by A. Perrig (*Michelangelo Buonarrotis letzte Pietà-Idee*, Berne, 1960, pp. 94 f.). The work is not free from later revision by other hands. The marble used for this sculpture is a piece of ancient Roman cornice. In my opinion this Pietà was begun by Michelangelo and continued by another hand; two stages of this later revision can be detected. The head, right arm and thighs of the Christ, and the right hand of the Madonna seem to me to be entirely by Michelangelo.

THE PORTA PIA IN ROME. Plate 264 (265; XIV–b). Commissioned by Pope Pius IV from Michelangelo in 1561. A number of assistants were employed; Jacomo del Duca, the most important amongst them, sculptured the mask on the keystone after Michelangelo's design, and also (with the help of Luca) the coat-of-arms.

In the time of Pius IX it was damaged by lightning and the top replaced by a 'torretta' designed by Virginio Vespignani (1853). An engraving published in 1568 shows the Porta Pia finished with the top-piece over the centre being of a simple, triangular shape.

ST PETER'S IN ROME. Plates 266–273. The year 1546 was an important point in Michelangelo's life as an architect. In this year he began his work on the Palazzo Farnese, the re-planning of the Capitol square, and the work on a clay model of the dome of St Peter's. On 1 January 1547 he was entrusted by Pope Paul III with the superintendence of the building of St Peter's, and so he became the successor of Bramante, Raphael, Giuliano and Antonio da Sangallo. On the whole Michelangelo returned to Bramante's plan and removed as much as possible of Sangallo's constructions. But he completed only the drum of the dome, and after his death Vignola, Giacomo della Porta and Domenico Fontana completed the dome after a large wooden model (Plate 266; XIX) which Giovanni Franzese had made from designs and under the eyes of the Master. This model measures one-fifteenth of the actual dome, namely 17 ft 8 in. high and 12 ft 8 in. wide. Vasari says: 'The completion of the model caused great satisfaction not only to Michelangelo's friends but to all Rome.' But the baroque façade, which Carlo Maderna built for the church (1607–14), and Bernini's colonnades have deviated so much from Michelangelo's intentions that (as Knapp pointed out) one can only feel what Michelangelo contemplated if one looks at the back of the church from a great distance and sees the large dome against a clear sky.

St. Peter's, eleven years after Michelangelo's death. Detail of an engraving by Giambattista Cavalieri, 1575.
(The drum completed, but still without the dome.)

ADDITIONAL NOTES. – Professor Edgar Wind (in *Italian Renaissance Studies*, edited by E. F. Jacob, London, 1960, pp. 312 ff.) has renamed some of the bronze medallions in a convincing way (our Plate Nos. 94–102). No. 94: *The Chastisement of Heliodorus*; No. 96: *Alexander the Great before the Priest of Jerusalem*; No. 102: *The Death of Nicanor*. (Edgar Wind's illustrations 22, 18, 20.) About the *Heliodorus* see also Frits Lugt, "Man and Angel", in Gazette des Beaux-Arts, XXV, June 1944, p. 345. According to Lugt, *The Expulsion of Heliodorus* symbolizes a victory of Julius II, the expulsion of the French from Italy. Concerning the dating of our Plate 249, see James S. Ackerman, *The Architecture of Michelangelo, Catalogue,* London, 1961, p. 50. 'The inscription on the base of the statue recording the removal and consecration is dated 1538.' A drawing in the Escorial Sketchbook by Francisco de Hollanda of c. 1539–40 shows already the equestrian statue on the base which Michelangelo designed. The execution of the base, however, was only finished in 1565 (Ch. de Tolnay, *Prussian Yearbook* LIII, Berlin 1932, p. 243).

·MICHAELANGELVS· BVONAROTVS· NOBILIS·
·FLORENTINVS· AN· AET· SVE· LXXI·

·QVI· SIM· NOMEN· HABES· SATQ. EST· NAM· CAETERA· CVI· NON·
·SVNT· NOTA· AVT· MENTEM· NON· HABET· AVT· OCVLOS·
·M· D· XLV·

Engraving, attributed to Giulio Bonasone, 1545.

BIBLIOGRAPHY

The following list is intentionally kept concise, in order to help the student to find the most important titles first. There is a complete Michelangelo Bibliography in Vols. I and VIII of the *Römische Forschungen* of the Biblioteca Hertziana in Rome: *Michelangelo-Bibliographie* by E. Steinmann and R. Wittkower (1927), and a continuation by H. W. Schmidt in E. Steinmann's *Michelangelo im Spiegel seiner Zeit* (1930). For publications after 1930, see *Art Index*, New York, 1929 f., and Cherubelli, *Supplemento alla bibliografia michelangiolesca, 1931–42* (in 'Michelangelo Buonarroti nel IV centenario del Giudizio Universale'), Florence, 1942; a few additions in E. Aeschlimann, *Bibliografia del Libro d'arte italiano 1940–52*, Rome, 1952. Bibliography from 1942 to the present in *Zeitschrift für Kunstgeschichte*, Munich; for literature after 1952 the *Annuario bibliografico* (Bibl. dell' Istituto nazionale d'archeologia e storia dell' arte, Rome). [See also the note on p. 6 above.]

I. THE OLD BIOGRAPHIES · DOCUMENTS · LETTERS

The two versions of the Michelangelo biography by Vasari (1550 and 1568) and the biography by Condivi are contained in a critical edition by Karl Frey, *Le vite di Michelagniolo Buonarroti scritte da Giorgio Vasari e da Ascanio Condivi*, Berlin, 1887. The first Vasari biography is separately available in a reprint by Corrado Ricci (Milan, 1927). There are three recent reprints of the Condivi biography; the best by Paolo d'Ancona (Milan, 1928). Many of the documents are to be found in Aurelio Gotti, *Vita di Michelangelo*, Florence, 1876; others in G. Gaye, *Carteggio inedito d'artisti*, 3 vols., Florence, 1839–40. – The only edition of Michelangelo's letters is still G. Milanesi, *Le lettere di Michelangelo Buonarroti*, Florence, 1875; the same editor collected Michelangelo's correspondence with Sebastiano del Piombo (*Les Correspondants de Michel-Ange*, I, Paris, 1890), whereas K. Frey gives a selection from all the letters addressed to the master in *Sammlung ausgewählter Briefe an Michelagniolo Buonarroti*, Berlin, 1899. The standard edition of Michelangelo's poetry is edited by K. Frey, Berlin, 1897. – There are several editions of the *Dialogues* of Francisco de Hollanda and those of Donato Giannotti. There is an English translation of Francisco de Hollanda's dialogues by Aubrey F. G. Bell, Oxford, 1928; the Portuguese text, with a German translation, was edited by Joaquim de Vasconcellos, Vienna, 1899 ('Quellenschriften', new series, vol IX). There are several English translations of the biographies by Vasari and Condivi. An English translation of Michelangelo's Letters was edited by Miss E. H. Ramsden, 2 vols., London 1963. Paola Barocchi's edition of *Giorgio Vasari, La Vita di Michelangelo* (Milan, 1962), 5 vols., with an extensive commentary, is of great help to any student.

II. THE LIFE AND WORK OF MICHELANGELO

Of the six volumes of Henry Thode's *Michelangelo* (Berlin, 1902–13) only vols IV and V will prove of great value to the reader of the present book. They are published separately as 'Kritische Untersuchungen, I–II'. The sixth volume contains a catalogue of the drawings and a short list of the models. – A good survey of Michelangelo's œuvre is available in Charles de Tolnay's article in *Thieme-Becker's Künsterlexikon*, vol. XXIV, Leipzig, 1930; another one, by Pietro Toesca, in *Enciclopedia Italiana*, vol. XXIII, pp. 165–191, Rome, 1934; and a recent one, by Ludwig Goldscheider, in the *Encyclopaedia Britannica* 1964. –

There is a corpus of illustrations, edited by F. Knapp in 'Klassiker der Kunst', vol. VII, Stuttgart, 1924, containing too much and too little; and a fat volume by Charles de Tolnay, Florence, 1951, also incomplete; for instance, of the twelve Prophets and Sibyls of the Sistine Ceiling, this volume shows only four, and of the twenty nude Youths only two. Though not complete, the book is of great value owing to some illustrative material not available elsewhere. – The best edition of the *Sculpture* is by F. Kriegbaum, Berlin, 1940. – For a full list of separate essays, see the Bibliographies above; the best of those essays are only published in German, as Carl Justi's *Beiträge*, Berlin, 1900 and 1909; A. Grünwald's *Florentiner Studien*, Dresden, 1920; and Adolf Hildebrand's *Gesammelte Aufsätze*, Strasbourg, 1915. There is no really good biography of Michelangelo available in English, as the popular book by Romain Rolland (Paris, 1914), of which there is a translation, is rather misleading (see E. Panofsky, *Michelangelo-Literatur*, 1914–22, in 'Jahrbuch für Kunstgeschichte', I, Vienna, 1923) and J. A. Symonds often reprinted *Life and Works of Michelangelo Buonarroti* (London, 1893) is definitely out of date. [See now also M. Weinberger: *Michelangelo, the Sculptor*, 2 vols., 1967; Howard Hibberd: *Michelangelo*, 1975.]

III. THE EARLY WORKS OF MICHELANGELO

Charles de Tolnay's *The Youth of Michelangelo*, 2nd ed., Princeton, 1947, containing full bibliographical references; some more in Aldo Bertini's *Michelangelo fino alla Sistina*, 2nd ed., Turin, 1945. The Piccolomini statuettes were reassessed by Friedrich Kriegbaum, *Le Statue di Michelangelo nell' Altare dei Piccolomini a Siena* (in 'Michelangelo Buonarroti nel IV centenario del Giudizio Universale'), Florence, 1942; and by W. R. Valentiner, *Michelangelo's Statues on the Piccolomini Altar in Siena* (in 'Art Quarterly', 1942; reprinted in *Studies of Italian Renaissance Sculpture*, London, 1950).

IV. THE SISTINE CEILING FRESCOES

Ernst Steinmann, *Die Sixtinische Kapelle*, Vol. II, Munich, 1905. (On pp. 687 f. the Documents, edited by H. Pogatscher.) – Charles de Tolnay, *The Sistine Ceiling*, Princeton, 1945. (With references to further literature – by Wölfflin, Justi, Panofsky, Biagetti, etc.) – F. Hartt, *Lignum vitae in medio Paradisi*, in 'The Art Bulletin', XXXII, 1950, pp. 115–218. [See now also *Michelangelo: The Sistine Ceiling*, ed. by Charles Seymour Jr., 1972.]

V. THE TOMB OF POPE JULIUS II

Karl August Laux, *Michelangelos Juliusmonument*, Berlin, 1943. On the ornamental reliefs: Frida Schottmüller, *Michelangelo und das Ornament*, in 'Vienna Yearbook', 1928. Ch. de Tolnay, *The Tomb of Julius II*, Princeton, 1954.

VI. THE MEDICI CHAPEL

F. Burger, *Geschichte des florentinischen Grabmals von den ältesten Zeiten bis Michelangelo*, Strasbourg, 1904. – H. Brockhaus, *Michelangelo und die Medici-Kapelle*, Leipzig, 1909. – A. E. Popp, *Die Medici-Kapelle Michelangelos*, Munich, 1922. – Charles de Tolnay, *The Medici Chapel*, Princeton, 1948. – Erwin Panofsky, *The Neoplatonic Movement and Michelangelo*, in 'Studies in Iconology', New York, 1939, pp. 129–230. – Ernst Steinmann, *Das Geheimnis der Medicigräber Michelangelos*, Leipzig, 1907.

VII. THE LAST JUDGEMENT AND THE PAOLINA FRESCOES

D. Redig de Campos and B. Biagetti, *Il Giudizio Universale*, 2 vols., Rome, 1943. – F. Baumgart and B. Biagetti, *Die Fresken des Michelangelo in der Cappella Paolina*, Città del Vaticano, 1934. – (Same, Italian edition, Coll. 'Monumenti Vaticani di Archeologia e d'Arte', Roma, 1934.) – V. Mariani, *Gli affreschi di Michelangelo nella Cappella Paolina*, Rome, 1931 and 1932. – D. Redig de Campos, *Affreschi della Cappella Paolina in Vaticano*, Milan, 1950. – Karl Borinski, *Das Altargemälde der Sixtina* (The Last Judgement), in 'Die Rätsel Michelangelos', Munich, 1908, pp. 281–330. – D. Redig de Campos, *Fonti di Giudizio di Michelangelo* in 'Raffaello e Michelangelo, Studi di storia e d'arte, Rome, 1946. – *Studi e provvidenze per gli affreschi di Michelangelo nelle Cappelle Sistina e Paolina*. Notizie . . . di B. Nogara e B. Biagetti, in 'Rendiconti della Pontificia Accademia Romana di Archeologia', IX, 1934, pp. 167–199. – B. Biagetti, *Technica e Stato di conservazione del Giudizio*, in 'Rendiconti', XVIII, 1941–2, pp. 29–46. – Charles de Tolnay, *Michelangelo*, V, The Final Period, Princeton, 1960.

VIII. ARCHITECTURE

Heinrich von Geymüller, *Michelagnolo Buon. als Architekt* ('Architektur der Renaissance in Toskana', Vol. VIII), Munich, 1904. – Armando Schiavo, *Michelangelo Architetto*, Roma, 1949; and *La vita e le opere architettonice di Michelangelo*, 1953. – C. Ricci, *Baukunst und dekorative Plastik der Hoch- und Spät-Renaissance in Italien*, Stuttgart, 1923 (340 Plates). – 'Geschichte der Neueren Baukunst', vol. I: Jacob Burckhardt, *Geschichte der Renaissance in Italien*, 5th edition, Esslingen, 1912. – A. E. Brinckmann, *Die Baukunst des 17. und 18. Jahrhunderts in den romanischen Ländern*, Berlin, 1915–19. – Jacques Veysset, *Le Palais Farnese*, Rome, 1948. – On the cornice of the Palazzo Farnese, S. Meller in 'Prussian Yearbook', XXX, 1909, p. 1 f. – On *Santa Maria degli Angeli*: Pasquinelli, Rome, 1932 and 1935. – Dagobert Frey, *Michelangelo-Studien*, Vienna, 1920 (on the 'Nicchione di Belvedere', and other essays). – Dagobert Frey, *Eine unbeachtete Zeichnung nach dem Modell Michelangelos für die Fassade von San Lorenzo*, in 'Kunstchronik', Dec. 1922, p. 226 f. – R. Wittkower, *Zur Peterskuppel Michelangelos*, in 'Zeitschrift für Kunstgeschichte', II, 1933, p. 348 f. – The same author on *the Biblioteca Laurenziana*, in 'Art Bulletin', XVI, 1934,

p. 123 f. – Charles de Tolnay, on *the façade of San Lorenzo*, in 'Gazette des Beaux-Arts', XI, 1934, p. 24 f. – The same author, on *the Libreria Laurenziana*, ib. XIV, 1935, p. 81 f. – The same author, in 'Prussian Yearbook', LI, 1930, p. 3 f., and LIII, 1932, p. 231 f.: *Beiträge zu den späten architektonischen Projekten Michelangelos*. – B. M. Apolloni, *Opere architettonice di Michelangelo a Firenze*, Rome 1936. – V. Fasolo, *La Cappella Sforza di Michelangelo*, in 'Architettura e Arti Decorative', III, 1924, p. 433 f. – A. Michaelis, *Michelangelos Plan zum Kapitol*, in 'Zeitschrift für bildende Kunst', 1891, new series, II, p. 184 f. – Dagobert Frey's essay on the model of the Cupola of St Peter's in his *Michelangelo-Studien*, Vienna, 1920, pp. 91–136, can only be used together with the corrections noted in Erwin Panofsky's *Die Michelangelo-Literatur seit 1914*, in 'Jahrbuch für Kunstgeschichte', I, Vienna, 1923, col. 18–21. – See also Hans Rose (in H. Wölfflin's 'Renaissance und Barock', fourth edition, Munich, 1926), *Der Kuppelbau*, pp. 291–310. – Valerio Mariani, *Michelangelo e la Facciata di S. Pietro*, Rome, 1943. – Adolfo Venturi, *L'architettura del Cinquecento* ('Storia dell'arte italiana', vol. XI, parte II), Milan, 1939. [See now also James S. Ackerman, The Architecture of Michelangelo, 2 vols., 1961; revised ed. 1970.]

IX. THE MODELS IN WAX AND CLAY

A. E. Popp, *Die Medicikapelle*, discusses the Edinburgh models. The same author in *Burlington Magazine*, LXIX, 1936, p. 202 f., on the terracotta torso in the British Museum. – F. Burger, *Studien zu Michelangelo*, 1907, p. 40 f. and J. Meier-Graefe, *Michelangelo: Die Terrakotten aus der Sammlung Hähnel*, 1924, discuss the Dresden models. – On the pieces in the British Museum, see Sir Charles Holmes, *Burlington Magazine*, XI, 1907, p. 189. – The best information on the models in the Victoria & Albert Museum is given by Sir Eric Maclagan in the 1932 catalogue, p. 127 f.; also in *Burlington Magazine*, XLIV, 1924, p. 4 f.; a few particulars in Brinckmann, *Barock-Bozzetti*. – Several terracotta models are catalogued in Cornelius von Fabriczy's *Kritisches Verzeichnis toskanischer Holz- und Tonstatuen bis zum Beginn des Cinquecento* in 'Prussian Yearbook', 1909, Beiheft, pp. 38–46. – The two terracotta models in the Pietri collection are discussed by Odoardo H. Giglioli, *Due Bozzetti inediti di Michelangelo*, Florence; and *Documenti di due bozzetti inediti*, Lugano, 1951 (with contributions by L. Planiscig, E. Sandberg-Vavalà, a.o.). – The terrasecca sketch for a battle group ('Hercules and Cacus') in the Casa Buonarroti is discussed by J. Wilde in 'Dedalo', VIII, 1928, p. 653 f. and in 'Vienna Yearbook', 1928, p. 199 f. – H. Thode, *Michelangelo: Kritische Untersuchungen über seine Werke*, III, Berlin, 1913, pp. 265–286, gives an incomplete catalogue of models attributed to Michelangelo. – L. Goldscheider, *Michelangelo's Bozzetti for Statues in the Medici Chapel*, London, 1957, and *A Survey of Michelangelo's Models in Wax and Clay*, London, 1962.

NOTE. – Two important publications are in preparation. The one, *Il Carteggio di Michelangelo*, a complete edition of the Correspondence, edited by Paola Barocchi & R. Ristori, 6 vols., Florence, 1964 ff. – The other, a reprint of the "Michelangelo-Bibliographie" by Steinmann and Wittkower, brought up to date, 2 vols., Hildesheim, 1964 f.

THE PLATES

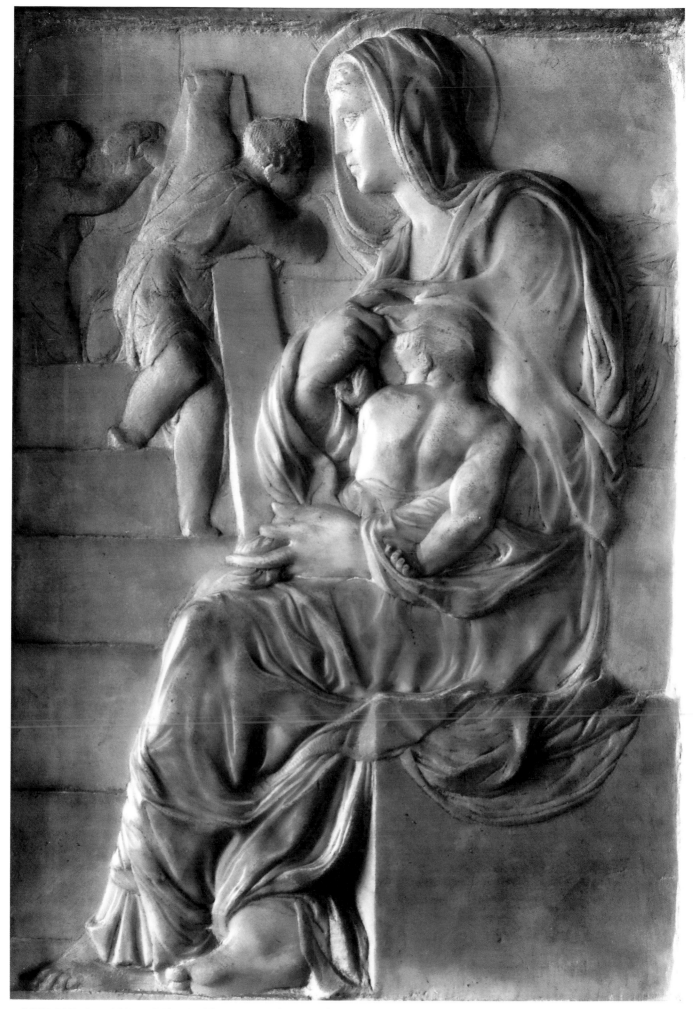

1. MADONNA OF THE STAIRS. About 1491. Florence, Casa Buonarroti

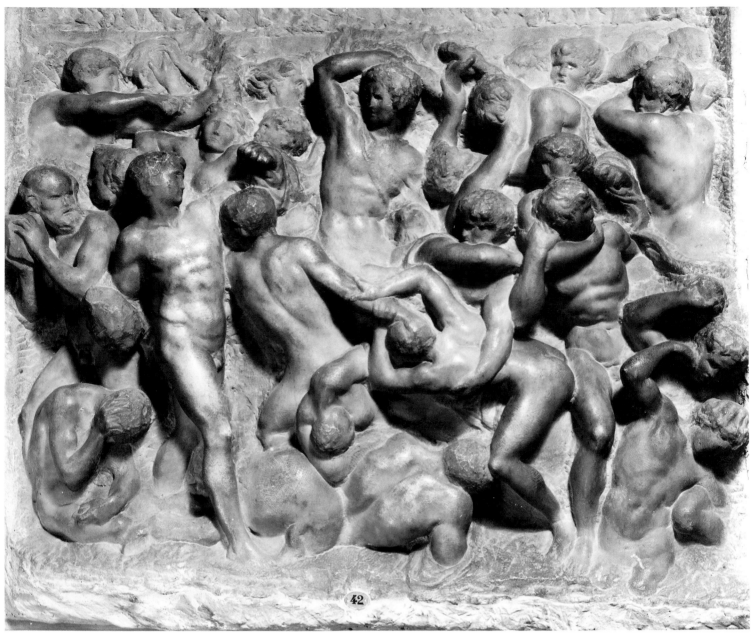

2. BATTLE OF THE CENTAURS. About 1492. Florence, Casa Buonarroti

3. BATTLE OF THE CENTAURS. Detail of Plate 2

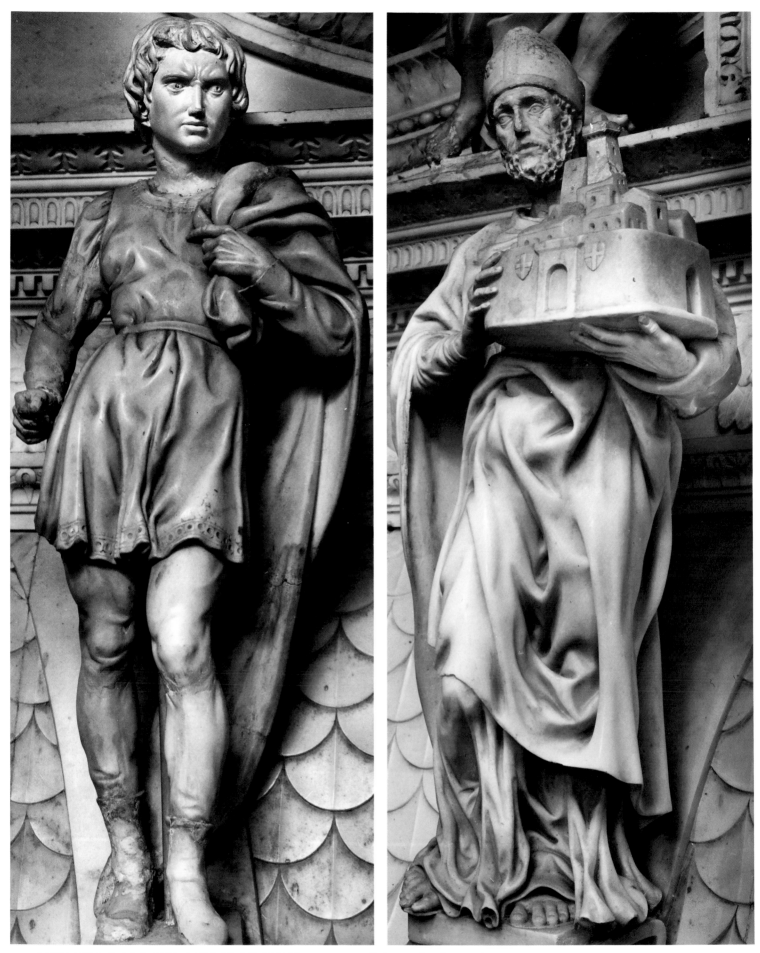

4–5. SAINT PROCULUS AND SAINT PETRONIUS. 1494–1495. Bologna, San Domenico

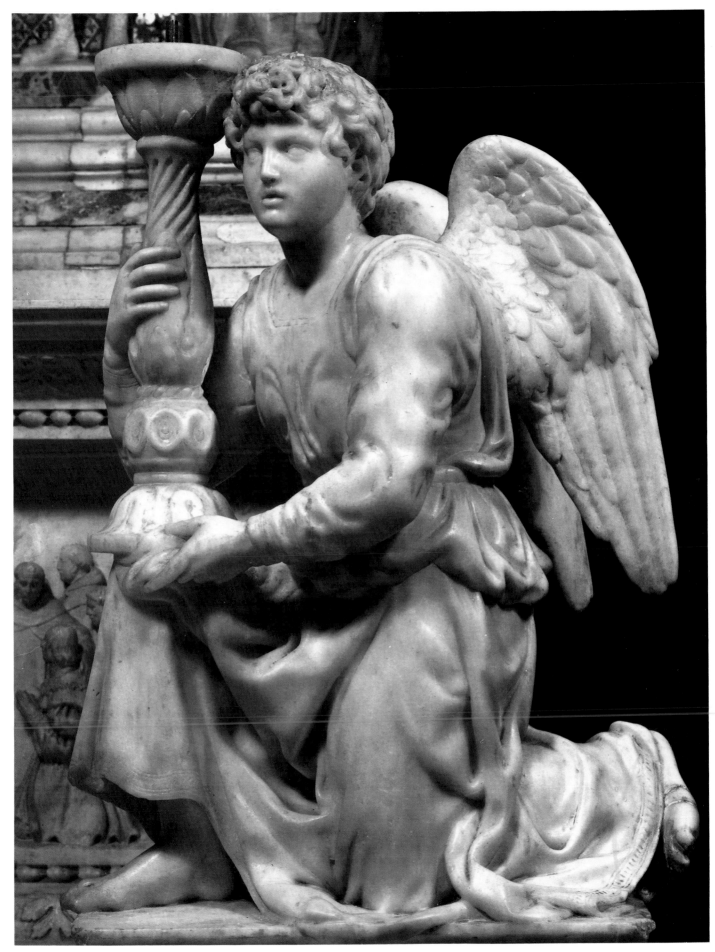

6. ANGEL WITH CANDLESTICK. 1494–1495. Bologna, San Domenico

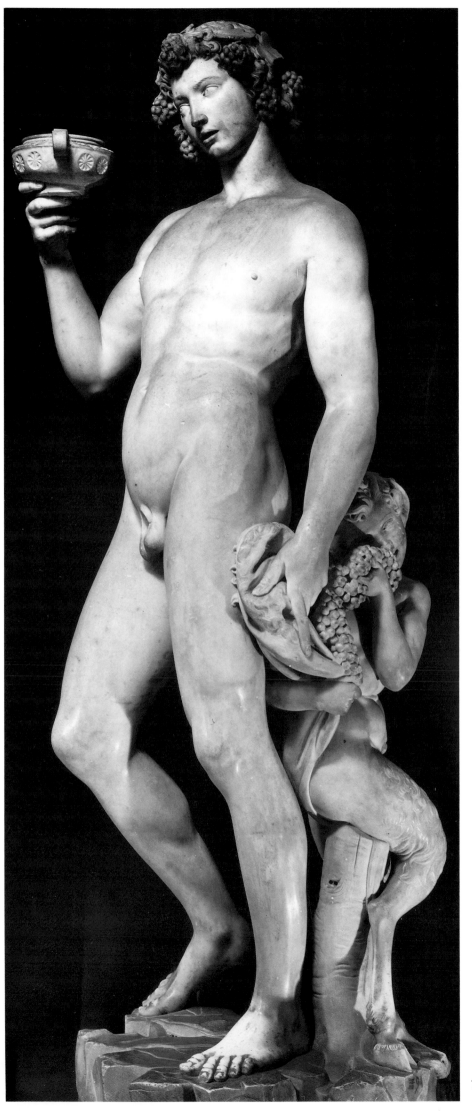

7. BACCHUS. 1496–1497. Florence,
Museo Nazionale del Bargello

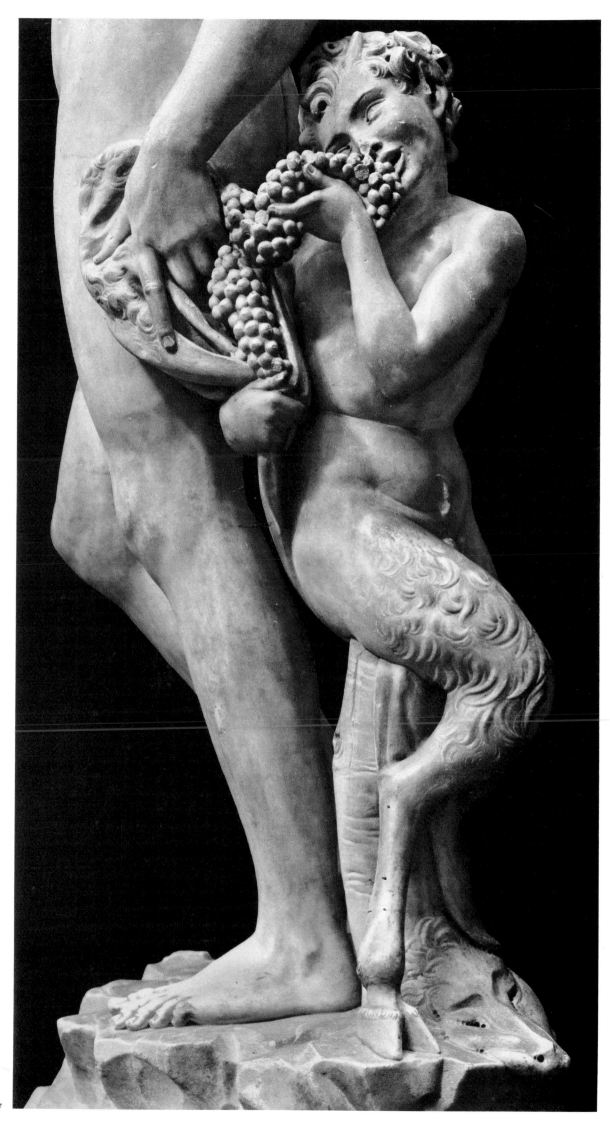

8. SATYR. Detail of Plate 7

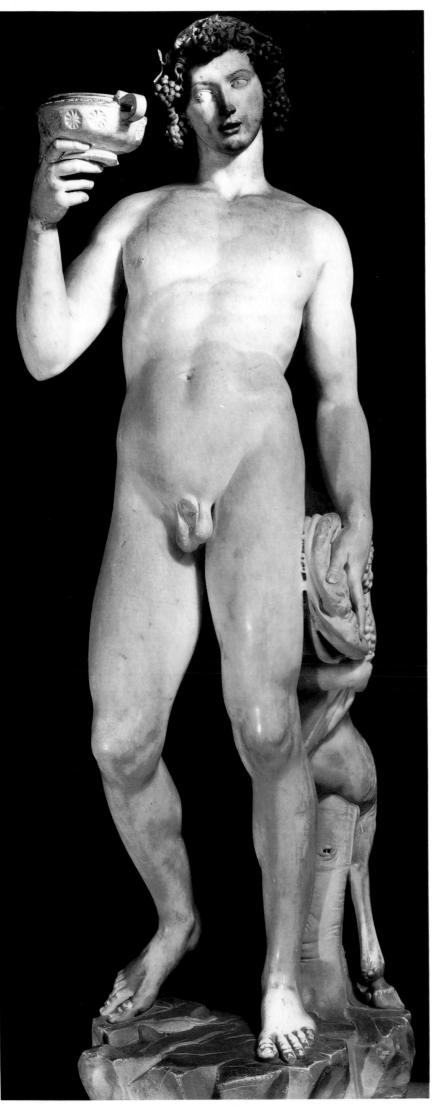

9. BACCHUS. Front view (see Plate 7)

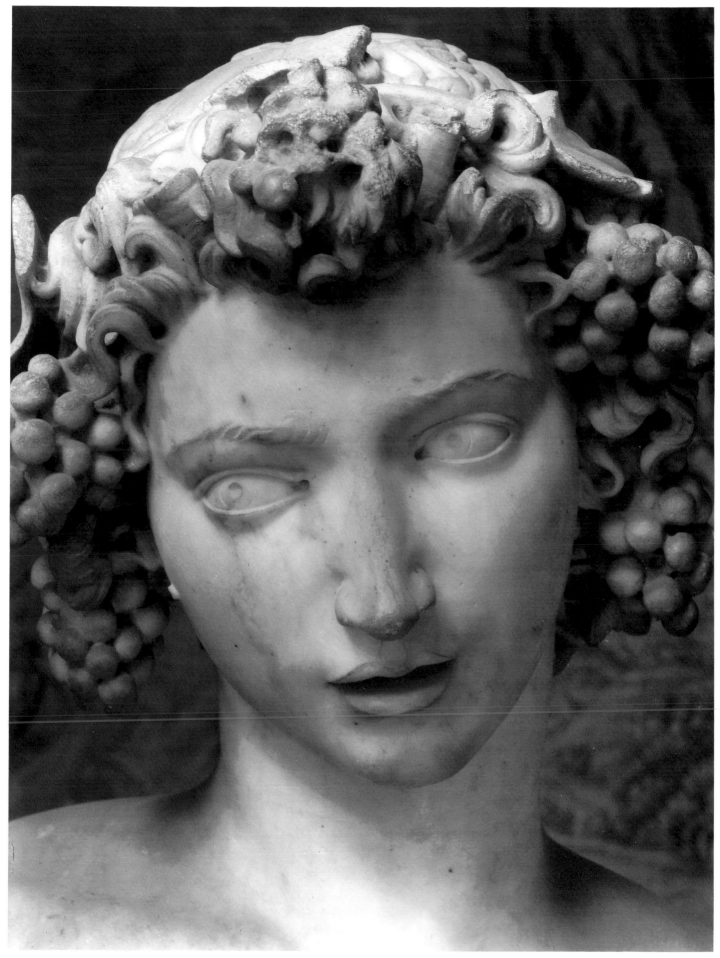

10. HEAD OF BACCHUS. Detail of Plate 9

11. HEAD ON THE LION'S PELT. Detail of Plate 8

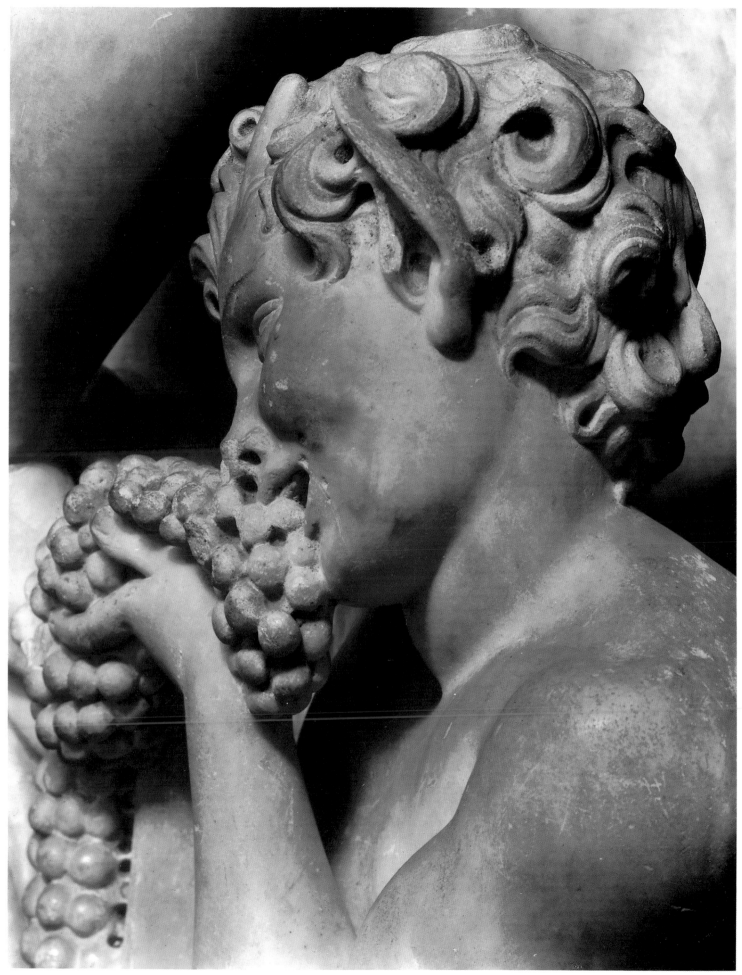

12. SATYR EATING GRAPES. Detail of Plate 7

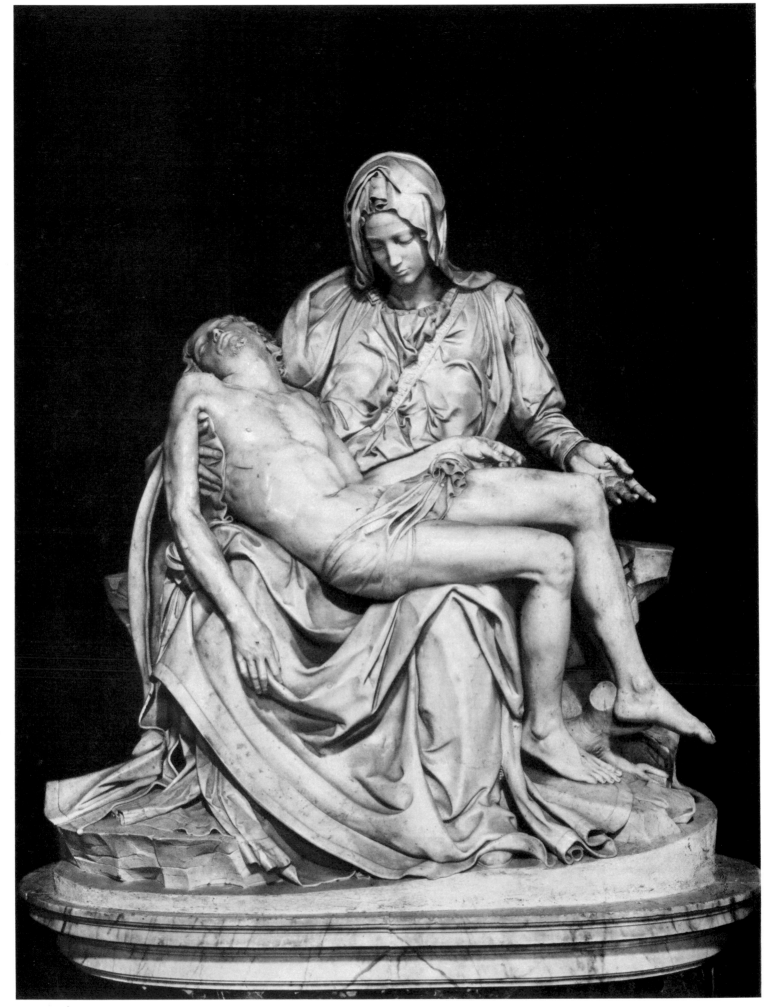

13. PIETÀ. 1498–1499. Rome, St Peter's

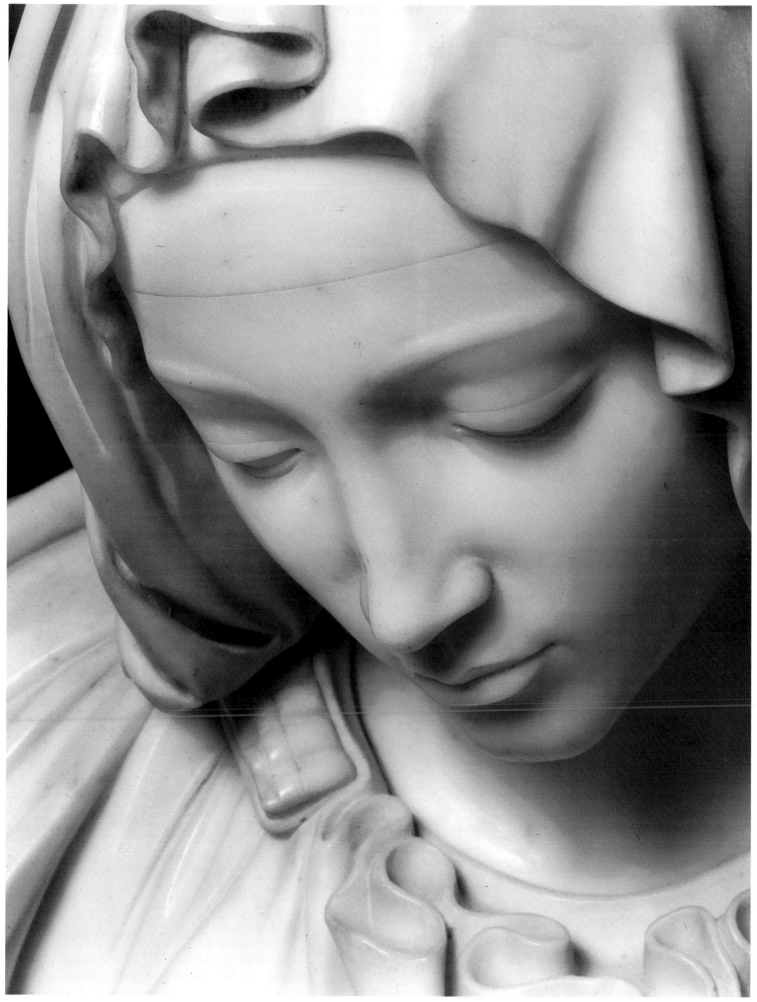

14. HEAD OF THE MADONNA. Detail of Plate 13

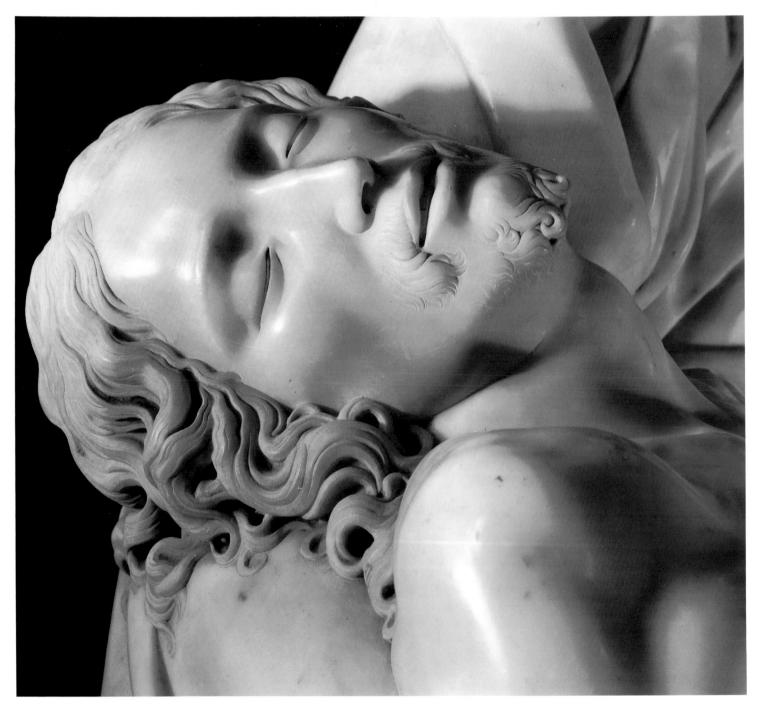

15. HEAD OF CHRIST. Detail of Plate 13

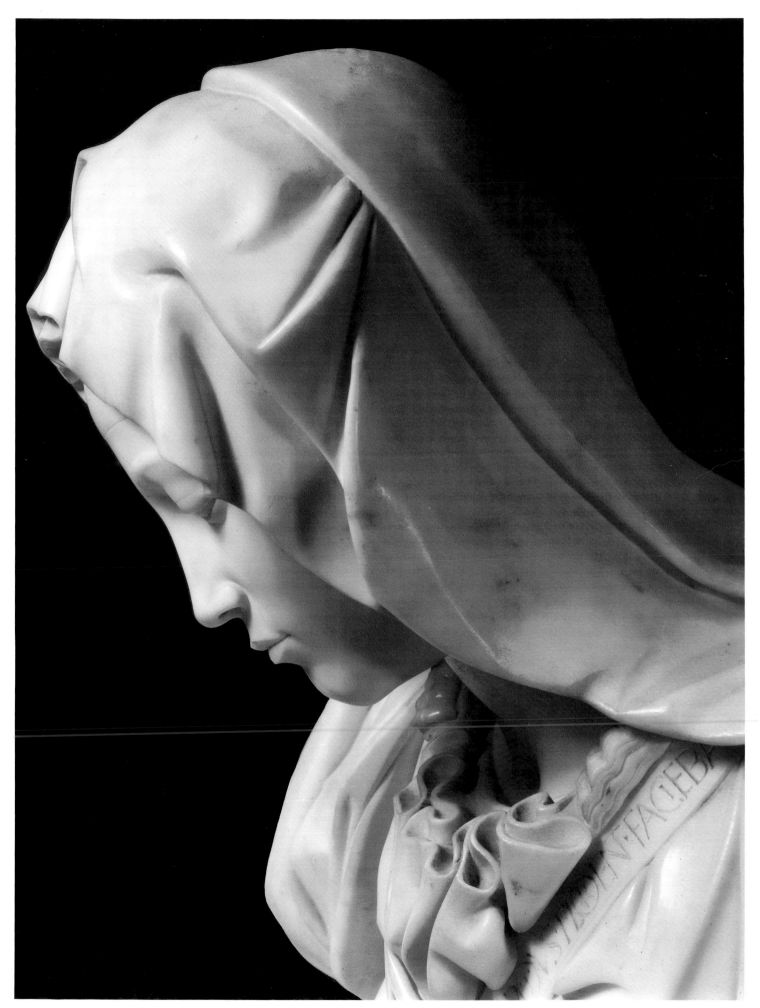

16. HEAD OF THE MADONNA. Detail of Plate 13

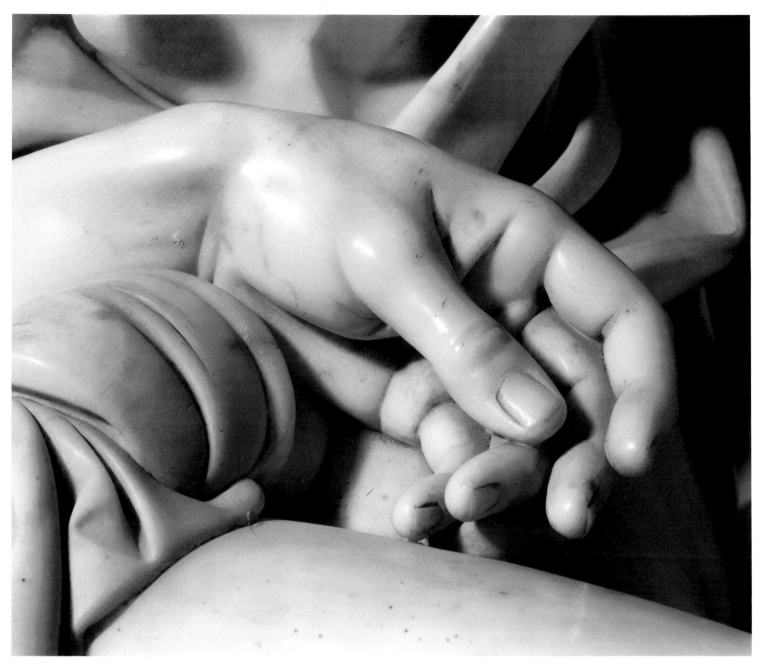

17. THE LEFT HAND OF CHRIST. Detail of Plate 13

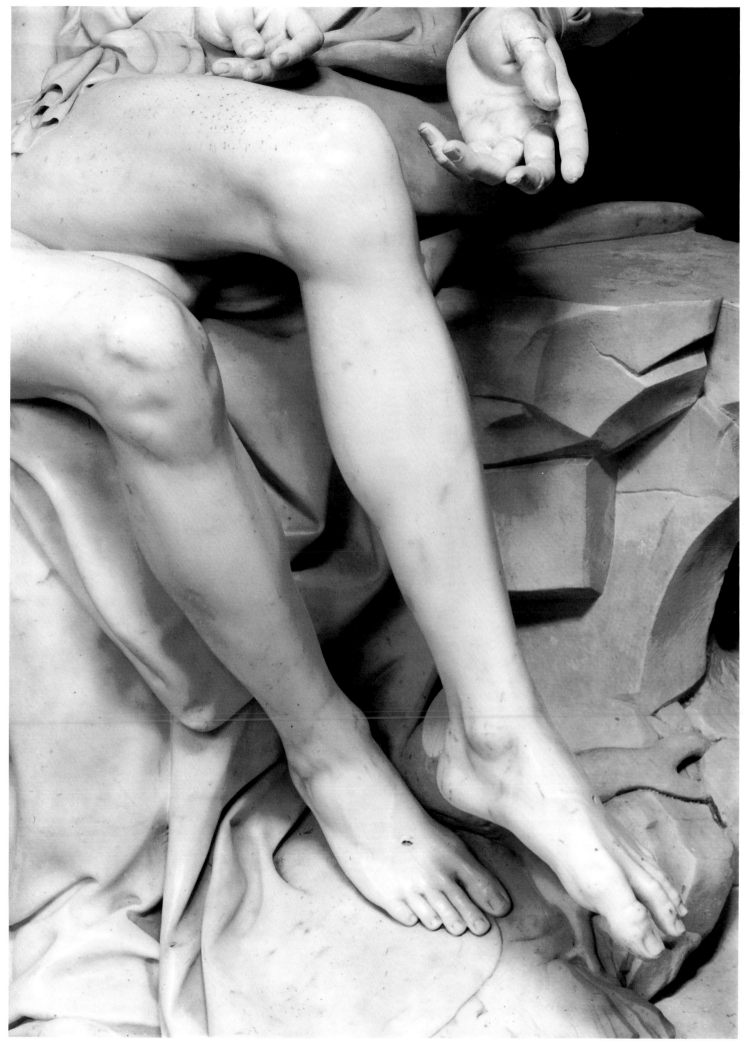

18. THE LEGS OF CHRIST. Detail of Plate 13

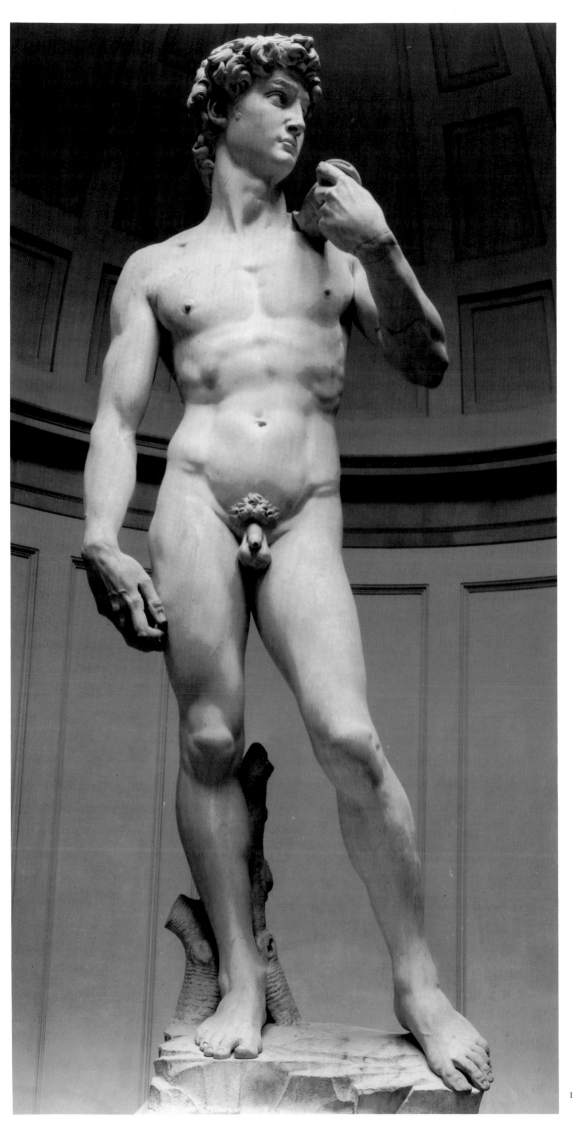

19. DAVID. 1501–1504.
Florence, Accademia

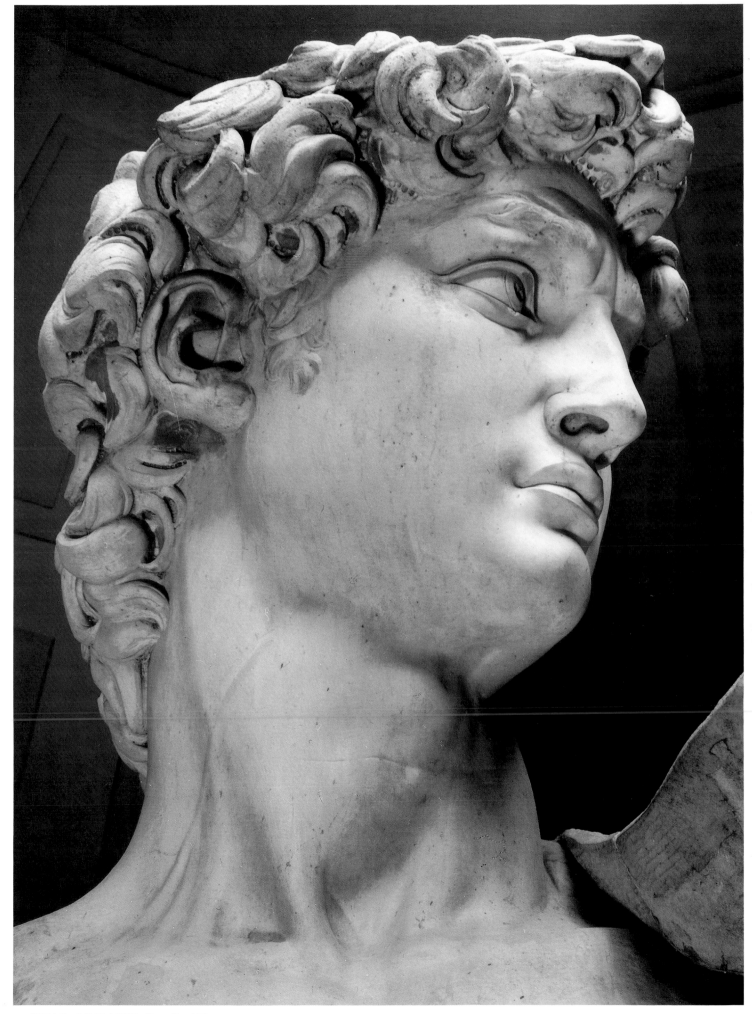

20. HEAD OF DAVID. Detail of Plate 19

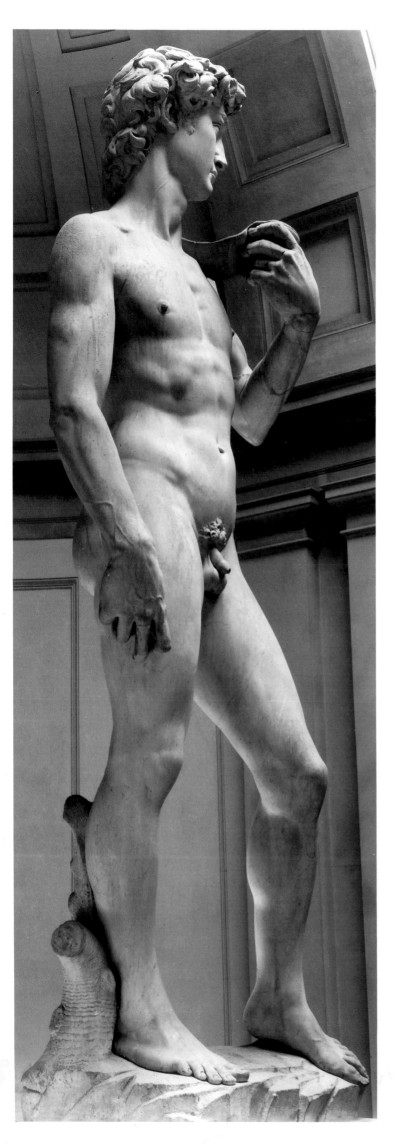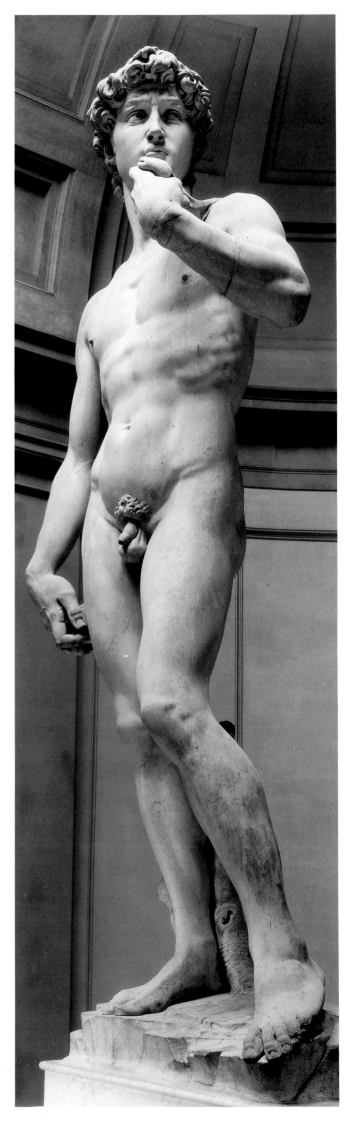

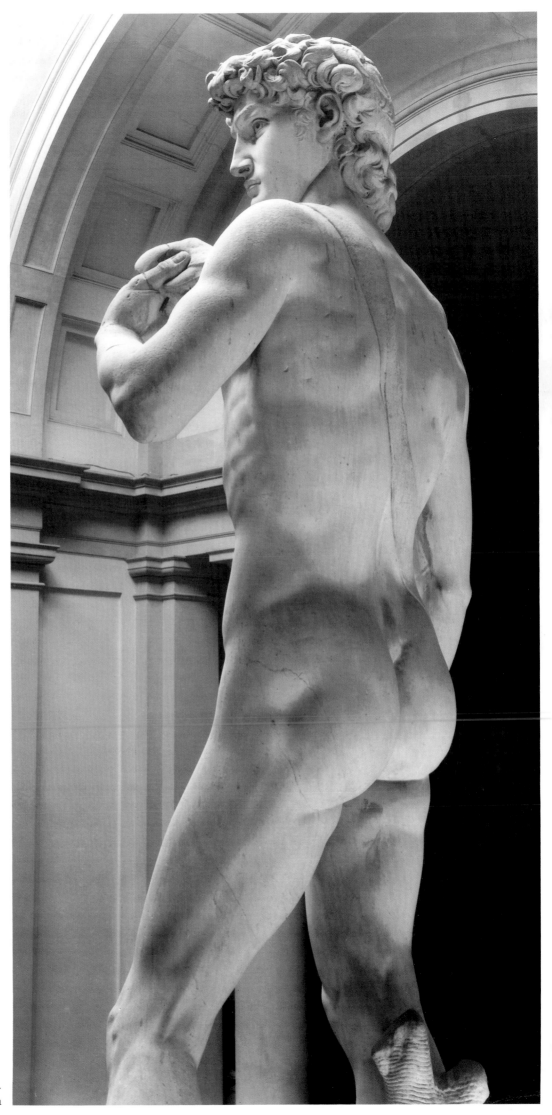

21-23. DAVID. 1501-1504.
Florence, Accademia

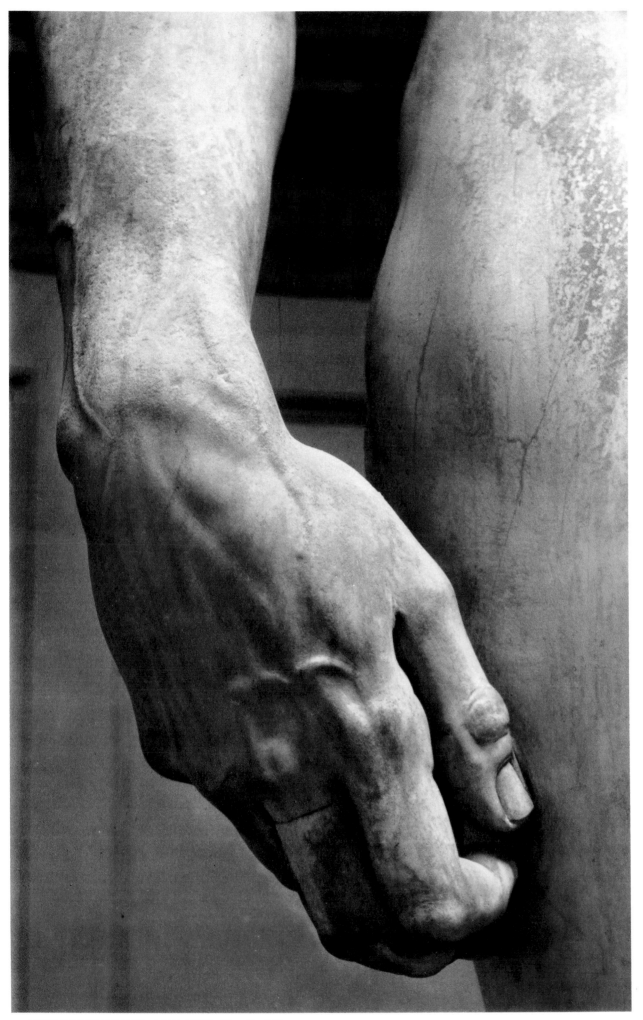

24. THE RIGHT HAND OF DAVID. Detail of Plate 19

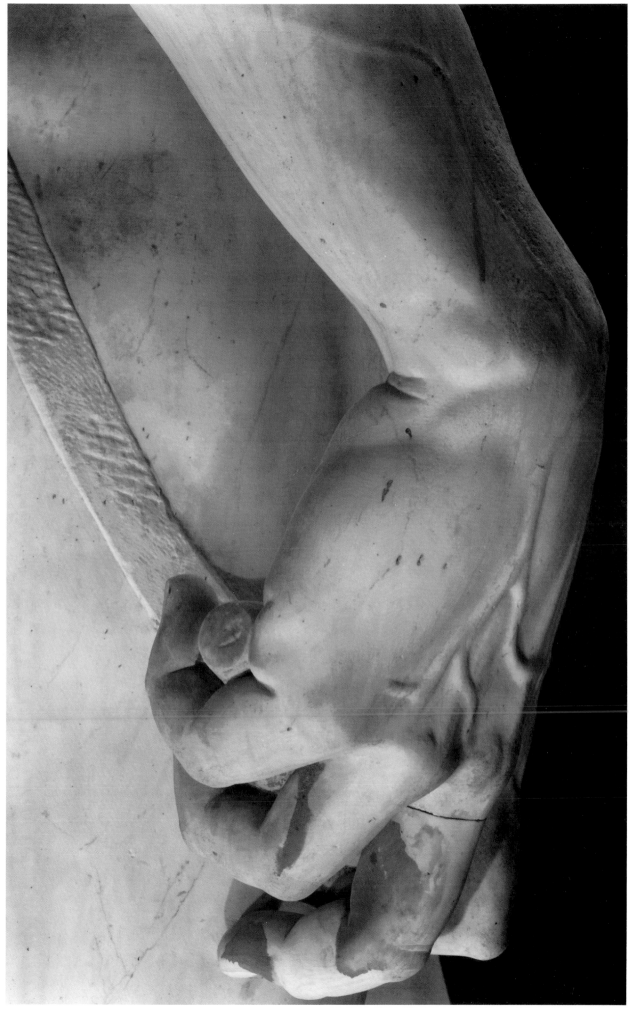

25. THE RIGHT HAND OF DAVID. Detail of Plate 19

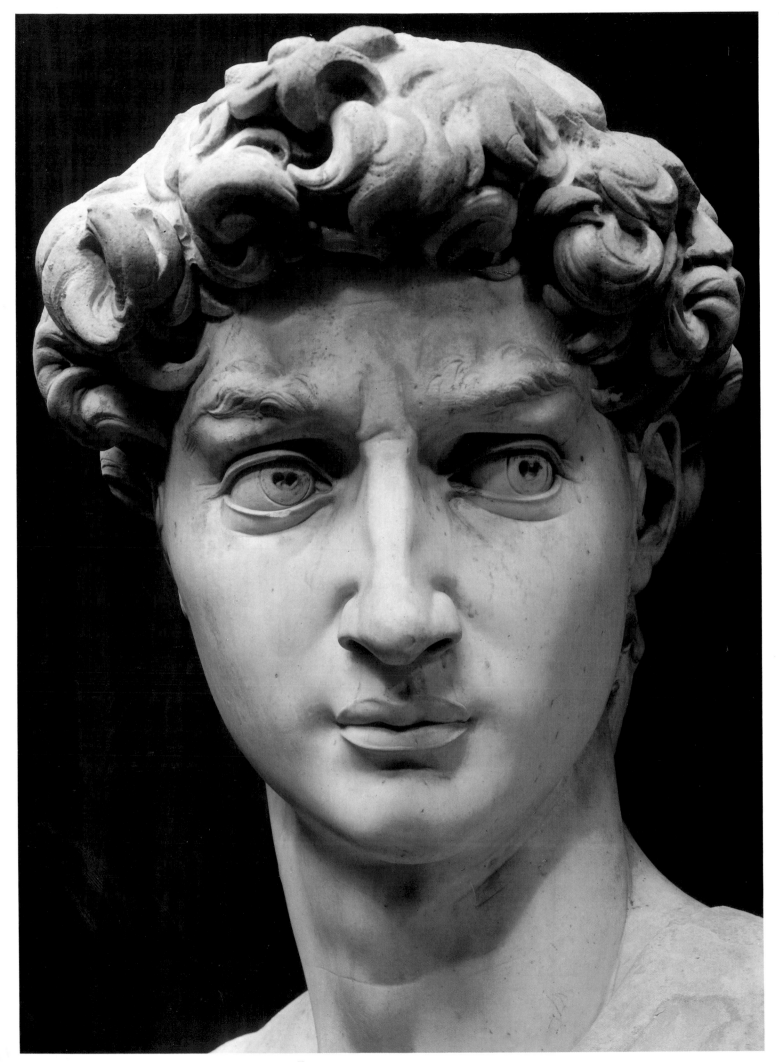

26. HEAD OF DAVID. Detail of Plate 22

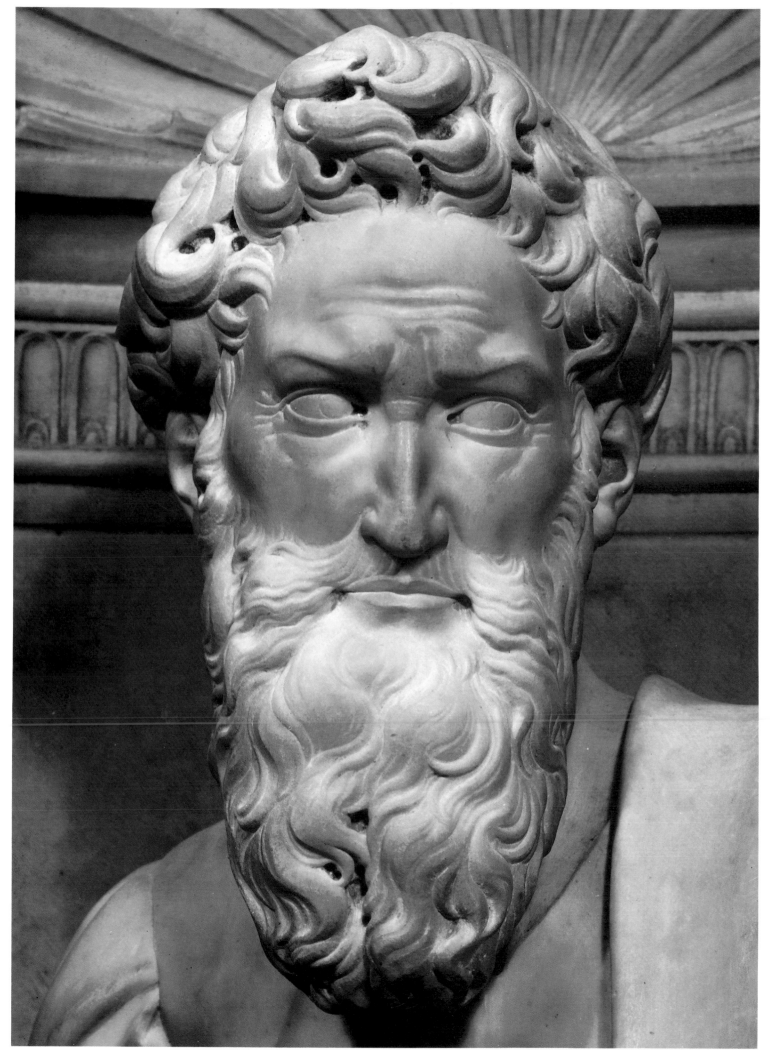

27. HEAD OF SAINT PAUL. Detail of Plate 33

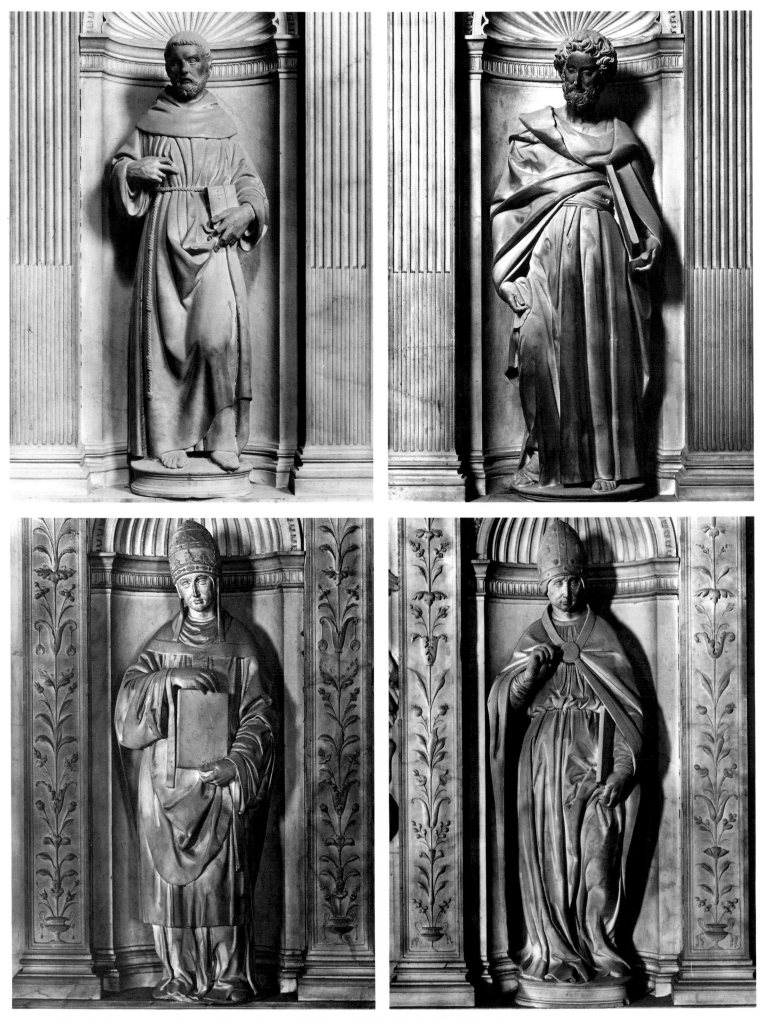

28–31. FOUR STATUES OF THE PICCOLOMINI ALTAR IN THE SIENA CATHEDRAL. 1501–1504.
Saint Francis – Saint Peter – Gregory the Great – Pope Pius I

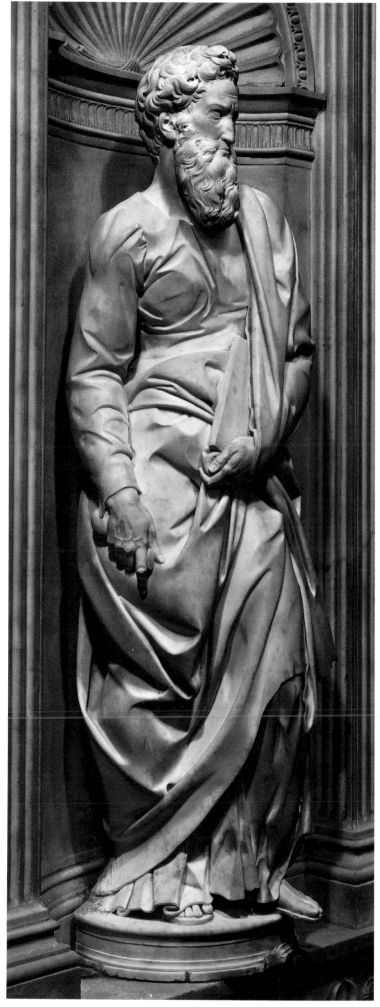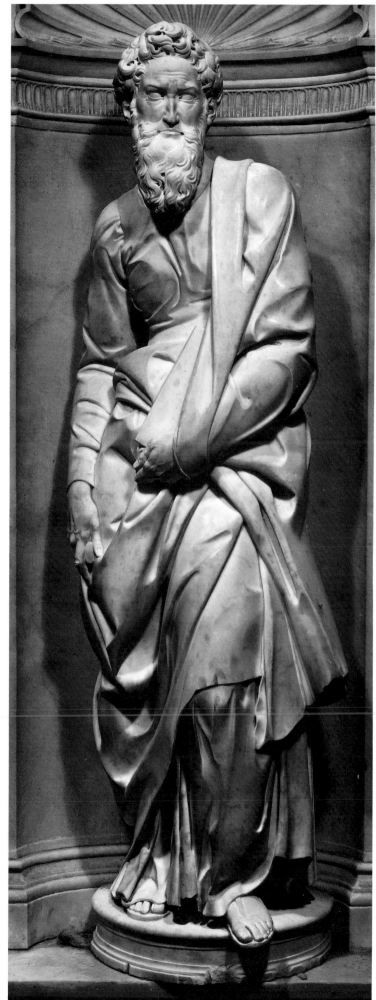

32–33. SAINT PAUL. Piccolomini Altar, Siena Cathedral. 1501–1504

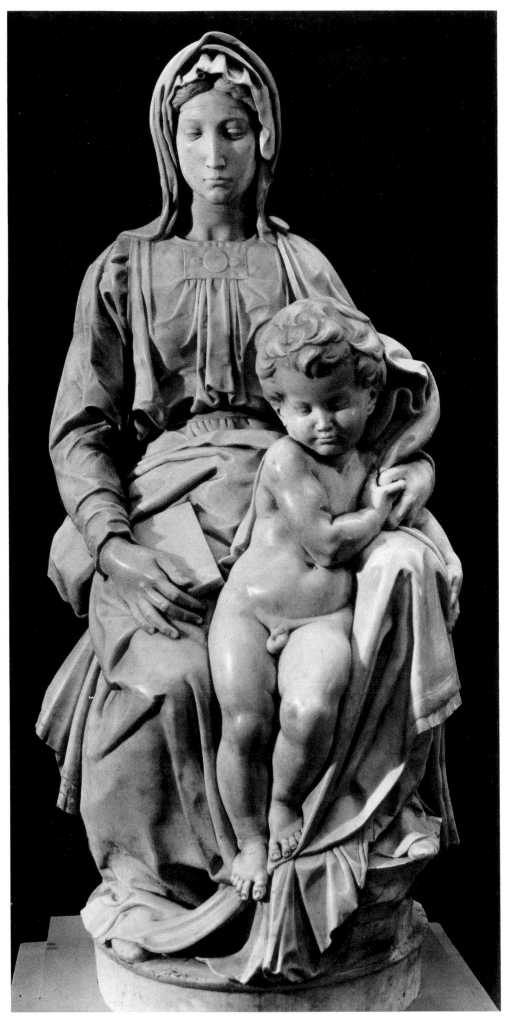

34. THE MOUSCRON MADONNA. About 1504. Bruges, Notre-Dame

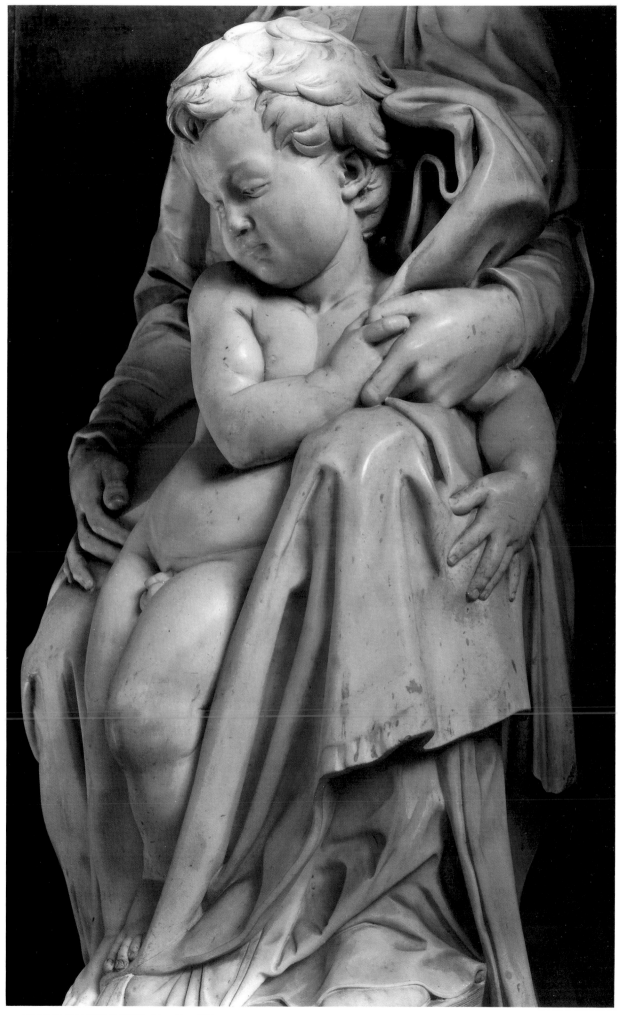

35. THE INFANT JESUS. Detail of Plate 34

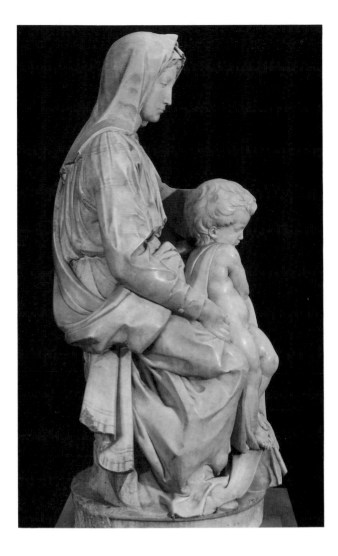
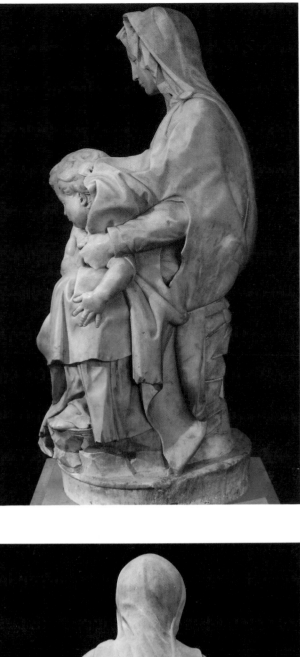
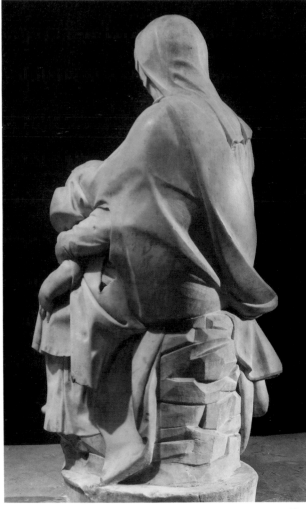
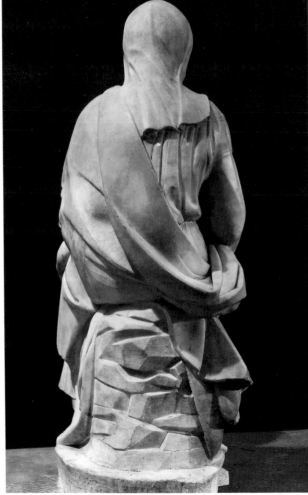

36–39. FOUR VIEWS OF THE MADONNA OF BRUGES (cf. Plate 34)

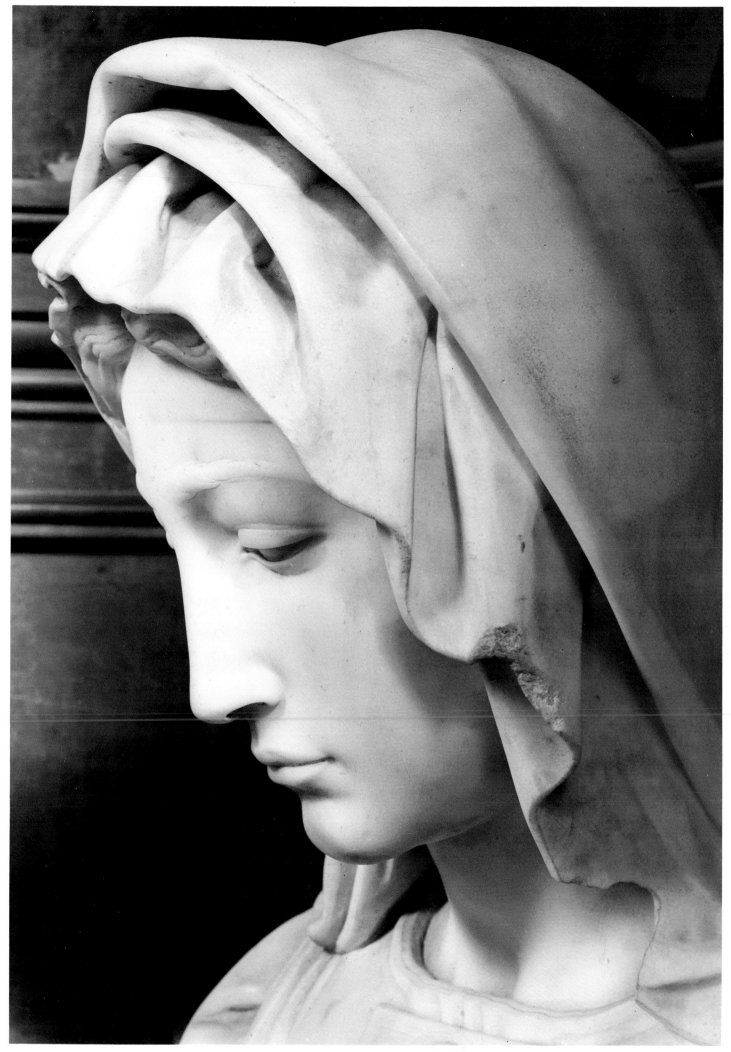

40. HEAD OF THE MADONNA OF BRUGES. Detail of Plate 37

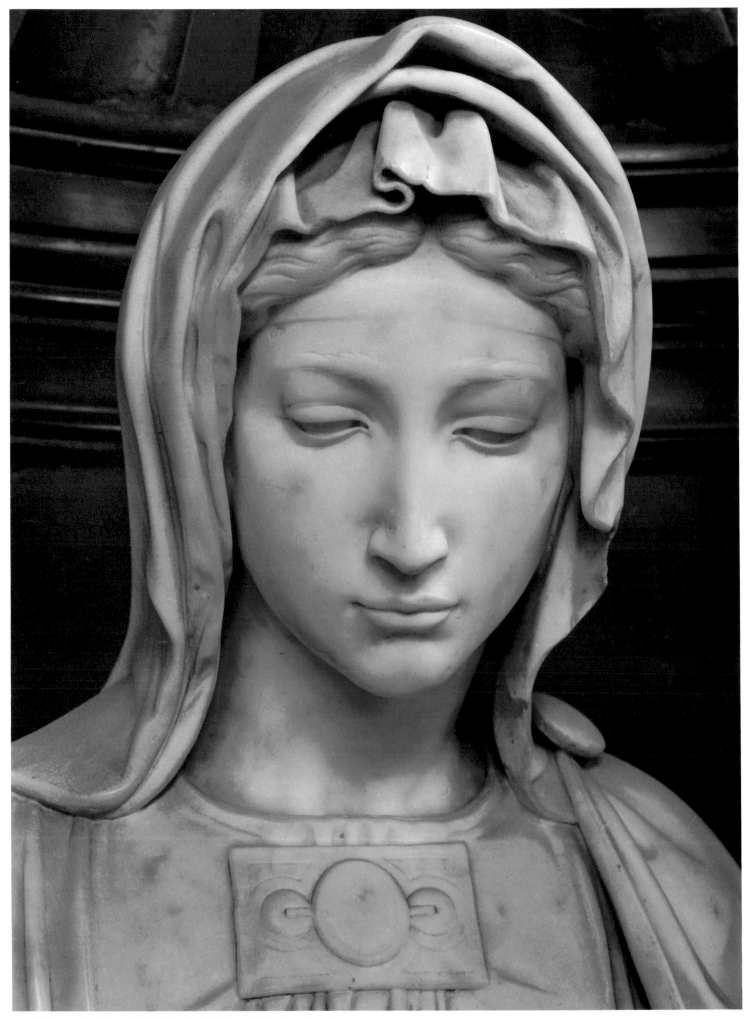

41. HEAD OF THE MADONNA OF BRUGES. Detail of Plate 34

42. HEAD OF THE INFANT JESUS. Detail of Plate 34

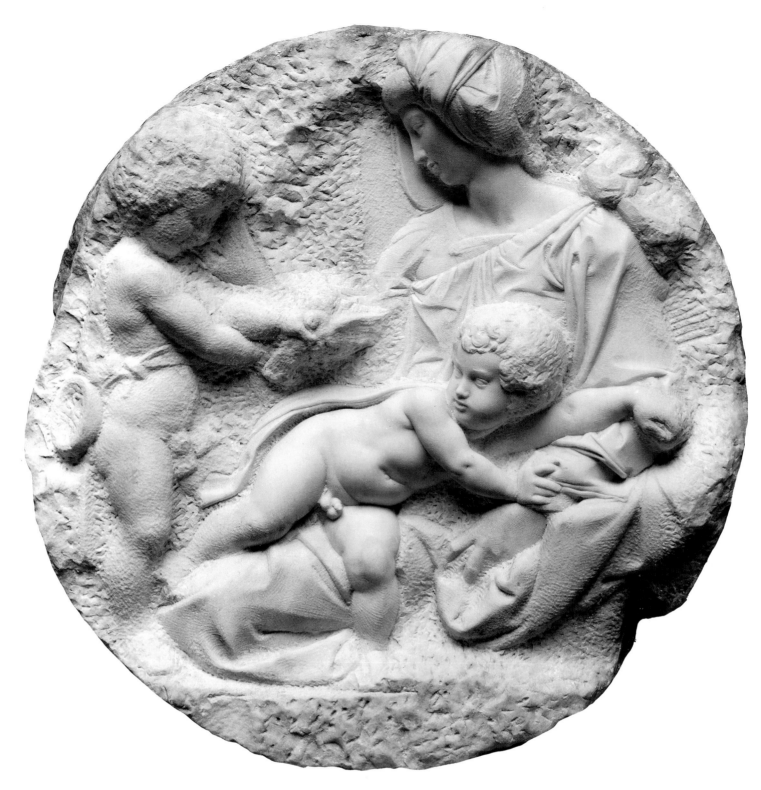

43. MADONNA TADDEI. About 1504. London, Royal Academy

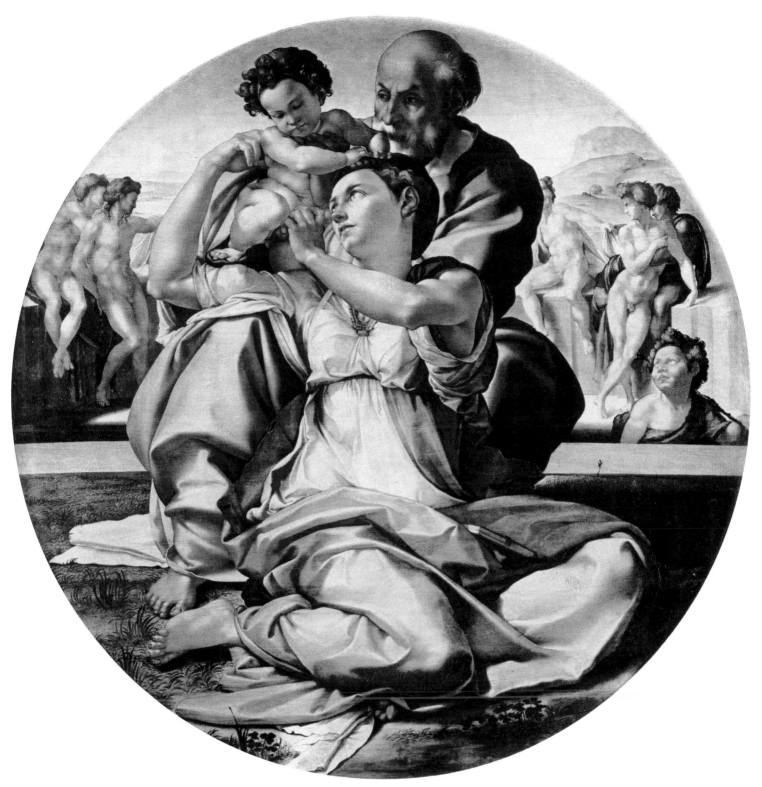

44. MADONNA DONI. About 1504. Florence, Uffizi

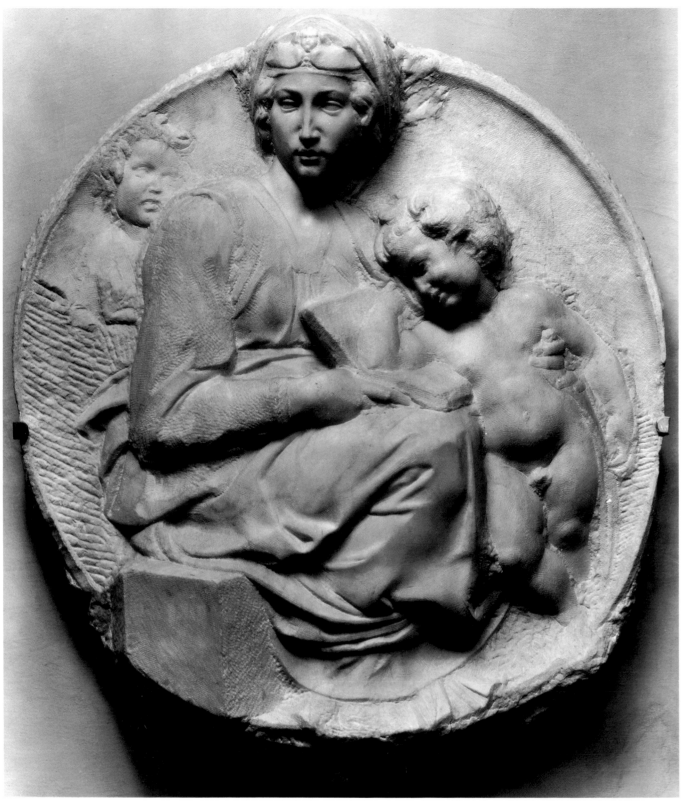

45. MADONNA PITTI. About 1505. Florence, Museo Nazionale del Bargello

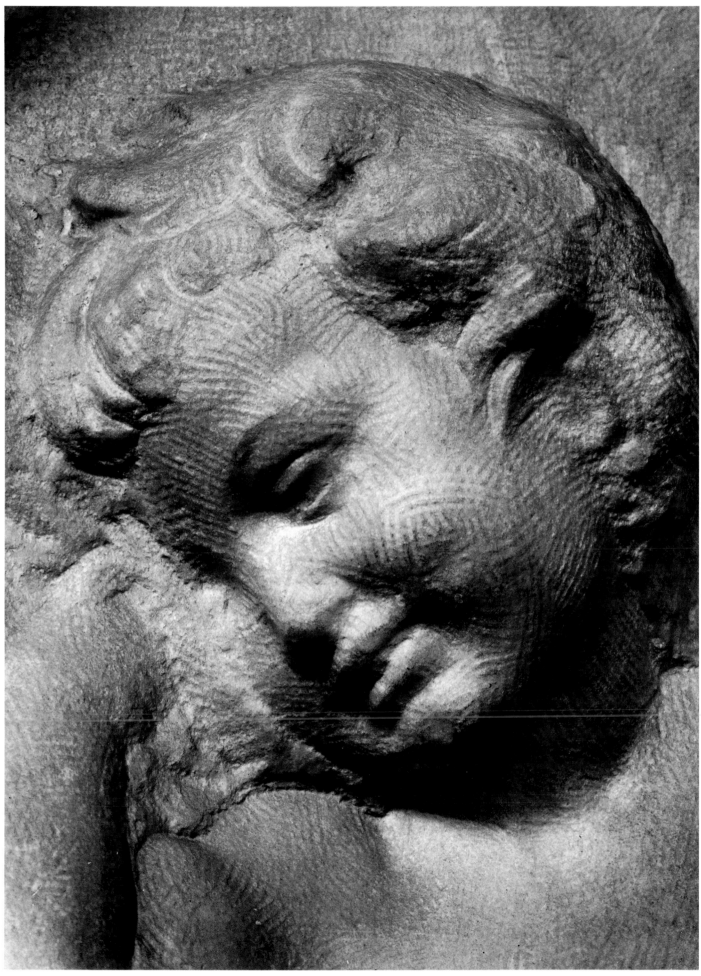

46. HEAD OF THE INFANT JESUS. Detail of Plate 45

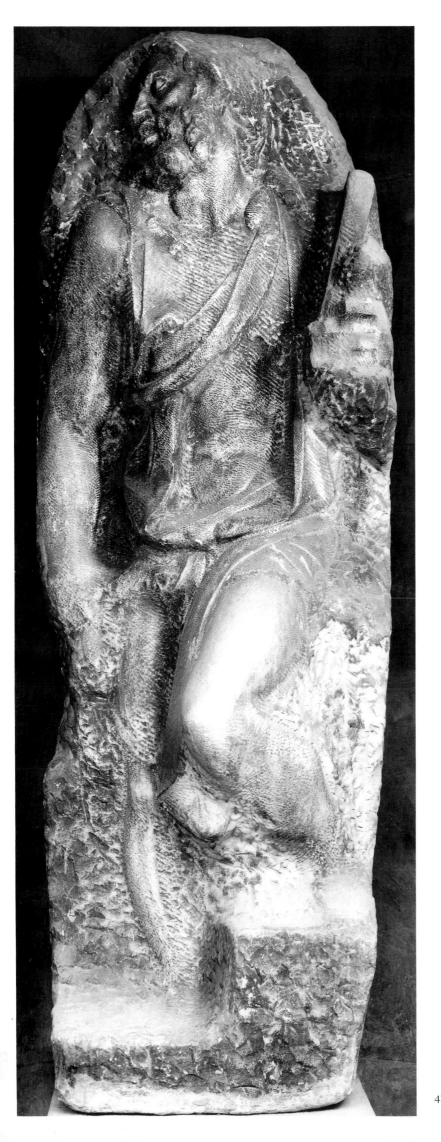

47. SAINT MATTHEW. About 1505–1506(?).
Florence, Accademia

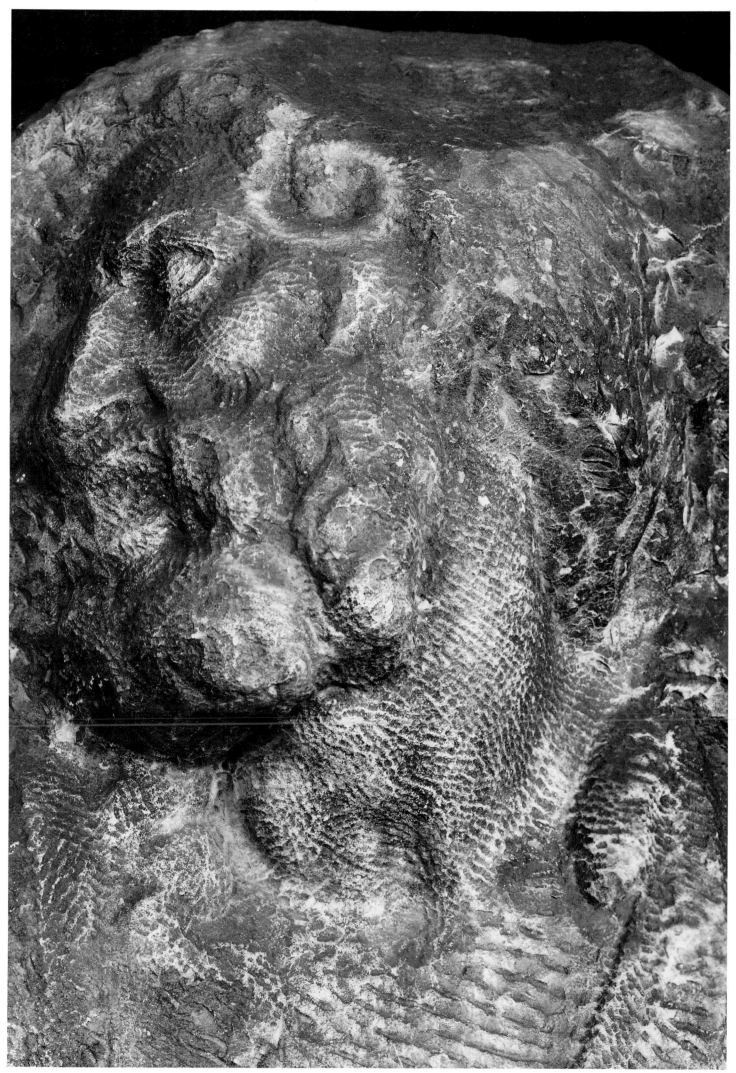

48. HEAD OF SAINT MATTHEW. Detail of Plate 47

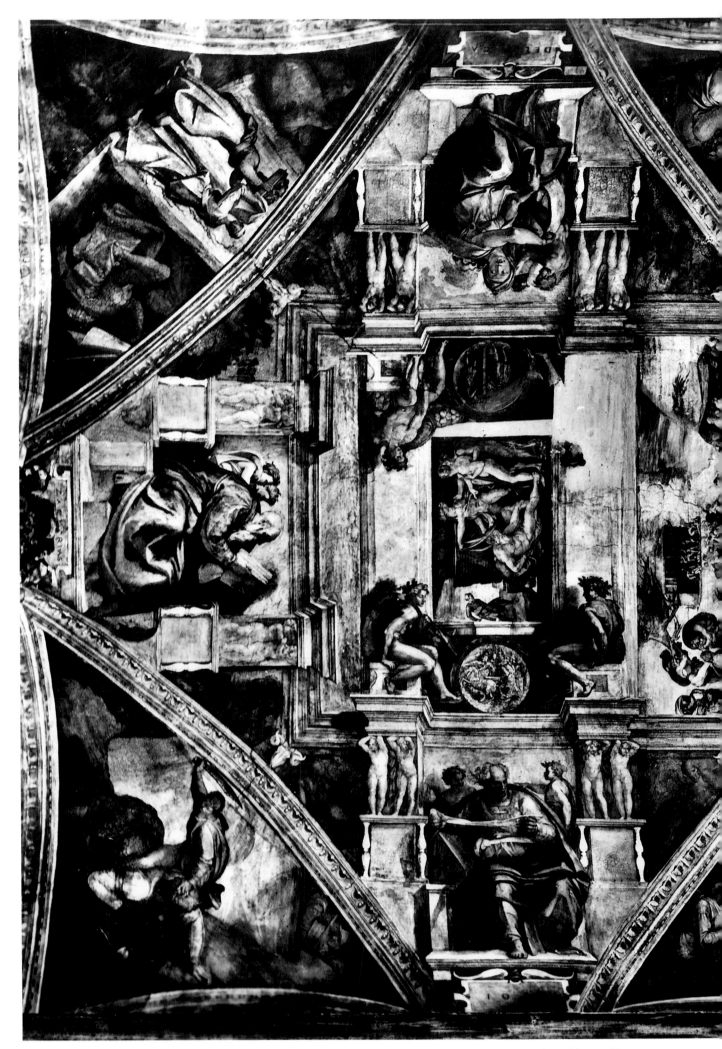

49a. THE FRESCOES ON THE CEILING OF THE SISTINE CHAPEL. 1508–1512. (Continued on Plate 49b)

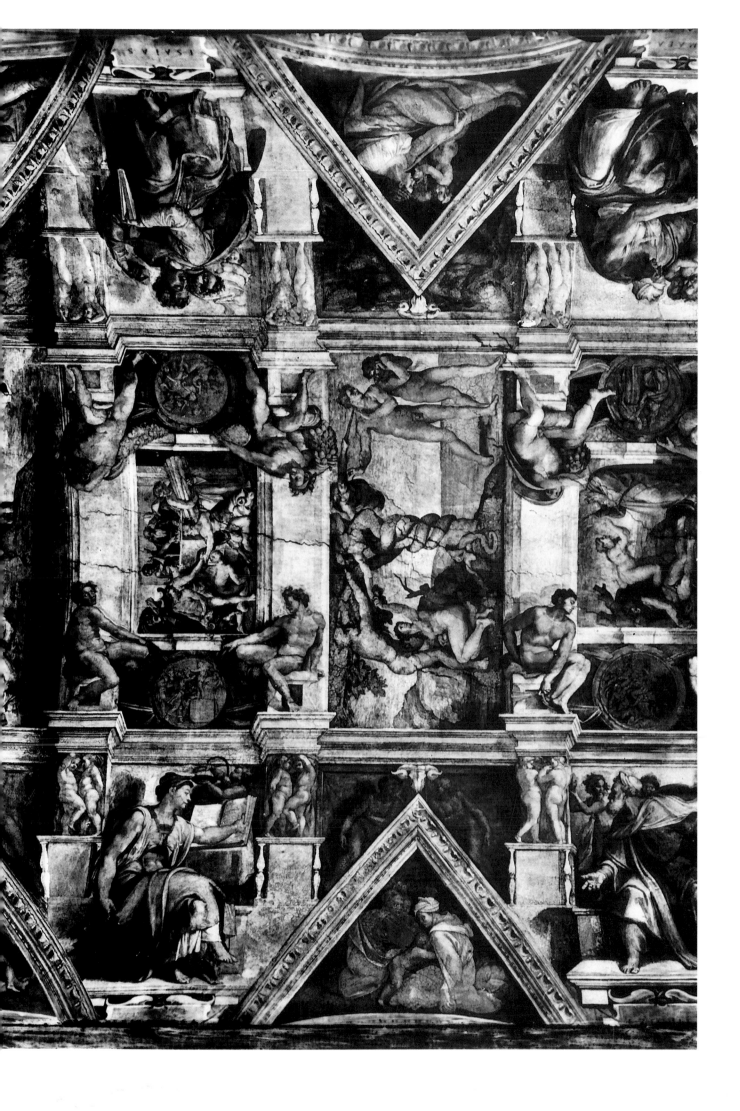

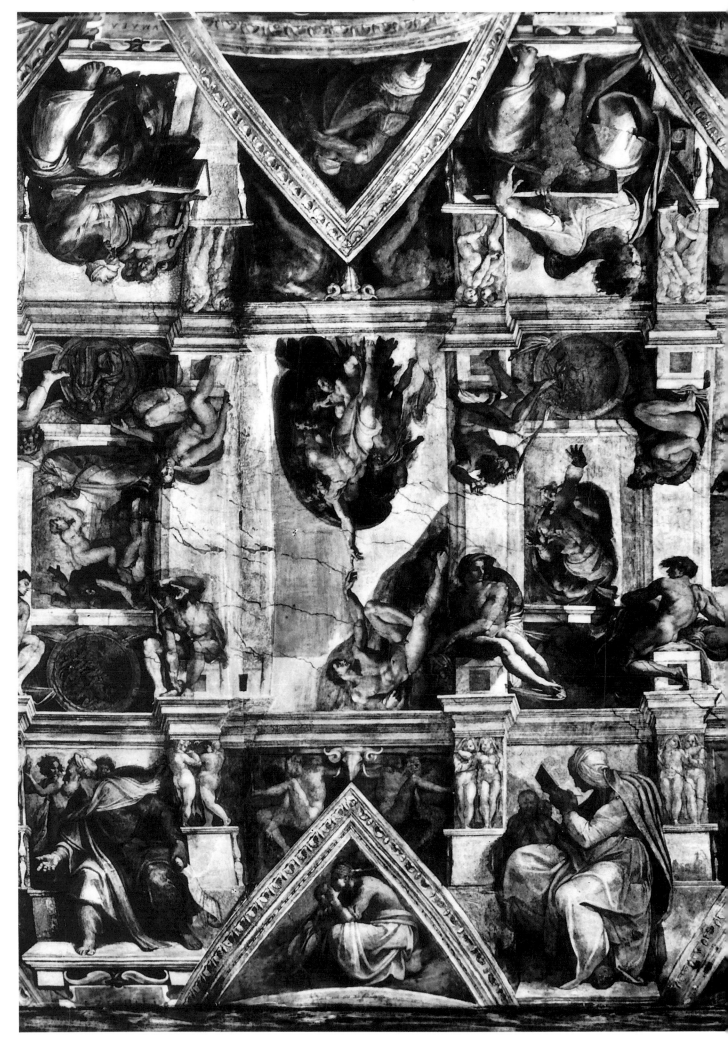

49b. THE FRESCOES ON THE CEILING OF THE SISTINE CHAPEL. 1508–1512. (Continued from Plate 49a)

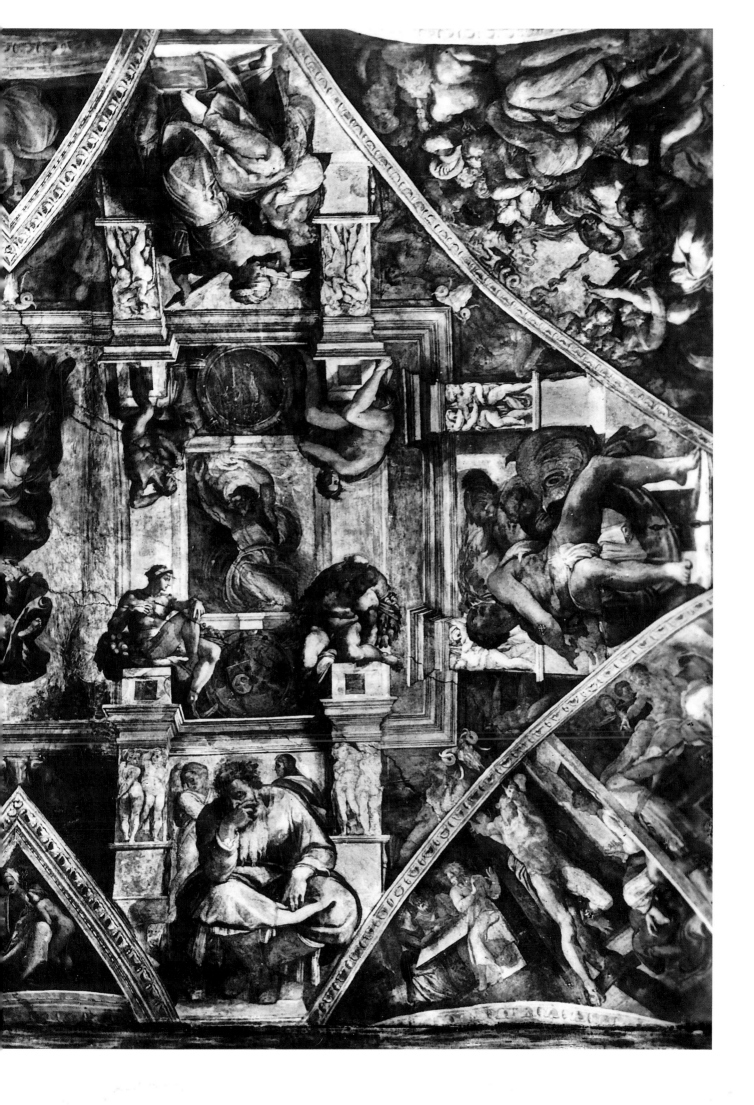

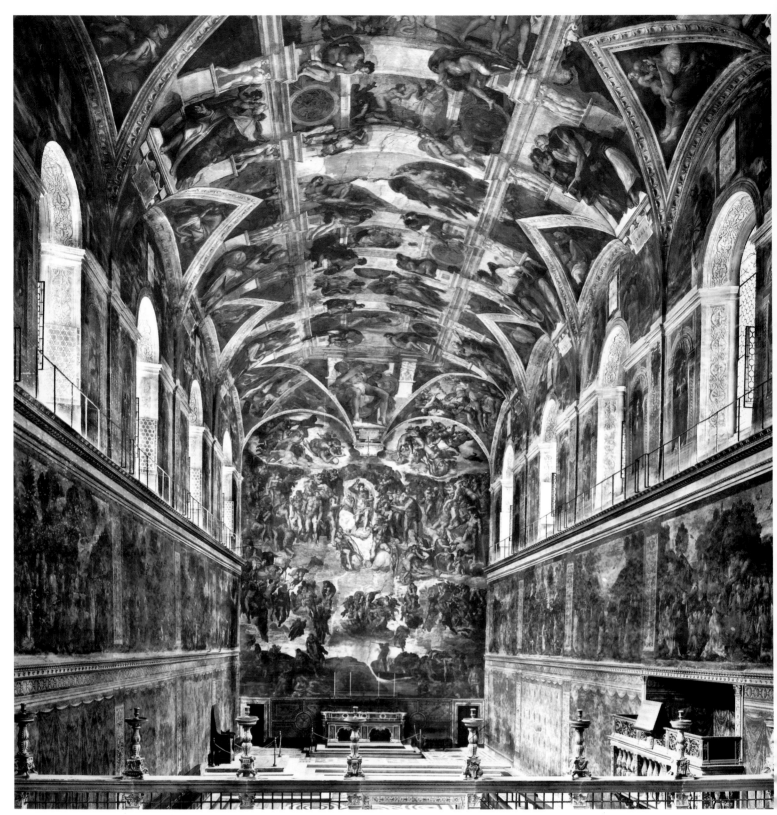

50. INTERIOR OF THE SISTINE CHAPEL. Vatican Palace, Rome

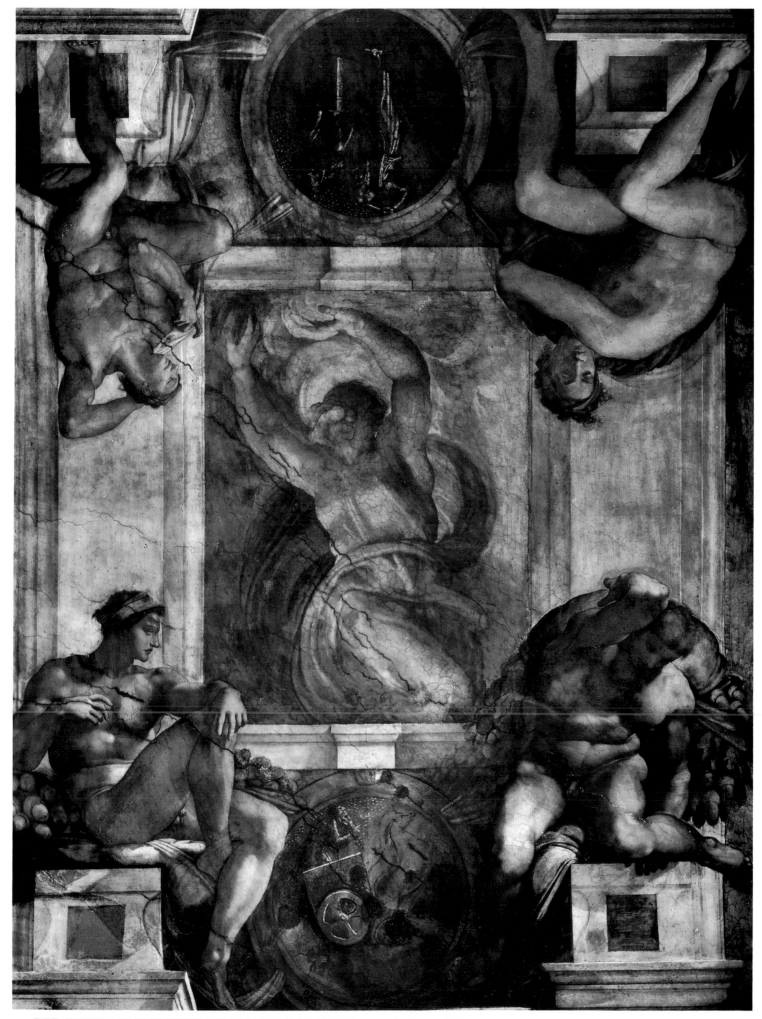

51. GOD DIVIDING THE LIGHT FROM THE DARKNESS. 1511. Section of the Sistine Chapel Ceiling

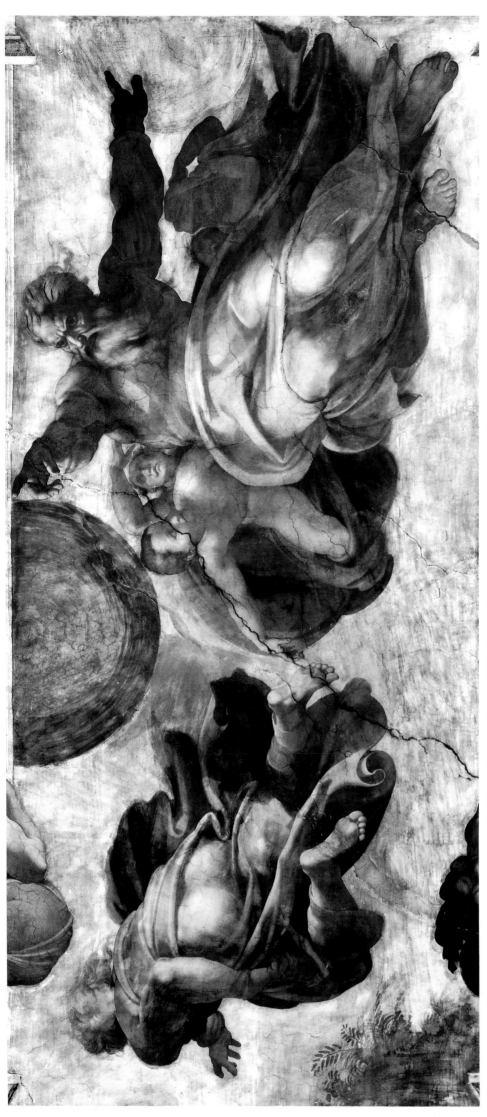

52. THE CREATION OF SUN AND MOON, AND THE CREATION OF THE PLANTS. 1511. Section of the Sistine Chapel Ceiling

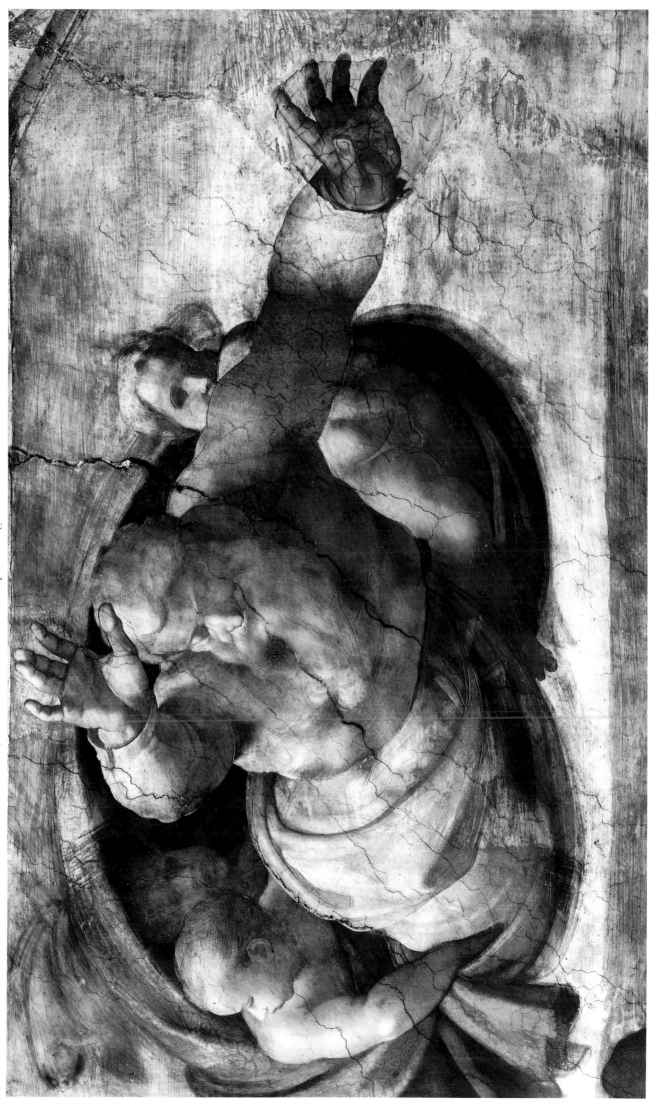

53. GOD DIVIDING THE WATERS FROM THE EARTH. 1511. Section of the Sistine Chapel Ceiling

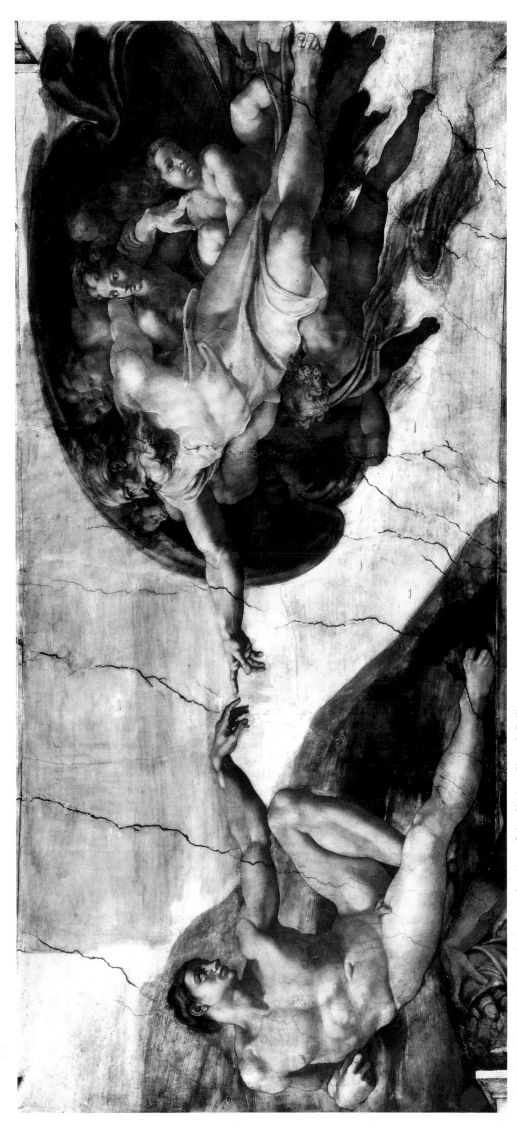

54. THE CREATION OF MAN. 1511. Section of the Sistine Chapel Ceiling

55. THE CREATION OF WOMAN. 1509–1510. Section of the Sistine Chapel Ceiling

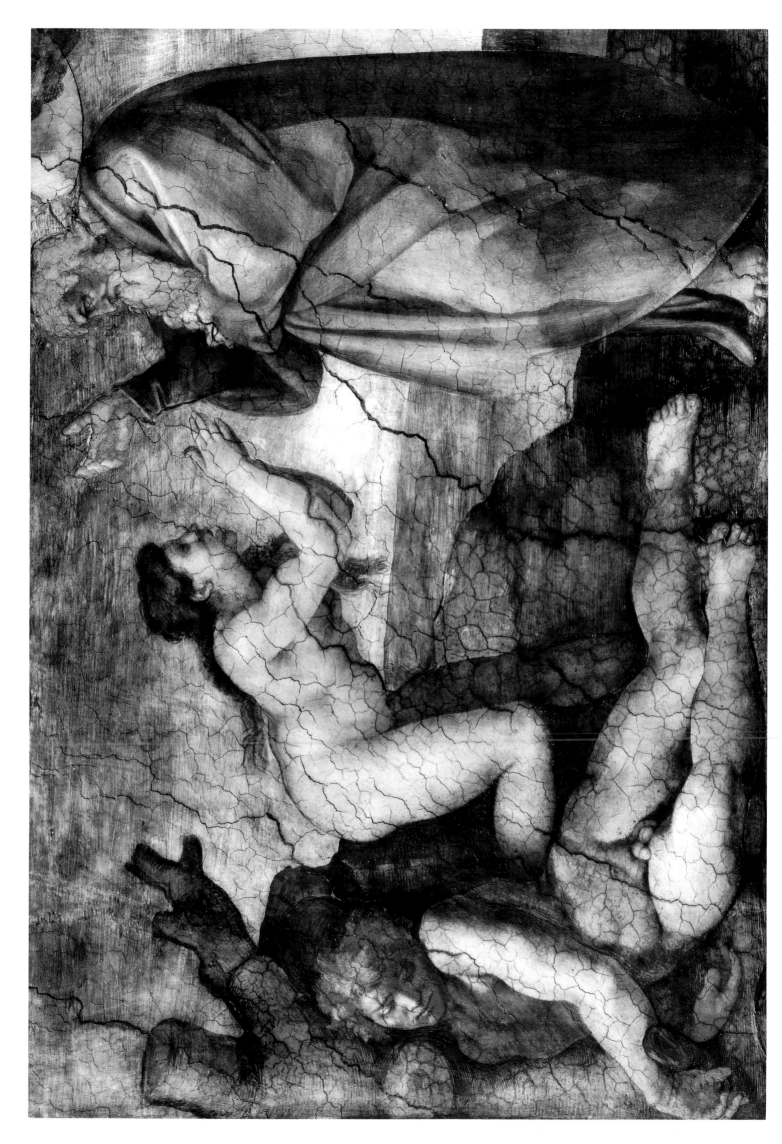

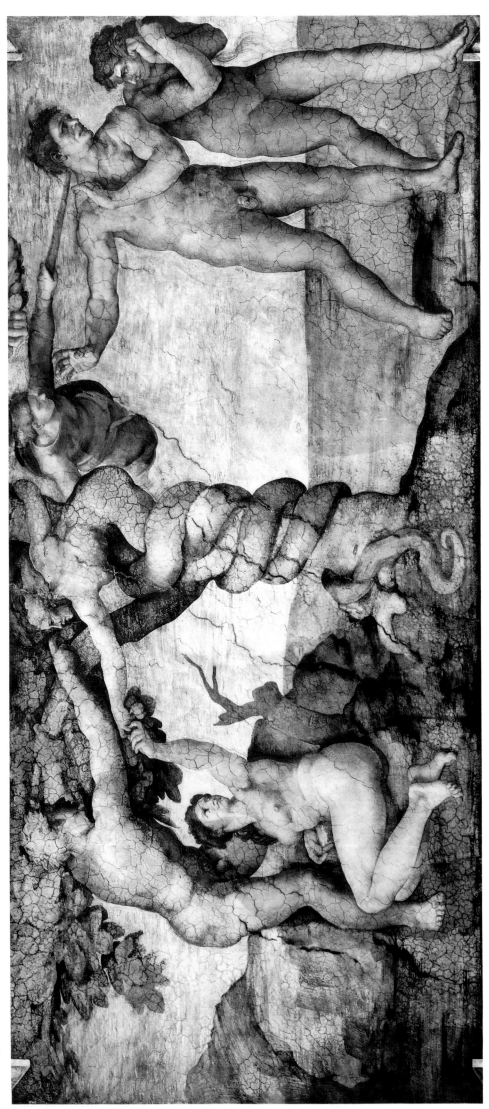

56. THE FALL OF MAN AND THE EXPULSION FROM THE GARDEN OF EDEN. 1509–1510. Section of the Sistine Chapel Ceiling

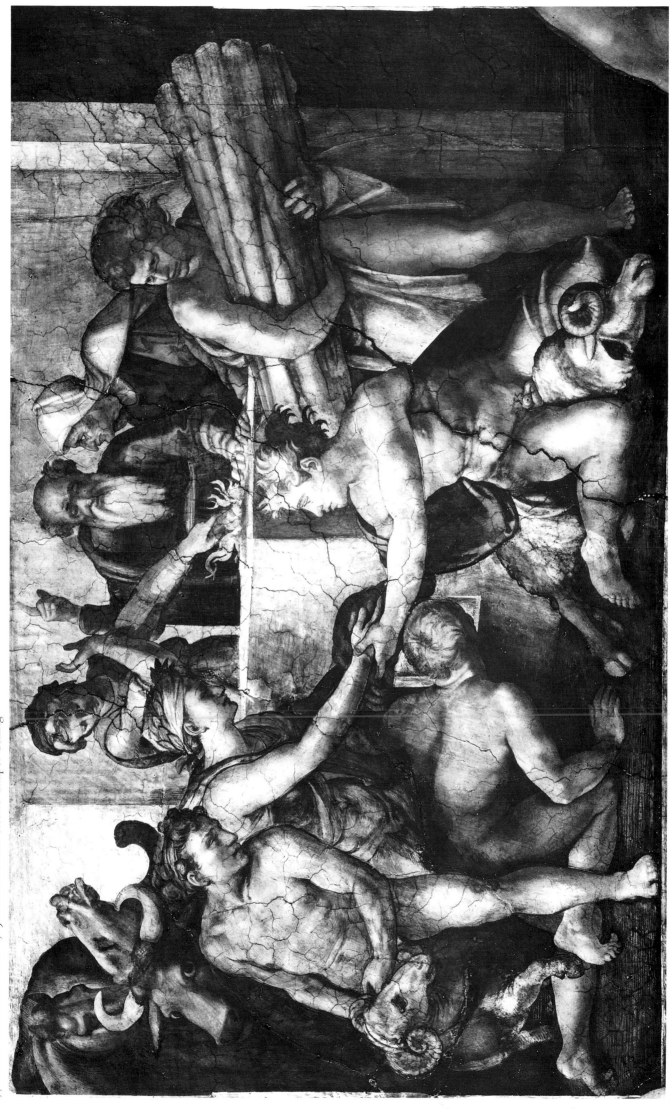

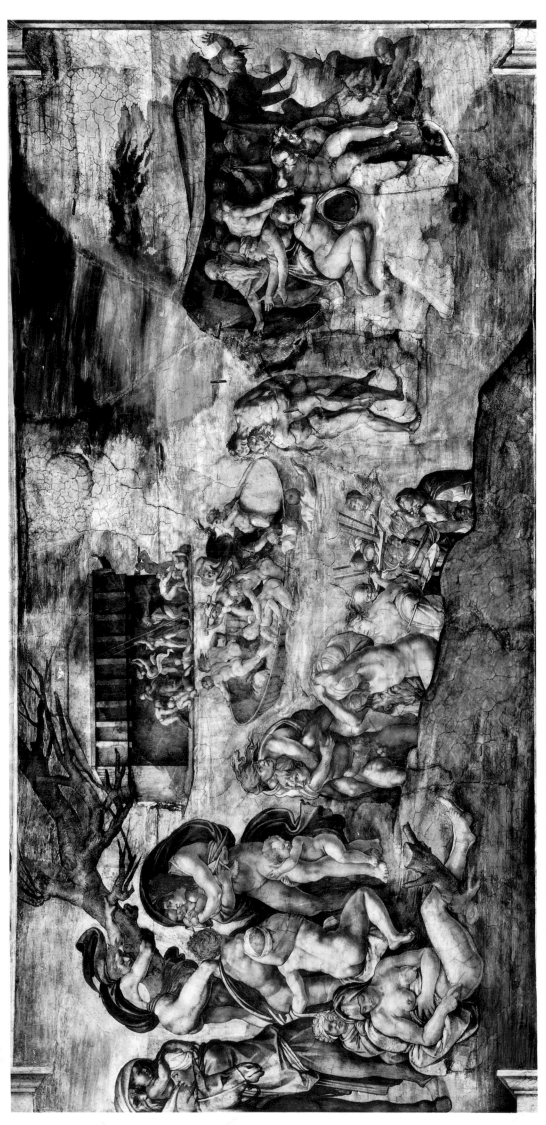

58. THE GREAT FLOOD. 1508–1509. Section of the Sistine Chapel Ceiling

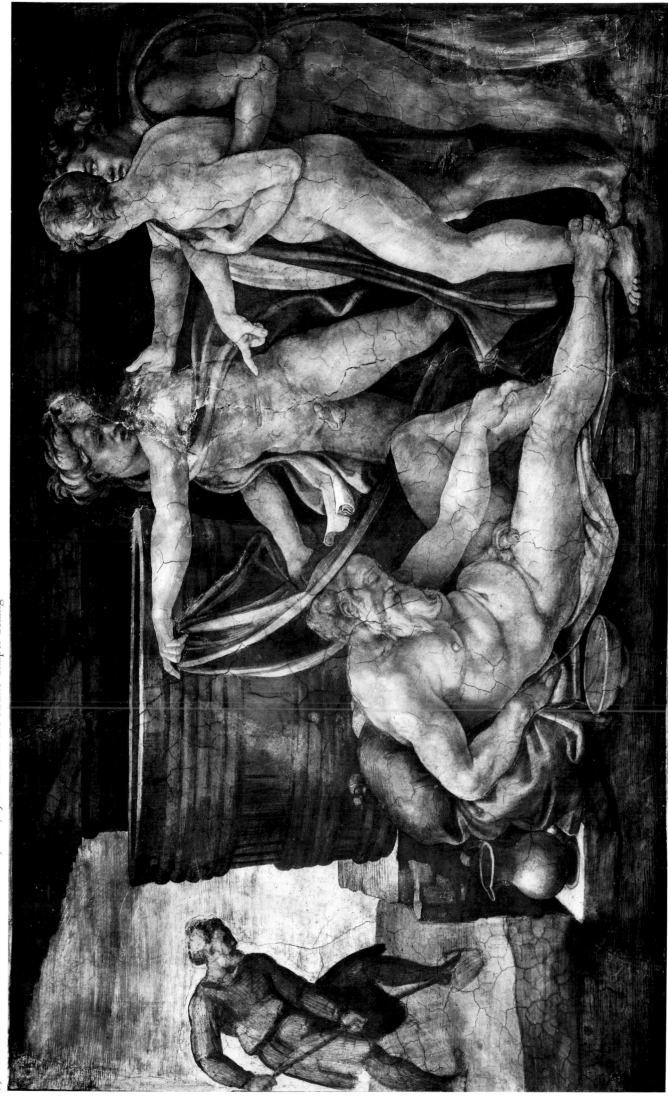

59. THE DRUNKENNESS OF NOAH. 1508-1509. Section of the Sistine Chapel Ceiling

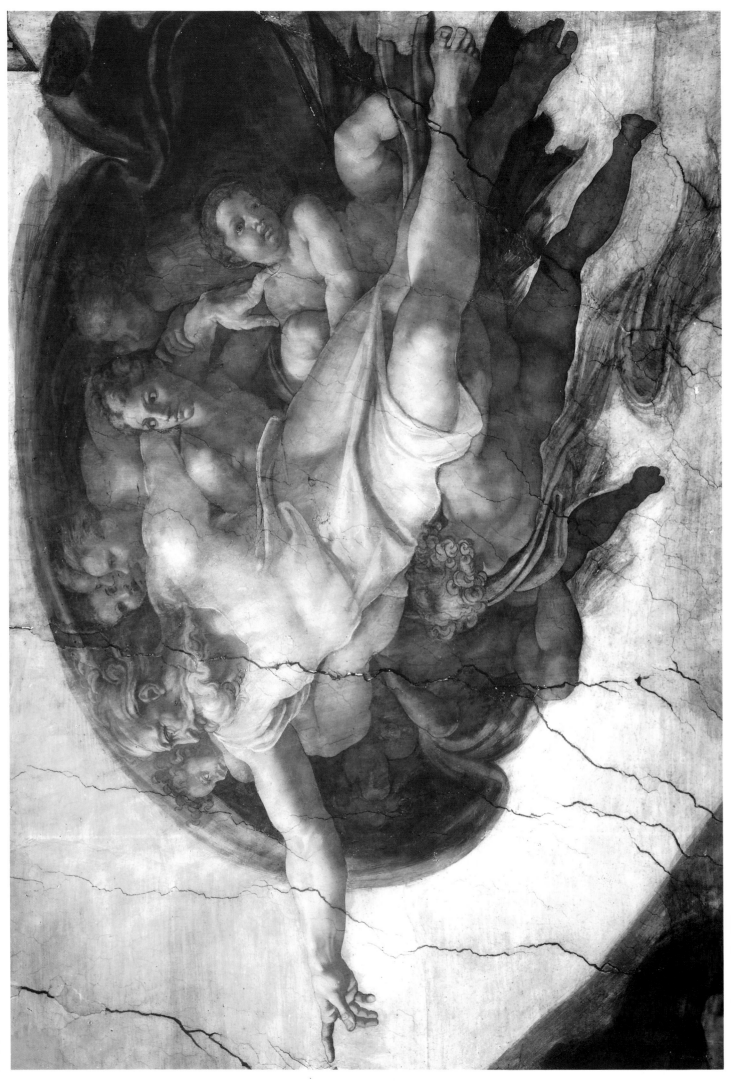

60. JEHOVAH. Detail of Plate 54

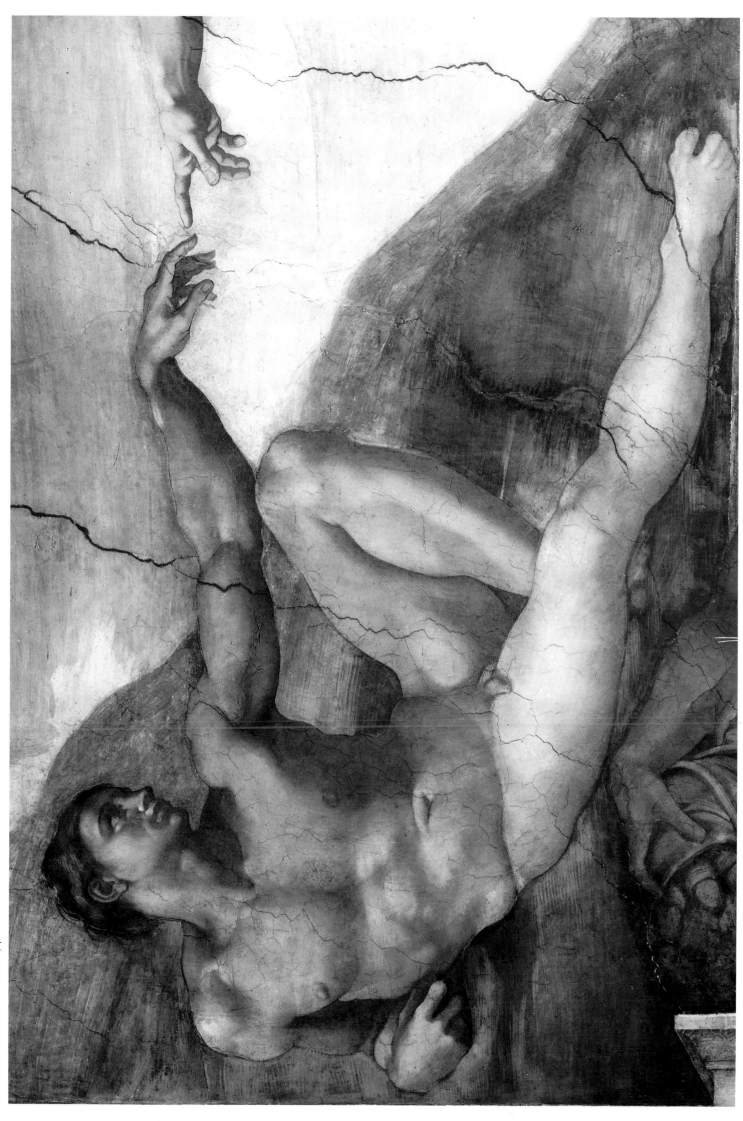

61. ADAM. Detail of Plate 54

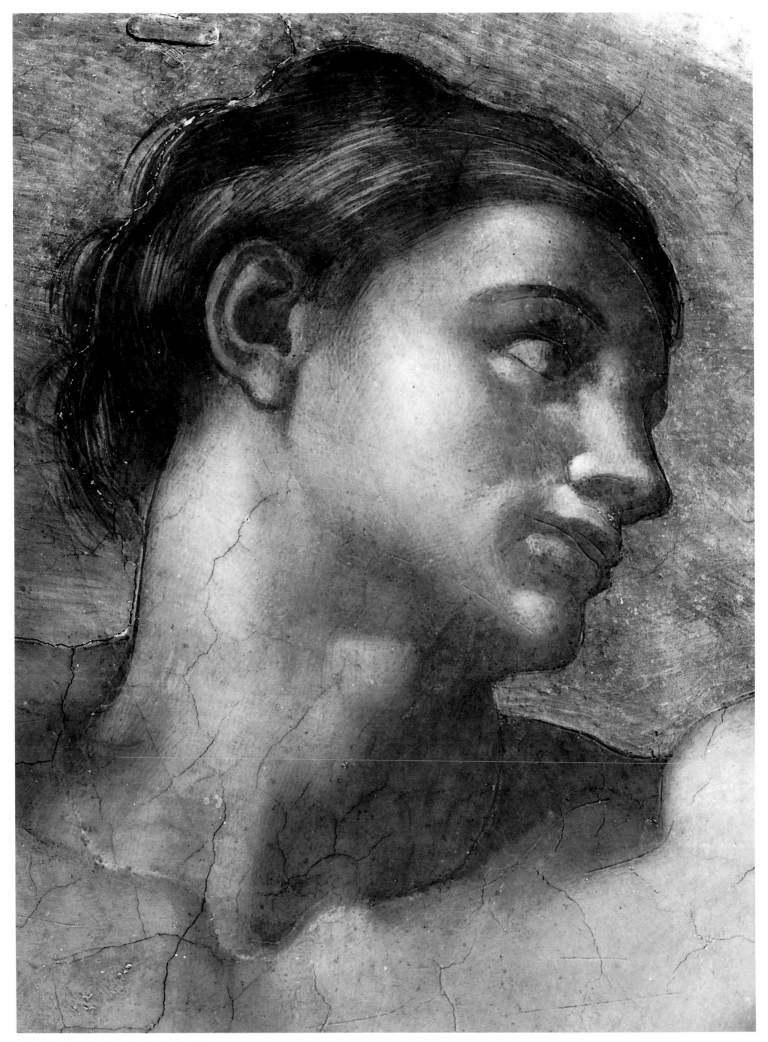

62. HEAD OF ADAM. Detail of Plate 54

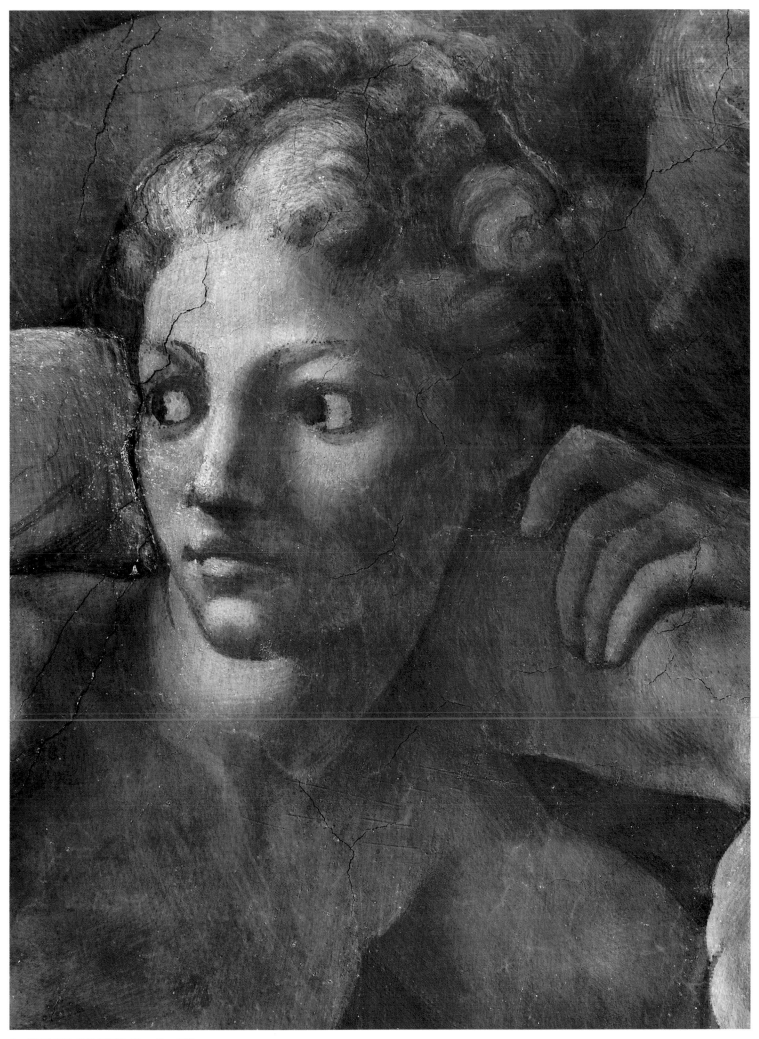

63. IMAGE OF EVE. Detail of Plate 54

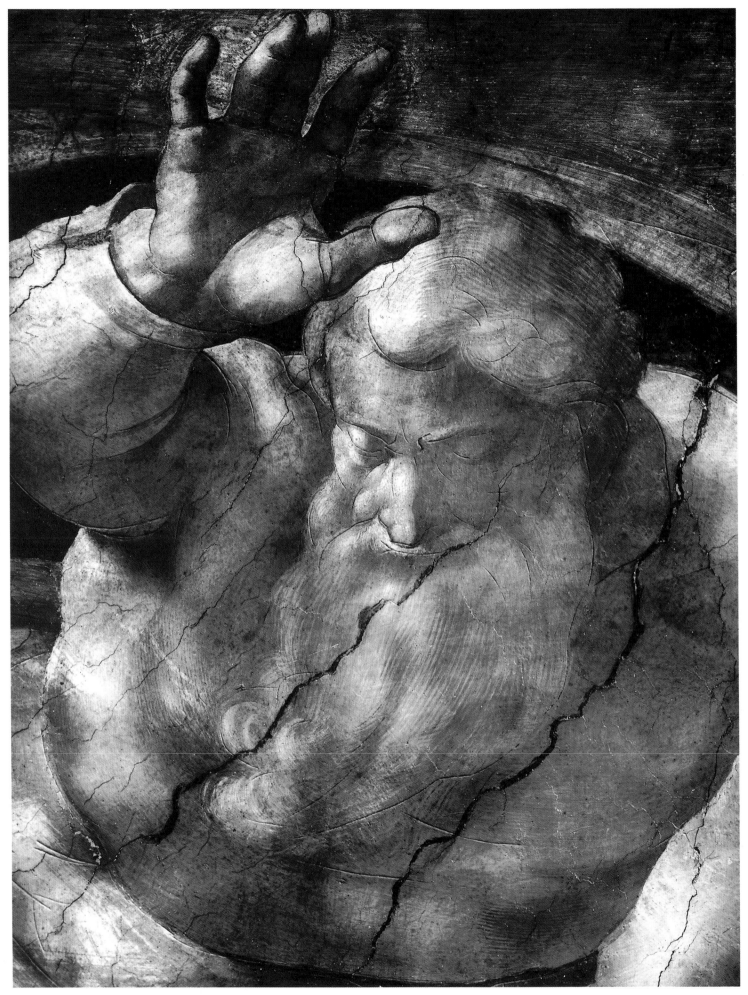

64. HEAD AND RIGHT ARM OF JEHOVAH. Detail of Plate 53

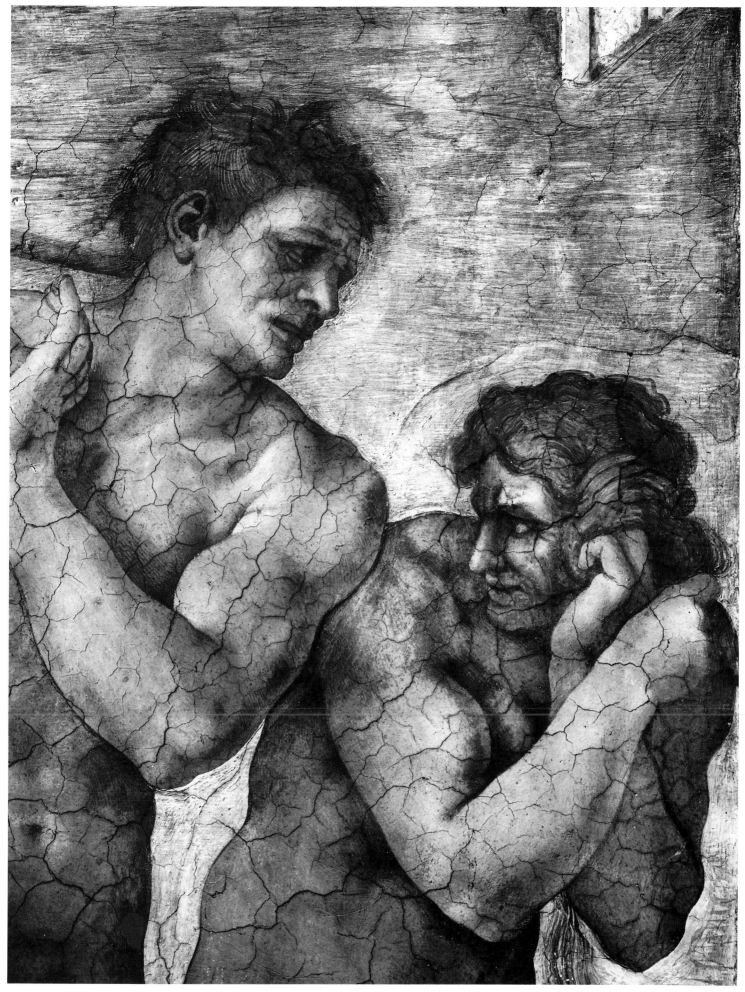

65. ADAM AND EVE. Detail of Plate 56

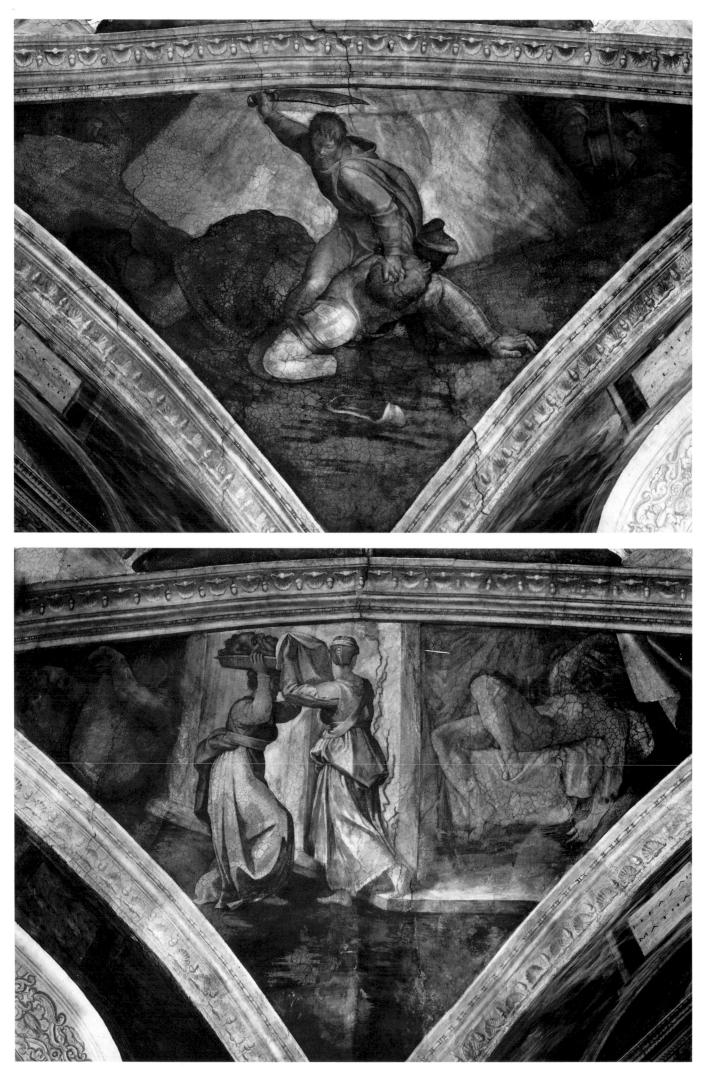

66–67. THE MIRACULOUS SALVATIONS OF ISRAEL: David's Victory over Goliath – Judith and Holofernes. 1509.
Corner spandrels, Sistine Chapel Ceiling

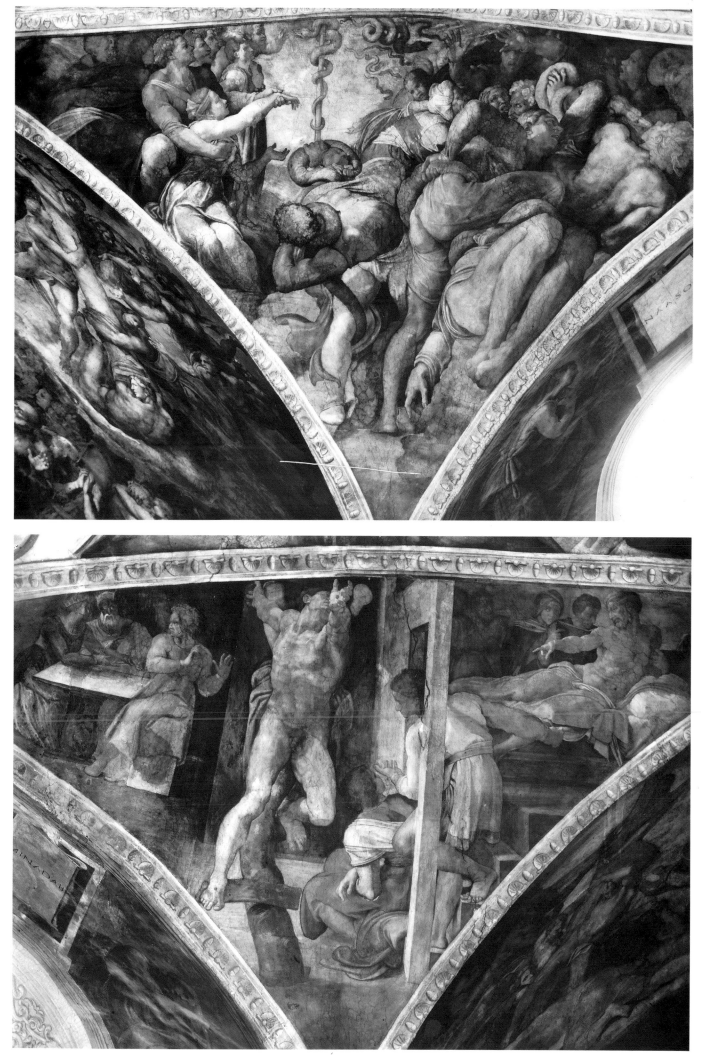

68–69. THE MIRACULOUS SALVATIONS OF ISRAEL: The Brazen Serpent – Esther and Haman. 1511.
Corner spandrels, Sistine Chapel Ceiling

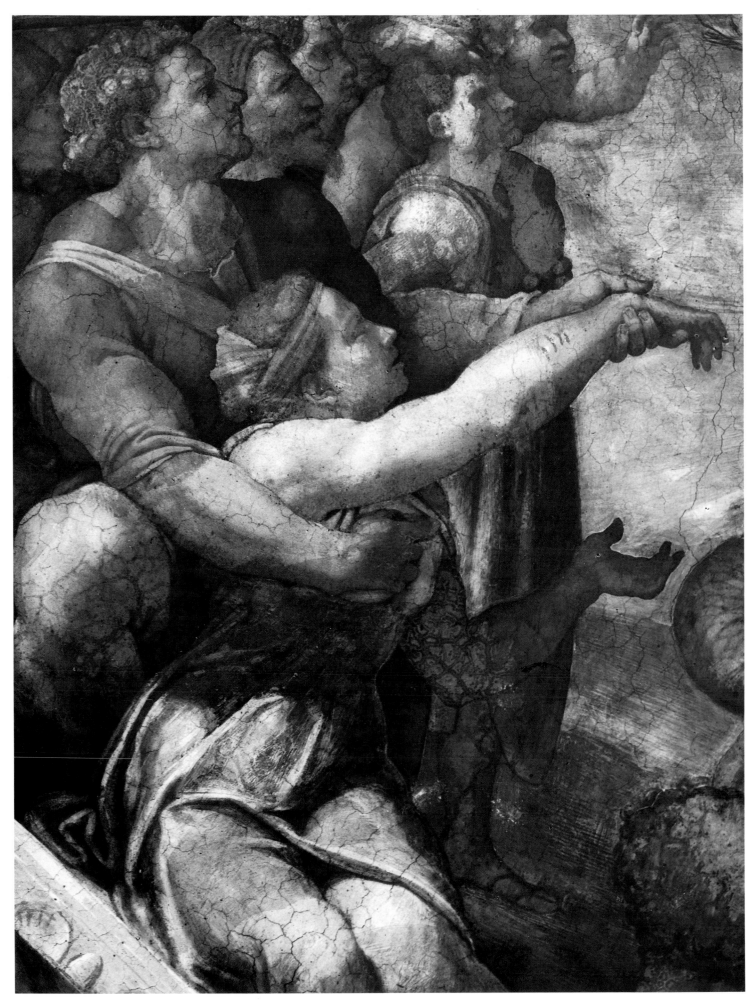

70. THE BRAZEN SERPENT. Detail of Plate 68

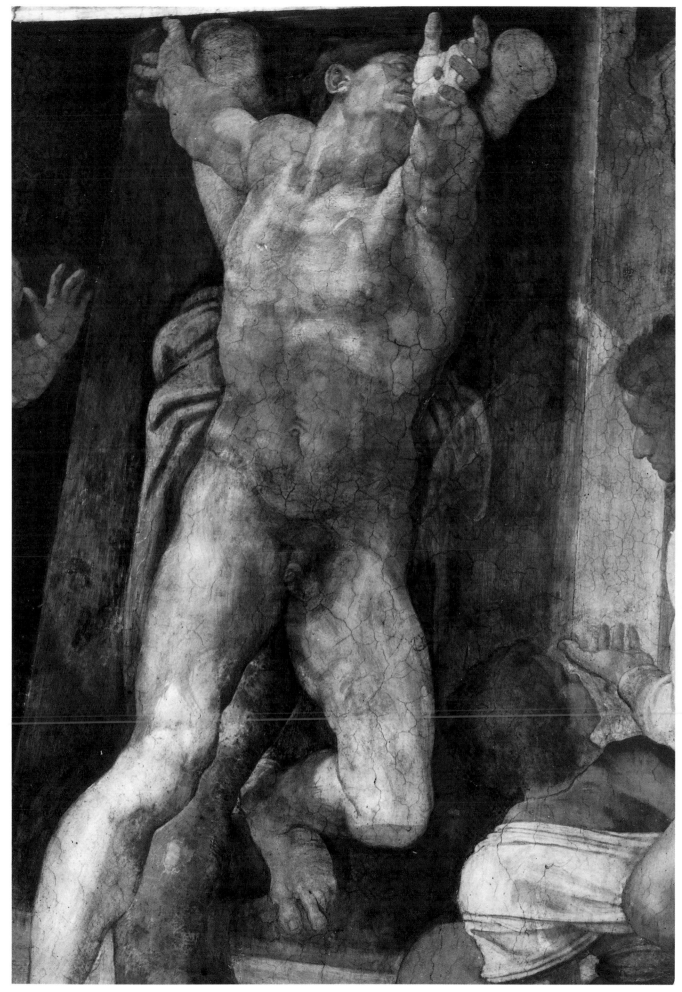

71. HAMAN CRUCIFIED. Detail of Plate 69

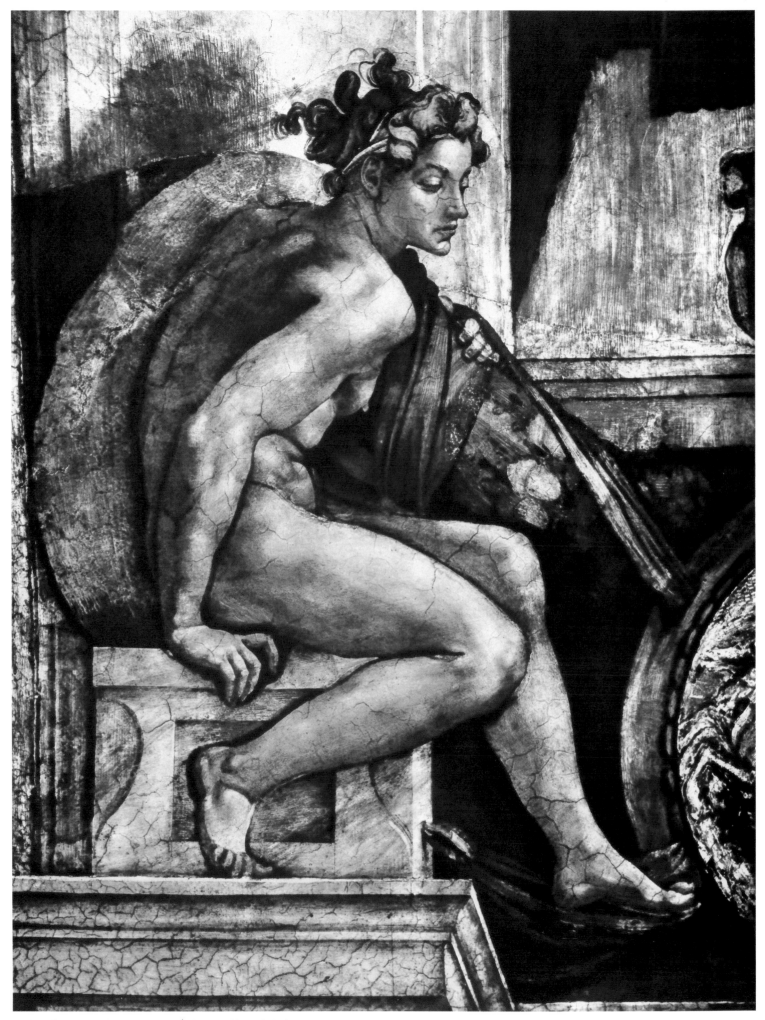

72. NUDE YOUTH. 1508–1509. Sistine Chapel Ceiling

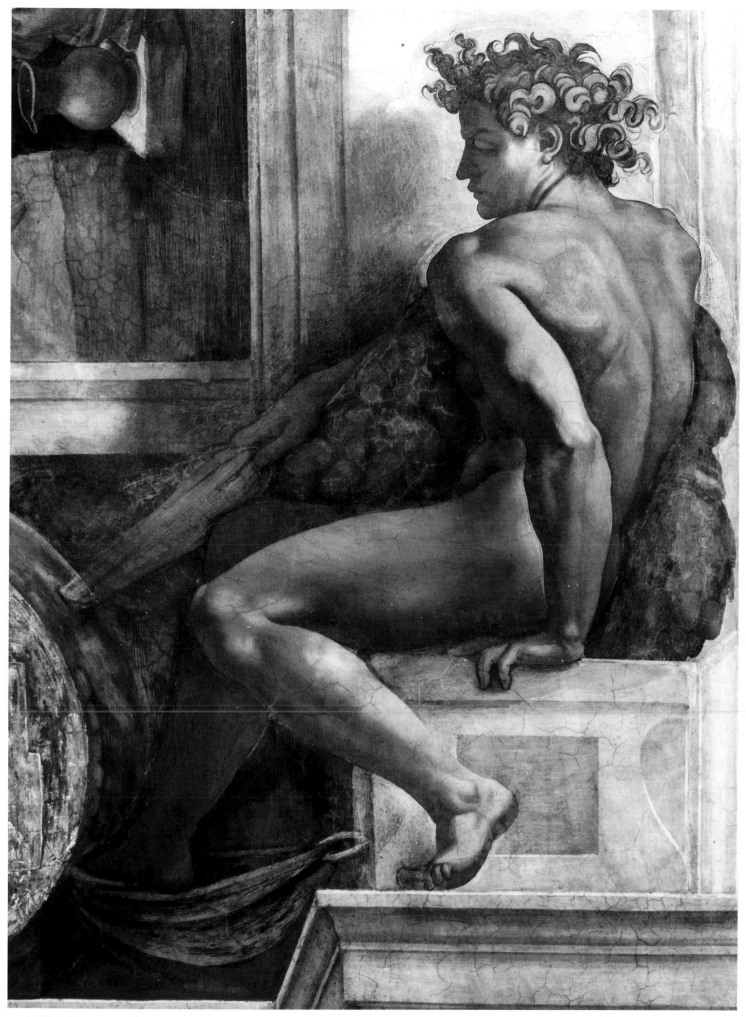

73. NUDE YOUTH. 1508–1509. Sistine Chapel Ceiling

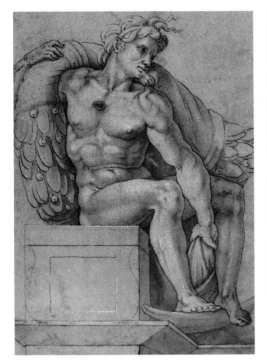 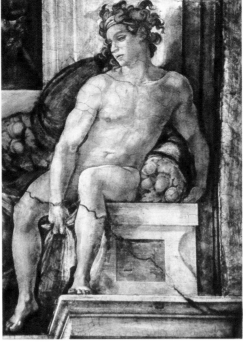 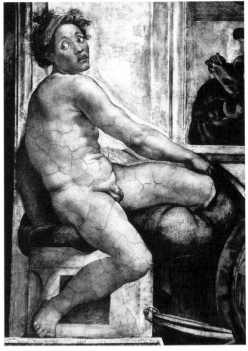

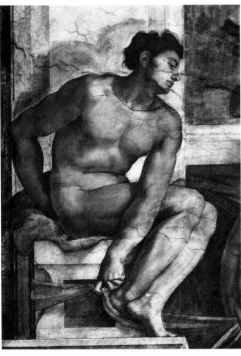 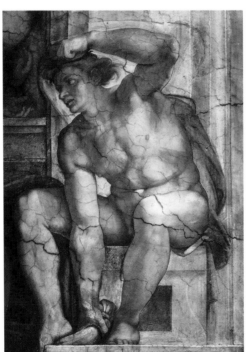 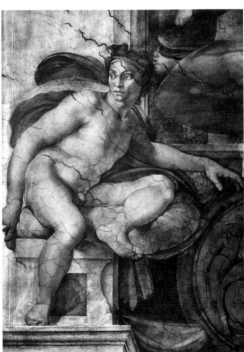

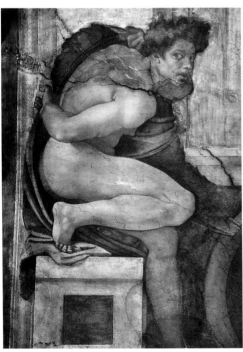 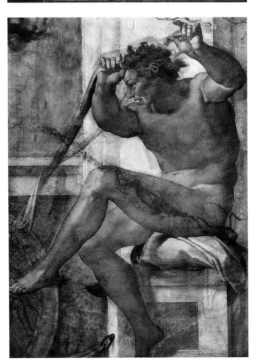 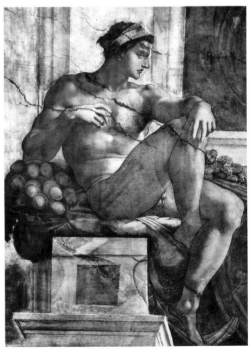

74–82. NUDE YOUTHS. 1508–1510. Sistine Chapel Ceiling

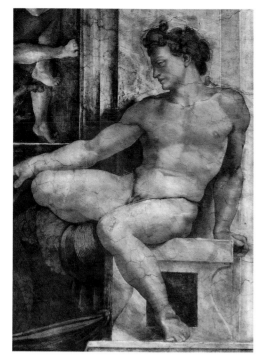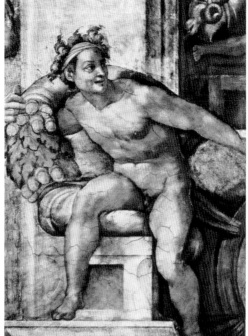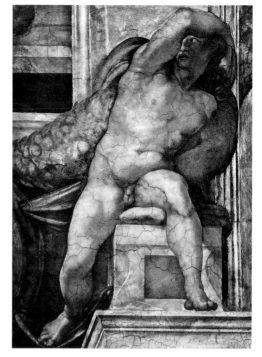

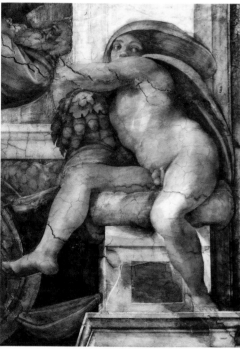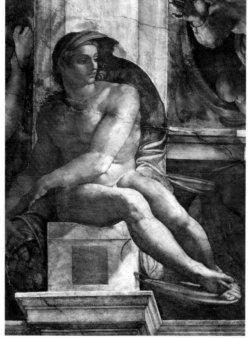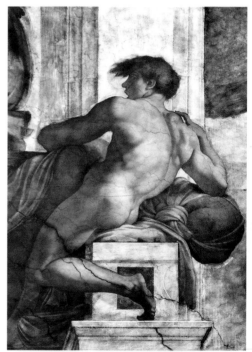

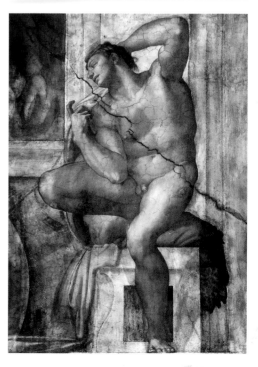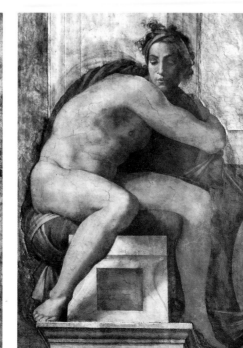

83–91. NUDE YOUTHS. 1508–1510. Sistine Chapel Ceiling

92. CORNER DECORATION above the Brazen Serpent spandrel: Bronze-coloured nude and grey putti. 1511. Sistine Chapel Ceiling

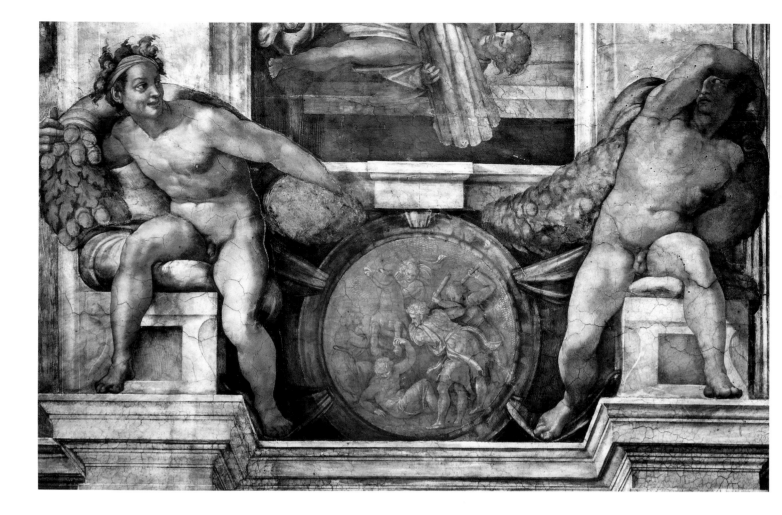

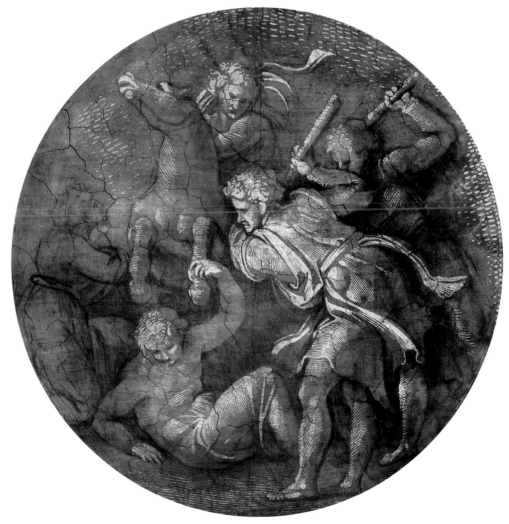

93–94. THE BRONZE-COLOURED MEDALLIONS BETWEEN THE IGNUDI. 1510–1512. Sistine Chapel Ceiling.
(I) The Death of Uriah

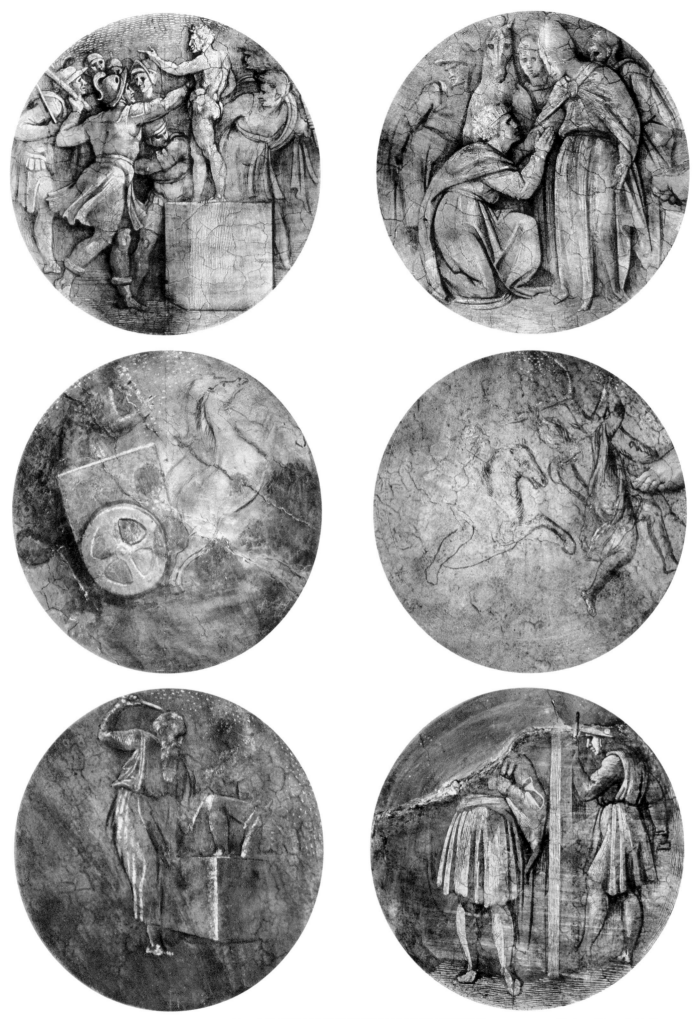

95–100. THE BRONZE-COLOURED MEDALLIONS BETWEEN THE IGNUDI. 1510–1512. Sistine Chapel Ceiling.
(II) The Destruction of the Statue of Baal – (III) King David before Nathan – (IV) The Ascension of Elijah –
(V) The Death of Absalom – (VI) The Sacrifice of Isaac – (VII) Abner being killed by Joab

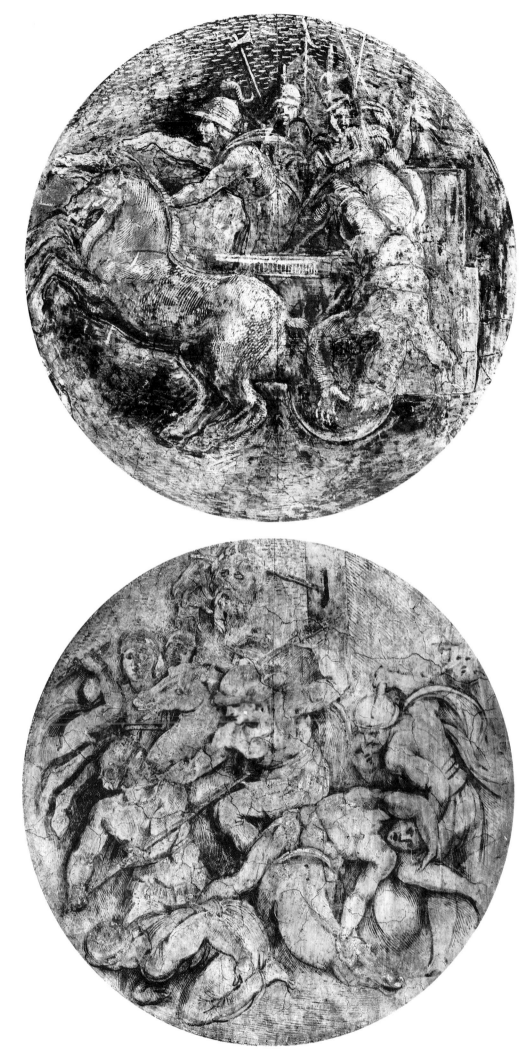

101–102. THE BRONZE-COLOURED MEDALLIONS BETWEEN THE IGNUDI. 1510–1512. Sistine Chapel Ceiling.
(VIII) The Death of Joram – (IX) The Destruction of the Worshippers of Baal

103–104. THE ANCESTORS OF CHRIST: Salmon, Roboam. 1511–1512. Spandrels of the Sistine Chapel Ceiling

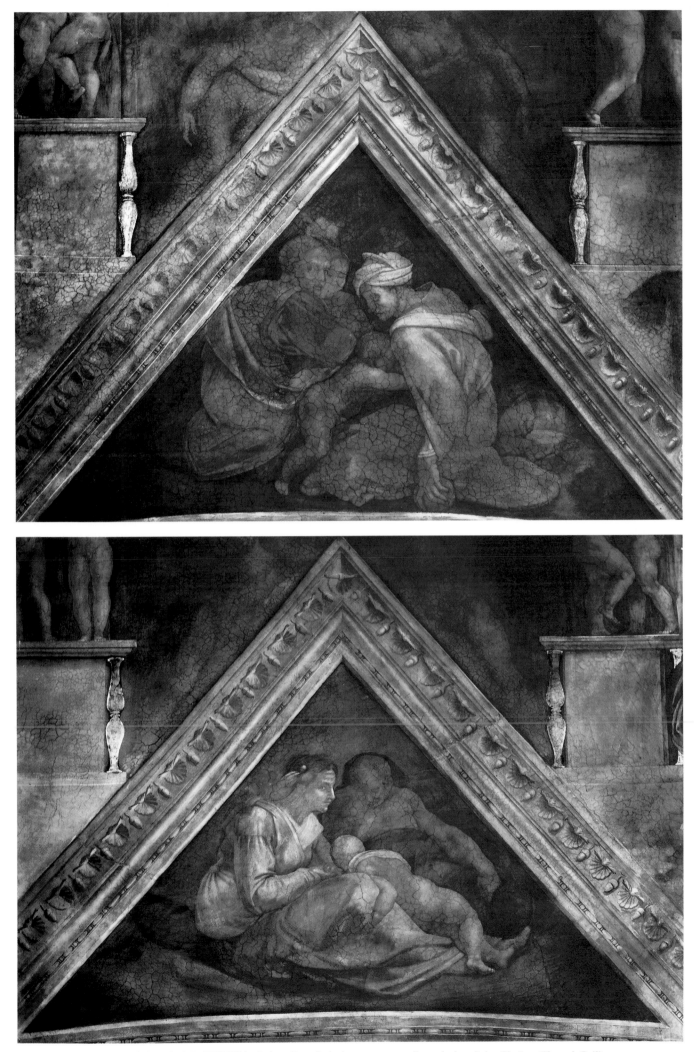

105–106. THE ANCESTORS OF CHRIST: Ozias, Zorobabel. 1511–1512. Spandrels of the Sistine Chapel Ceiling

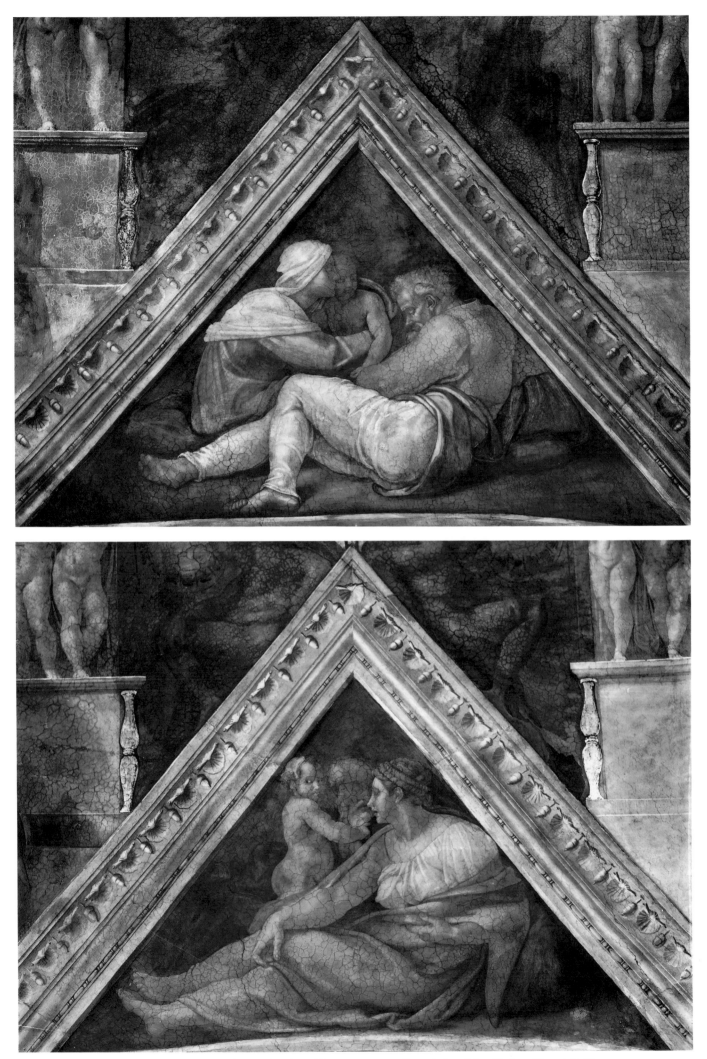

107–108. THE ANCESTORS OF CHRIST: Josias, Ezechias. 1511–1512. Spandrels of the Sistine Chapel Ceiling

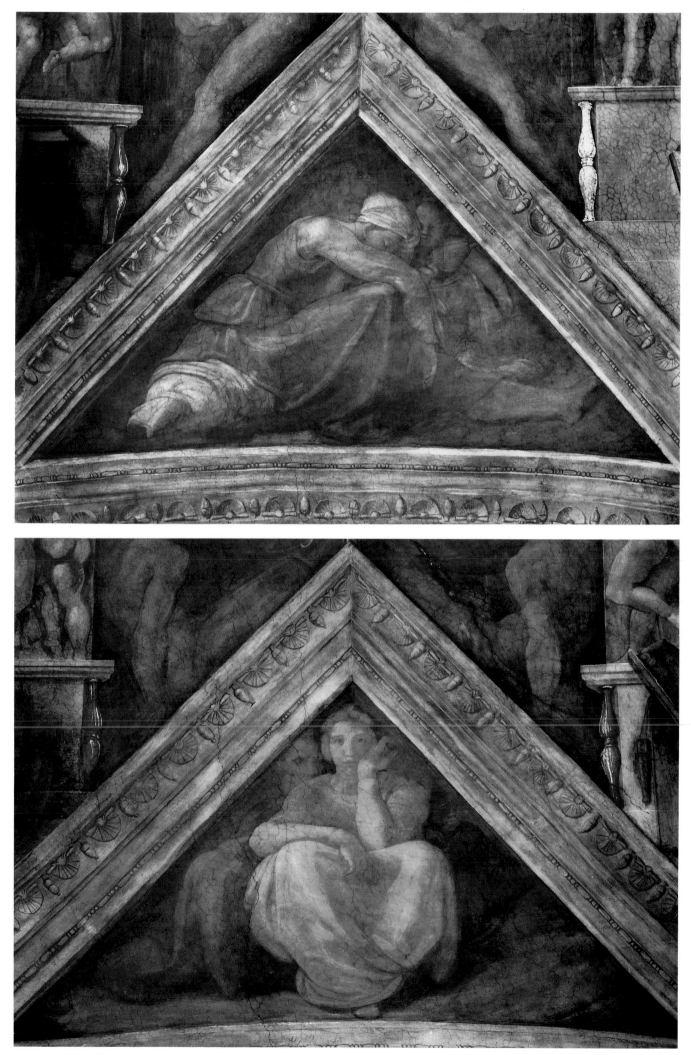

109–110. THE ANCESTORS OF CHRIST: Asa, Jesse. 1511–1512. Spandrels of the Sistine Chapel Ceiling

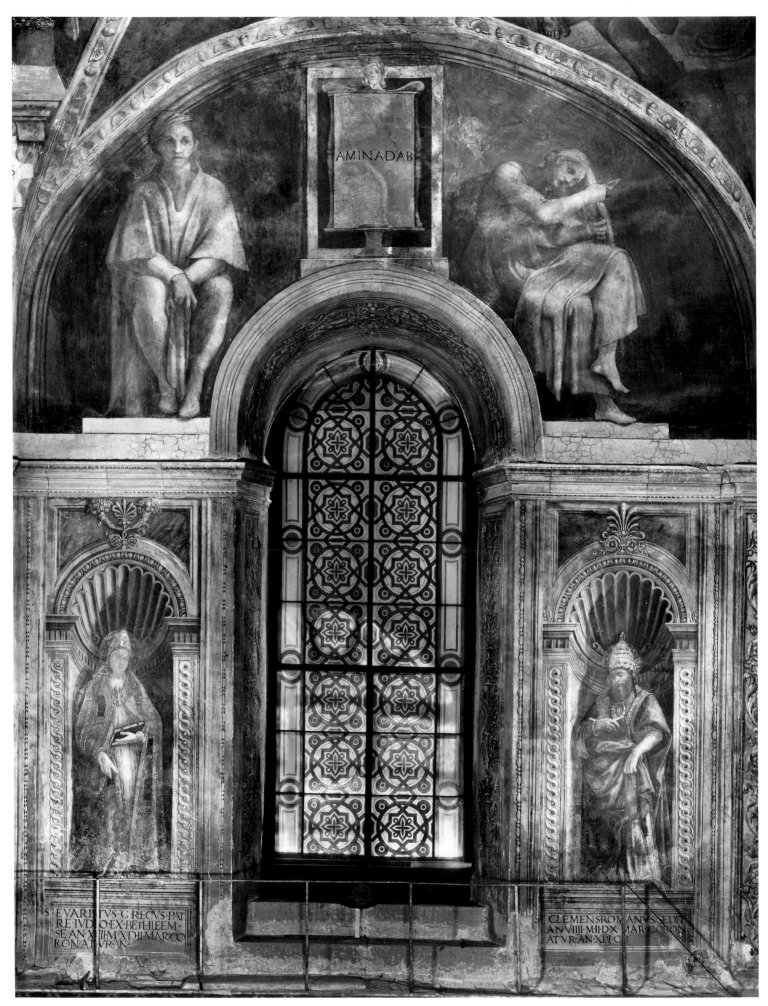

AMINADAB

S·EVARISTVS·GRECVS·PAT
RE·IVDEO·EX·BETHLEEM·
SE·AN·XIIII·M·X·DII·MAR·CO
RONATVR·AN·

S·CLEMENSROMANVS·SEDIT·
AN·VIIII·M·I·DX·MAR·CORON·
ATVR·AN·XPI·C?

III. THE ANCESTORS OF CHRIST. 1511–1512. A window in the Sistine Chapel, the lunette painted by Michelangelo

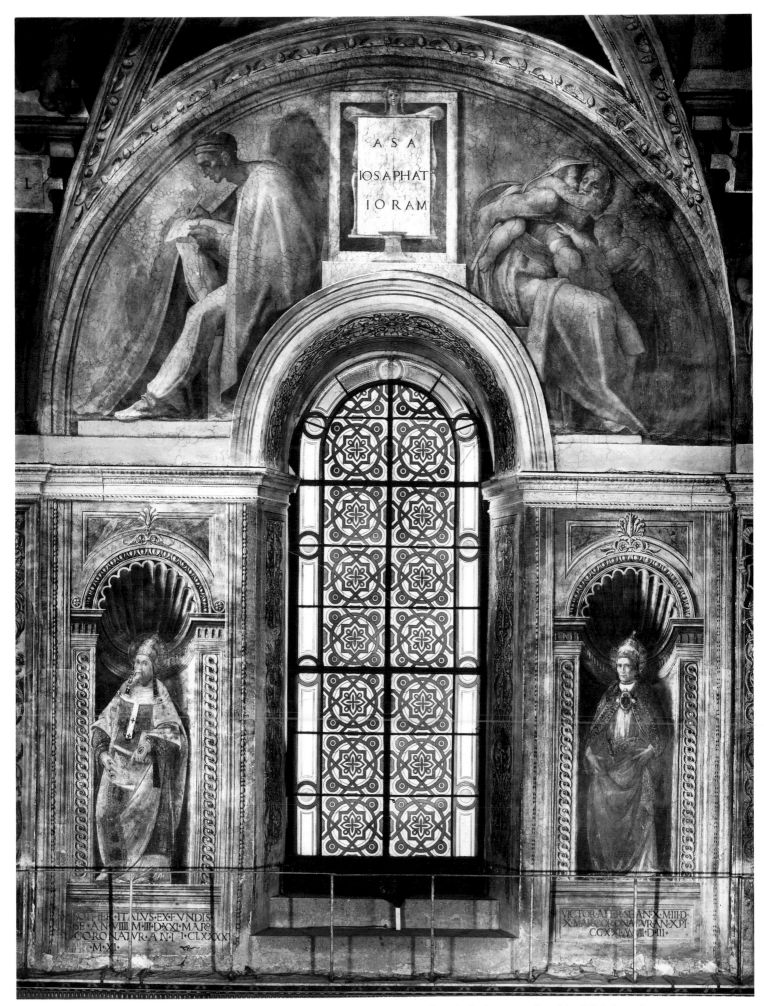

112. THE ANCESTORS OF CHRIST. 1511–1512. A window in the Sistine Chapel, the lunette painted by Michelangelo

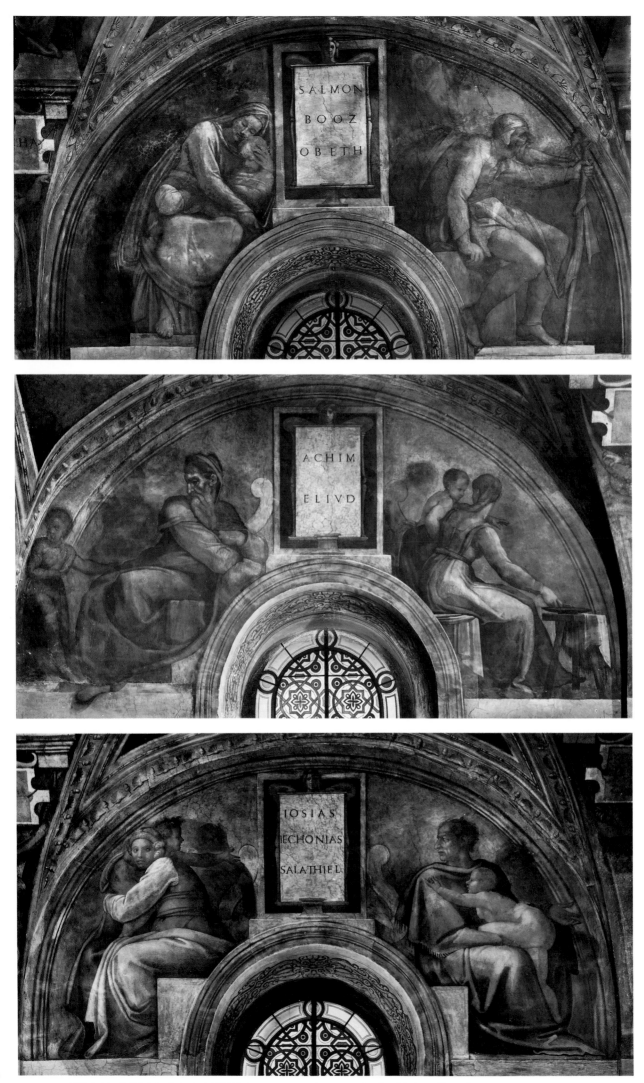

113–115. THE ANCESTORS OF CHRIST. 1511–1512. Lunettes in the Sistine Chapel

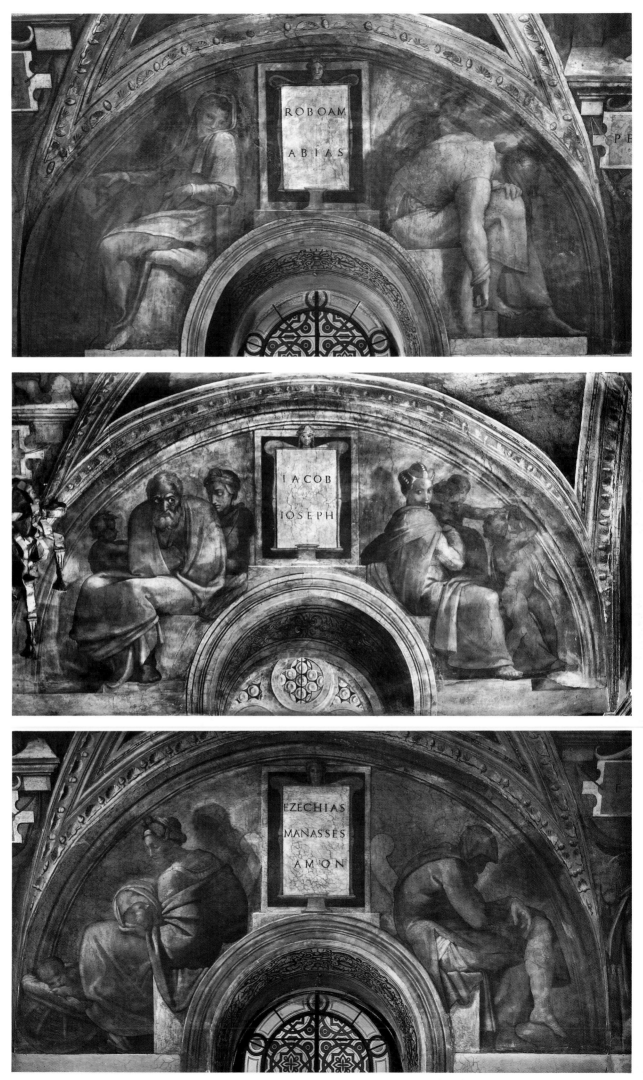

116–118. THE ANCESTORS OF CHRIST. 1511–1512. Lunettes in the Sistine Chapel

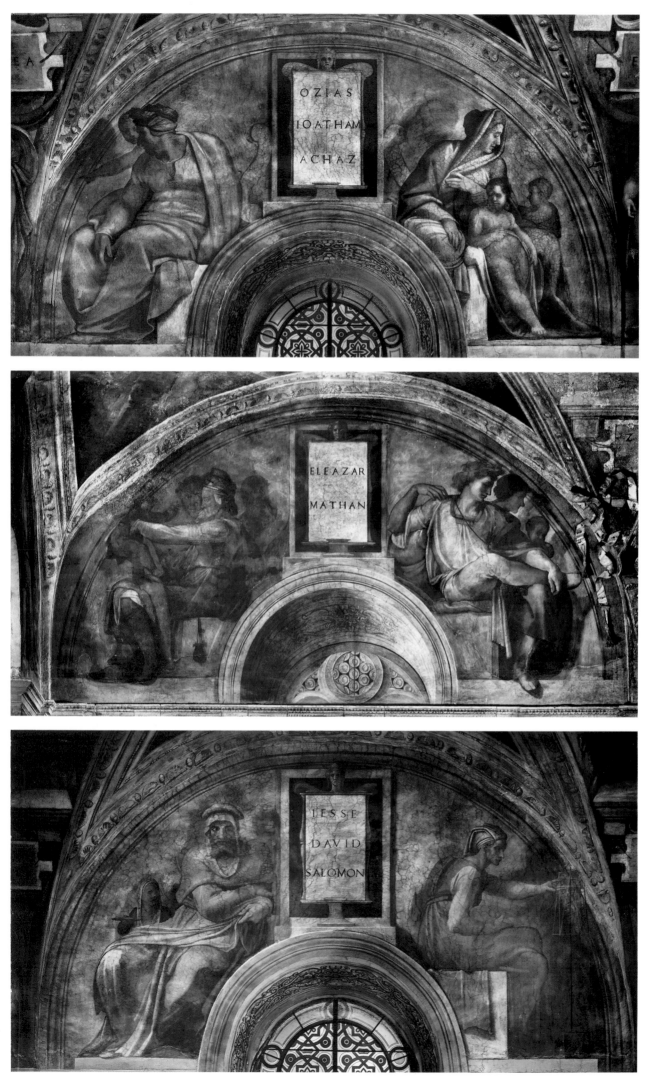

119–121. THE ANCESTORS OF CHRIST. 1511–1512. Lunettes in the Sistine Chapel

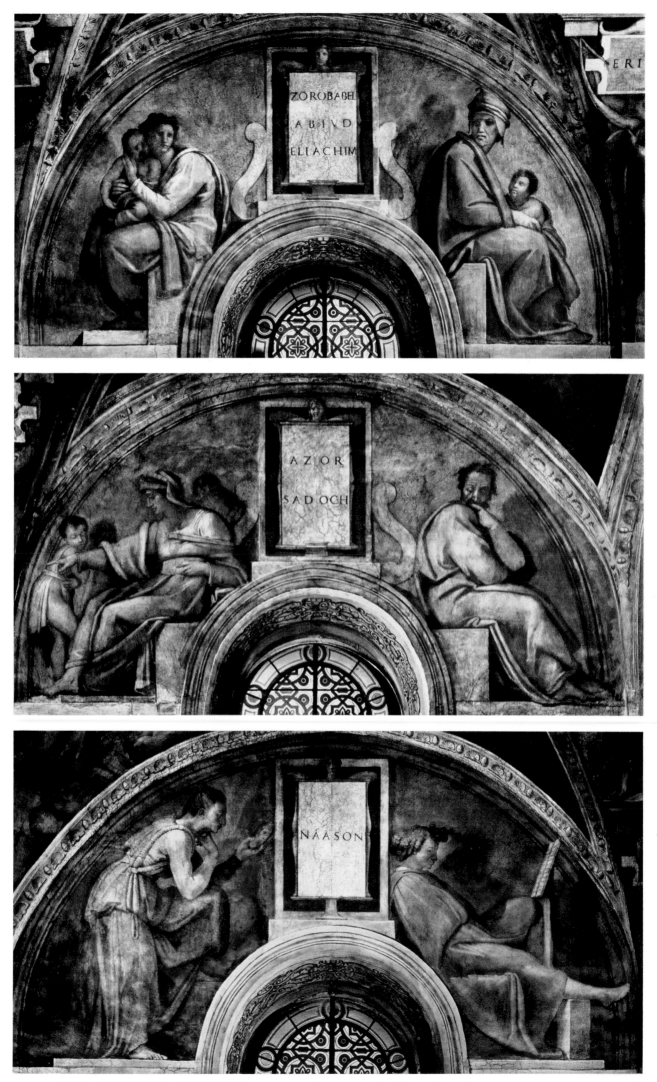

122–124. THE ANCESTORS OF CHRIST. 1511–1512. Lunettes in the Sistine Chapel

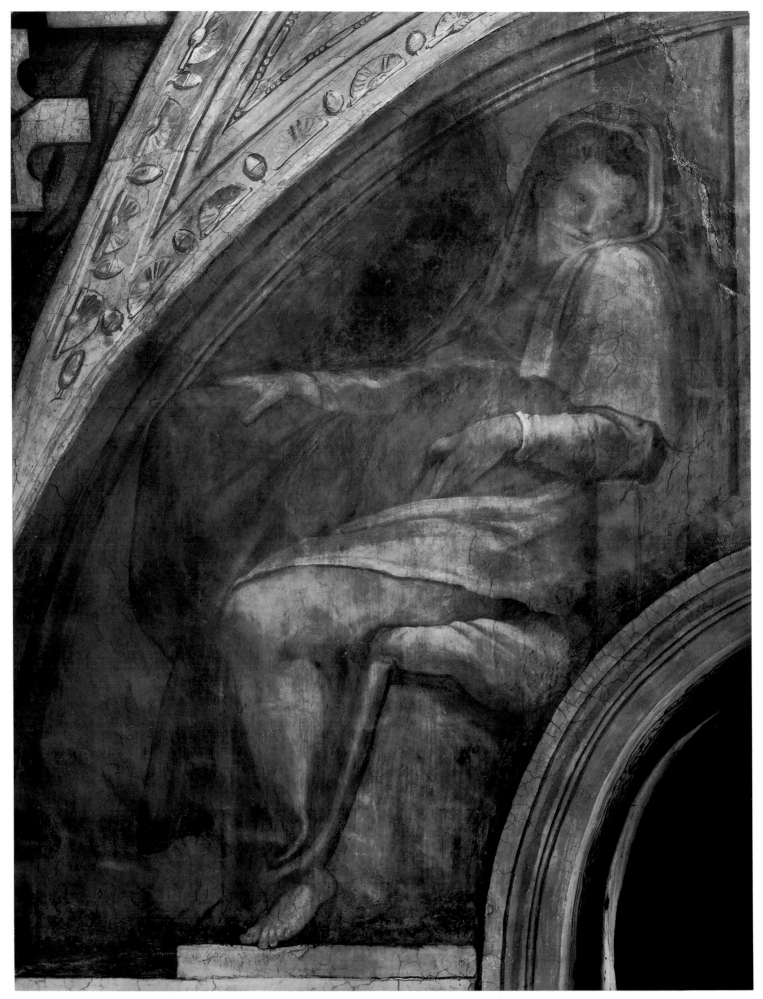

125. 'ABIAS'. Detail of Plate 116

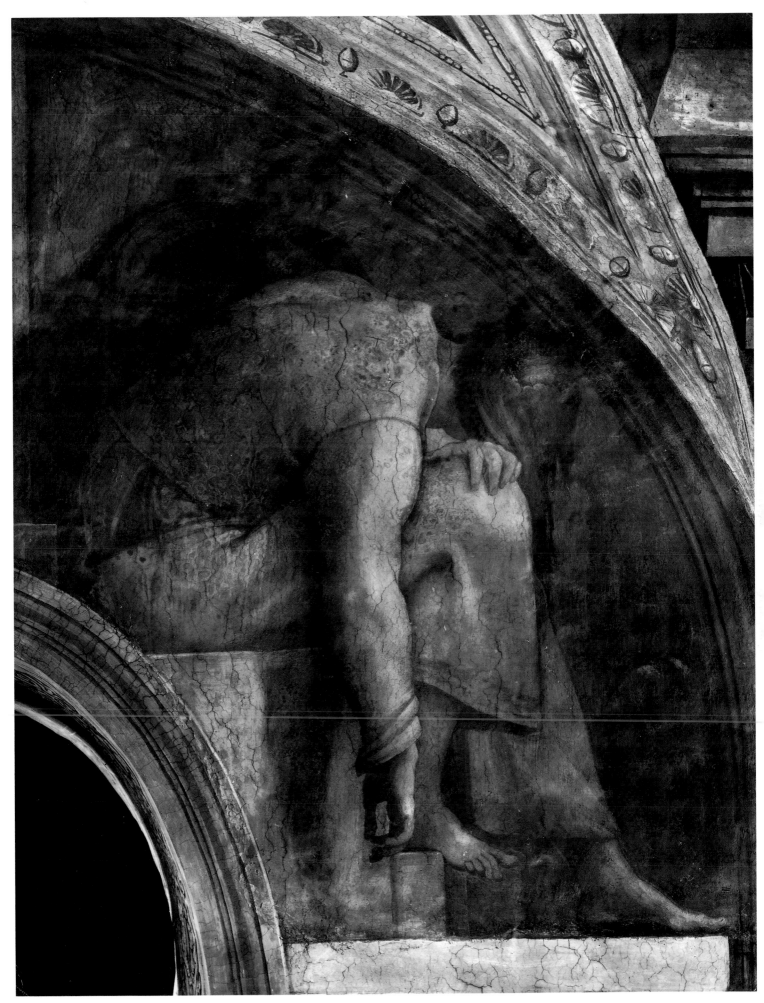

126. 'ABIAS'. Detail of Plate 116

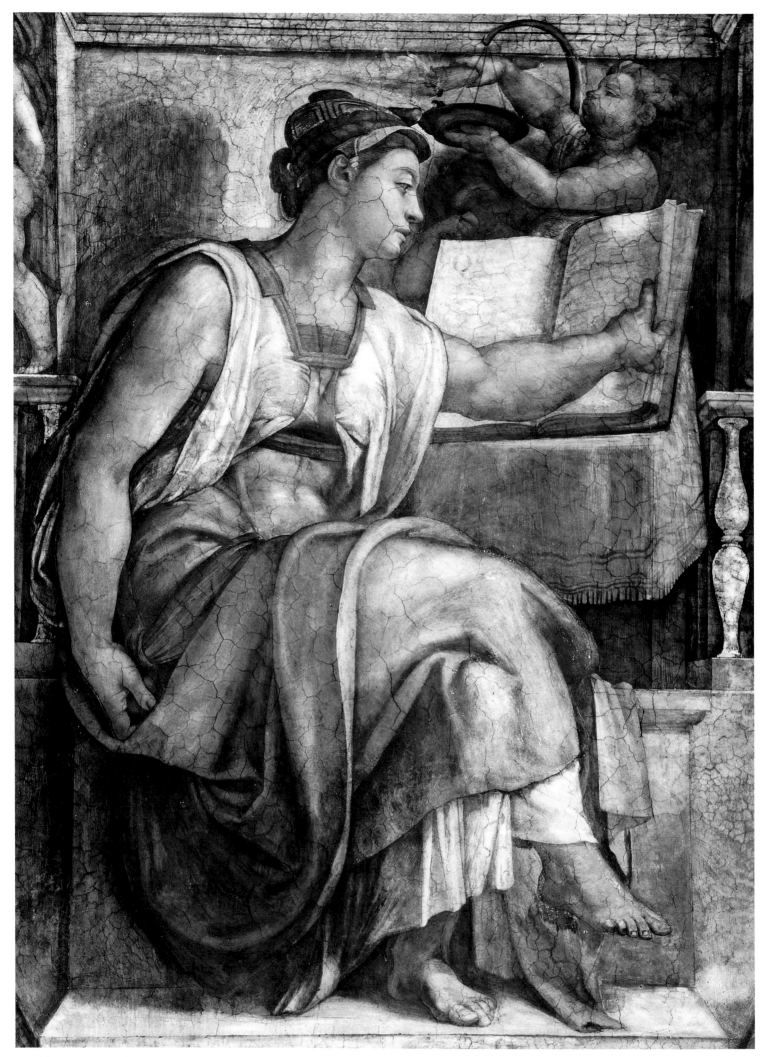

127. THE ERYTHRAEAN SIBYL. 1509. Sistine Chapel Ceiling

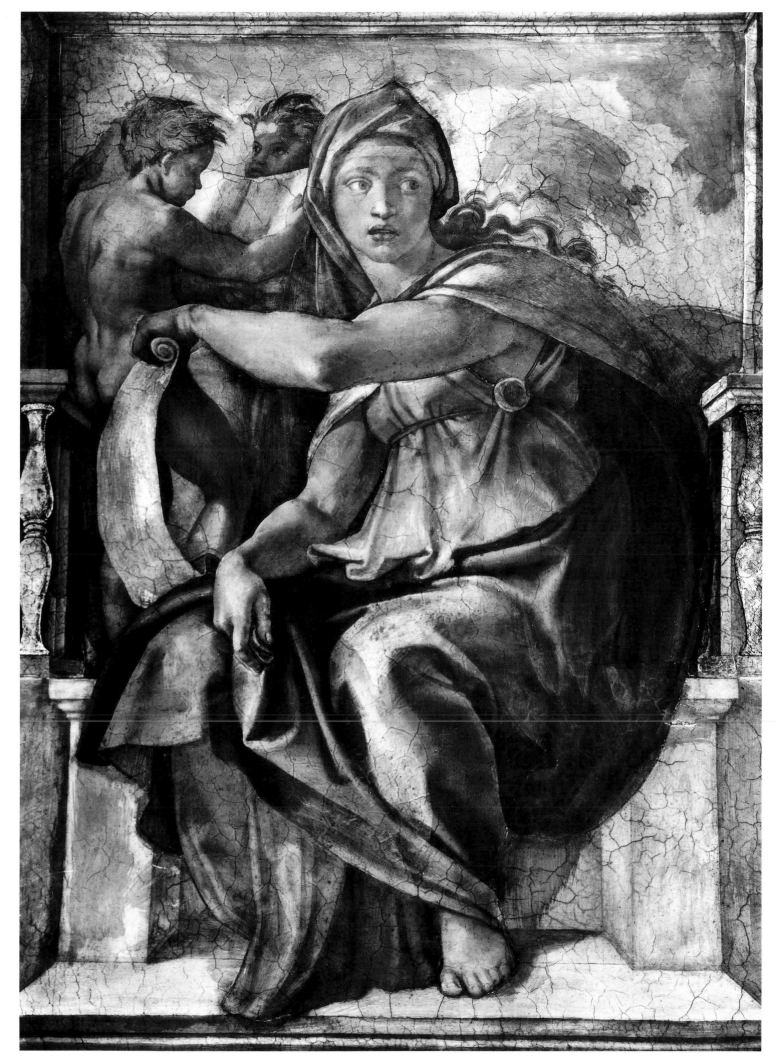

128. THE DELPHIC SIBYL. 1509. Sistine Chapel Ceiling

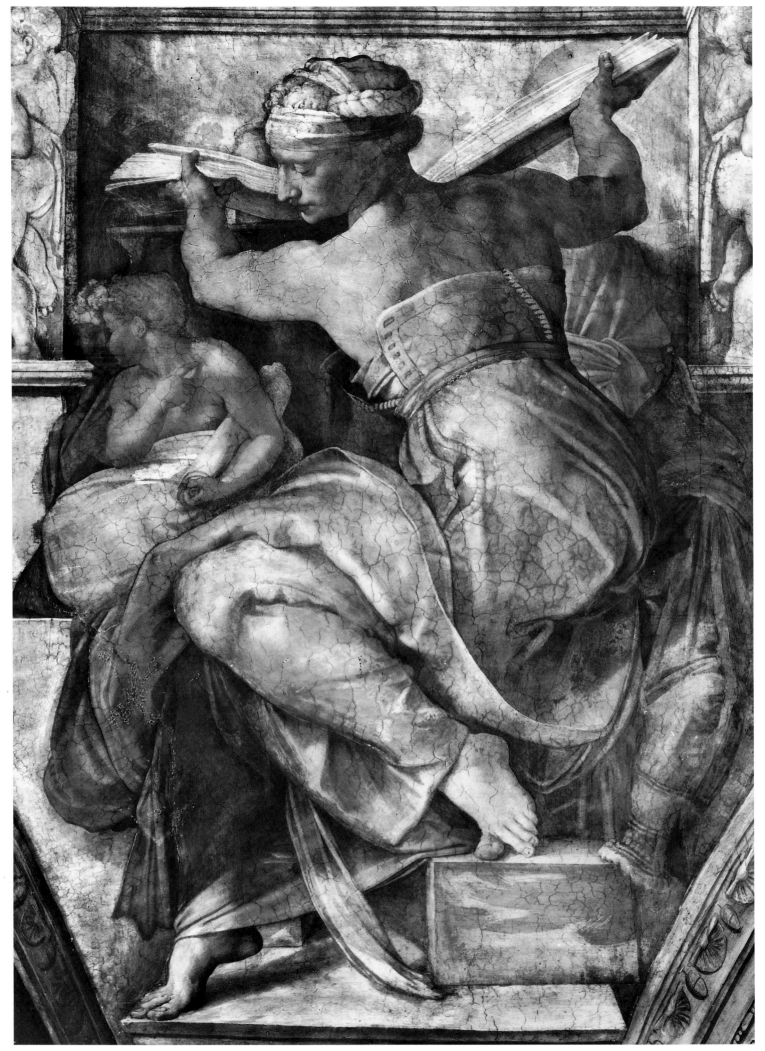

129. THE LIBYAN SIBYL. 1511. Sistine Chapel Ceiling

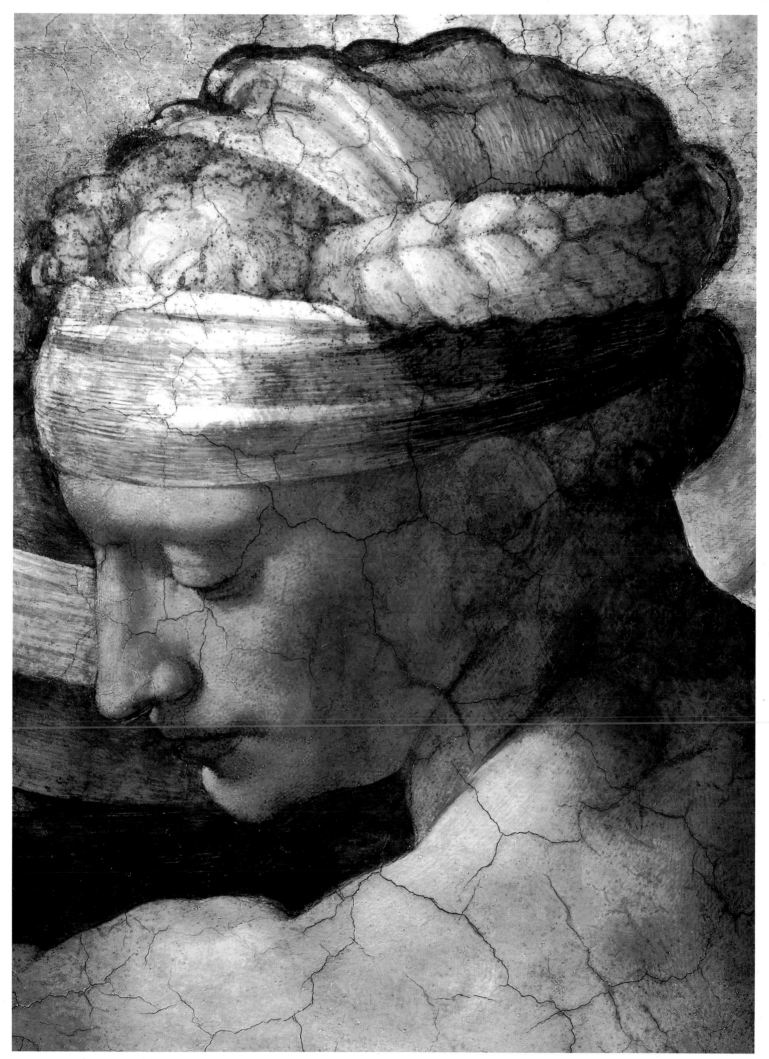

130. THE HEAD OF THE LIBYAN SIBYL. Detail of Plate 129

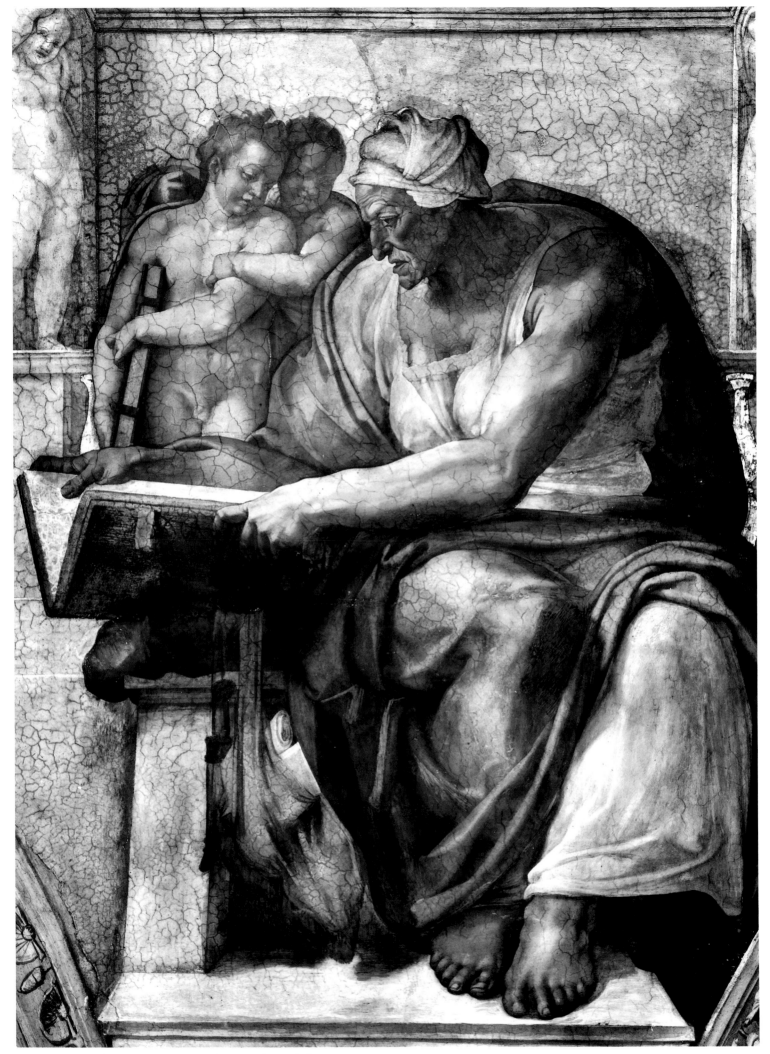

131. THE CUMAEAN SIBYL. 1510. Sistine Chapel Ceiling

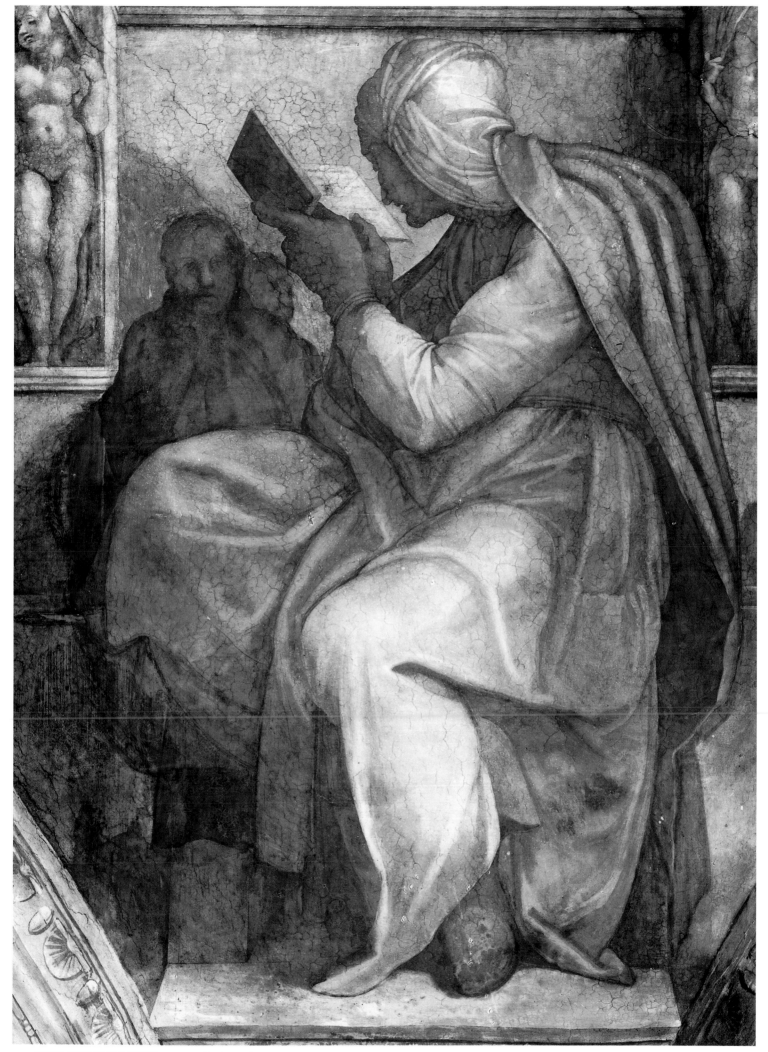

132. THE PERSIAN SIBYL. 1511. Sistine Chapel Ceiling

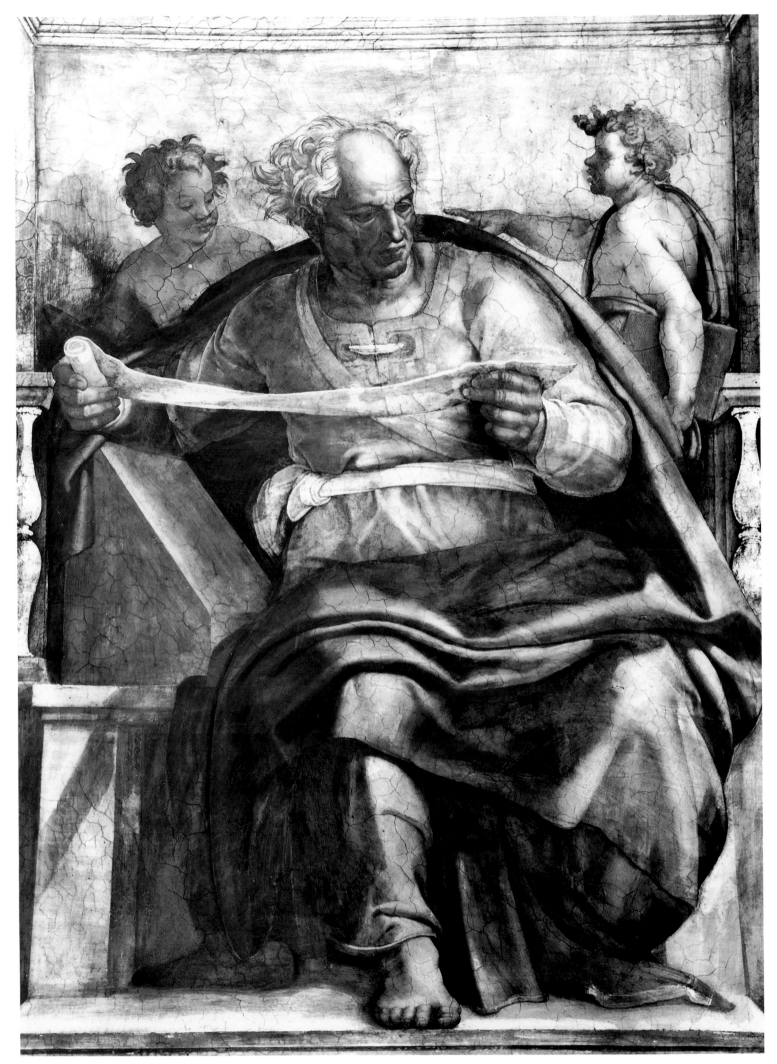

133. JOËL. 1509. Sistine Chapel Ceiling

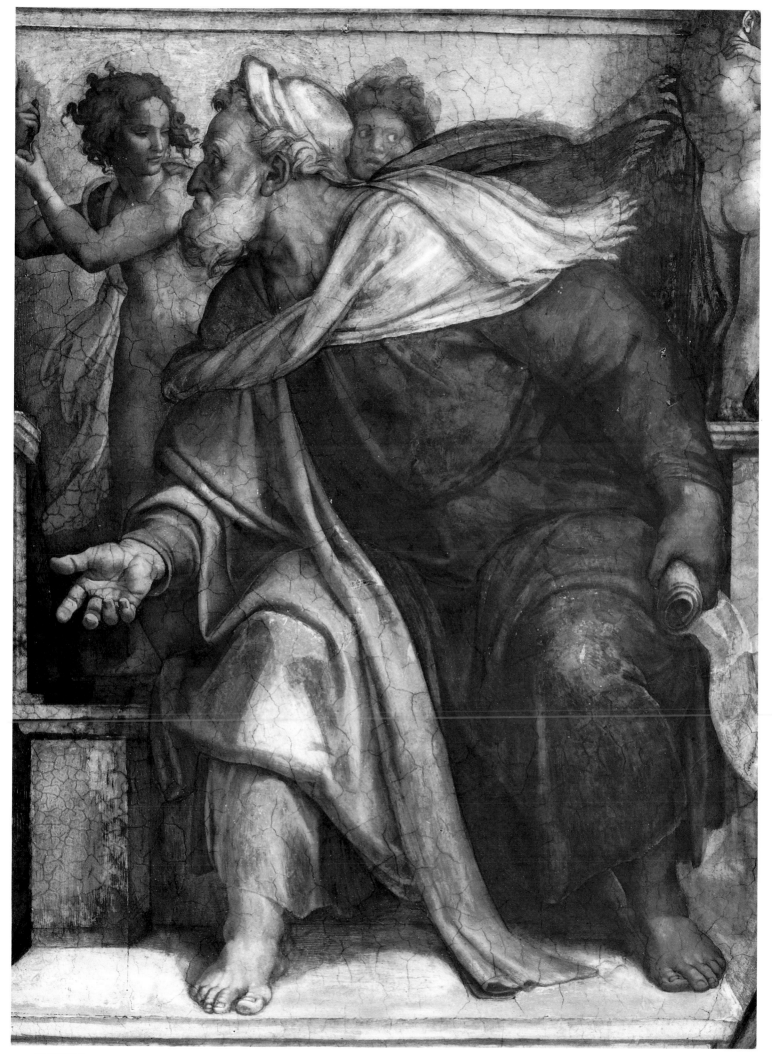

134. EZEKIEL. 1509–1510. Sistine Chapel Ceiling

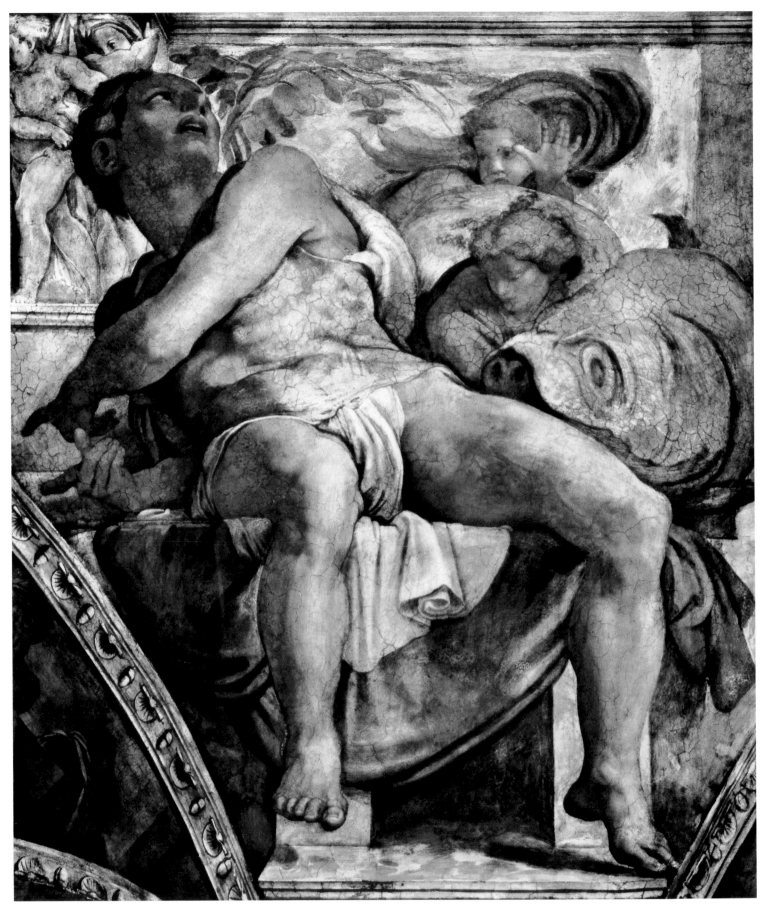

135. JONAH. 1511. Sistine Chapel Ceiling

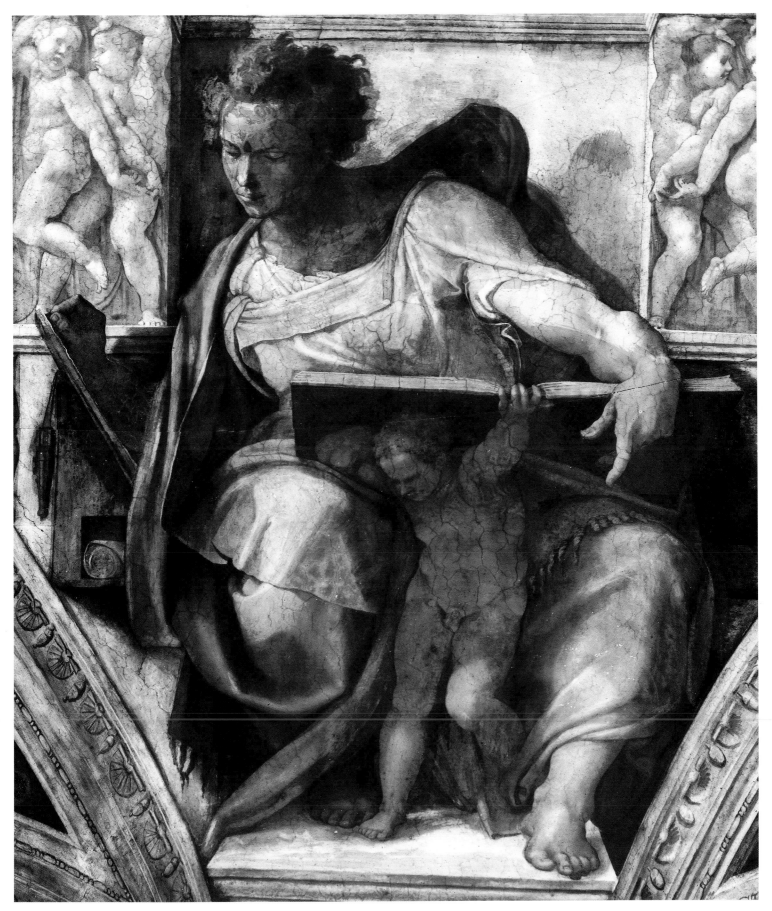

136. DANIEL. 1511. Sistine Chapel Ceiling

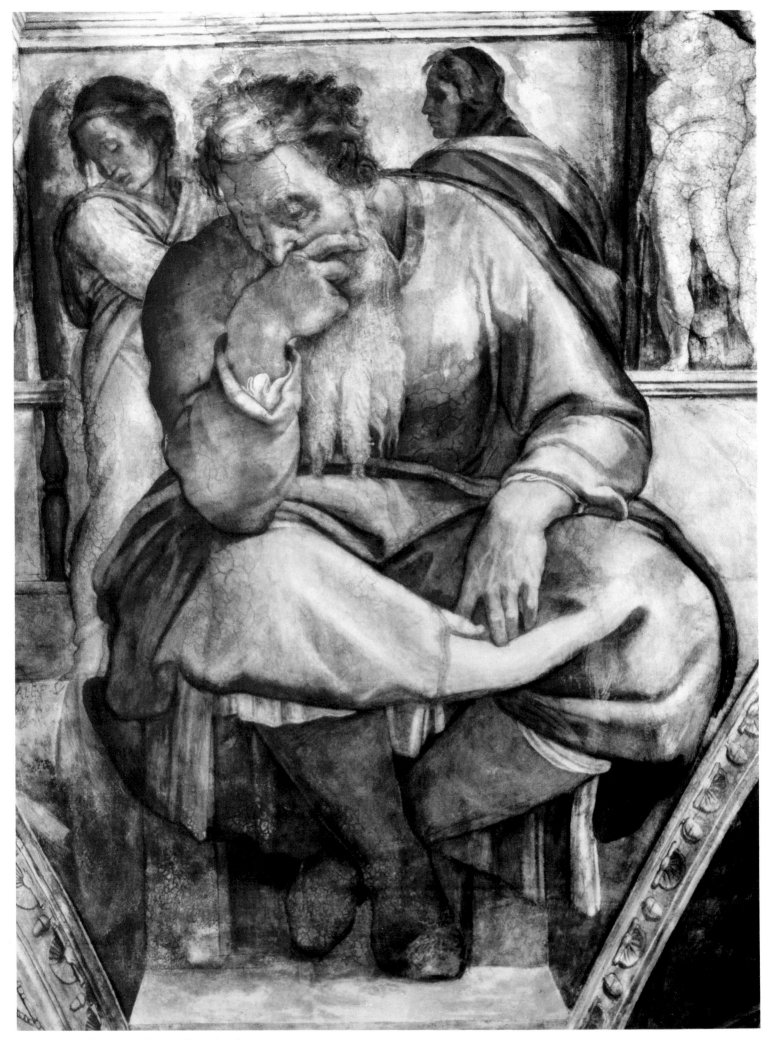

137. JEREMIAH. 1511. Sistine Chapel Ceiling

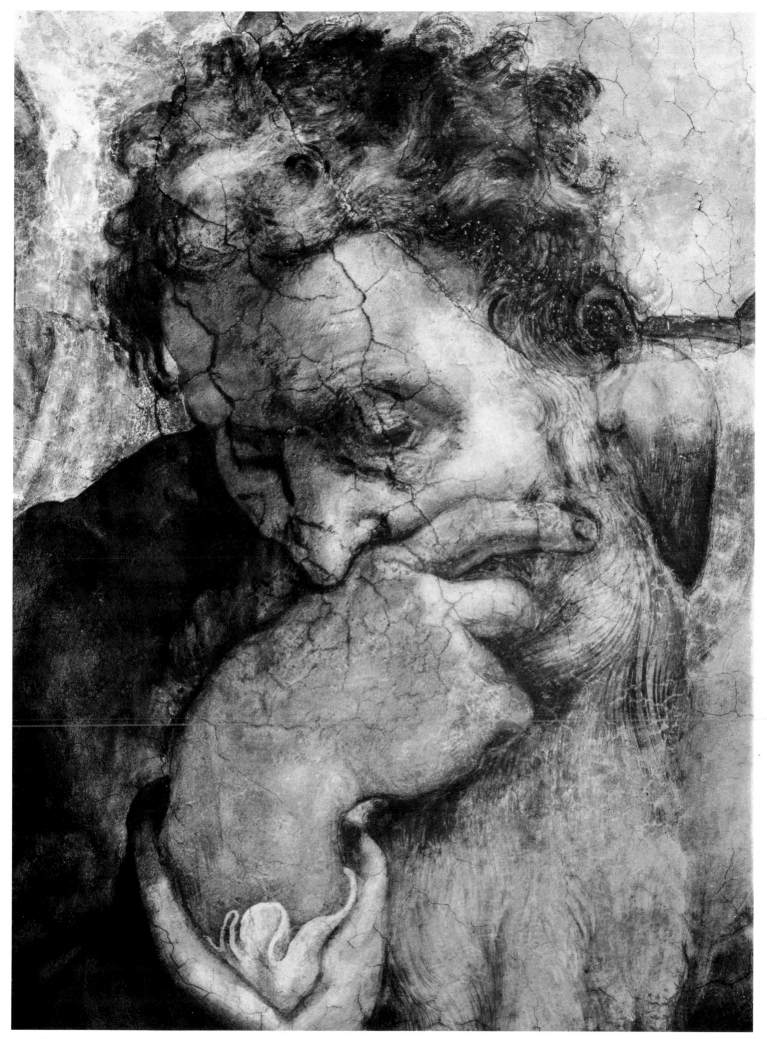

138. THE HEAD OF JEREMIAH. Detail of Plate 137

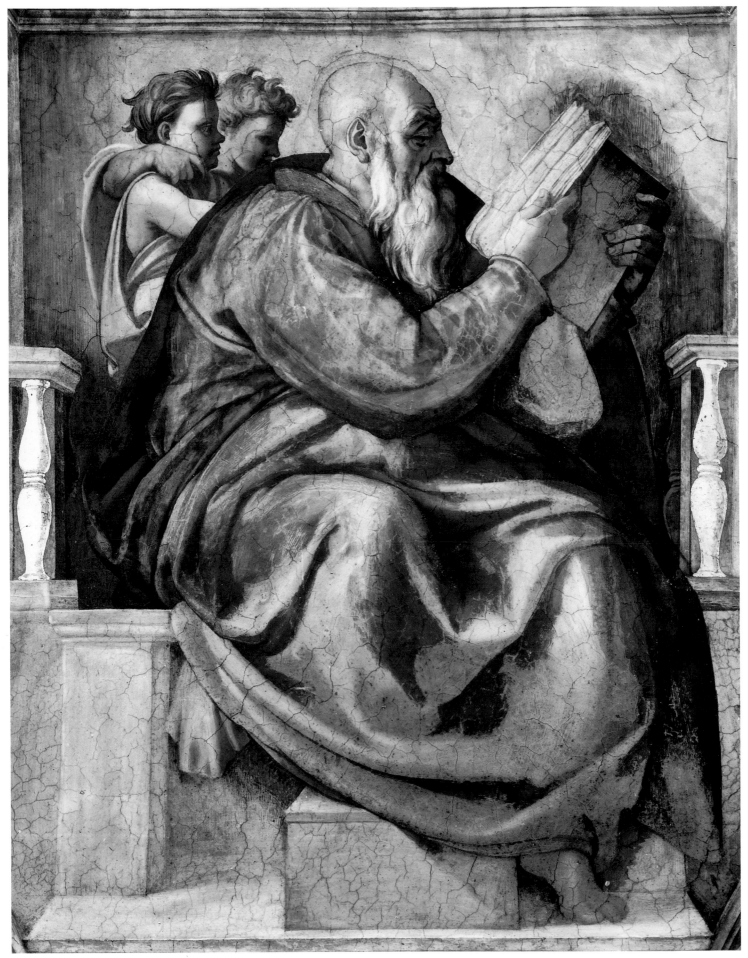

139. ZECHARIAH. 1509. Sistine Chapel Ceiling

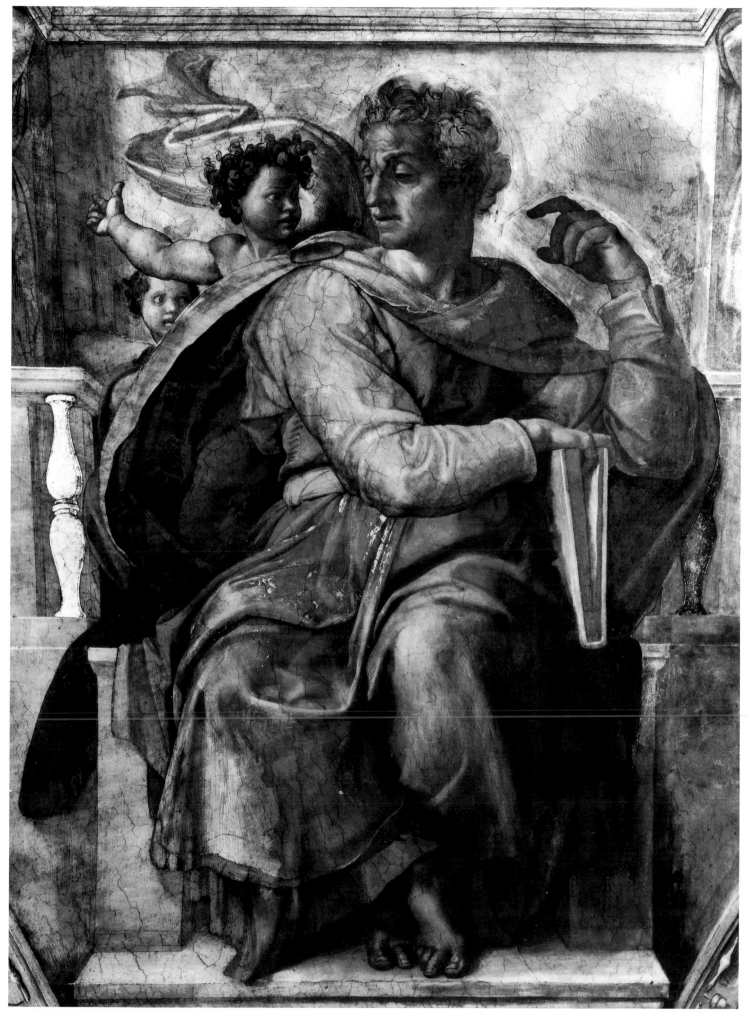

140. ISAIAH. 1509. Sistine Chapel Ceiling

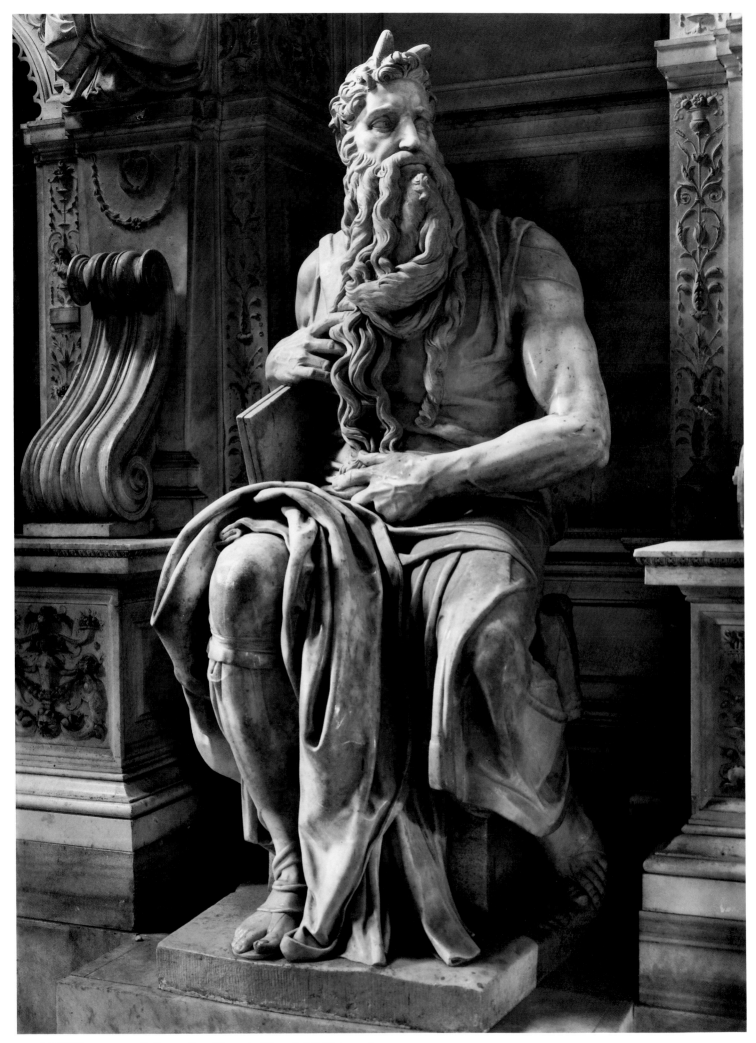

141. MOSES. 1513–1516. Rome, San Pietro in Vincoli (cf. Plate 234)

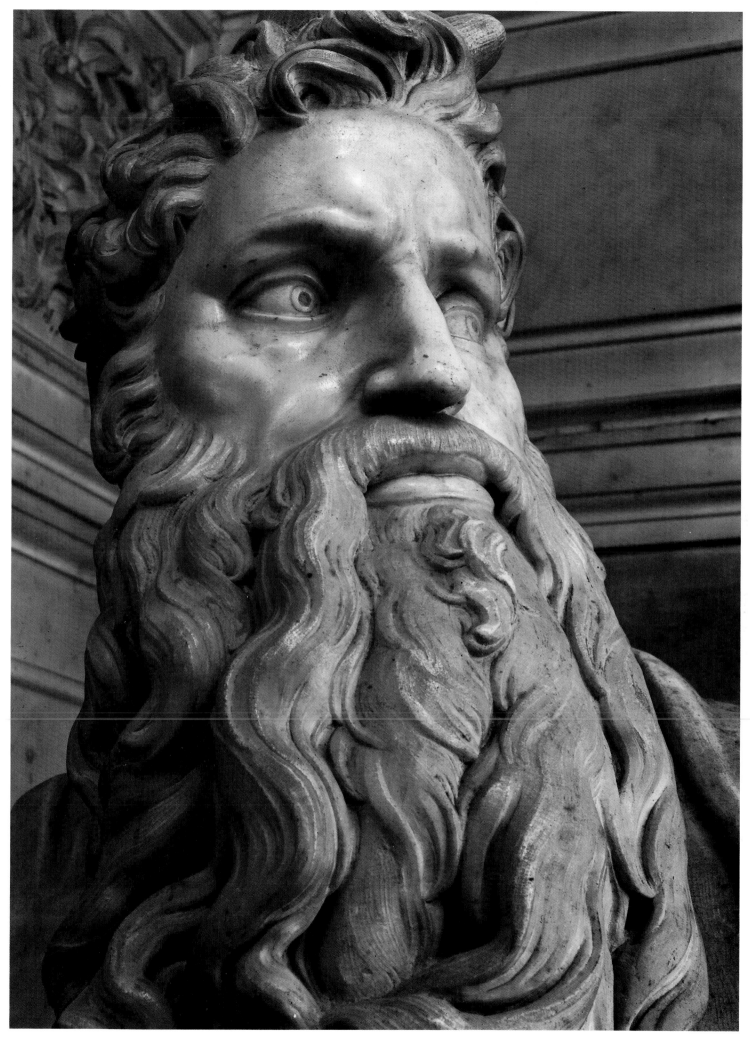

142. THE HEAD OF MOSES. Detail of Plate 141

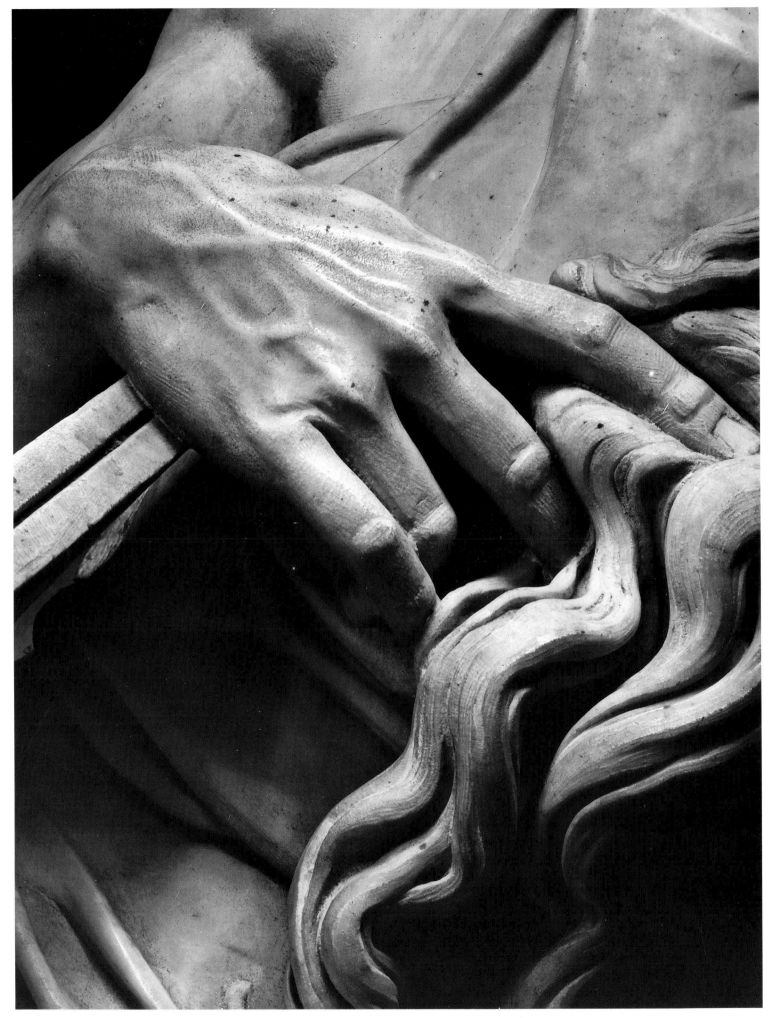

143. THE RIGHT HAND OF MOSES. Detail of Plate 141

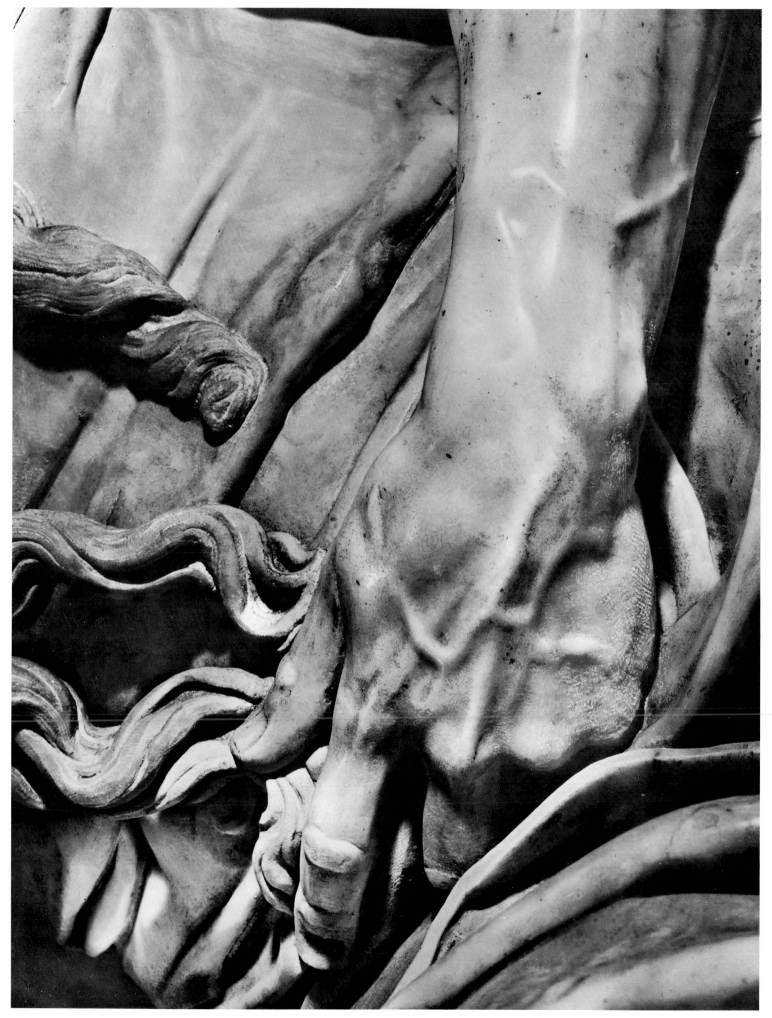

144. THE LEFT HAND OF MOSES. Detail of Plate 141

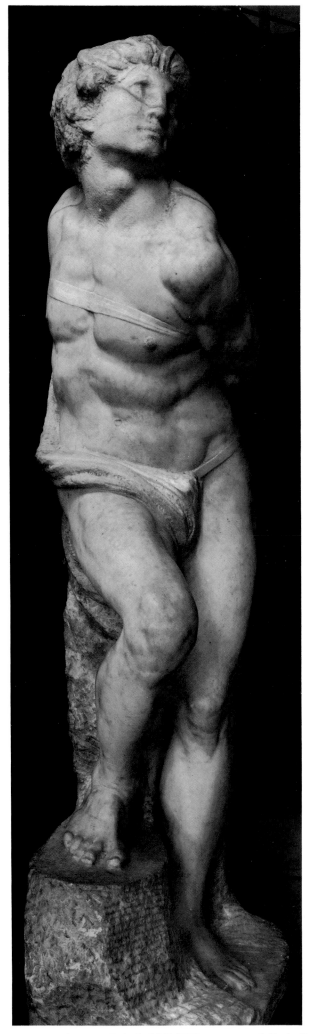
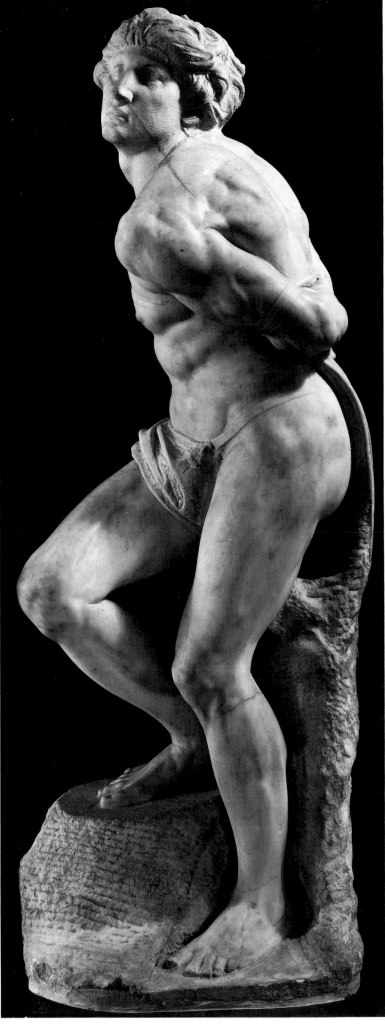

145–146. THE HEROIC CAPTIVE. 1514–1516. Paris, Louvre

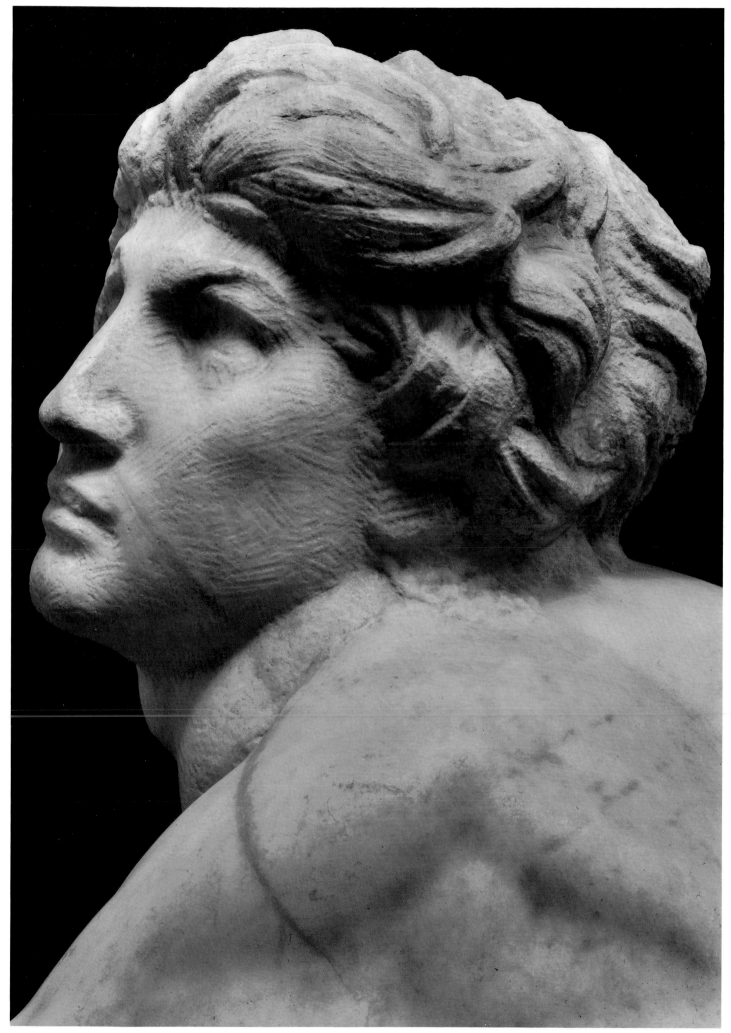

147. THE HEAD OF THE HEROIC CAPTIVE. Detail of Plate 146

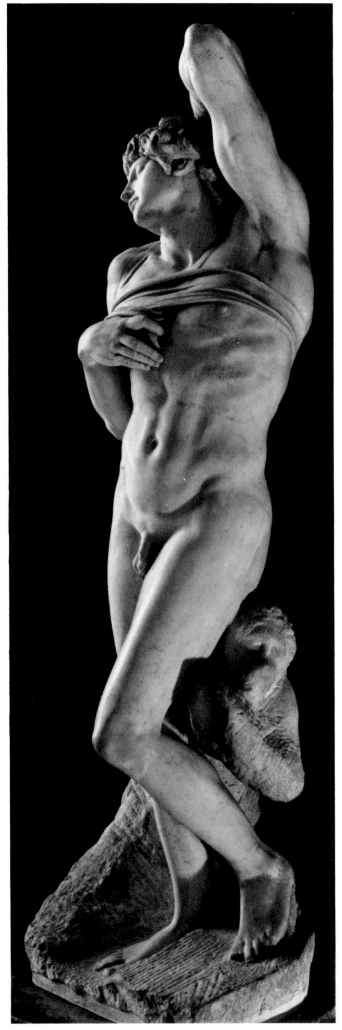
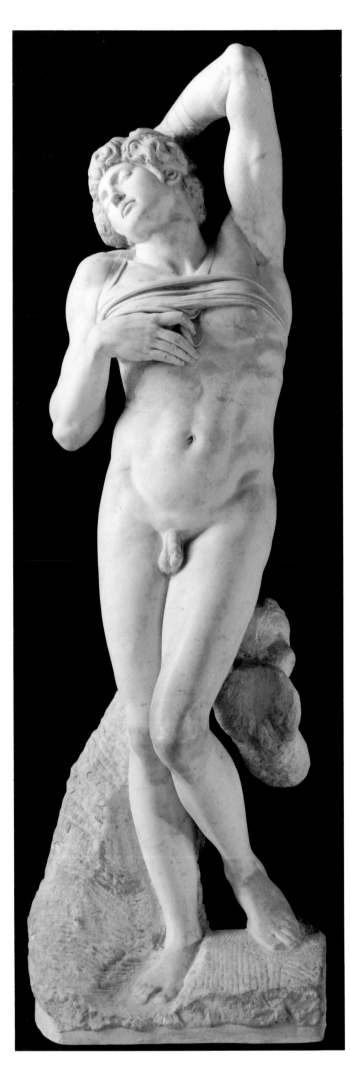

148–149. THE DYING CAPTIVE. 1514–1516. Paris, Louvre

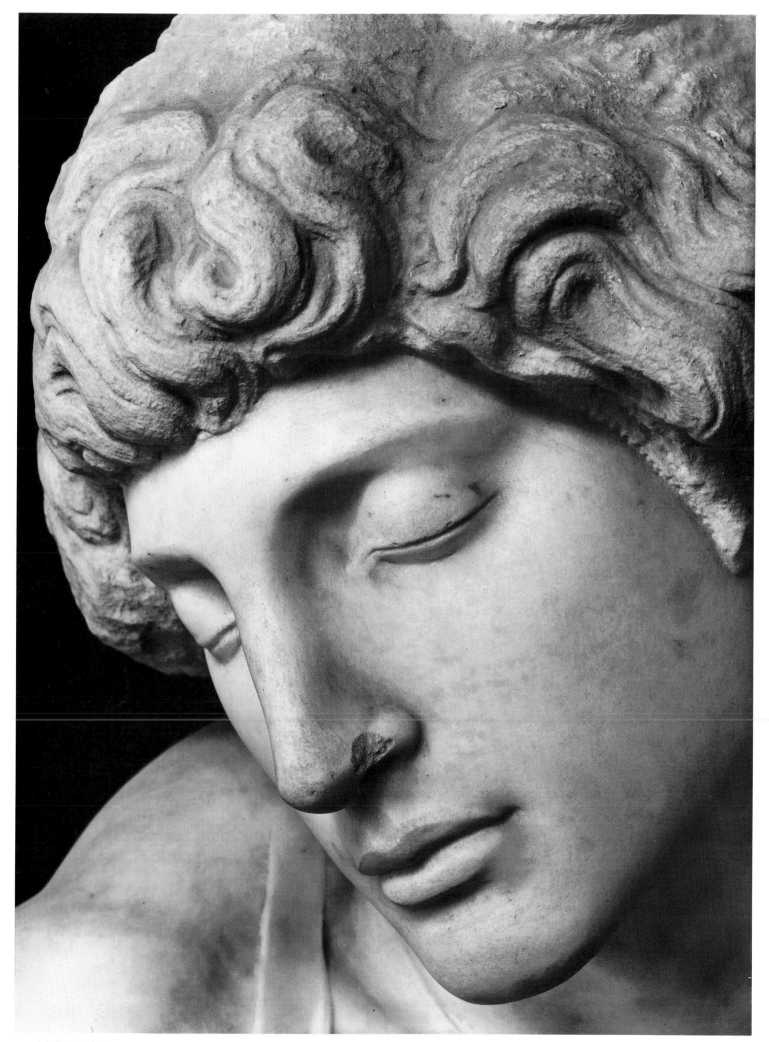

150. THE HEAD OF THE DYING CAPTIVE. Detail of Plate 149

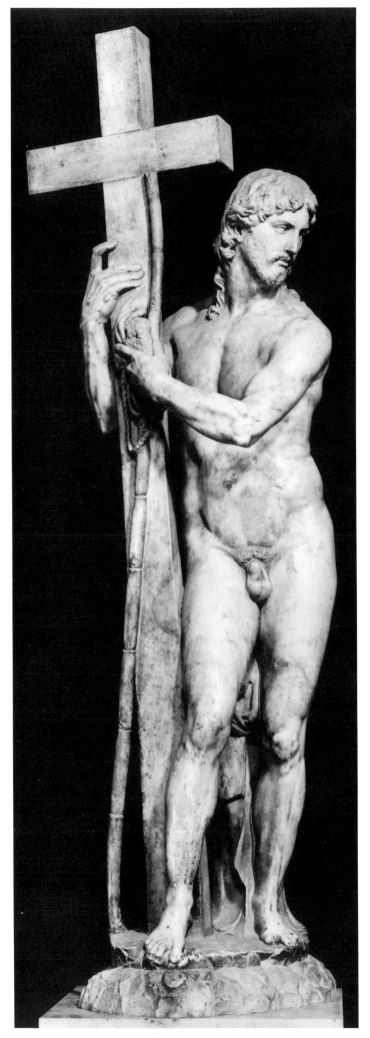
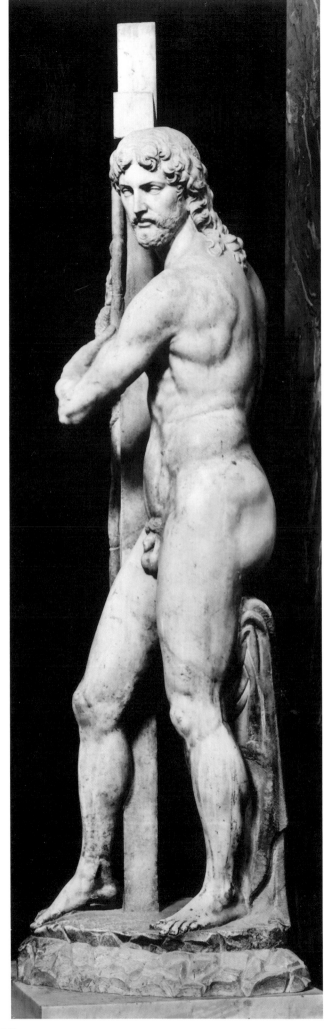

151–152. THE RISEN CHRIST. 1519–1520. Rome, Santa Maria sopra Minerva

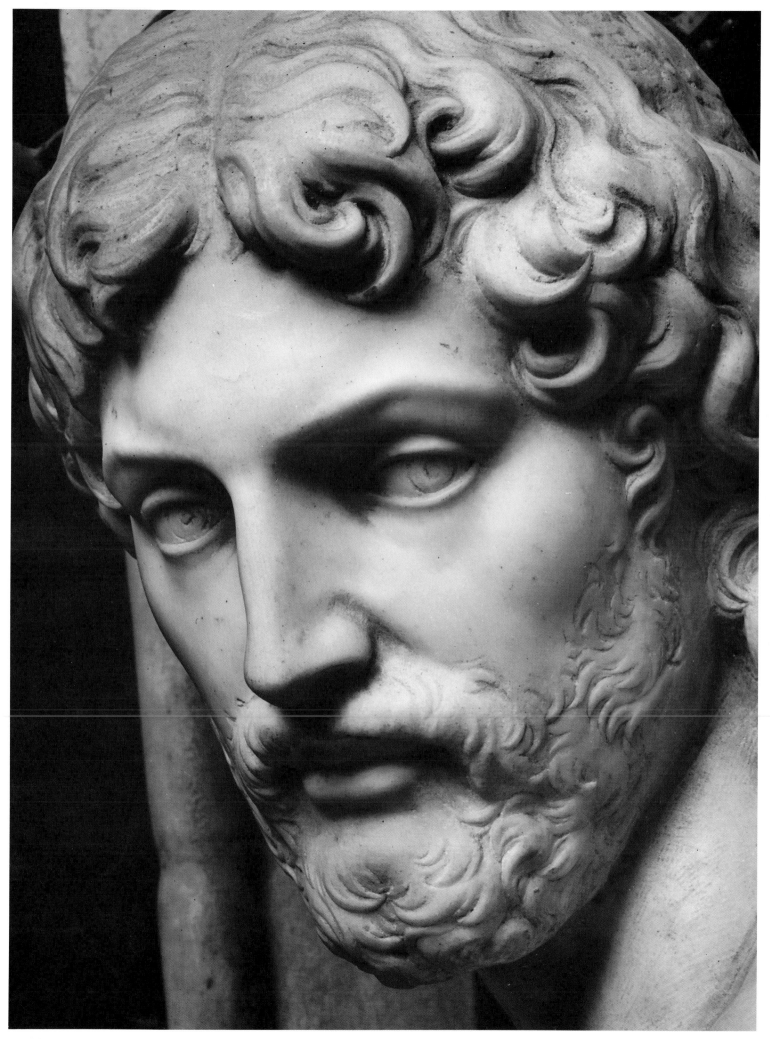

153. THE HEAD OF CHRIST. Detail of Plate 152

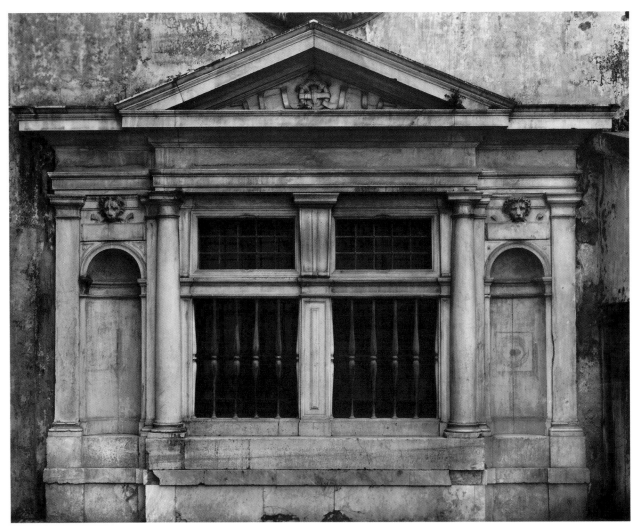

154. MARBLE FRONT OF A SMALL CHAPEL, CASTEL SANT'ANGELO, ROME. About 1513–1516

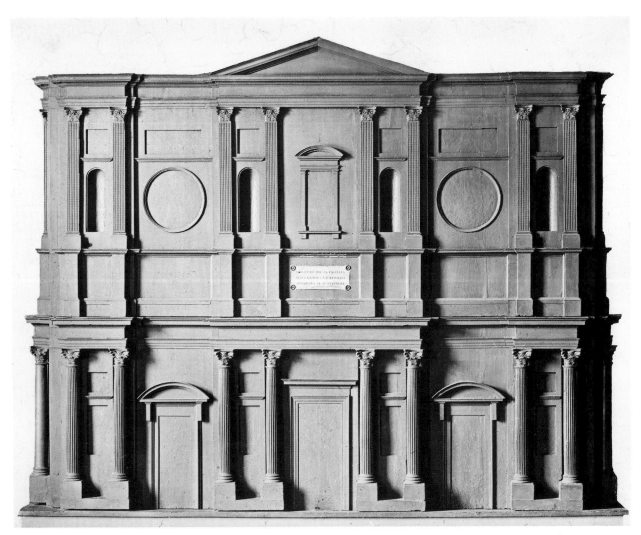

155. WOODEN MODEL FOR THE FAÇADE OF SAN LORENZO. 1518. Florence, Casa Buonarroti

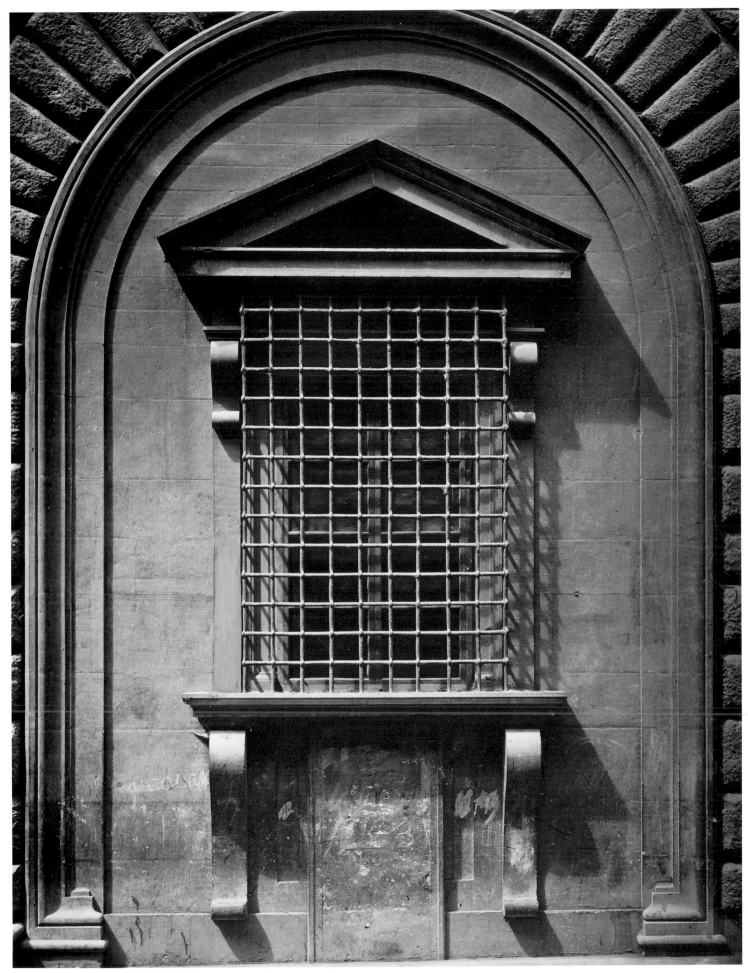

156. A WINDOW OF THE MEDICI PALACE, FLORENCE. About 1517–1520

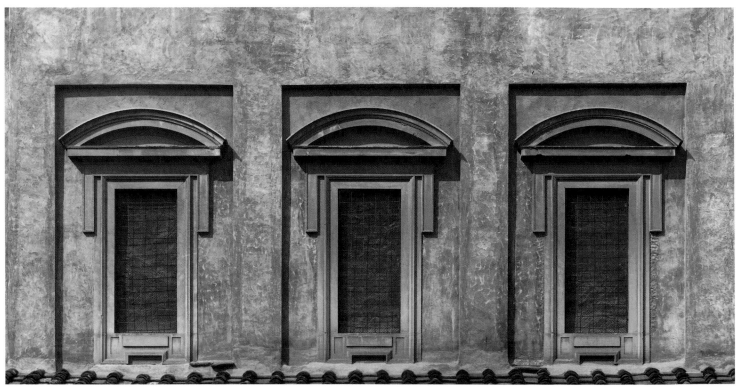

157. ROW OF WINDOWS ON THE OUTSIDE OF THE BIBLIOTECA LAURENZIANA, FLORENCE. About 1524

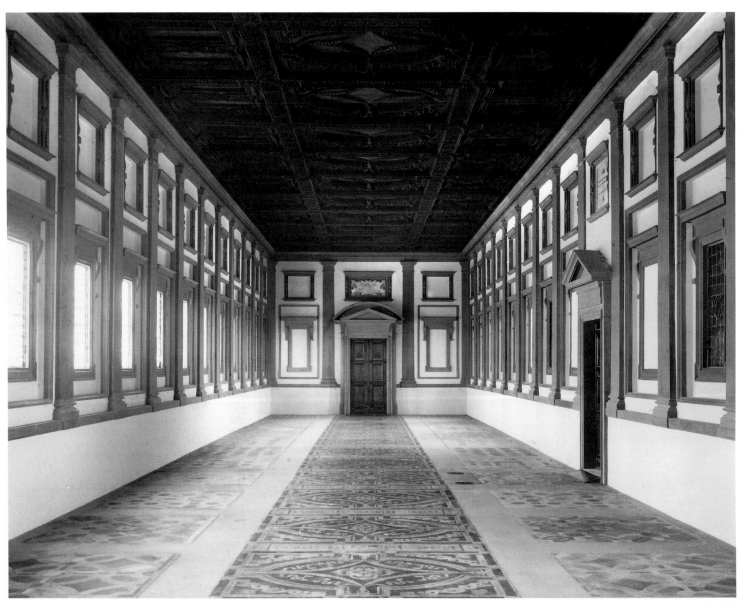

158. THE READING ROOM IN THE BIBLIOTECA LAURENZIANA, FLORENCE. About 1524–1534. View without desks and tables (cf. Appendix Plates VIII–IX)

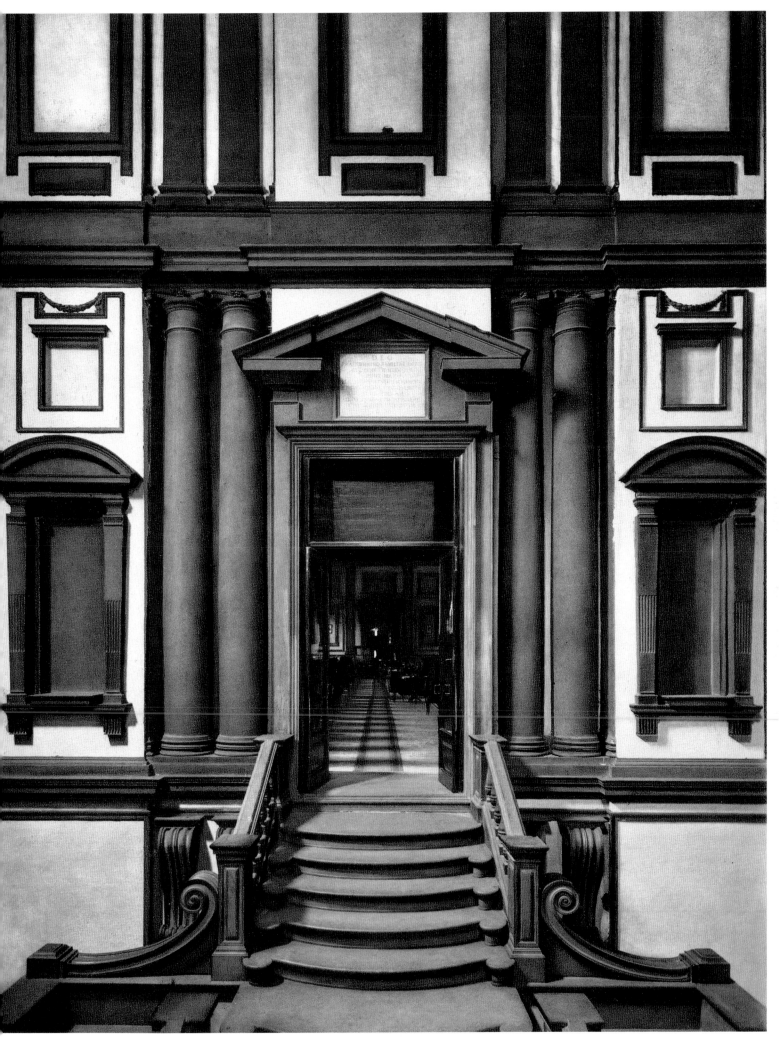

59. THE VESTIBULE OF THE BIBLIOTECA LAURENZIANA, FLORENCE. About 1524–1526

160–161. A DOOR IN THE VESTIBULE AND A DOOR IN THE READING ROOM OF THE BIBLIOTECA LAURENZIANA

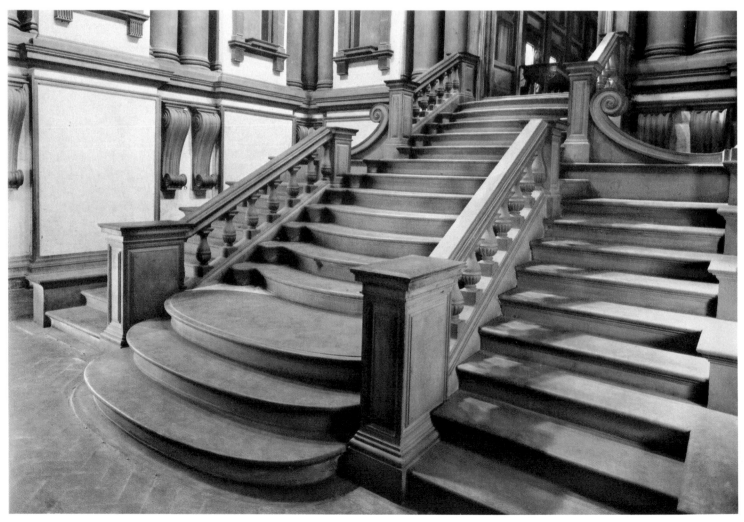

162. STAIRCASE LEADING TO THE READING ROOM OF THE BIBLIOTECA LAURENZIANA. About 1524–1526.
Completed 1559 by Ammanati and Vasari

163. THE VESTIBULE OF THE BIBLIOTECA LAURENZIANA, FLORENCE. About 1524–1526

164. THE 'PERGAMO' OF SAN LORENZO, FLORENCE. 1526–1532

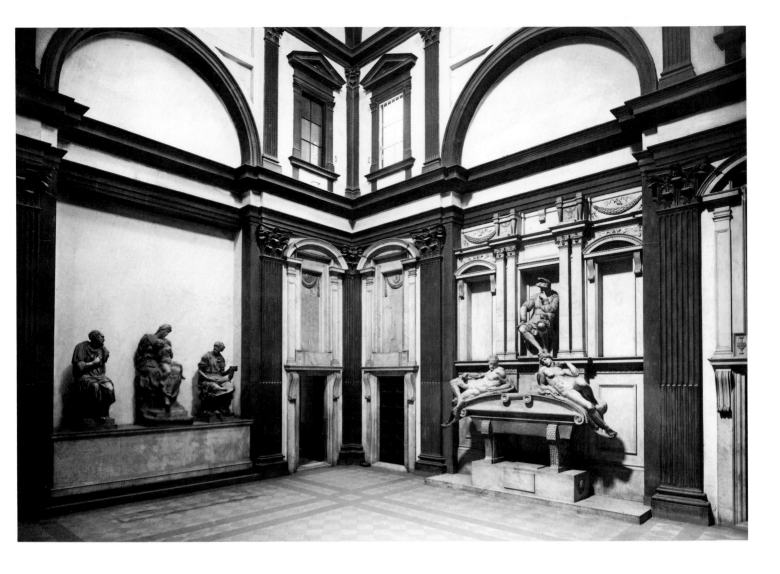

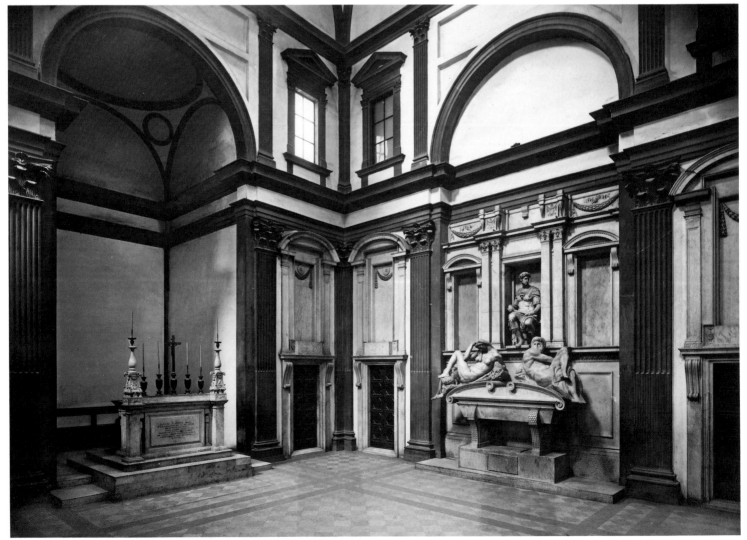

165–166. THE MEDICI CHAPEL. Florence, San Lorenzo, Sagrestia Nuova. 1520–1534

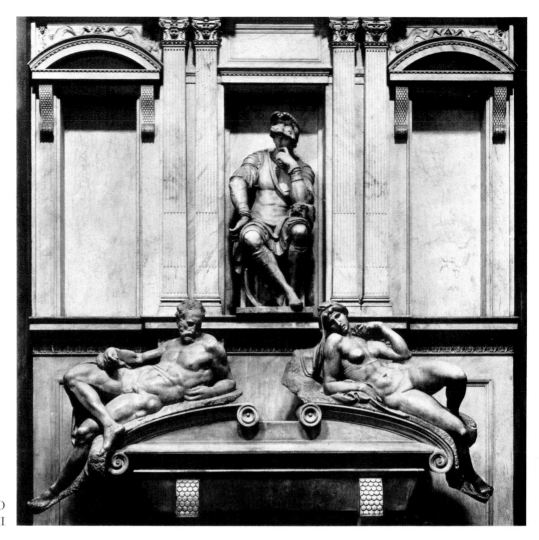

167. THE TOMB OF LORENZO
DE' MEDICI

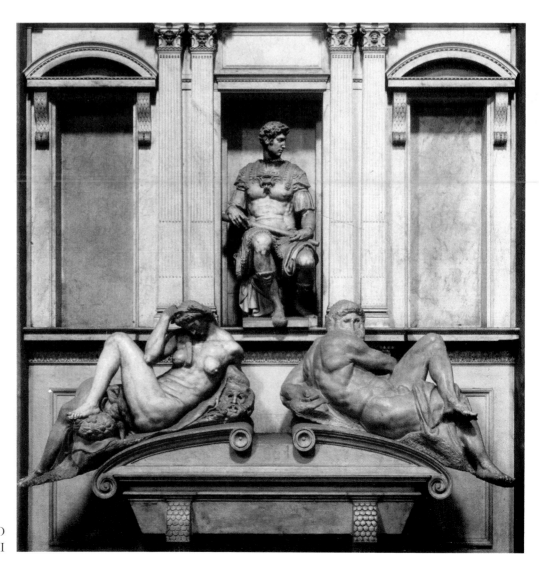

168. THE TOMB OF GIULIANO
DE' MEDICI

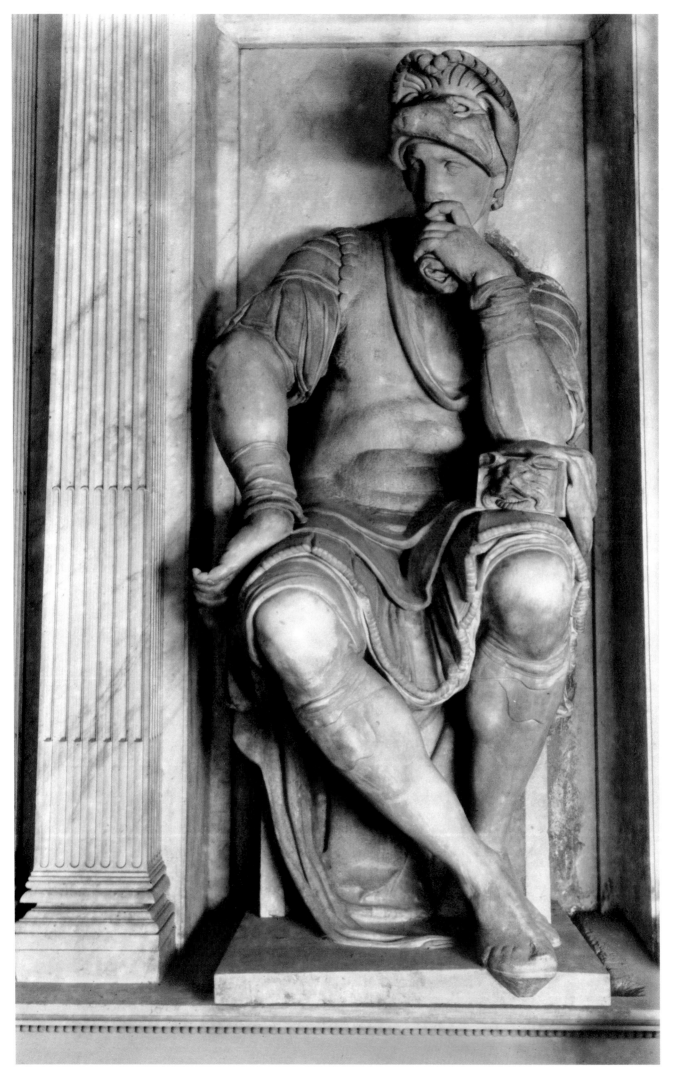

169. LORENZO DE' MEDICI, DUKE OF URBINO. Detail of Plate 167. Florence, Medici Chapel

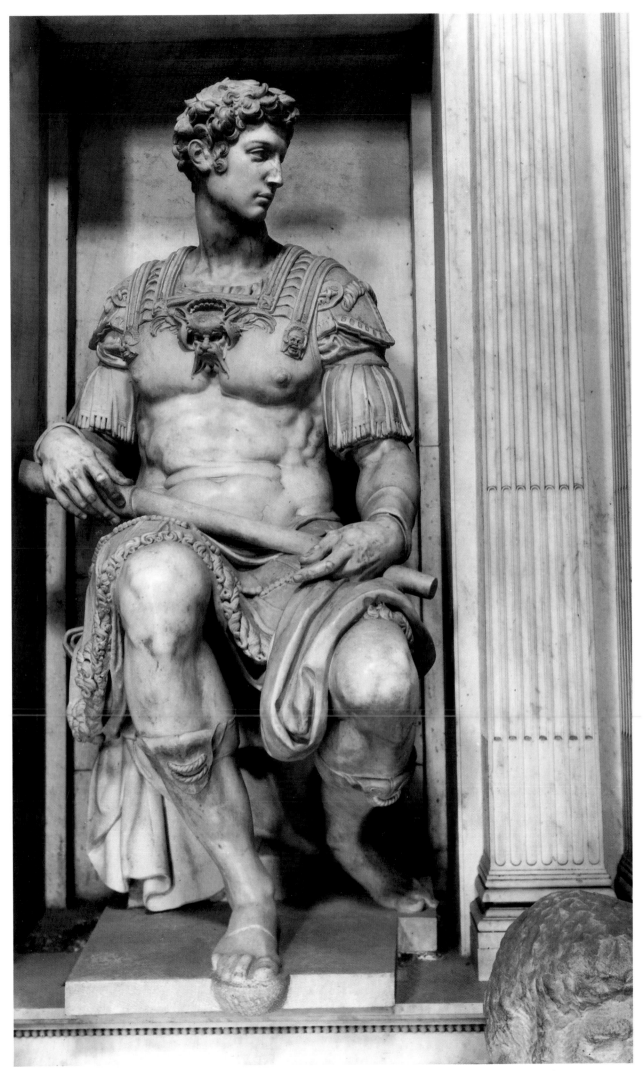

170. GIULIANO DE' MEDICI, DUKE OF NEMOURS. Detail of Plate 168. Florence, Medici Chapel

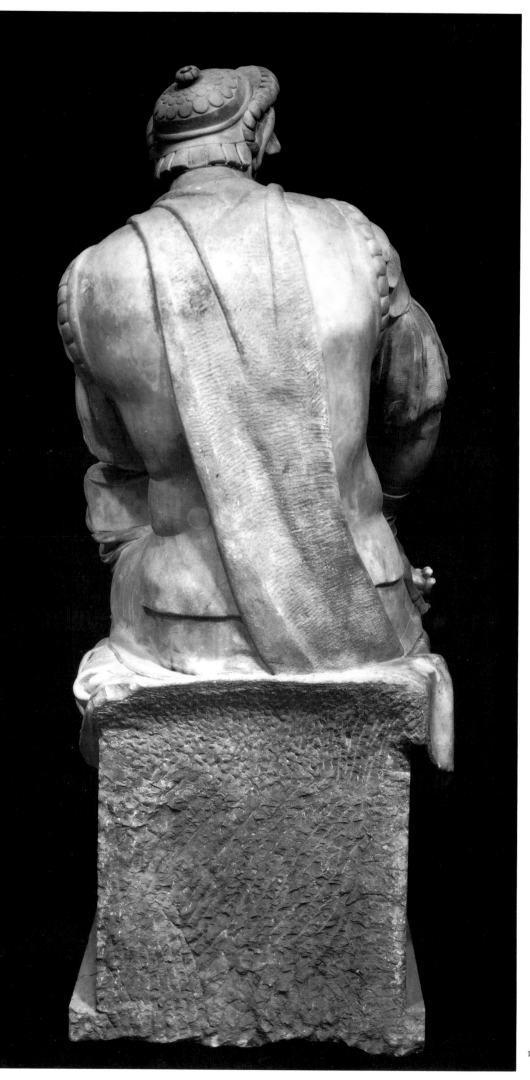

171. BACK VIEW OF LORENZO
DE' MEDICI (cf. Plate 169)

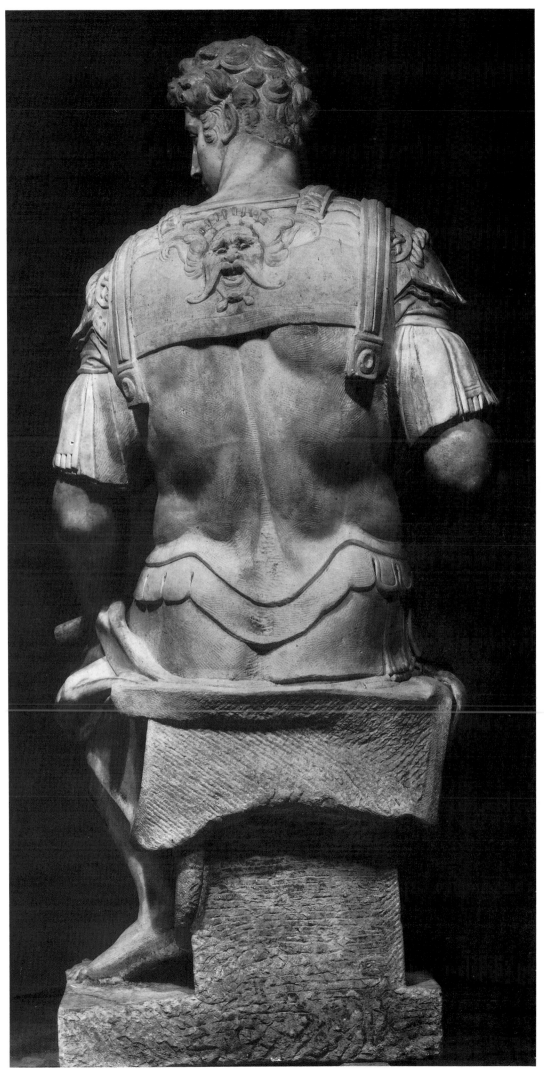

172. BACK VIEW OF GIULIANO
DE' MEDICI (cf. Plate 170)

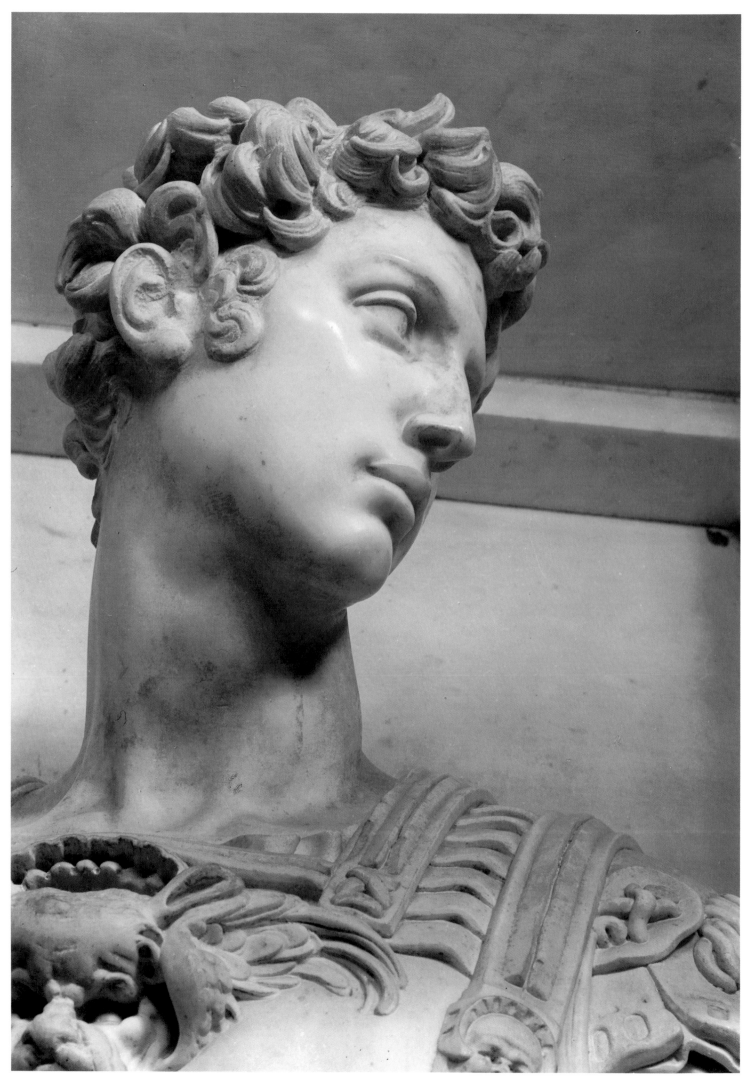

173. HEAD OF GIULIANO DE' MEDICI. Detail of Plate 170

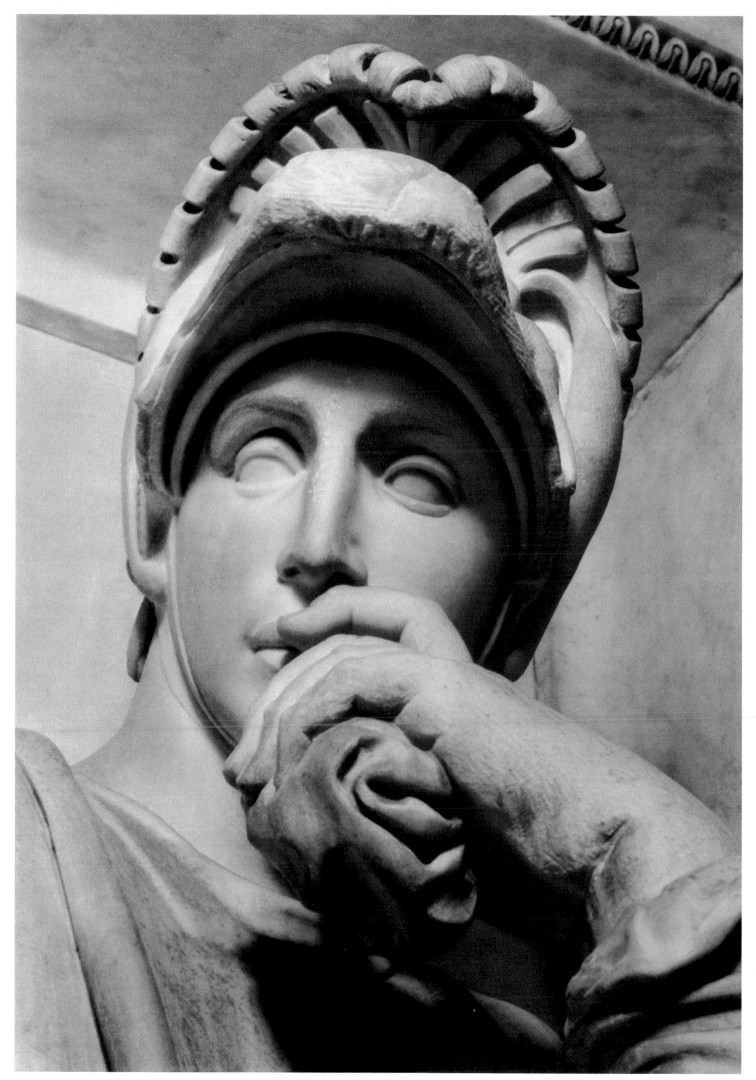

174. HEAD OF LORENZO DE' MEDICI. Detail of Plate 169

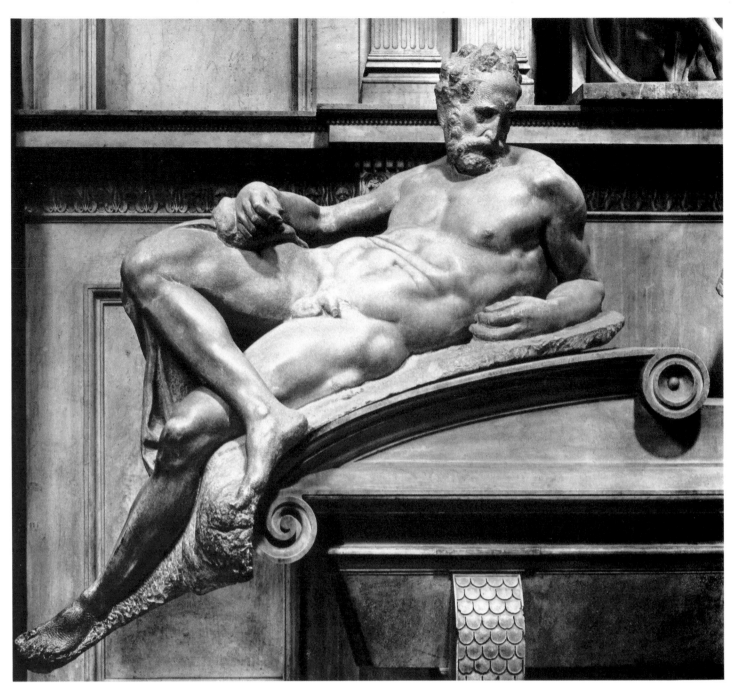

175. CREPUSCOLO (Evening). Detail of Plate 167

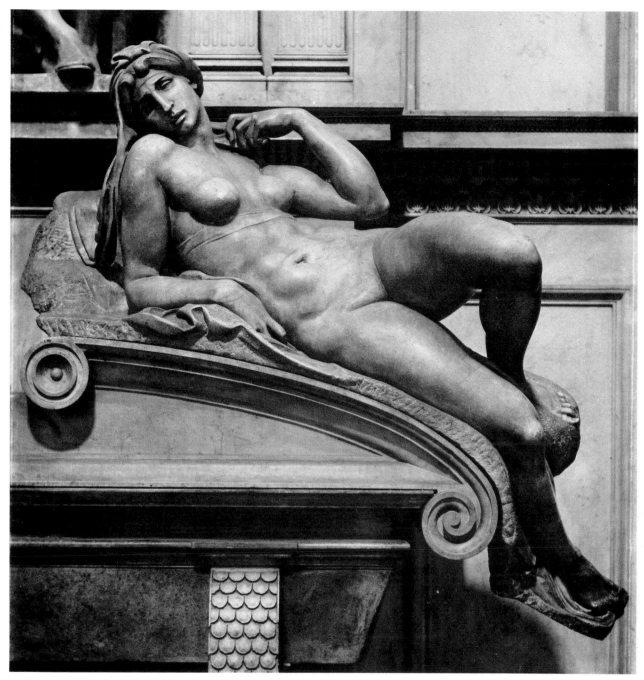

176. AURORA (Dawn). Detail of Plate 167

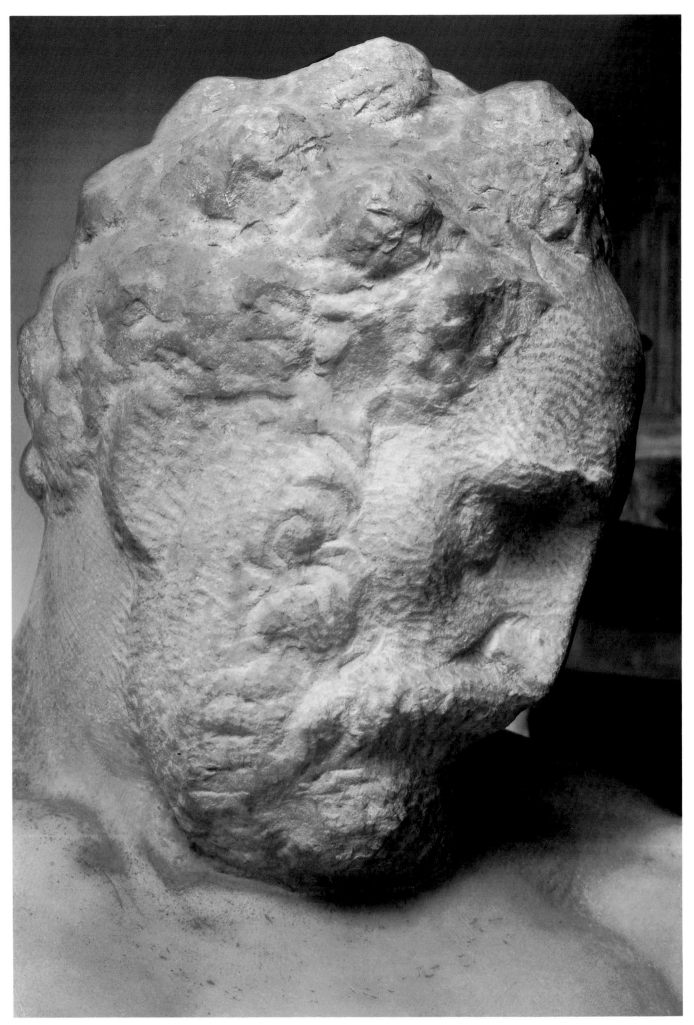

177. CREPUSCOLO. Detail of Plate 175

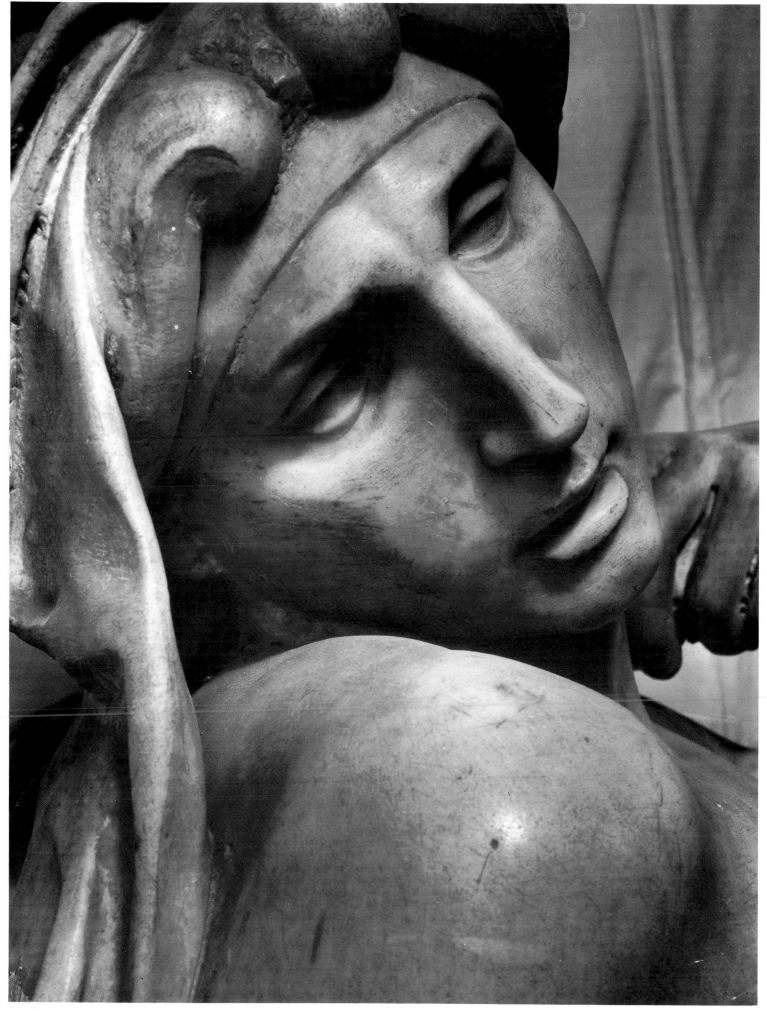

178. AURORA. Detail of Plate 176

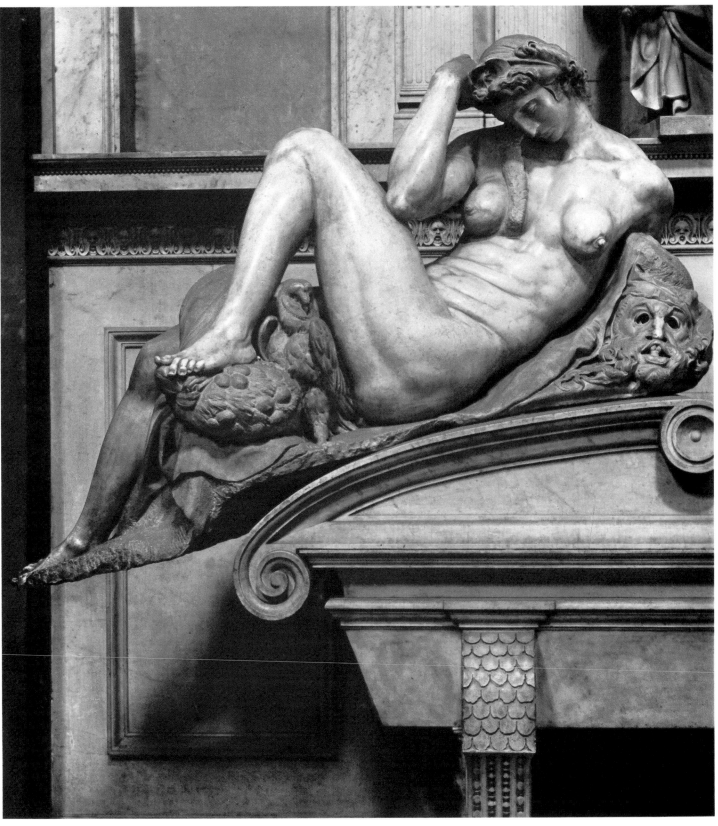

179. NOTTE (Night). Detail of Plate 168

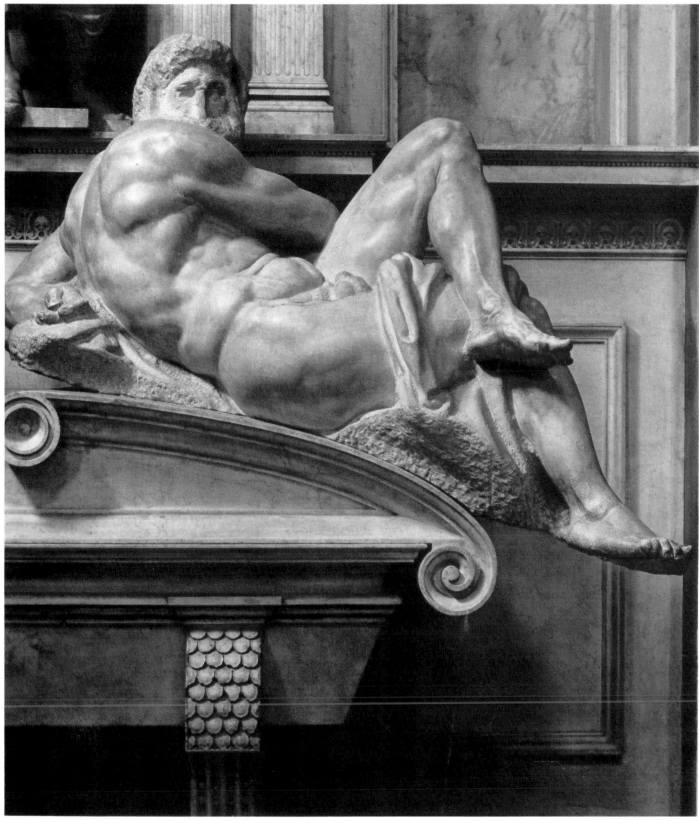

180. GIORNO (Day). Detail of Plate 168

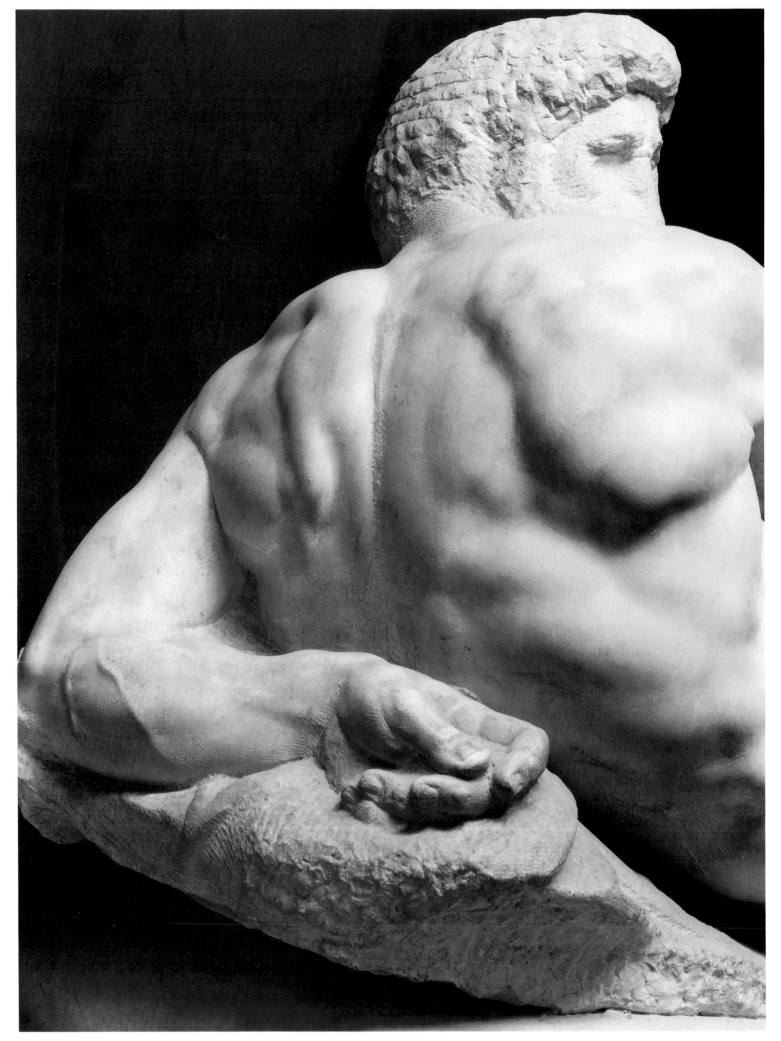

181. GIORNO. Detail of Plate 180

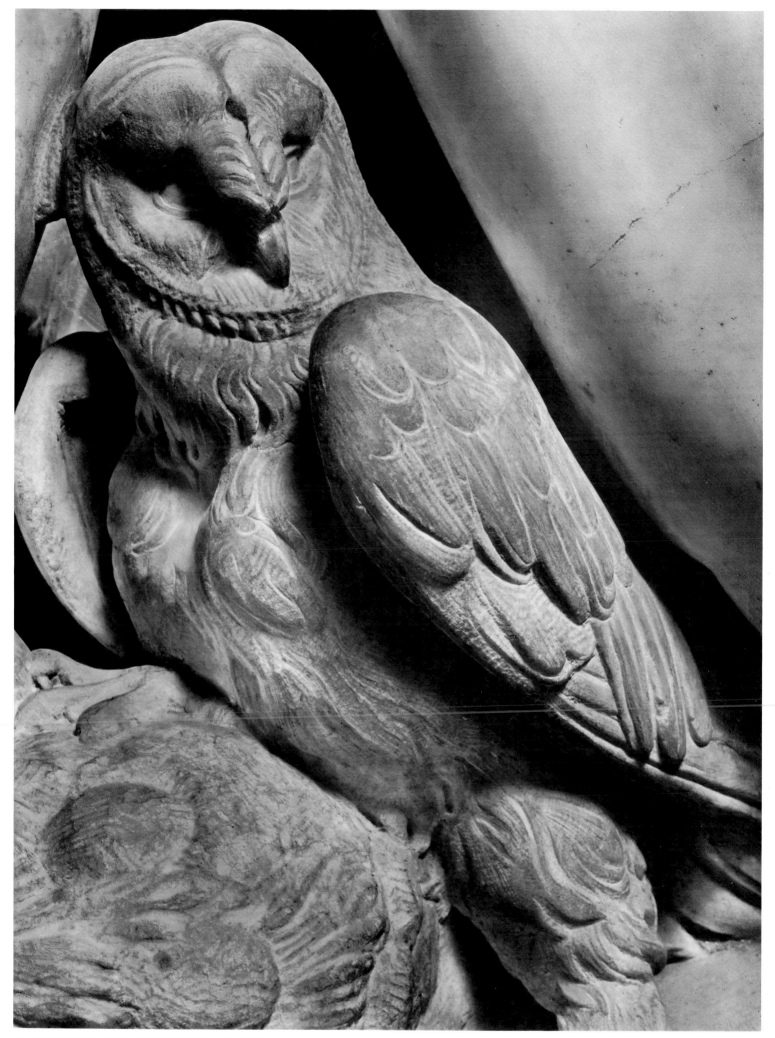

182. THE OWL OF LA NOTTE. Detail of Plate 179

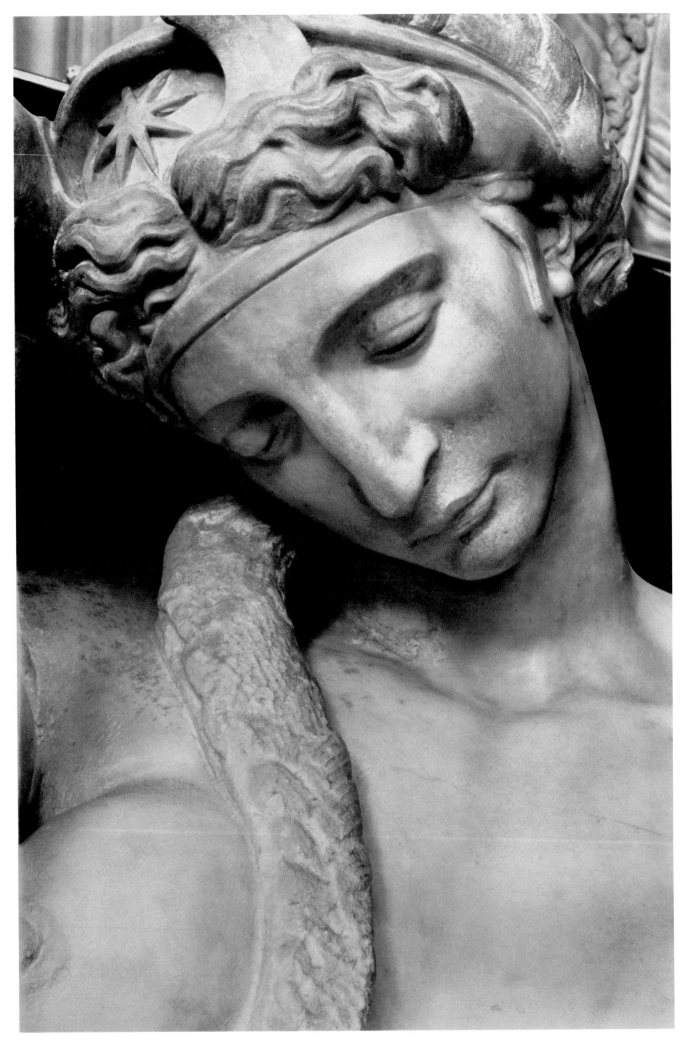

183. NOTTE. Detail of Plate 179

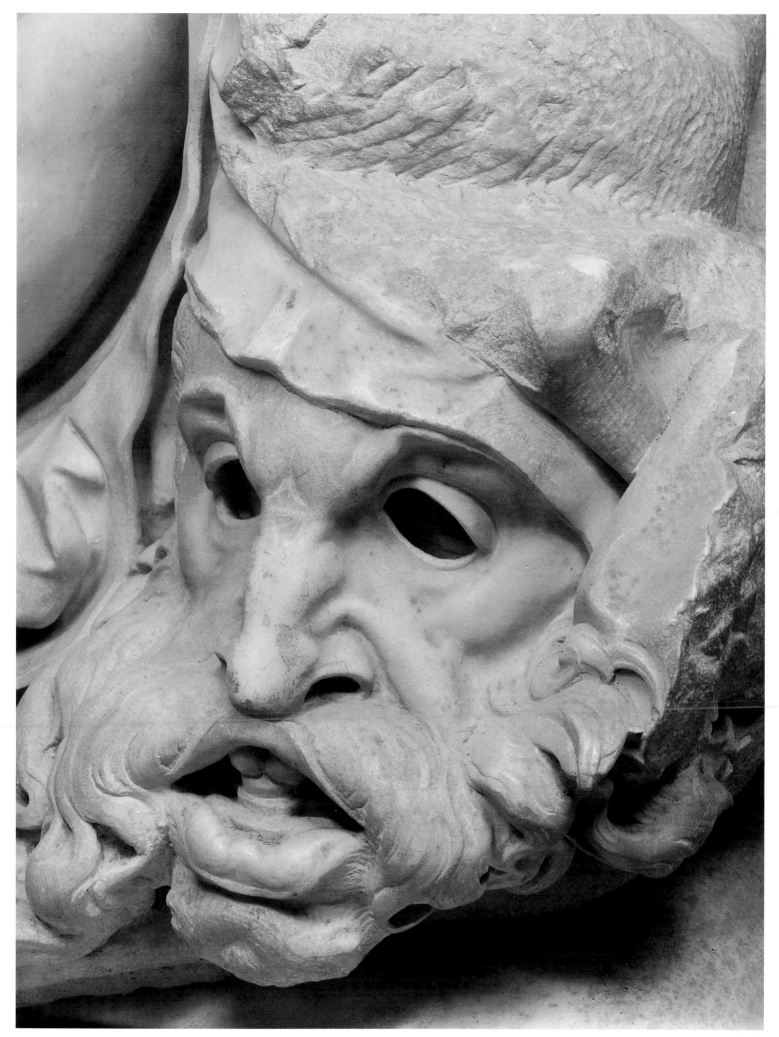

184. THE MASK OF LA NOTTE. Detail of Plate 179

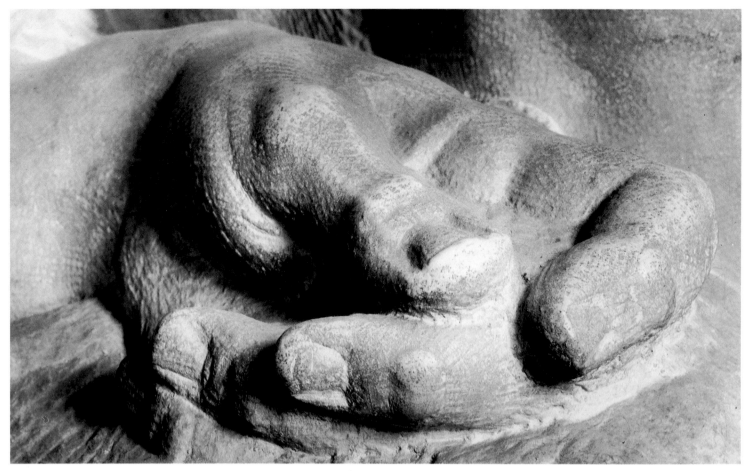

185. THE LEFT HAND OF GIORNO. Detail of Plate 181

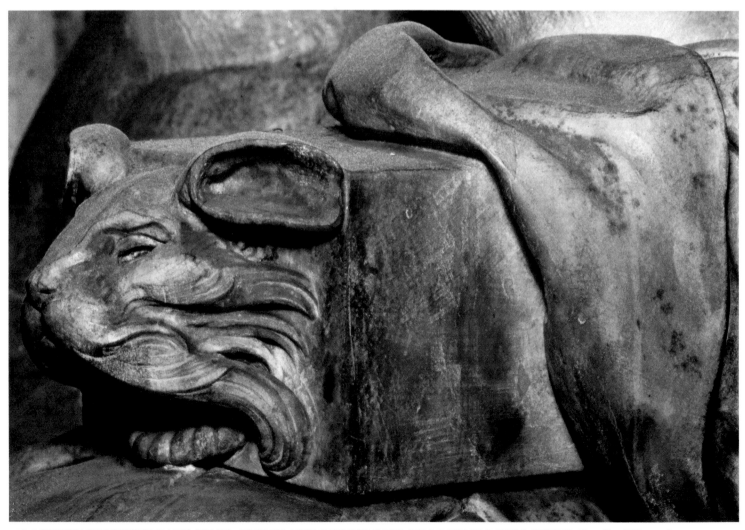

186. MONEY-BOX WITH BAT'S HEAD, UNDER THE LEFT ELBOW OF LORENZO DE' MEDICI. Detail of Plate 169

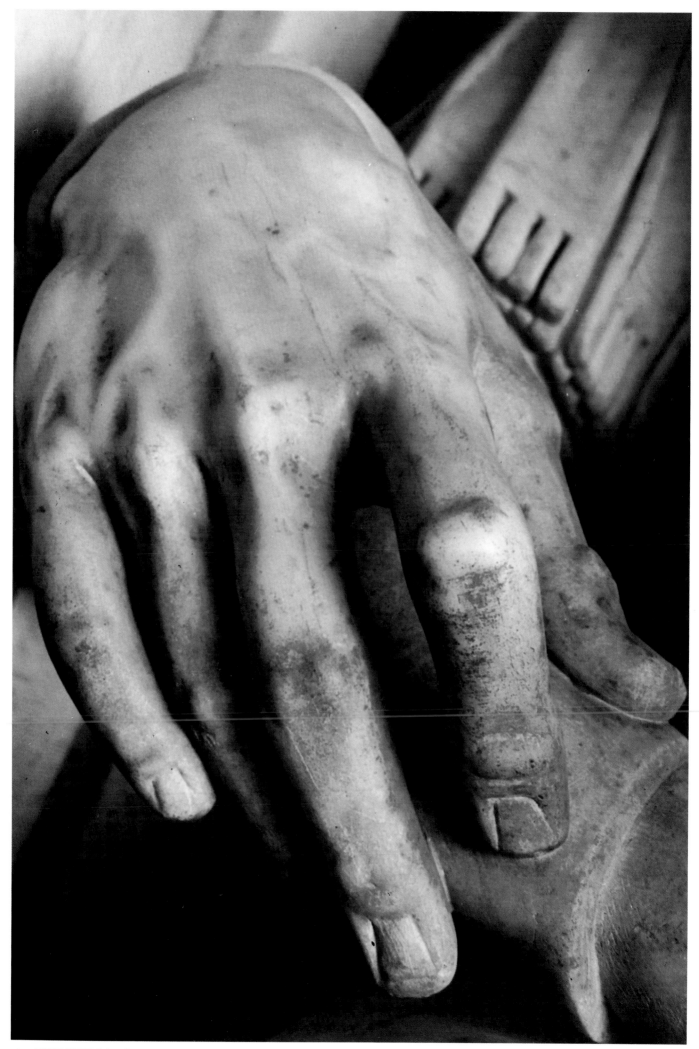

187. THE RIGHT HAND OF GIULIANO DE' MEDICI. Detail of Plate 170

188. ORNAMENTS ON THE SIDE OF THE SARCOPHAGUS OF GIULIANO. Marble relief. Detail of Plate 166

189. FRIEZE OF MASKS BEHIND 'NOTTE'. Marble relief. Detail of Plate 179

190–191 MASKS. Ornaments on the front and back of the cuirass of Giuliano de' Medici. Details of Plates 170 and 172

192. BACK VIEW OF 'GIORNO' (cf. Plate 180)

193. BACK VIEW OF 'AURORA' (cf. Plate 176)

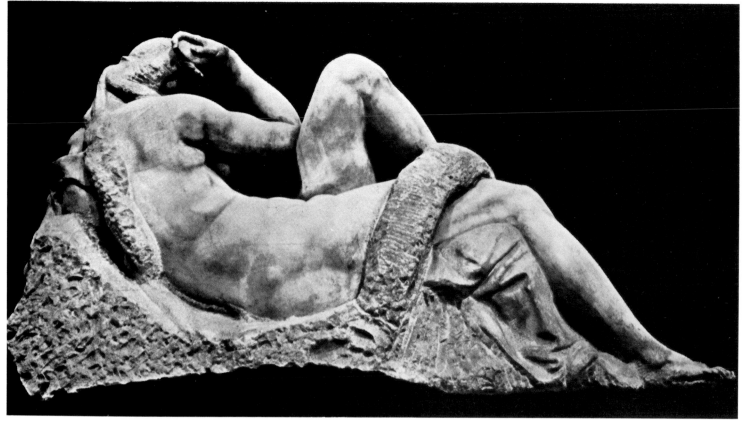

194. BACK VIEW OF 'NOTTE' (cf. Plate 179)

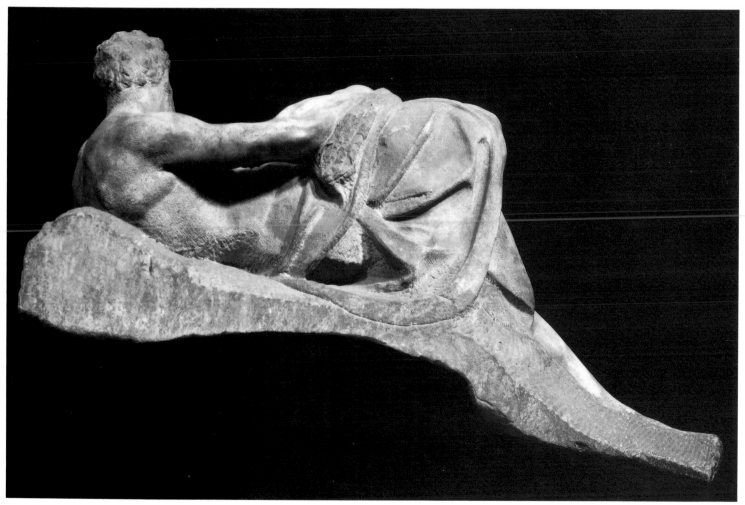

195. BACK VIEW OF 'CREPUSCOLO' (cf. Plate 175)

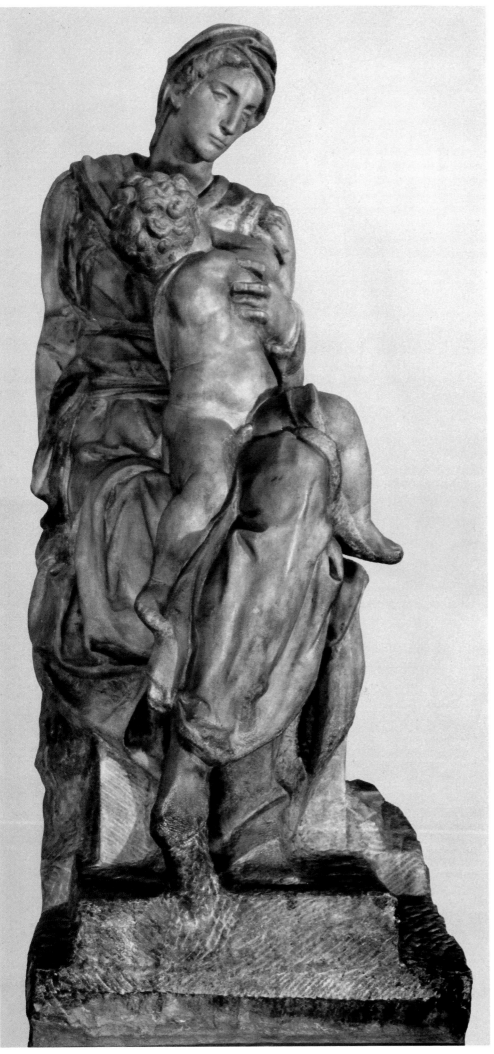

196. THE MEDICI MADONNA. 1524–1534.
Detail of Plate 165. Florence, Medici Chape

197. BACK VIEW OF THE MEDICI
MADONNA

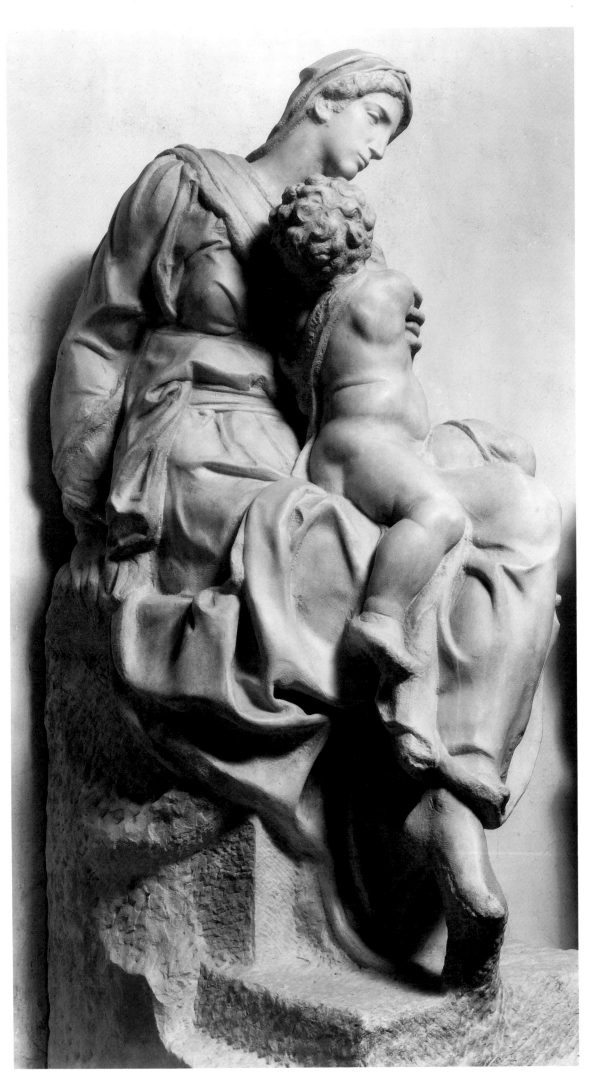

198. SIDE VIEW OF THE MEDICI MADONNA

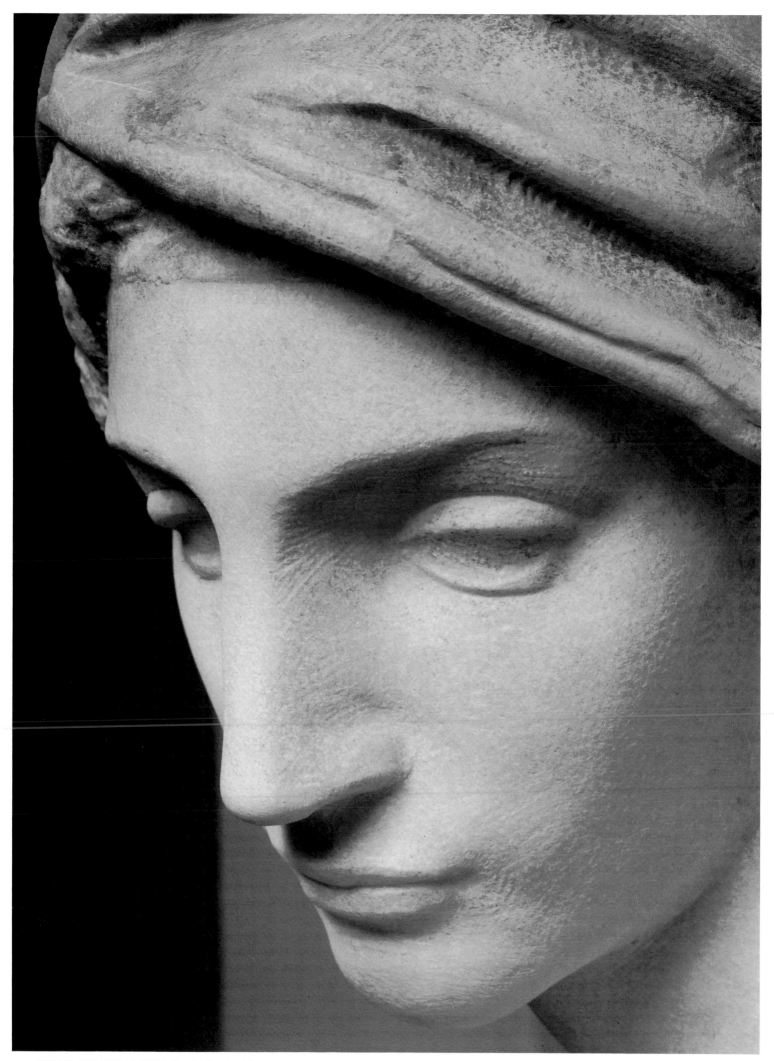

199. HEAD OF THE MEDICI MADONNA

200–201. CLAY MODEL FOR A RIVER GOD. About 1525. Florence, Accademia

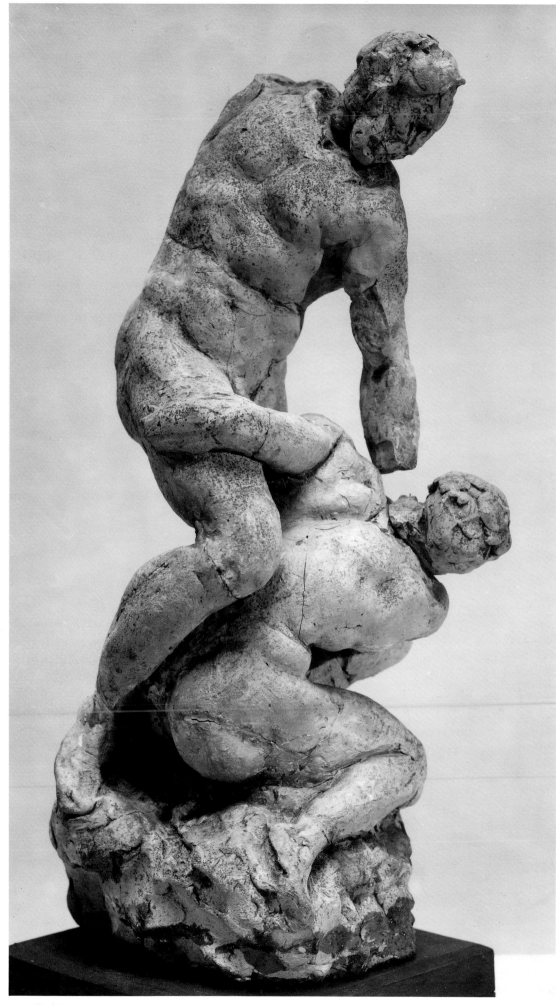

202. CLAY MODEL FOR A VICTORY GROUP. About 1525–1528. Florence, Casa Buonarroti

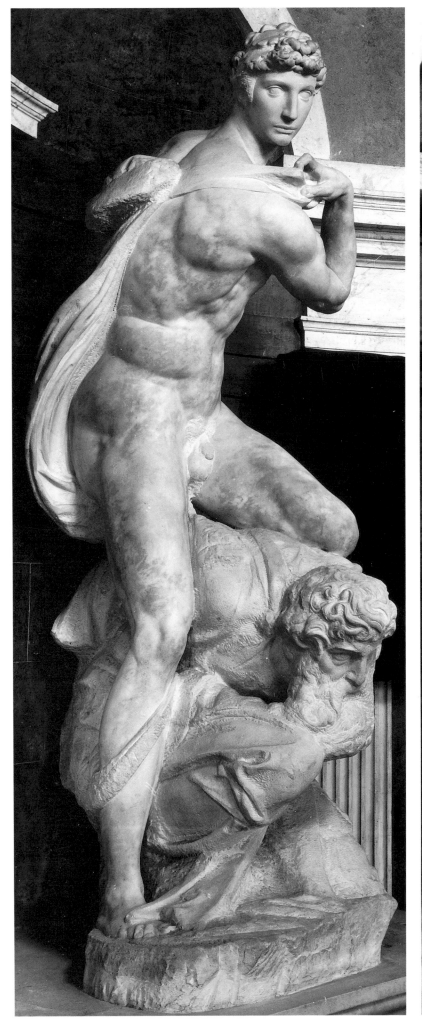

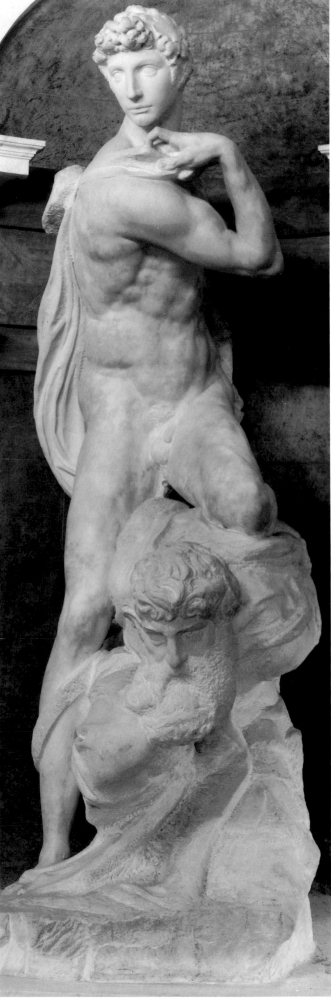

203–204. VICTORY. 1525–1530. Florence, Palazzo Vecchio

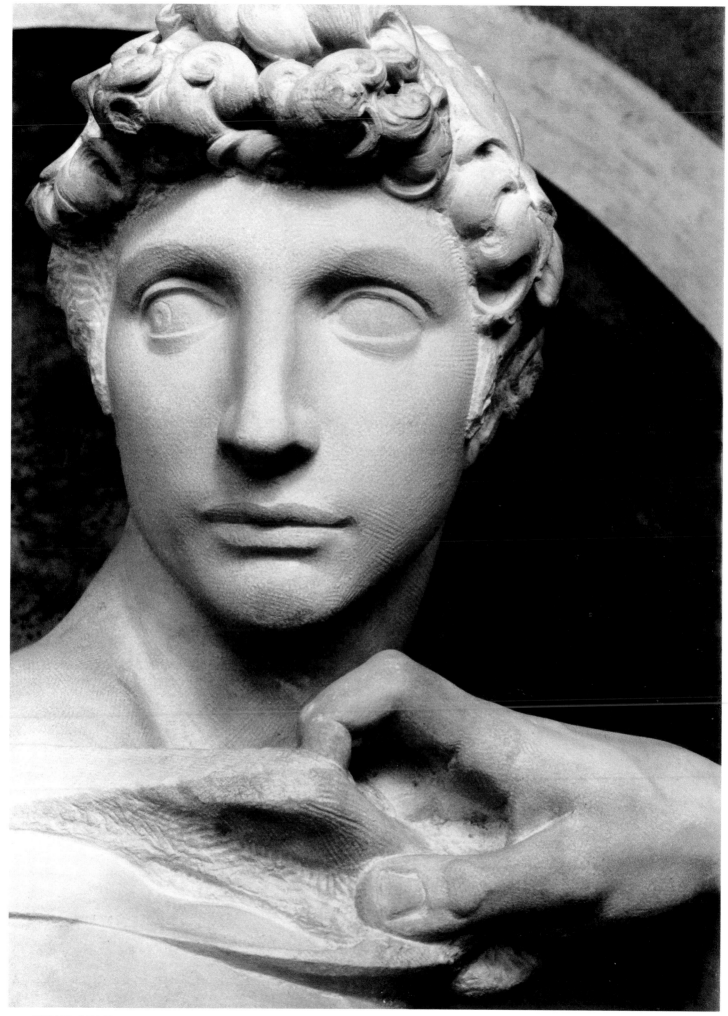

205. HEAD OF THE VICTOR. Detail of Plate 204

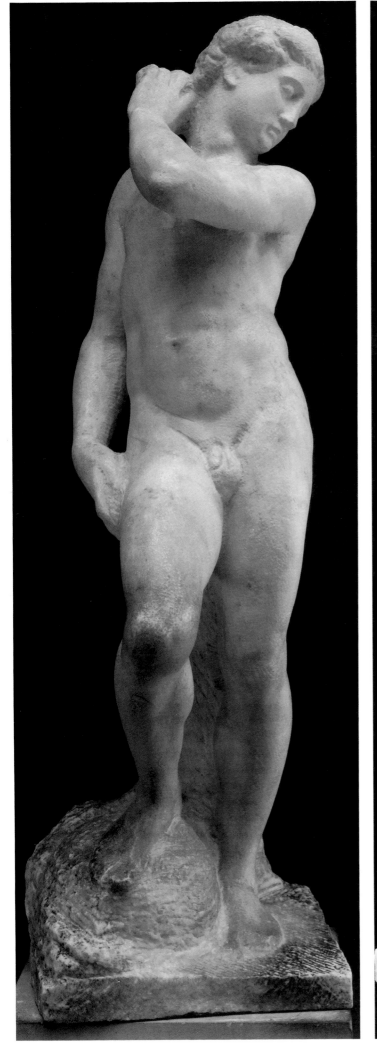
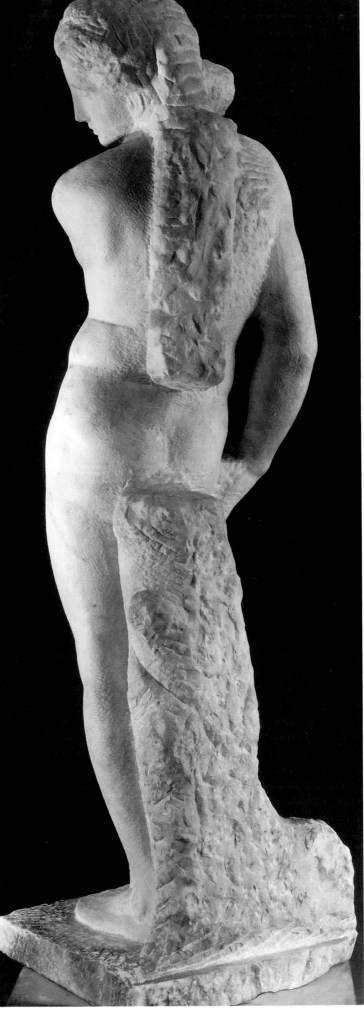

206–207. APOLLO. About 1530. Florence, Museo Nazionale del Bargello

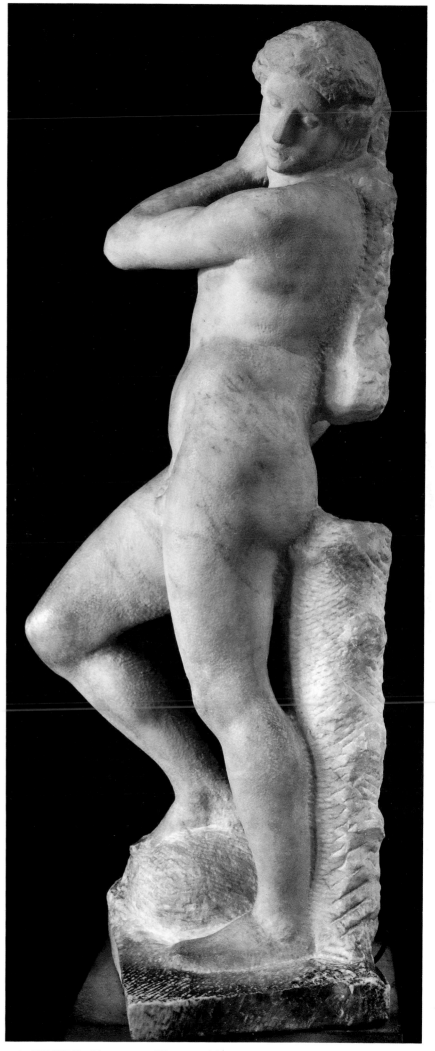

208. APOLLO. About 1530. Florence, Museo Nazionale del Bargello

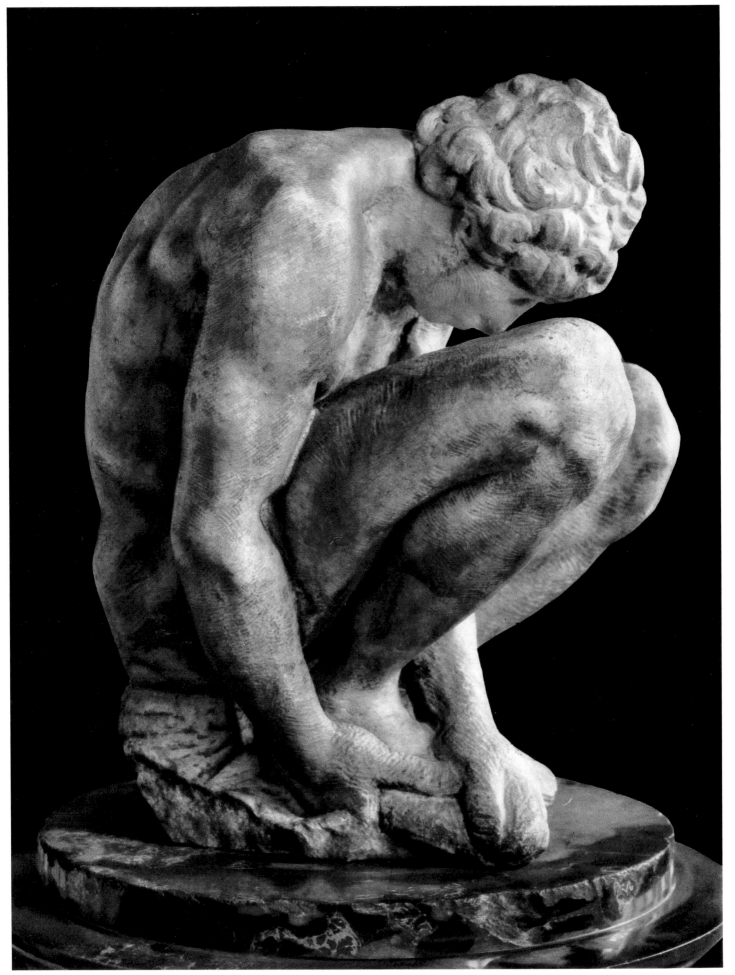

209. CROUCHING BOY. About 1530. Leningrad, Hermitage

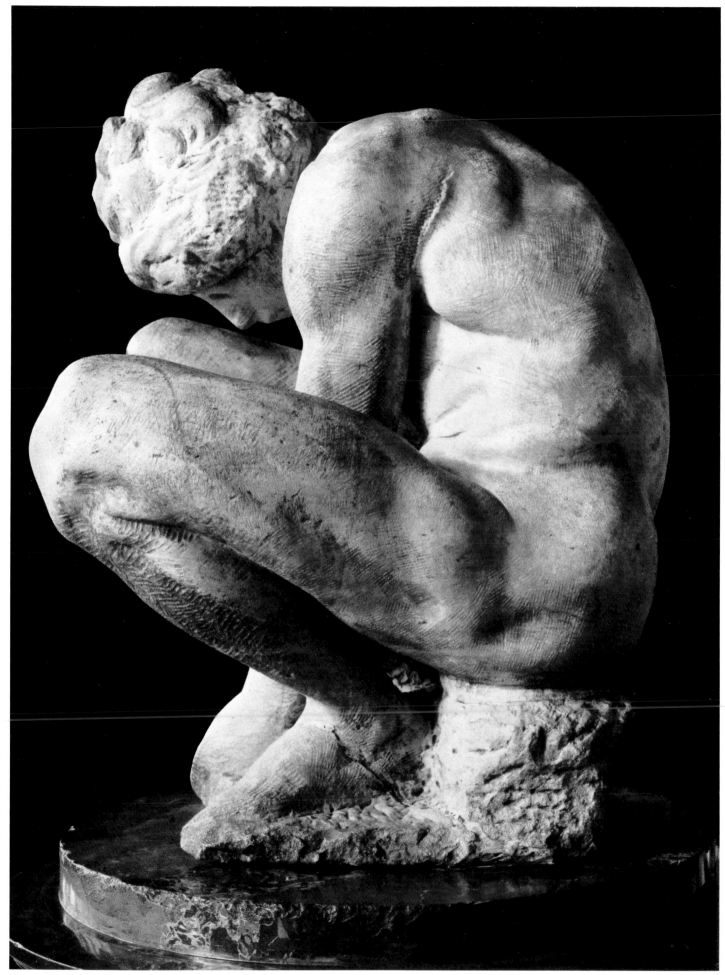

210. CROUCHING BOY. About 1530. Leningrad, Hermitage

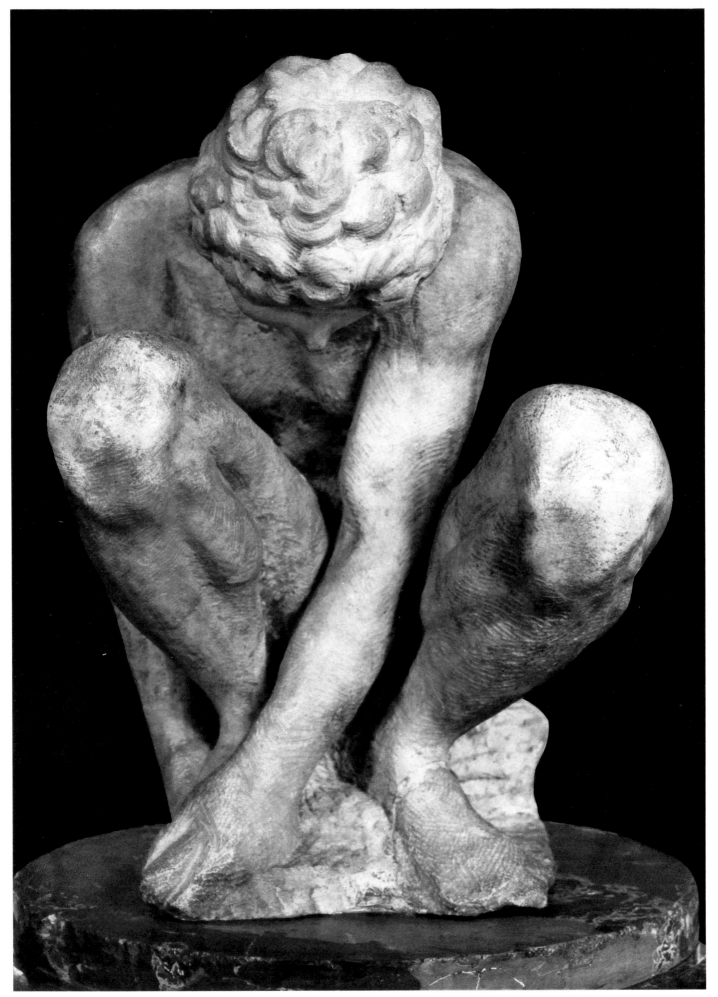

211. CROUCHING BOY. About 1530. Leningrad, Hermitage

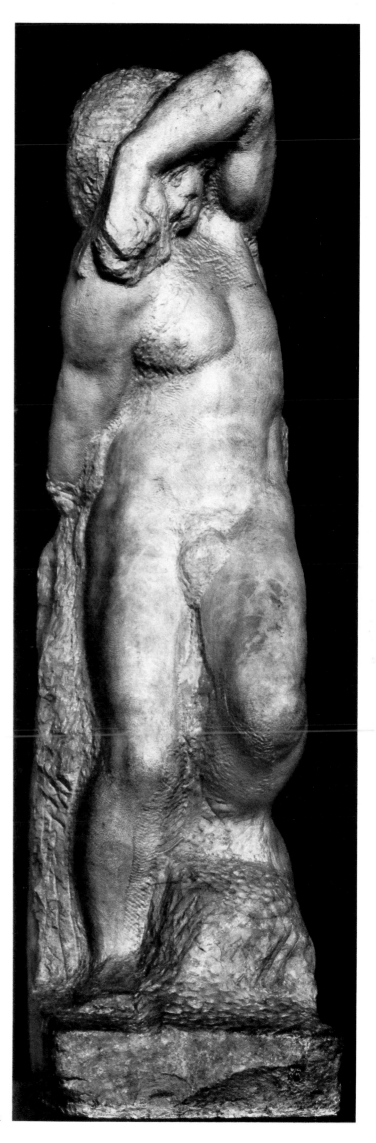

212. FIRST CAPTIVE
 FROM THE BOBOLI GARDENS:
 'THE YOUNG GIANT'.
 About 1530–1533. Florence, Accademia

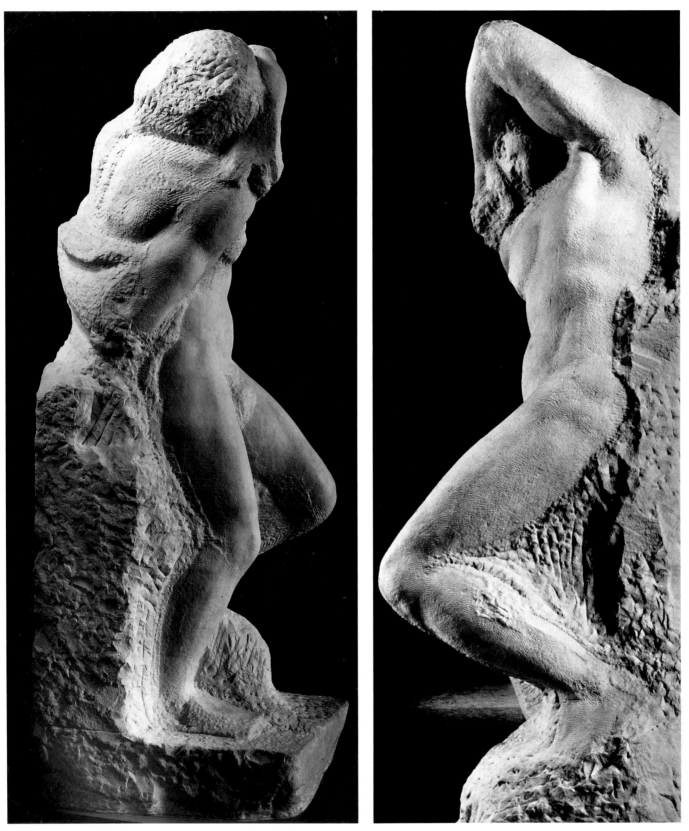

213–214. FIRST CAPTIVE FROM THE BOBOLI GARDENS: 'THE YOUNG GIANT'. 1530–1533. Florence, Accademia

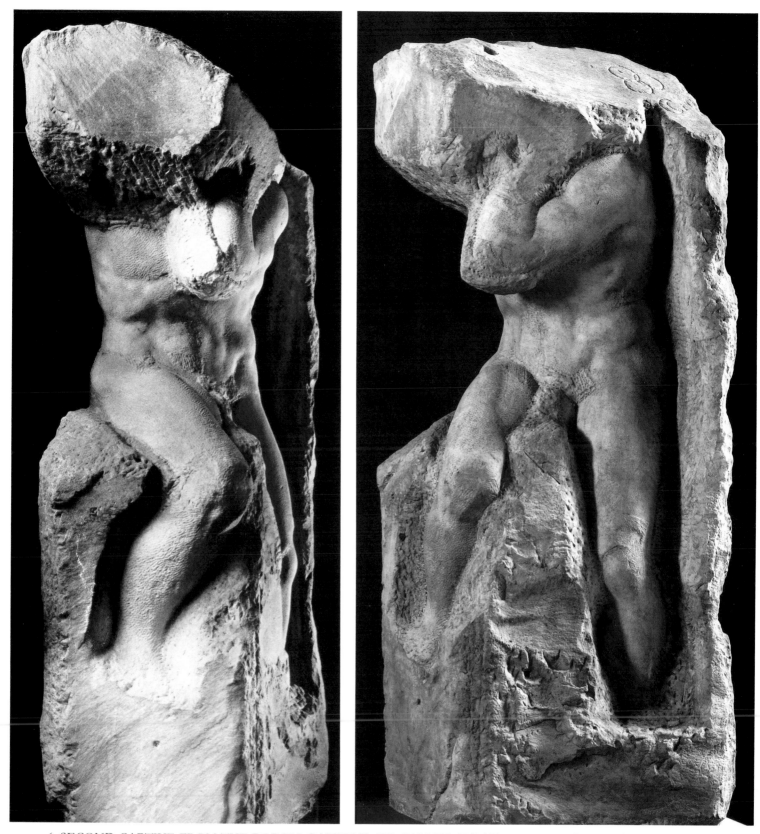

215–216. SECOND CAPTIVE FROM THE BOBOLI GARDENS: 'SO-CALLED ATLAS'. 1530–1533. Florence, Accademia

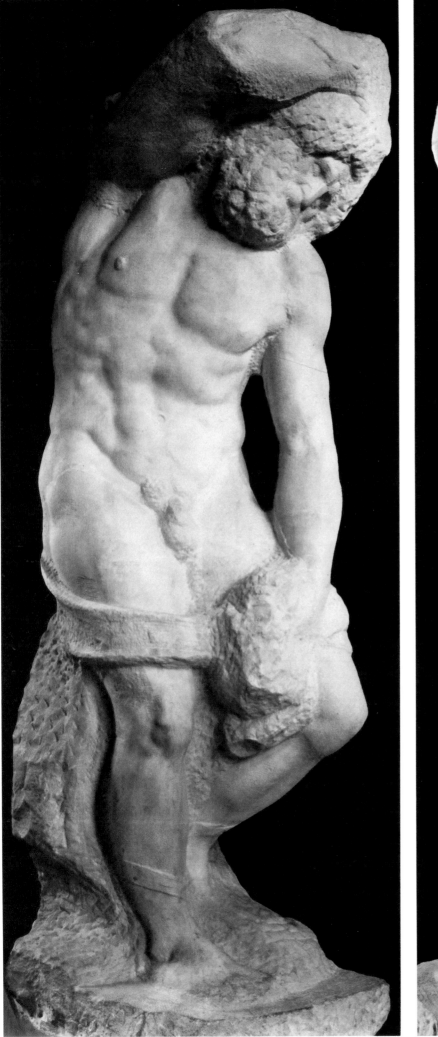
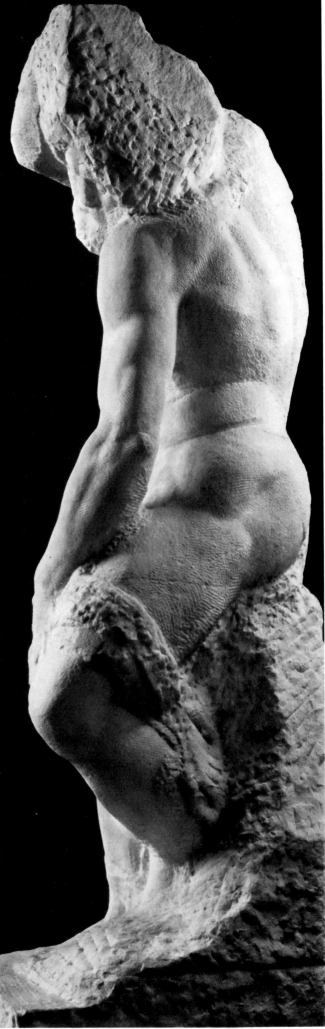

217–218. THIRD CAPTIVE FROM THE BOBOLI GARDENS: 'THE BEARDED GIANT'. 1530–1533. Florence, Accademia

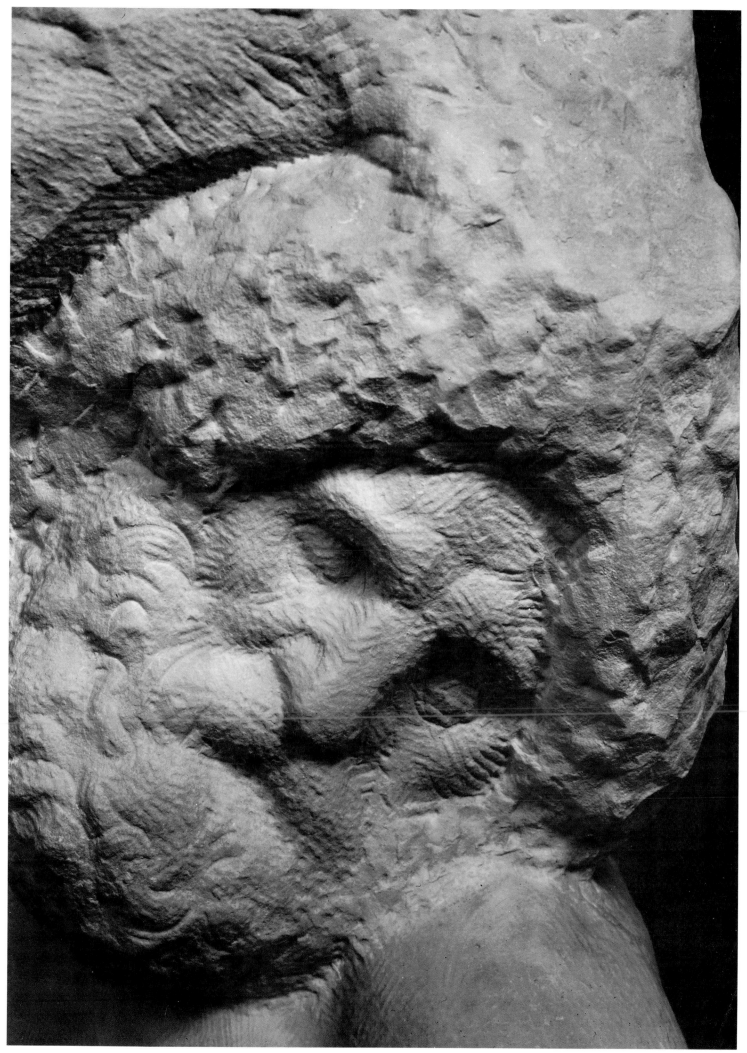

219. HEAD OF THE BEARDED GIANT. Detail of Plate 217

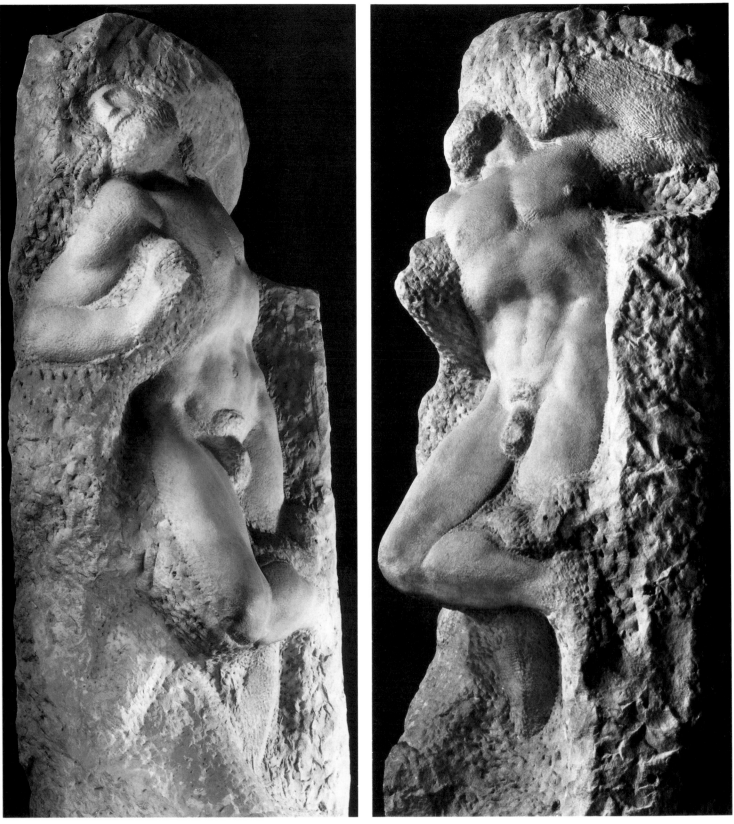

220–221. FOURTH CAPTIVE FROM THE BOBOLI GARDENS: 'THE AWAKENING GIANT'. 1530–1533. Florence, Accademia

222. CLAY MODEL FOR A GIANT. About 1530.
Florence, Casa Buonarroti

223. CLAY MODEL FOR A GIANT. About 1530.
London, British Museum

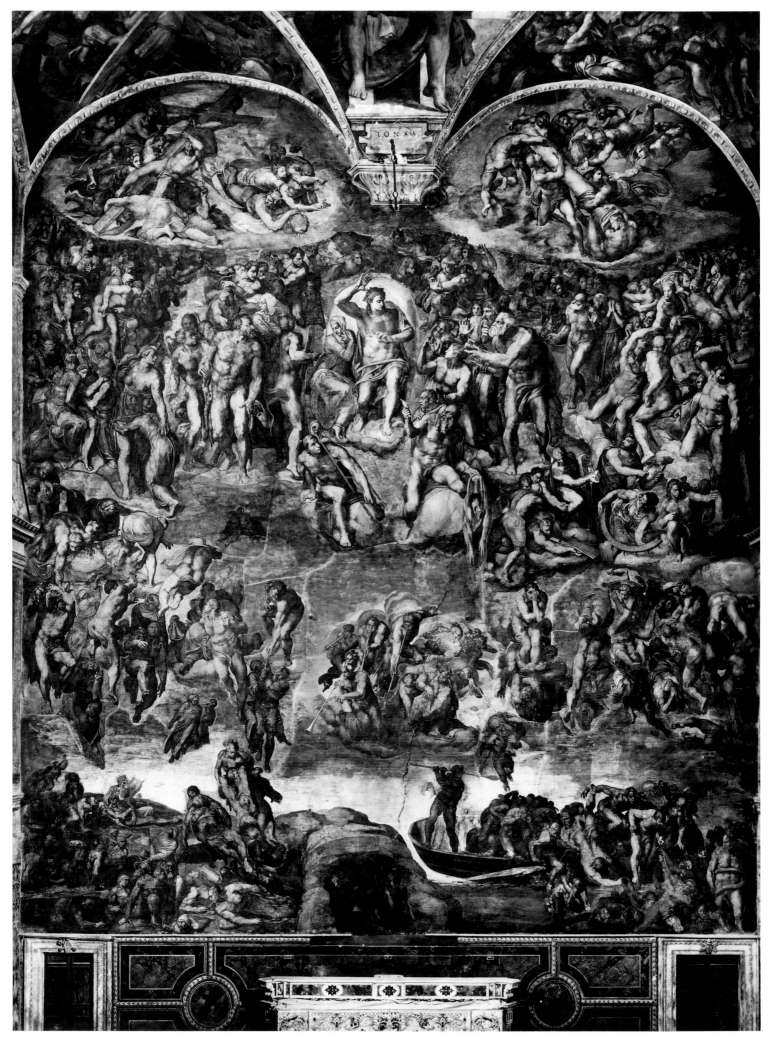

224. THE LAST JUDGEMENT. 1536–1541. Rome, Sistine Chapel

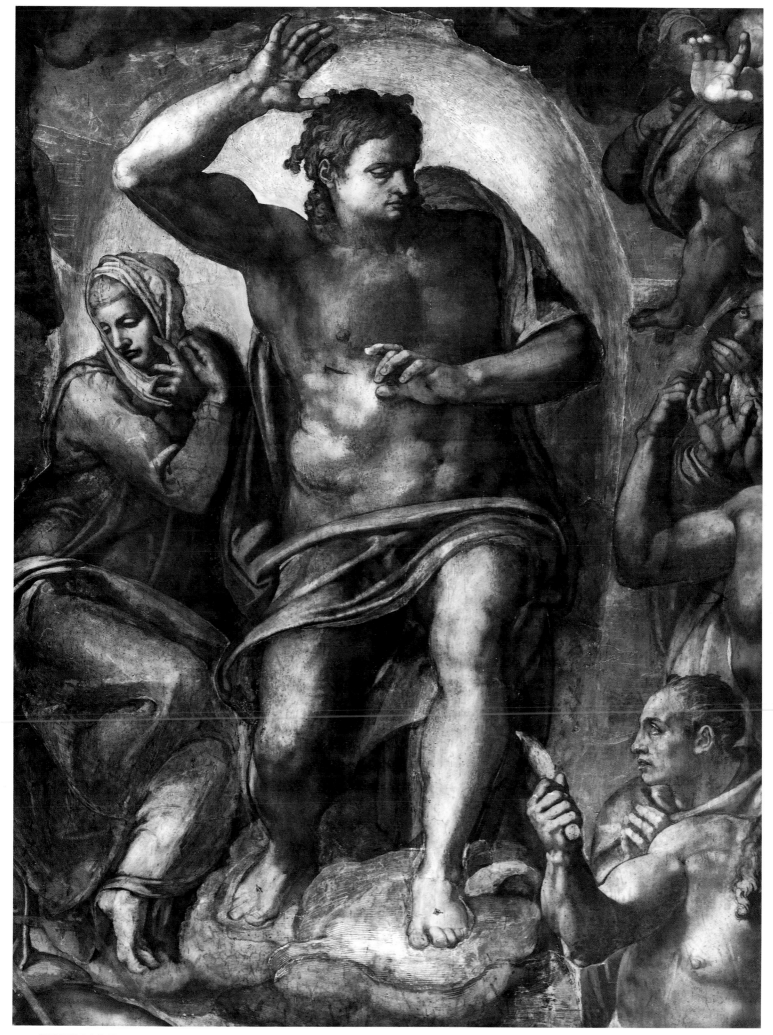

225. CHRIST AS JUDGE AND THE HOLY VIRGIN. Detail of Plate 224

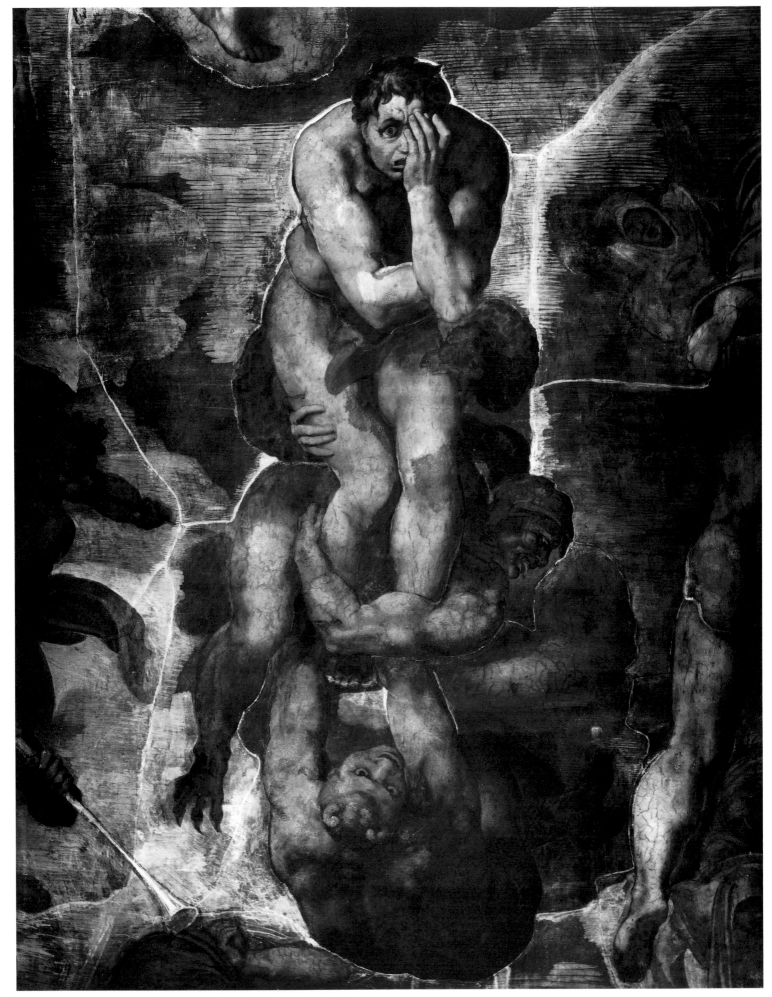

226. FALL OF THE DAMNED. Detail of Plate 224

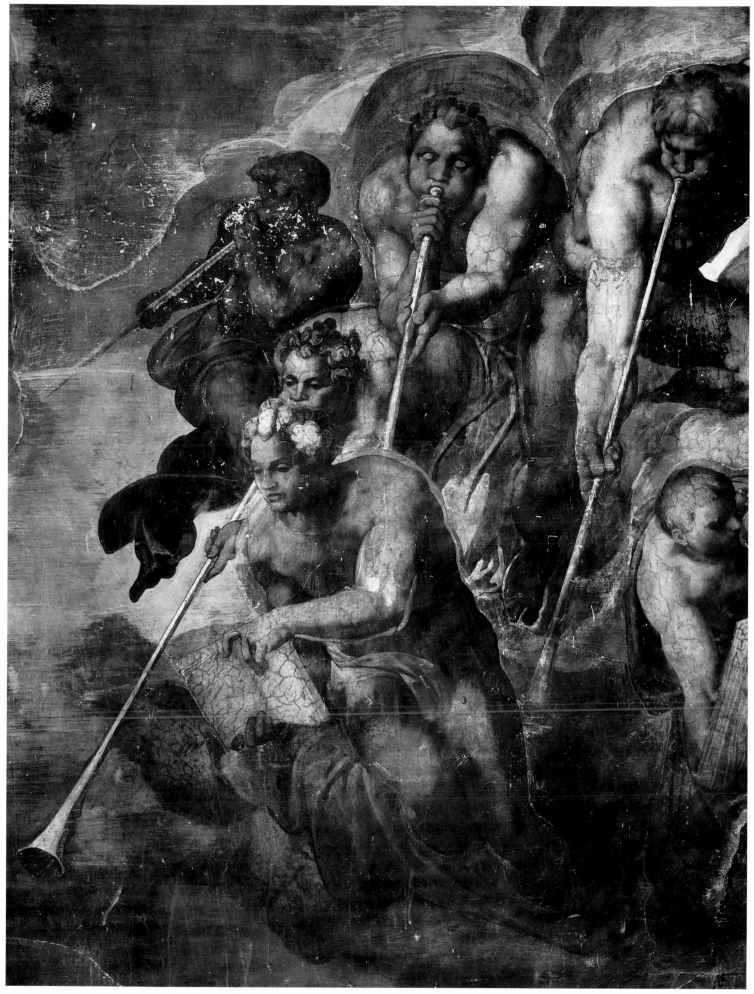

227. ANGELS SOUNDING THE TRUMPETS OF DOOM. Detail of Plate 224

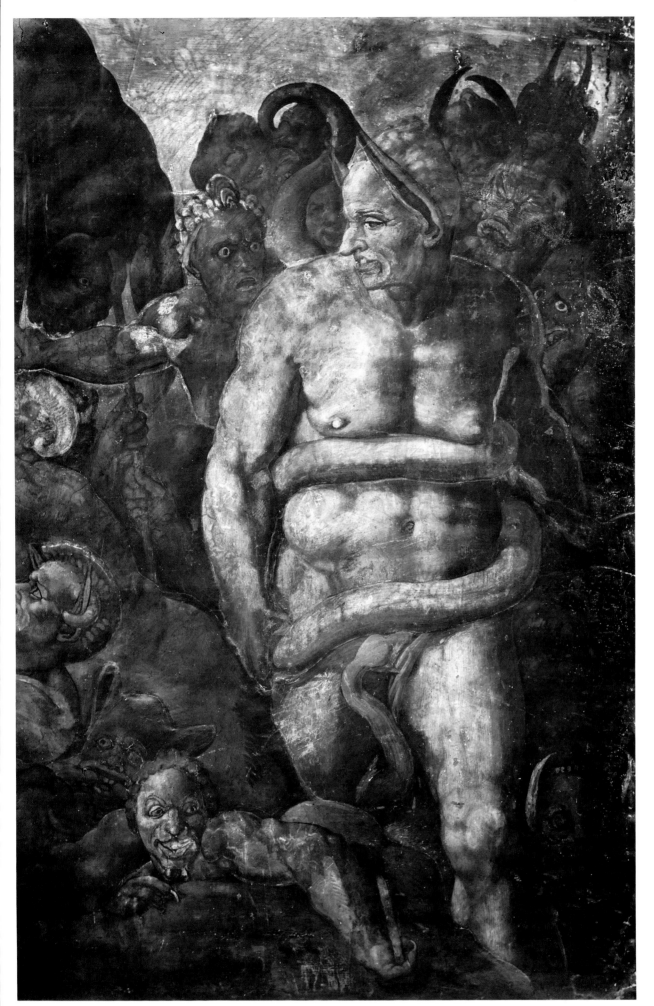

228. MINOS, PRINCE OF HELL (Portrait of the Master of Ceremonies, Biagio da Cesena). Detail of Plate 224

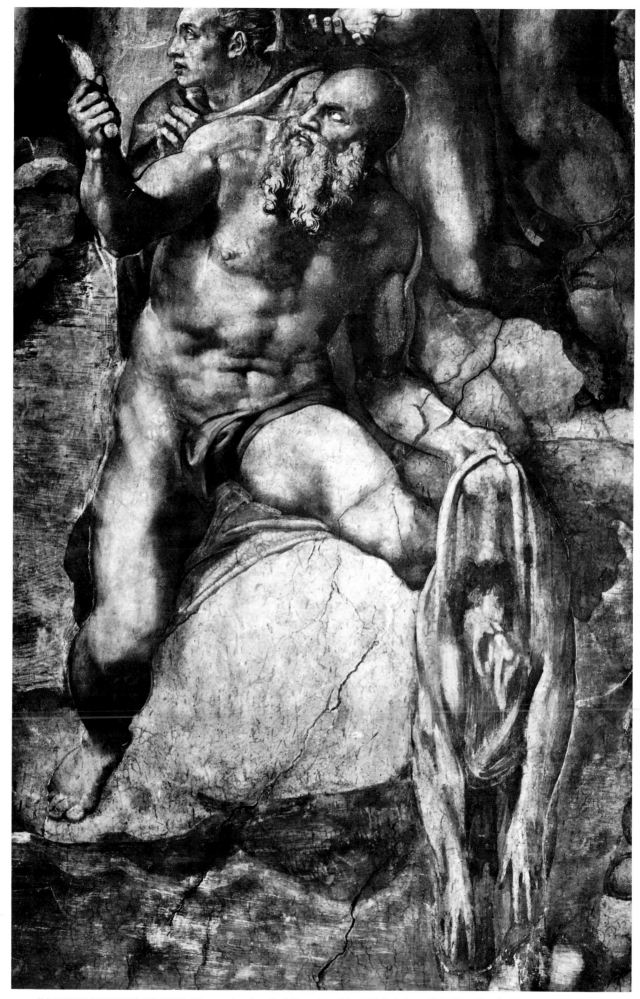

229. SAINT BARTHOLOMEW (Pietro Aretino holding the skin of Michelangelo). Detail of Plate 224

230. MICHELANGELO'S SELF-PORTRAIT. Detail of Plate 229

231. ASCENDING FIGURE. Detail of Plate 224

232. A DEVIL. Detail of Plate 224

233. DEATH. Detail of Plate 224

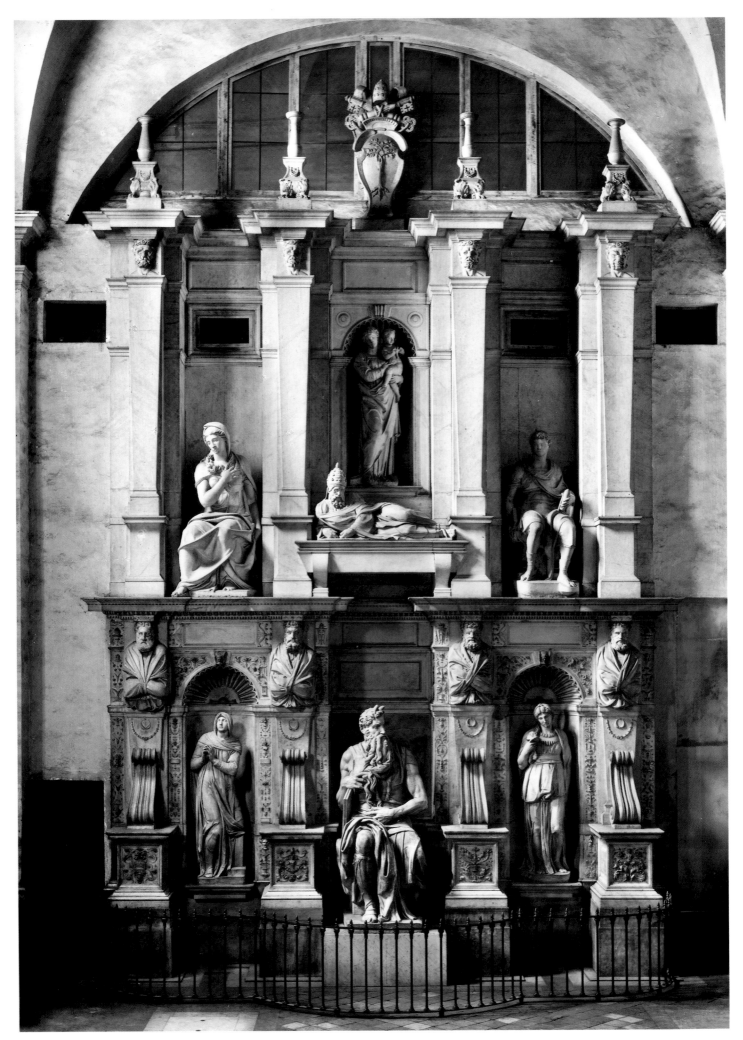

234. THE TOMB OF POPE JULIUS II. 1505–1545. By Michelangelo: Moses (see Plate 141), Rachel and Leah.
By Montelupo: Madonna, Prophet and Sibyl. By Boscoli: The Figure of the Pope. Rome, San Pietro in Vincoli

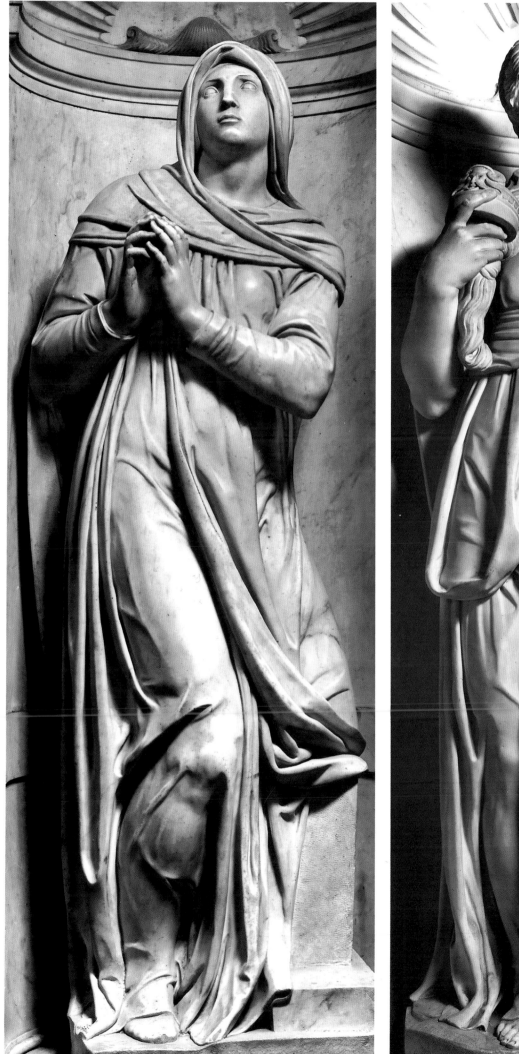
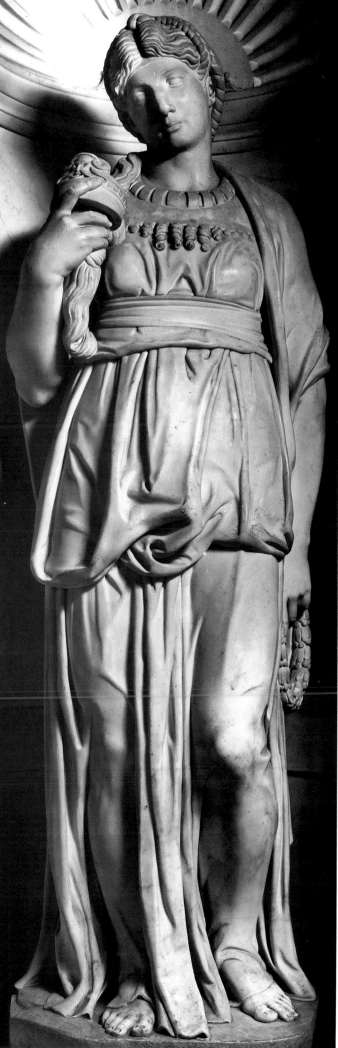

235–236. RACHEL AND LEAH: Vita contemplativa and Vita activa. 1542. Detail of Plate 234

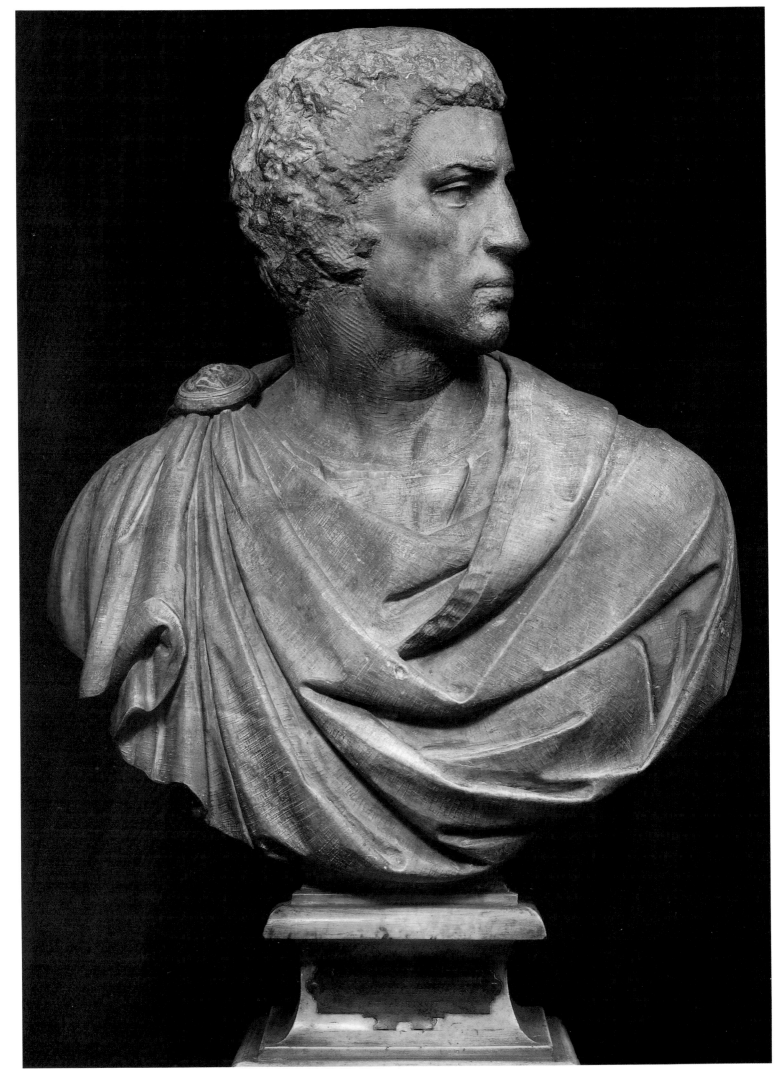

237. BRUTUS. About 1542. Florence, Museo Nazionale del Bargello

238. BRUTUS. Detail of Plate 237

239. THE CONVERSION OF SAINT PAUL. Fresco, 1542–1545. Vatican, Cappella Paolina

240. THE CRUCIFIXION OF SAINT PETER. Fresco, 1546–1550. Vatican, Cappella Paolina

241. THE CONVERSION OF SAINT PAUL. Detail of Plate 239

242. LANDSCAPE FROM 'THE CONVERSION OF SAINT PAUL'. Detail of Plate 239

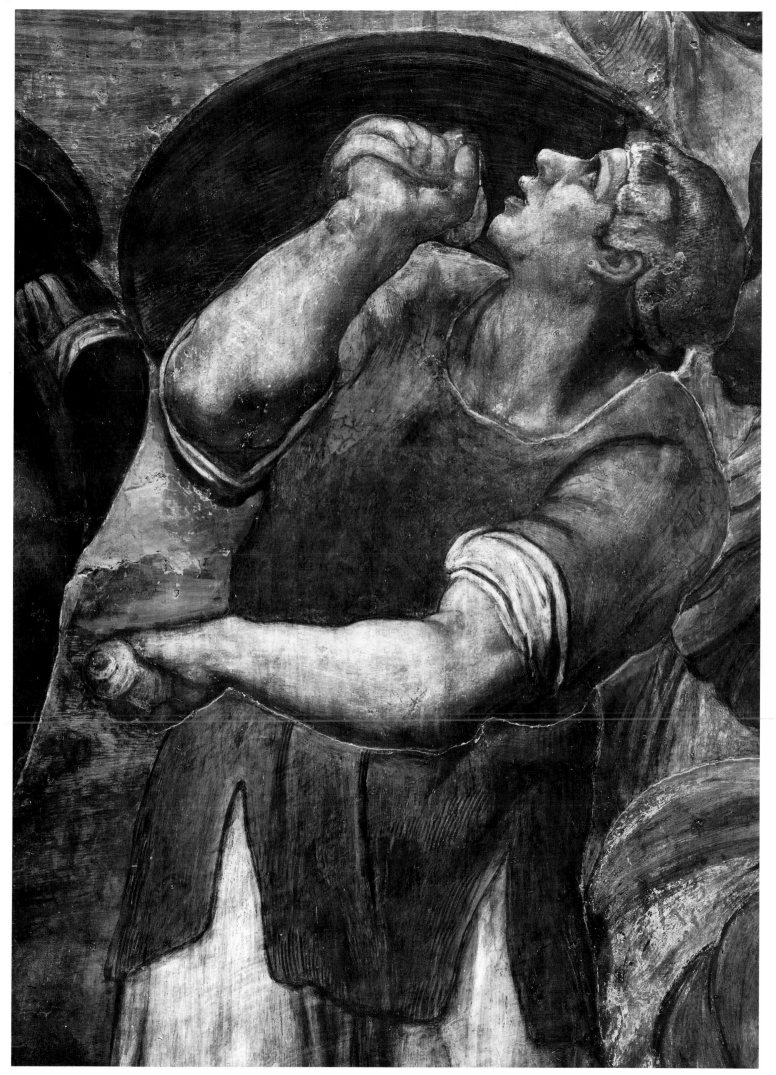

243. THE CONVERSION OF SAINT PAUL. Detail of Plate 239

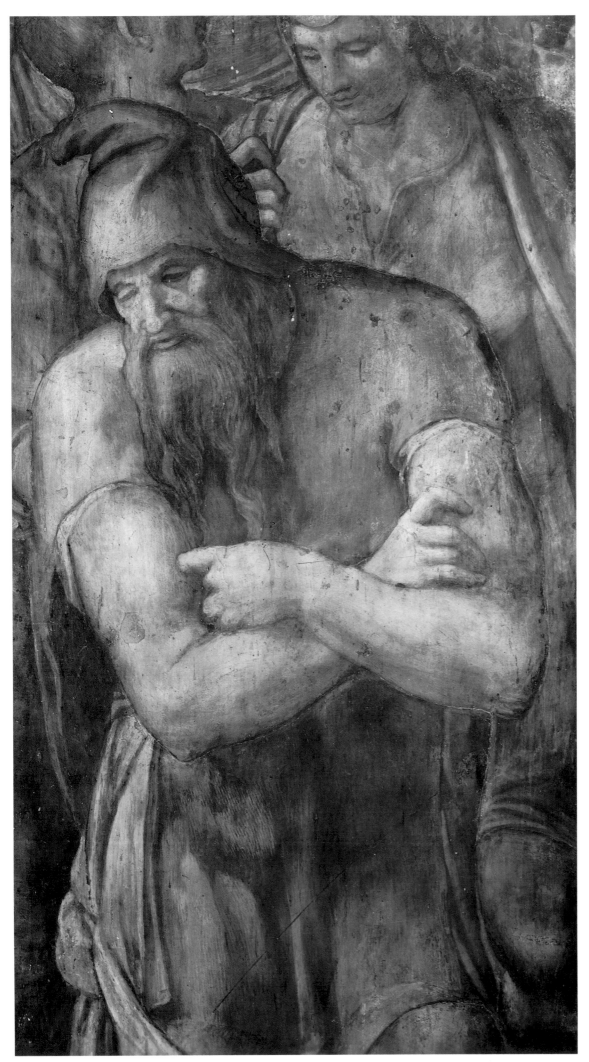

244. THE CRUCIFIXION OF SAINT PETER. Detail of Plate 240

245. THE CRUCIFIXION OF SAINT PETER. Detail of Plate 240

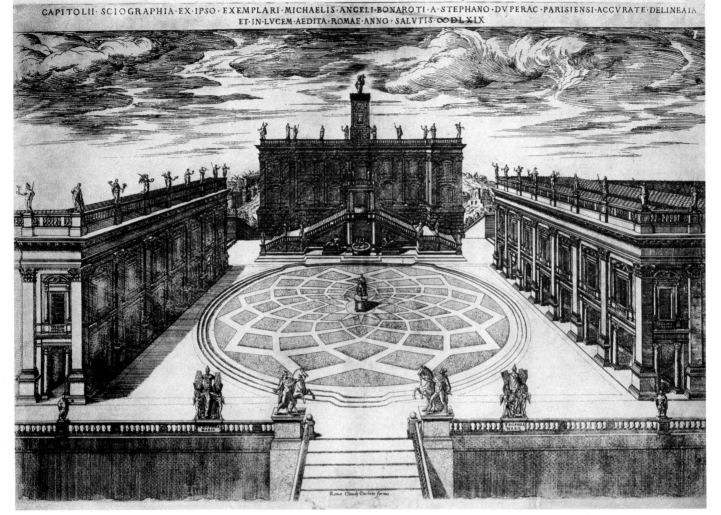

246. MICHELANGELO'S PLAN FOR THE PIAZZA OF THE CAPITOL IN ROME. 1546. Etching by Etienne du Pérac (1569)

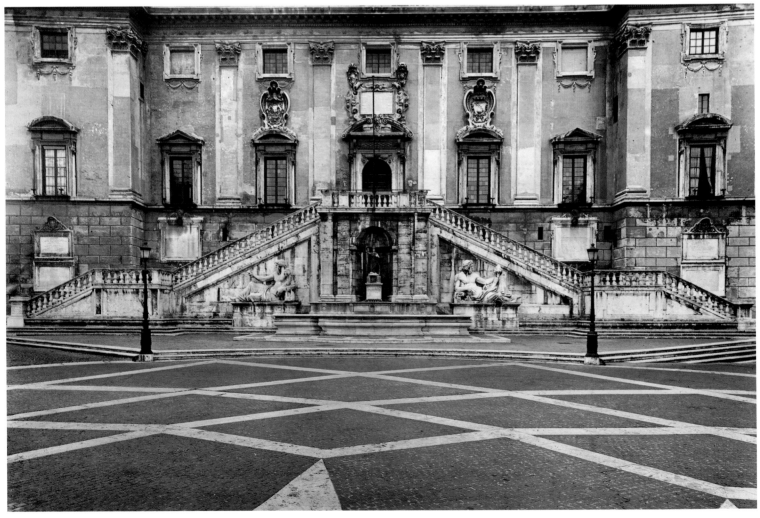

247. THE OUTSIDE STEPS OF THE PALAZZO SENATORIO. Designed by Michelangelo, 1544–1552

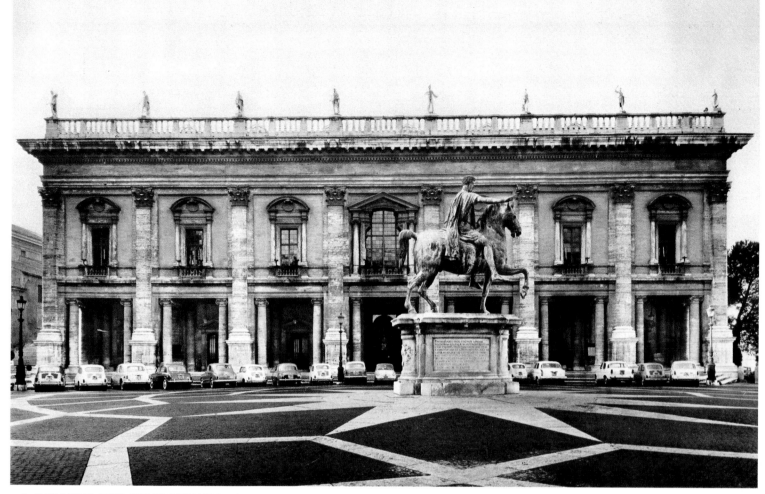

248. PALAZZO DEI CONSERVATORI, ROME. Planned by Michelangelo in 1546, finished after his death

249. TWO VIEWS OF THE B`SE FOR THE MARCUS AURELIUS STATUE.
(Michelangelo designed this base for the antique equestrian statue about 1539)

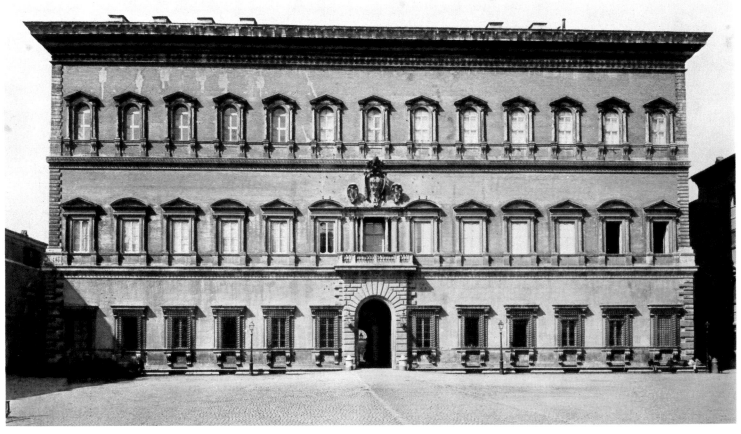

250. PALAZZO FARNESE, ROME. Begun by Antonio da Sangallo the Younger, and continued after his death (1546) by Michelangelo, who designed the large window over the door, the windows of the upper storey and the cornice

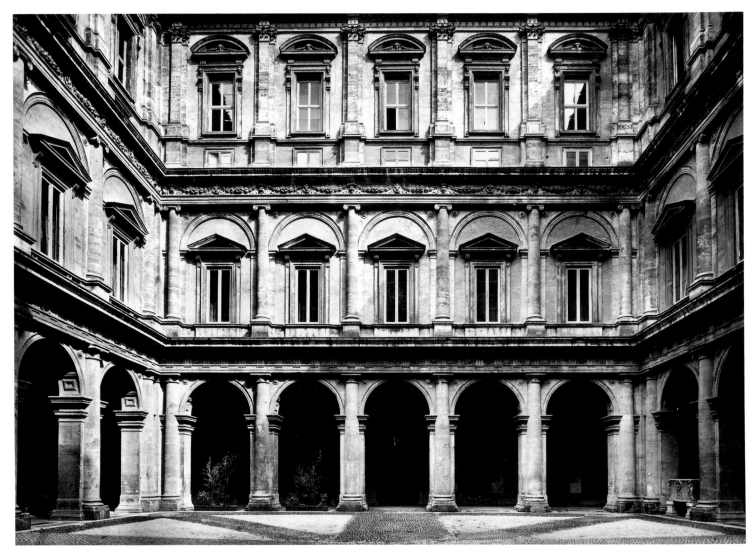

251. THE COURTYARD OF THE PALAZZO FARNESE, from designs by Antonio da Sangallo the Younger.
The upper storey designed by Michelangelo, about 1547–1550

252. CORNICE OF THE PALAZZO FARNESE. Designed by Michelangelo, 1547

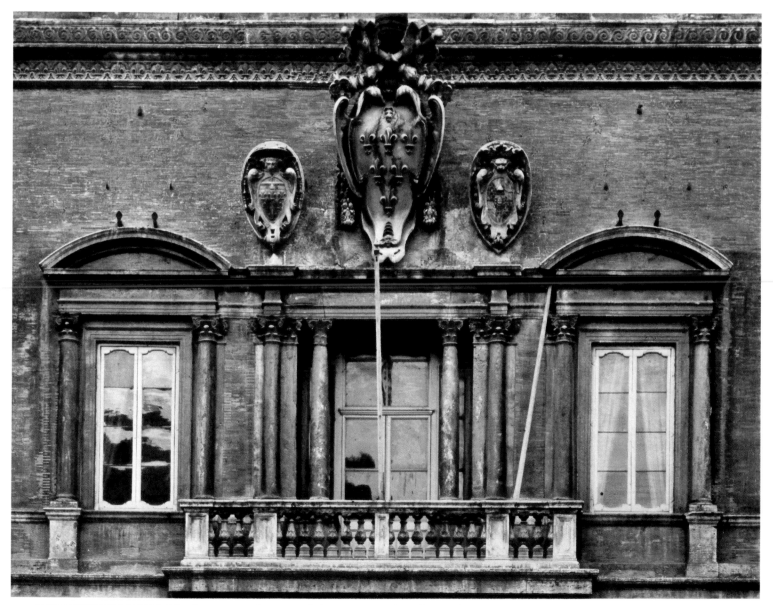

253. PALAZZO FARNESE. The large coat-of-arms and the centre window designed by Michelangelo, about 1550

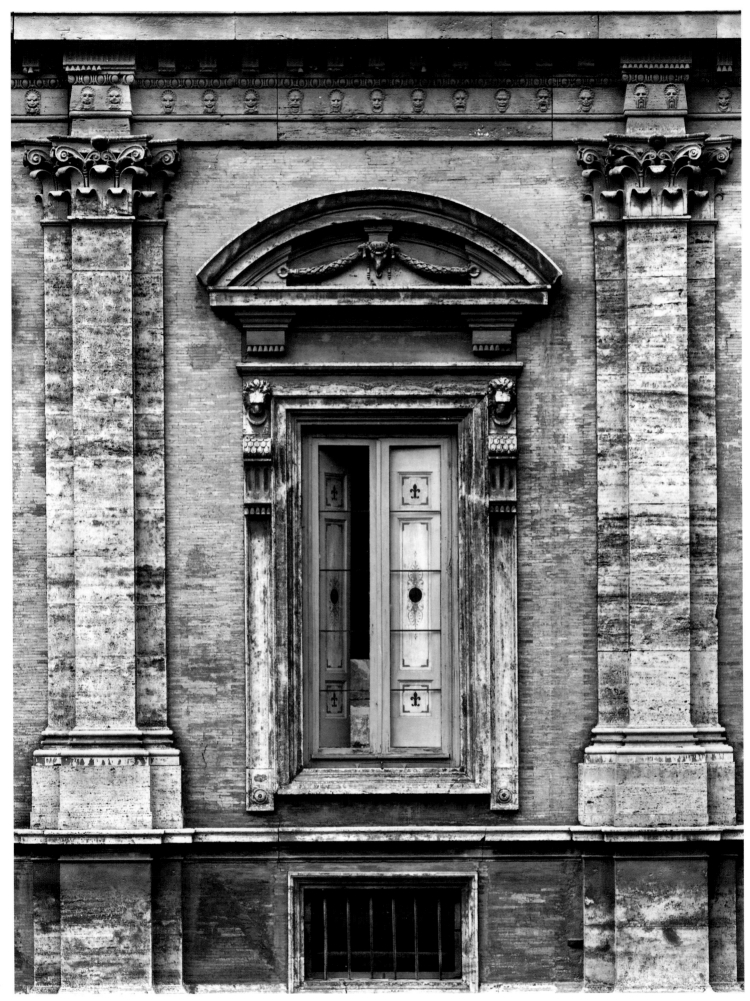

254. PALAZZO FARNESE. Window in the upper storey of the courtyard. About 1550

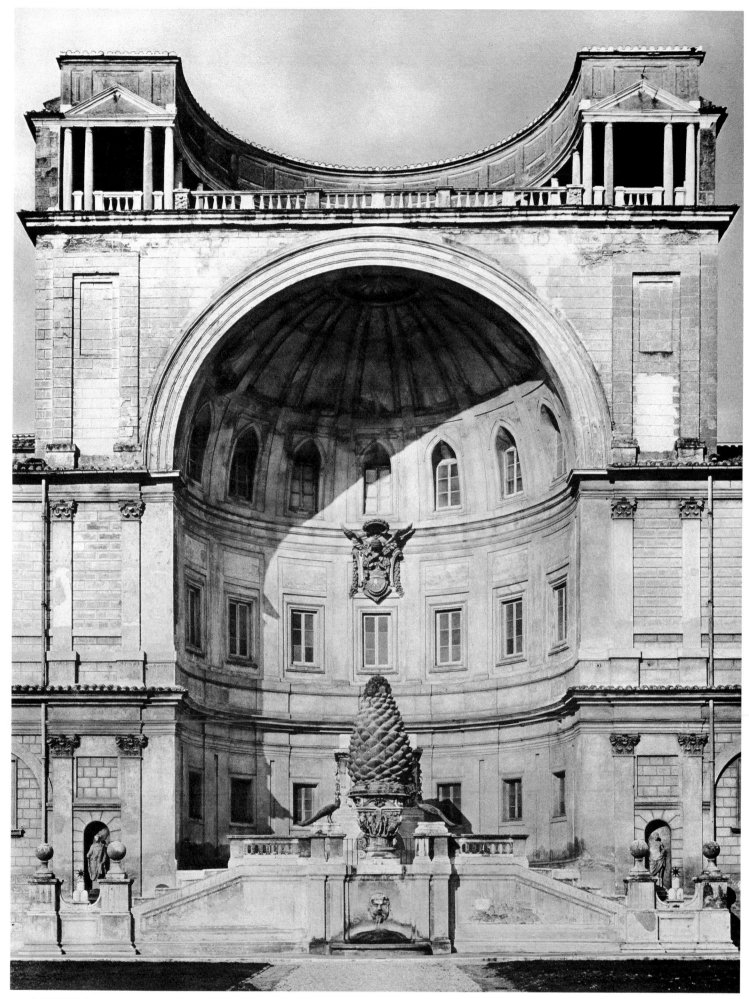

255. NICCHIONE DEL BELVEDERE. (The stairway designed 1550–1551)

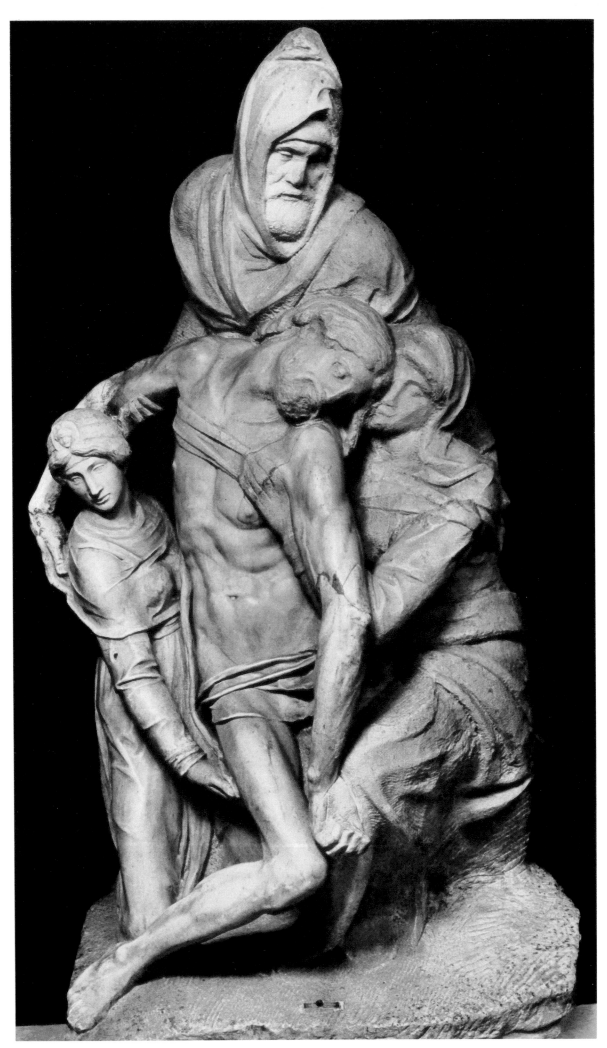

256. PIETÀ. About 1548–1556. Florence, Duomo

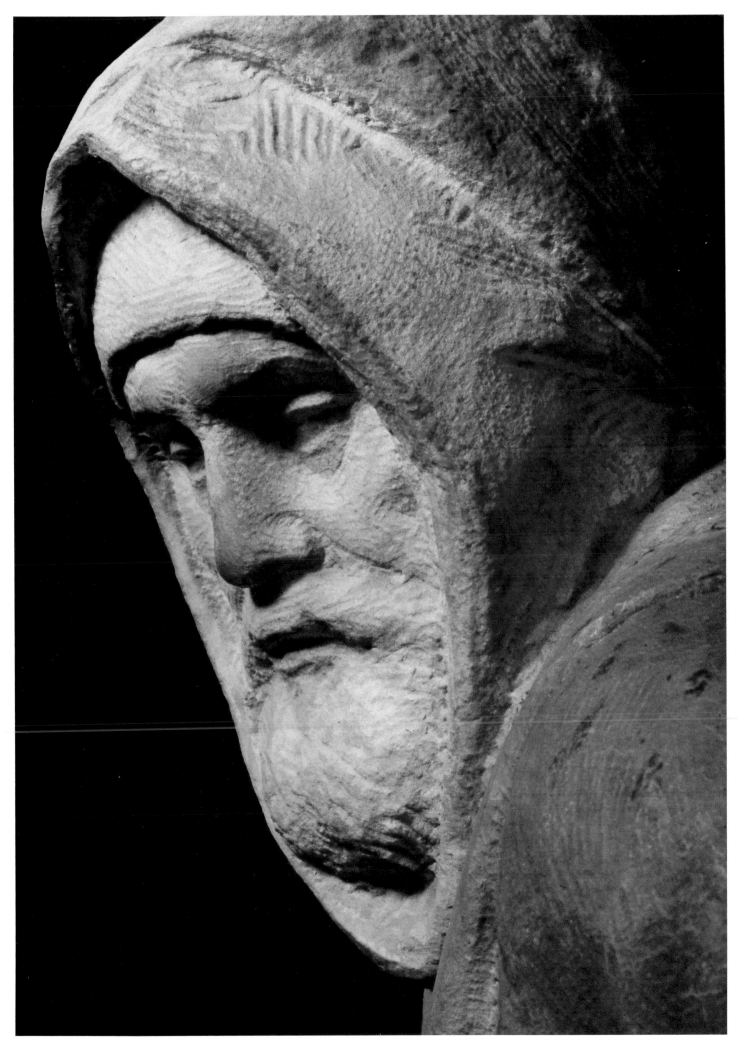

257. MICHELANGELO'S SELF-PORTRAIT AT THE AGE OF ABOUT EIGHTY. Detail of Plate 256

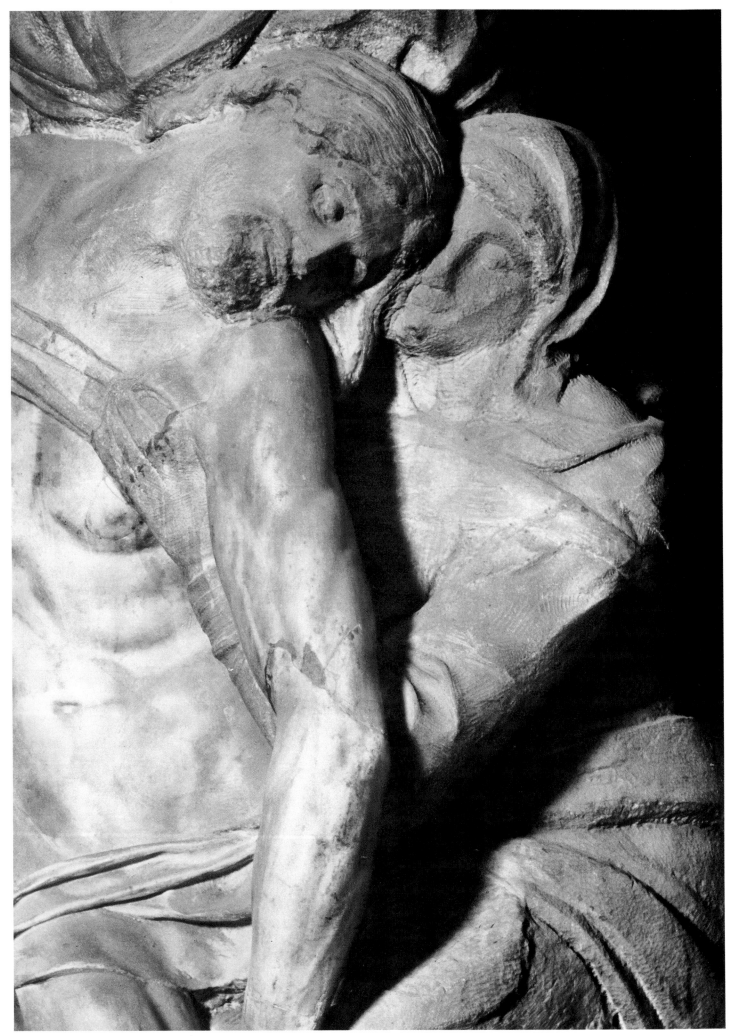

258. THE FLORENTINE PIETÀ. Detail of Plate 256

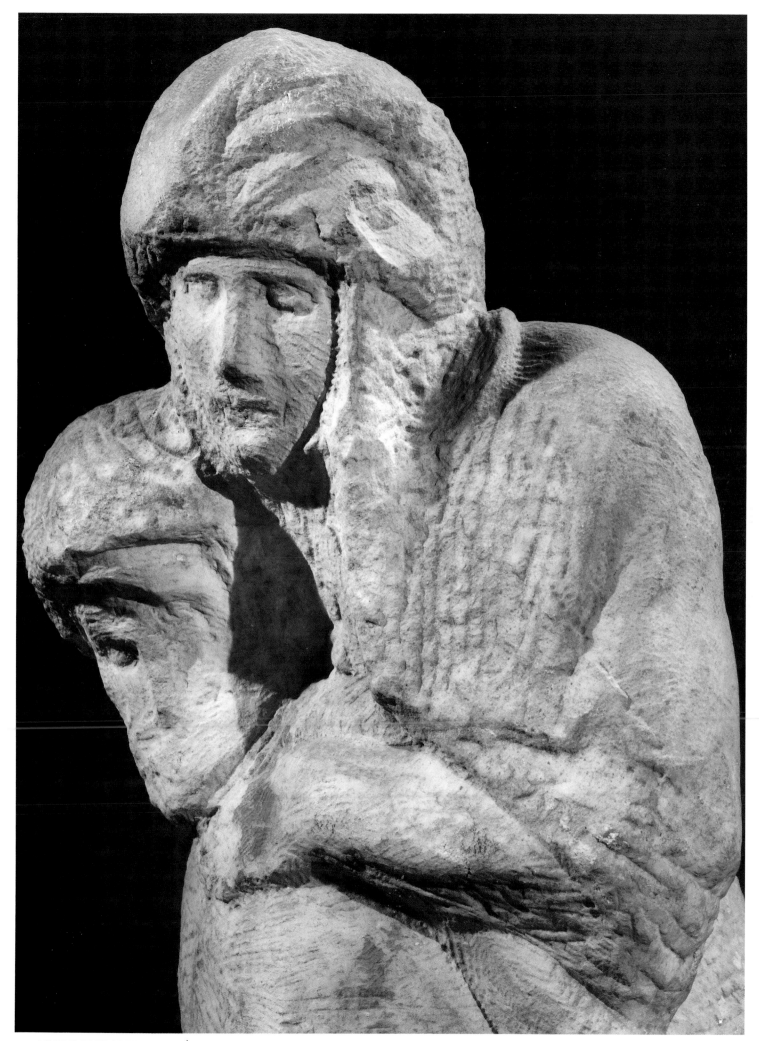

259. THE RONDANINI PIETÀ. 1556–1564. Detail of Plate 261

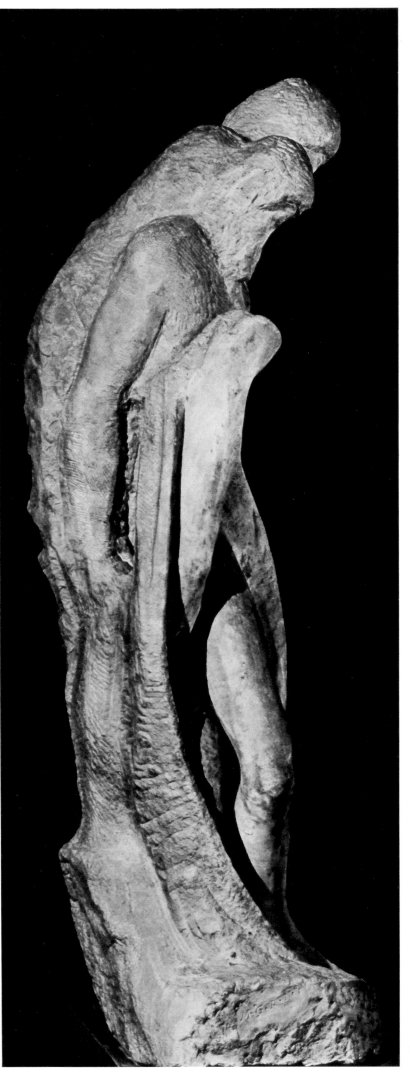

260. THE RONDANINI PIETÀ. 1556–1564.
Milan, Castello Sforzesco

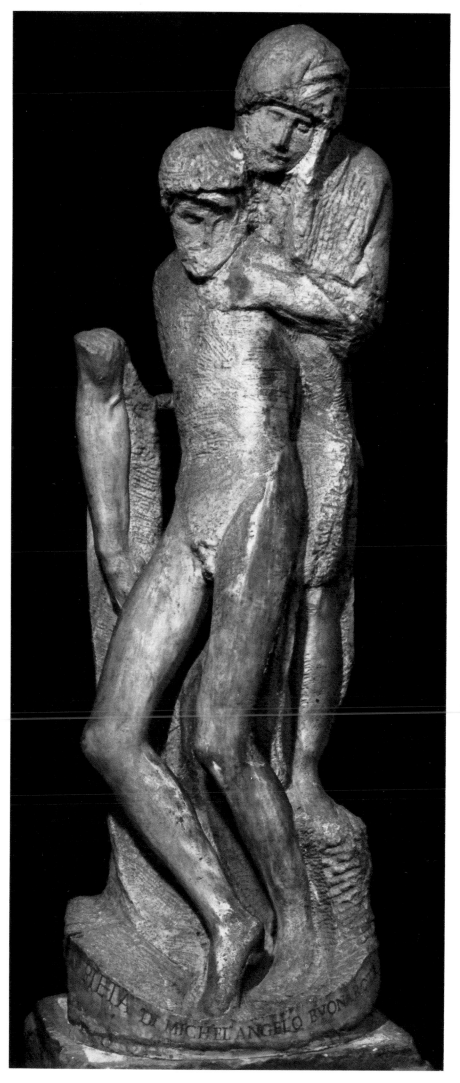

261. THE RONDANINI PIETÀ. 1556–1564.
Milan, Castello Sforzesco

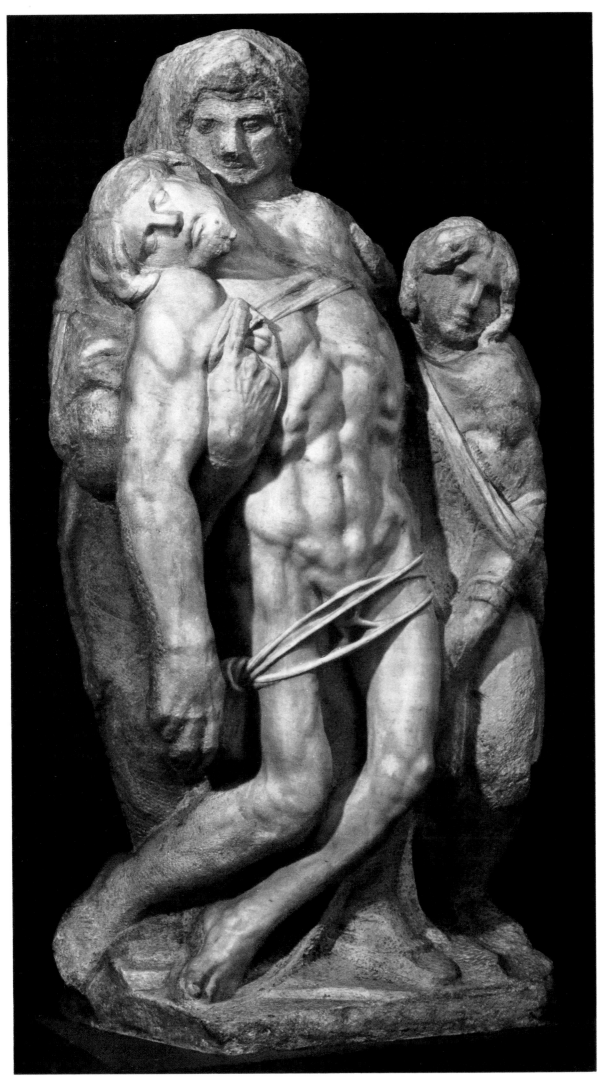

262. THE PALESTRINA PIETÀ. By Michelangelo and a follower. About 1556. Florence, Accademia

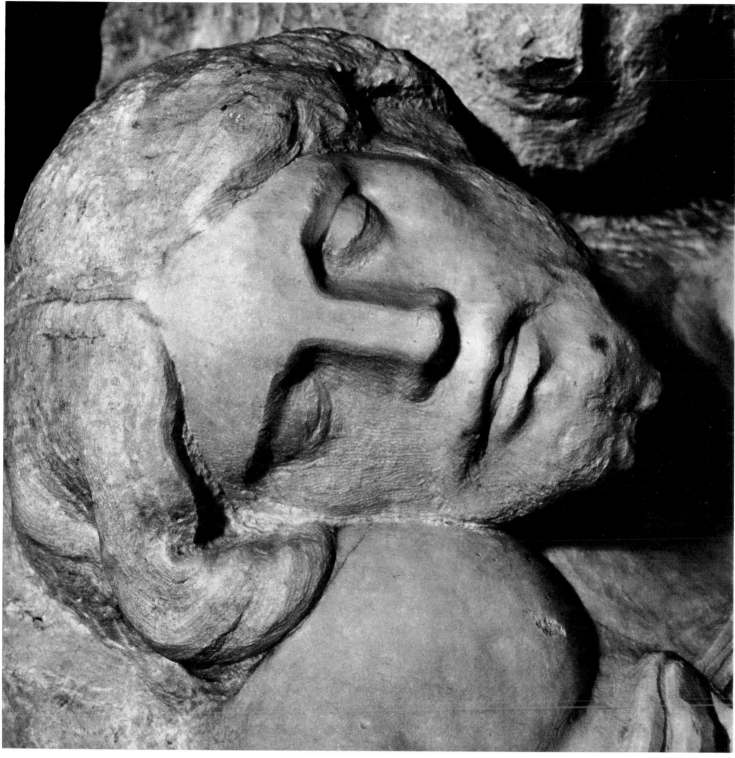

263. THE HEAD OF CHRIST. Detail of Plate 262

264. PORTA PIA, ROME. After Michelangelo's design, 1561–1564.
(The coat-of-arms of Pius IV by Jacomo del Duca, 1562; the centre top-piece added in 1853)

265. PORTA PIA, ROME. Detail of Plate 264

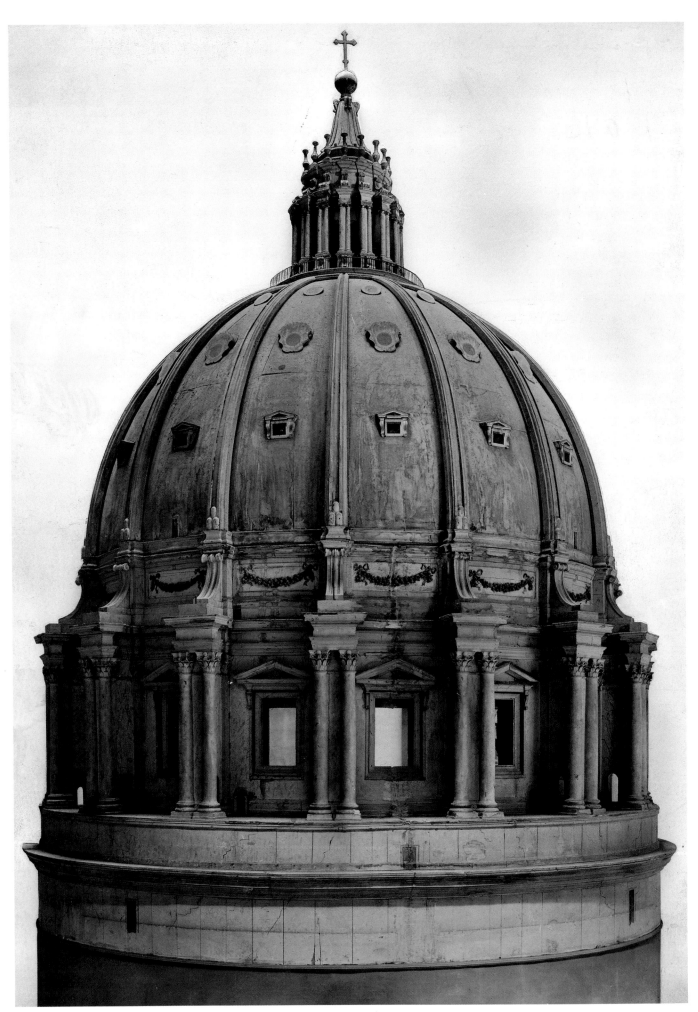

266. WOODEN MODEL FOR THE CUPOLA OF ST PETER'S. 1558–1561. Rome, Museo Petriano (cf. Plate XIX)
(The hemispherical dome, planned by Michelangelo, was altered and elevated by Giacomo della Porta)

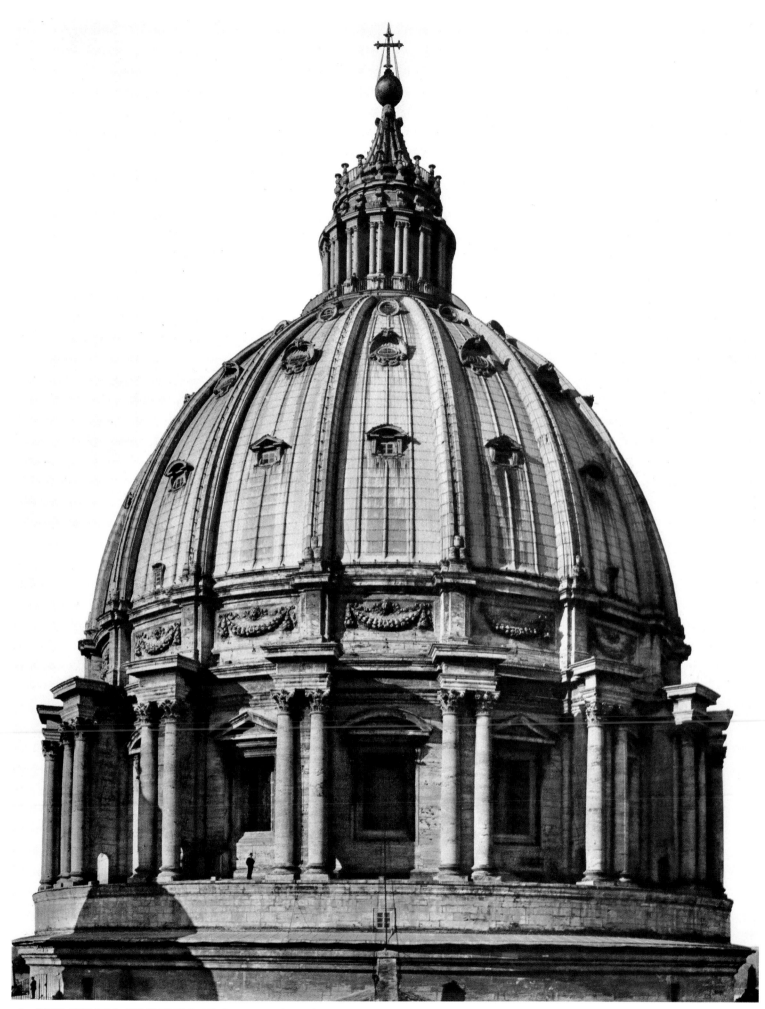

267. THE CUPOLA OF ST PETER'S, ROME. (Planned by Michelangelo, built after the master's death by Giacomo della Porta and other architects)

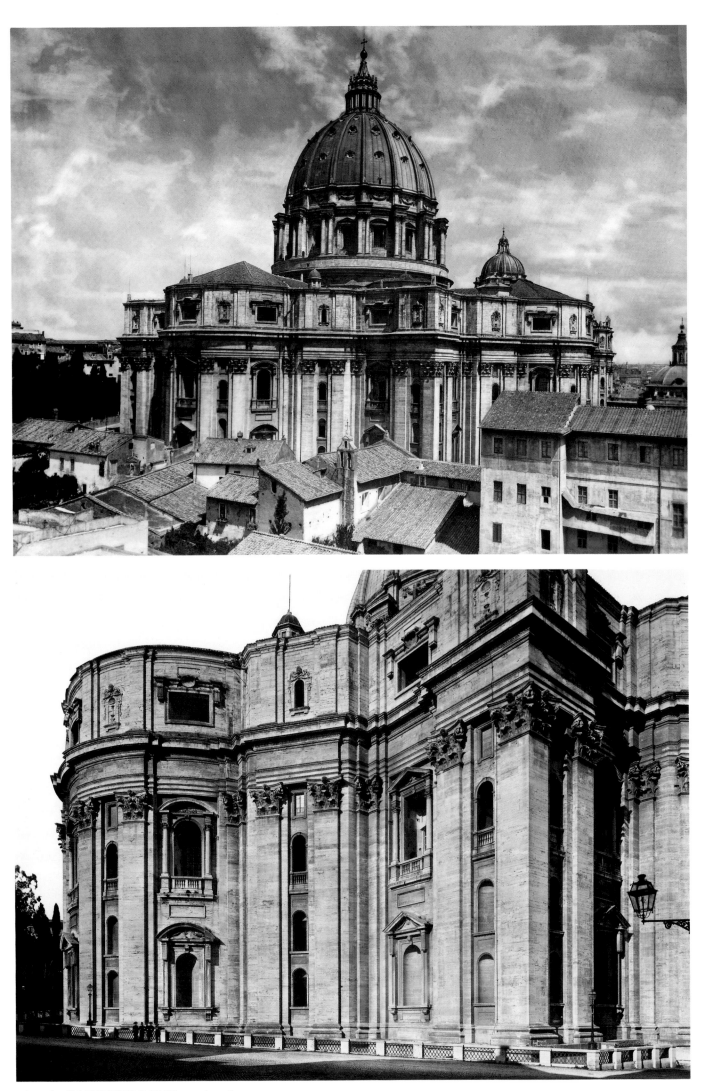

268–269. ST PETER'S ROME. 1546–1564

270. ST PETER'S, ROME. Detail of the southern apse

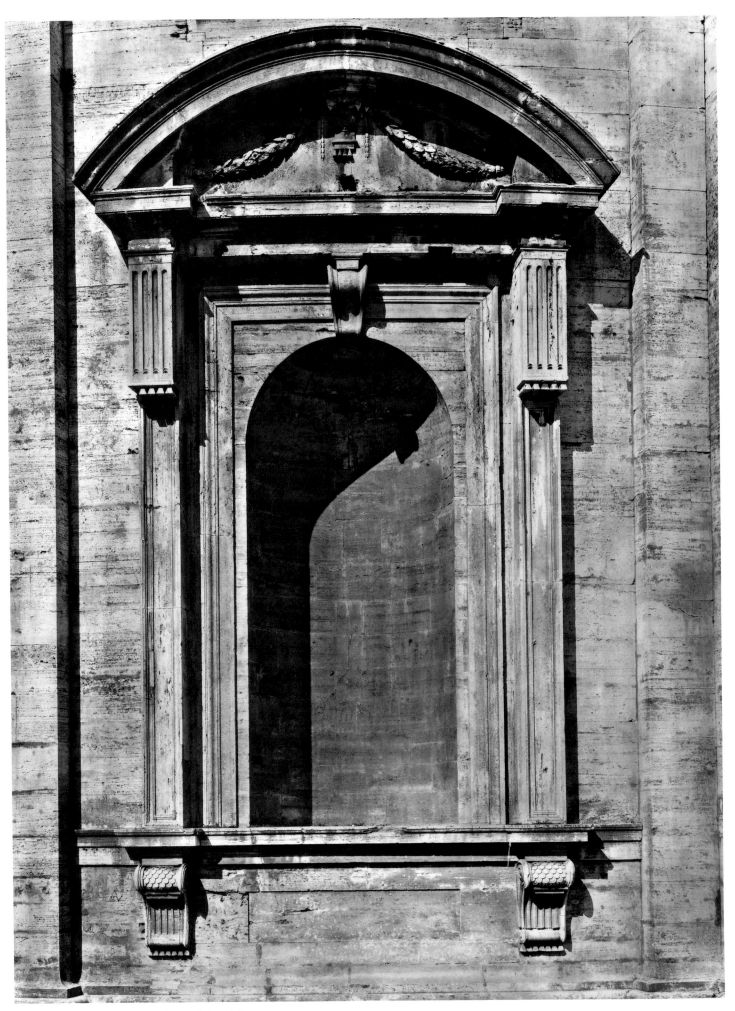

271. ST PETER'S, ROME. One of the niches

272. ST PETER'S, ROME. One of the capitals

273. THE PAPAL INSIGNIA. Detail of Plate 270

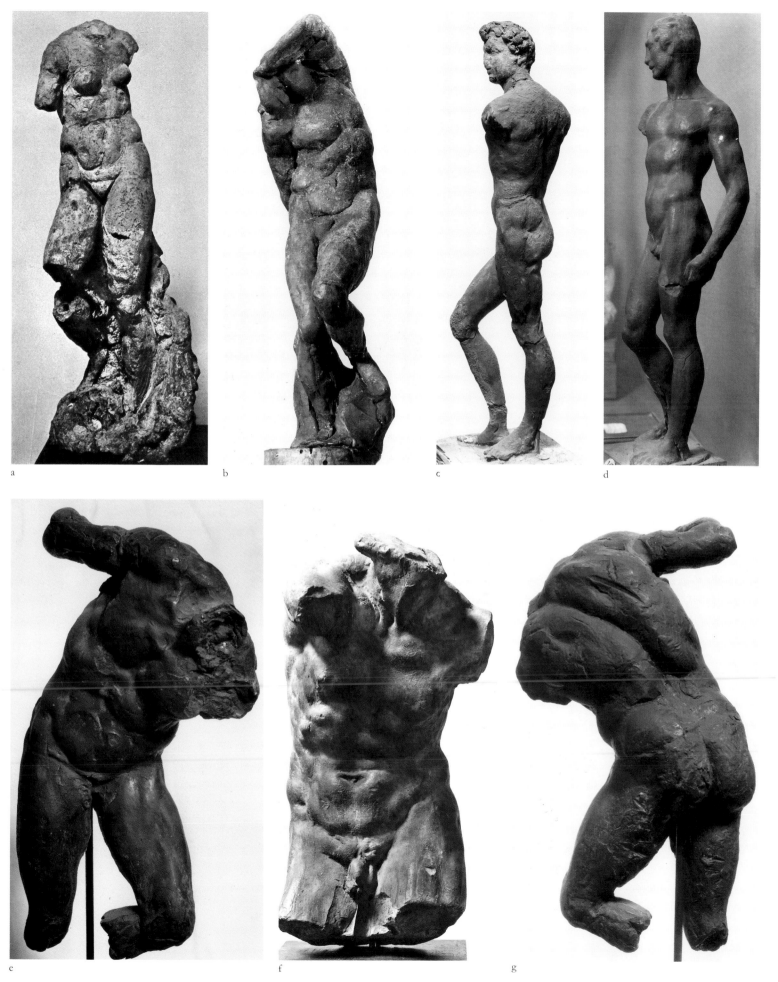

a b c d

e f g

PLATE I. *Models in clay and wax, all probably for the Julius monument.* (a) Female statuette for a Victory group, clay. Casa Buonarroti. (b) Dark-red wax sketch for the 'Young Giant' (Plate 212). London, Victoria and Albert Museum. (c) Light wax sketch for a Captive. Casa Buonarroti. (d) Dark brown-red wax sketch for a Captive. Casa Buonarroti. (e) and (g) Front and back views of a wax sketch for a 'Giant'. Casa Buonarroti. (f) Clay sketch for a 'Giant'. Casa Buonarroti.

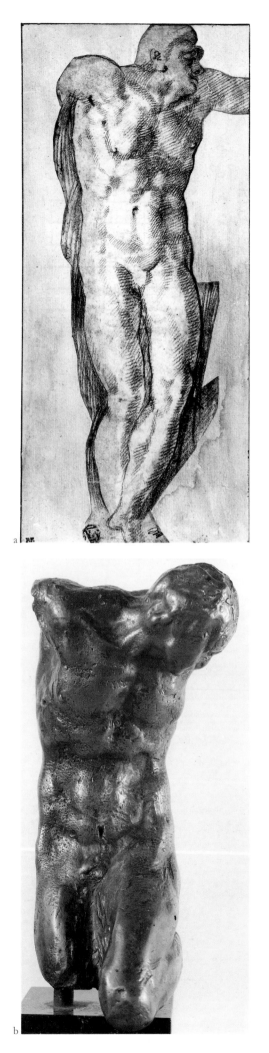

PLATE II. *After Lost Models*. (a) Thief on the Cross (drawing by Granacci after a Michelangelo model). Louvre. (b) Thief on the Cross, bronze cast from a wax model by Michelangelo. Berlin. (c) Drawing by Tintoretto after a lost model of Giuliano de' Medici by Michelangelo. Oxford, Christ Church. (d) Wax statuette of Giuliano de' Medici, by an imitator of Michelangelo, Edinburgh.

b

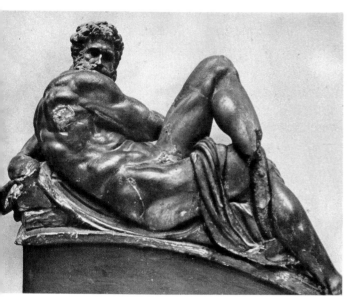

d

f

PLATE III. *The Problem of the Models for the Medici Chapel.* (a) Copy of Michelangelo's 'Notte', stucco, life size, by Vincenzo Danti, 1573. Perugia, Accademia. (b) Bronze copy of a model for the Madonna Medici. Louvre. (c) Terracotta copy by Tribolo of the 'Giorno'. Bargello. (d) Wax sketch for the 'Crepuscolo' by Michelangelo. British Museum. (e) Detail of a drawing by Joseph Heintz, about 1592, after a model by Michelangelo for a 'River God'. Vienna, Albertina. (f) Detail of a drawing by Pierino da Vinci, about 1540, after a model for Michelangelo's 'River God'. London, Victor Koch Collection.

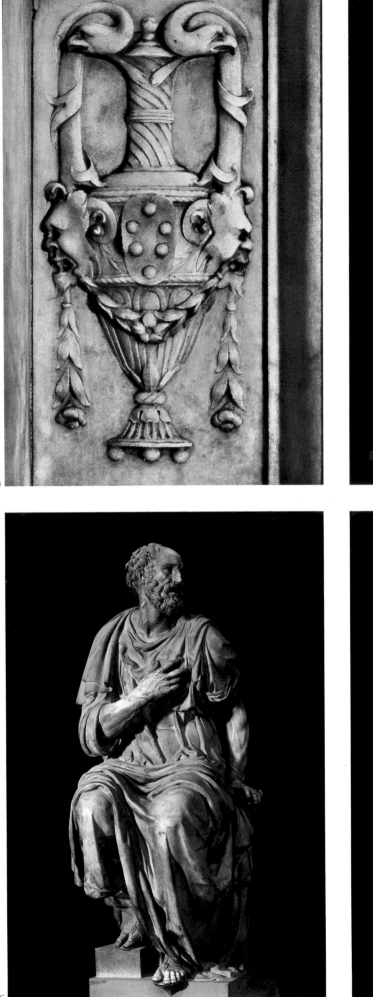

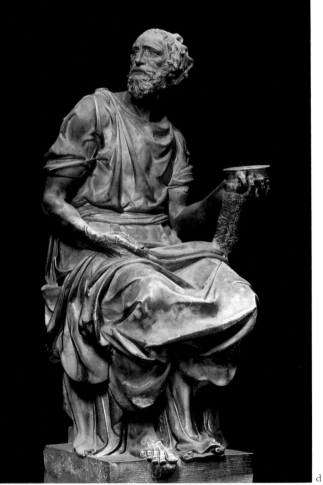

PLATE IV. *Designs and Models for the Medici Chapel.* (a) One of the sixteen marble reliefs with the Medici coat-of-arms. (b) Marble candelabrum in the Medici Chapel. Designed by Michelangelo. (c) St. Cosmas, by Giovanni Montorsoli; and (d) St. Damian, by Raffaello da Montelupo, after models by Michelangelo. Florence, Medici Chapel. See Plate 165.

PLATE V. Terracotta models of 'Notte' and 'Aurora'. (Attributed to Michelangelo by L. Planiscig, E. Sandberg-Vavalà and O.H. Giglioli.) Caracas, Venezuela, Dr. Alejandro Pietri Collection.

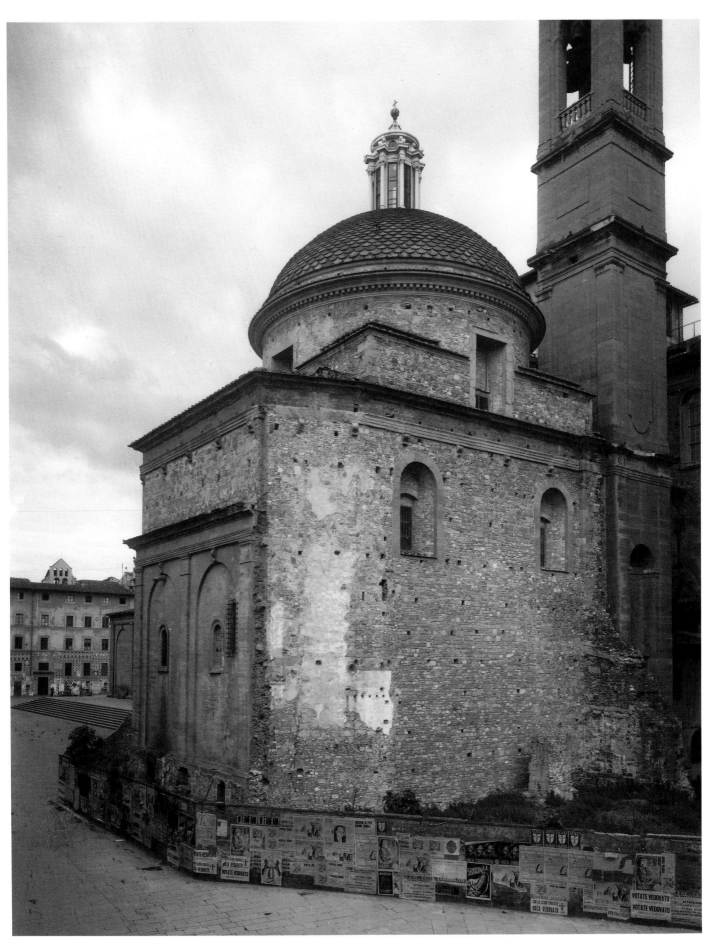

PLATE VI. The Medici Chapel, Florence.

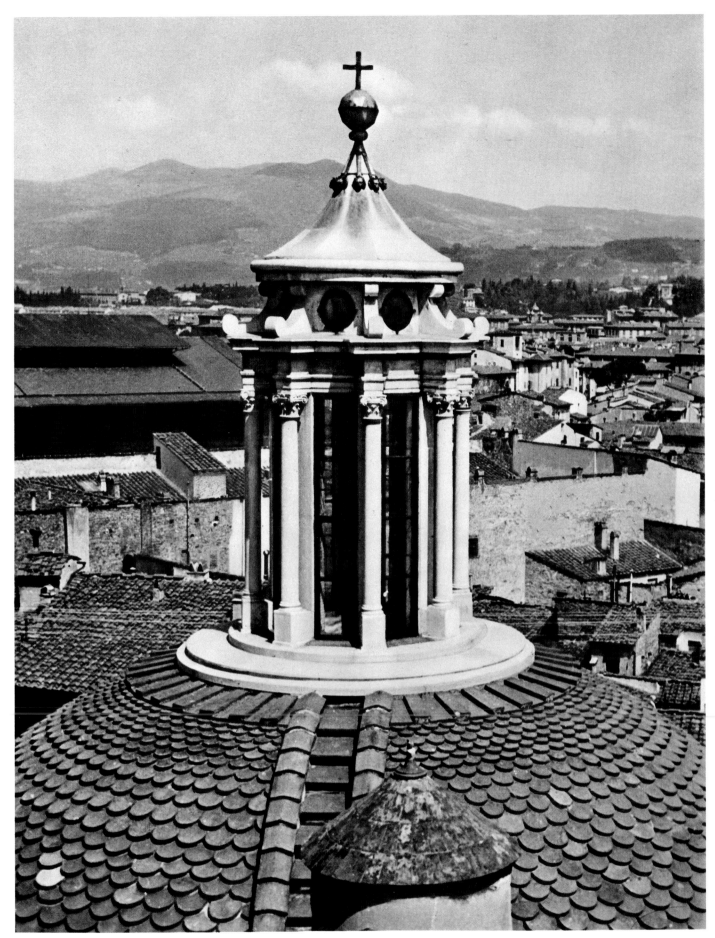

PLATE VII. The Lantern on the Cupola of the Medici Chapel, 1524–1525, designed by Michelangelo.

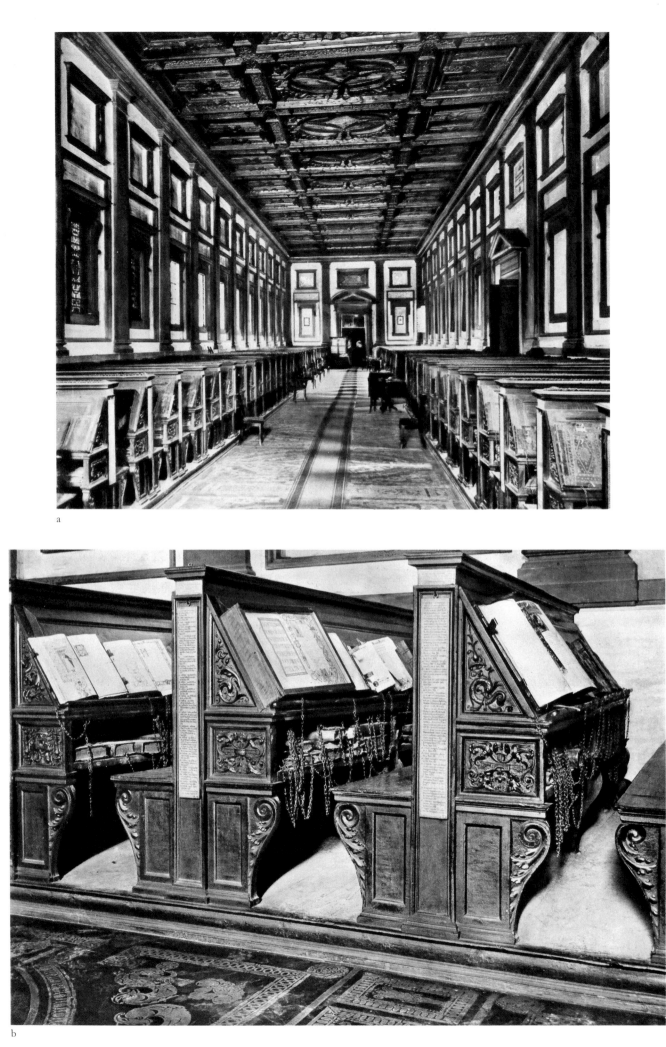

a

b

PLATE VIII. (a) The Reading Room of the Biblioteca Laurenziana, Florence. (b) Desks in the Reading Room of the Biblioteca Laurenziana, carved by Battista del Cinque and Ciappino, 1534, after sketches by Michelangelo.

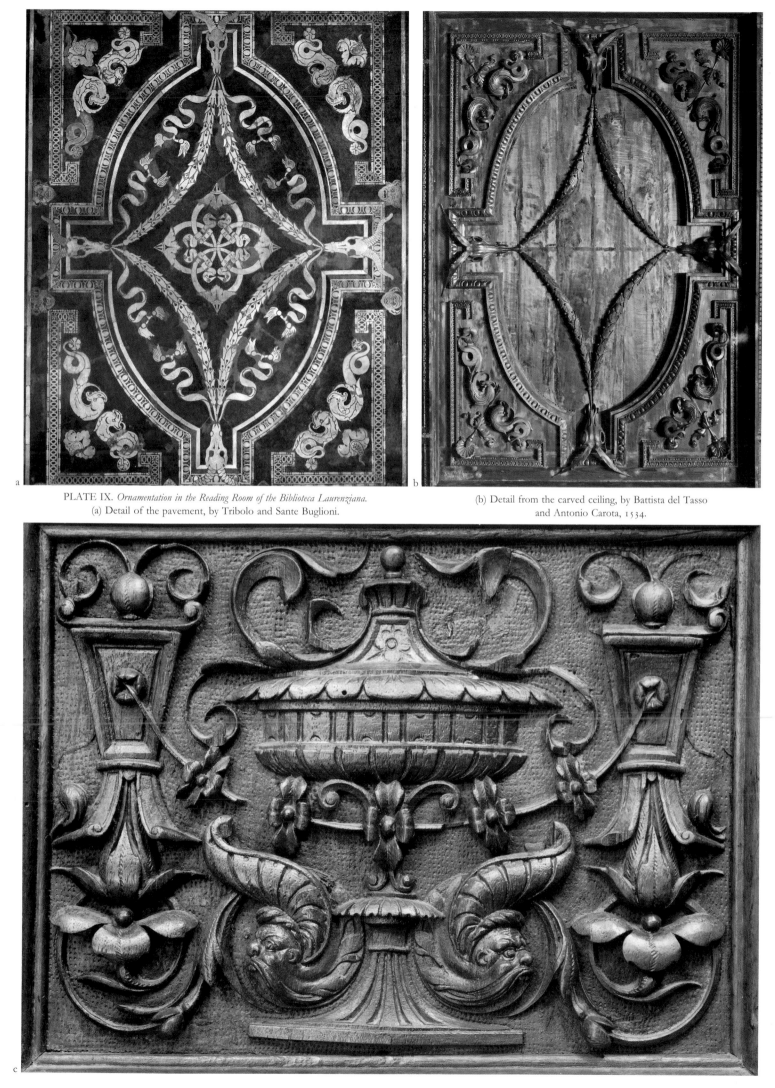

a

b

PLATE IX. *Ornamentation in the Reading Room of the Biblioteca Laurenziana.*
(a) Detail of the pavement, by Tribolo and Sante Buglioni.

(b) Detail from the carved ceiling, by Battista del Tasso
and Antonio Carota, 1534.

c

PLATE IX. (c) One of the wooden reliefs on the desks (cf. Plate VIII-b).

PLATE X. *Ornamentation on the Tabernacle of the Julius Monument* (a) to (d) The four reliefs on the front, by Antonio del Pontasieve, 1513, after drawings by Michelangelo. (e) and (f) The two lower reliefs inside the niche of Moses.

PLATE XI. *Ornamentation on the Tabernacle of the Julius Monument.* (a) and (b) Two halves of archivolts above the niches of Rachel and Leah.
(c) and (d) The two upper reliefs inside the niche of Moses, by Antonio del Pontasieve, after sketches by Michelangelo.

PLATE XII. *Designs for pavements.* (a) Detail of a Roman floor mosaic, about A.D. 100. Rome, Museo Nazionale. (b) Detail of the floor of the Florence Baptistery, about 1225. (c) Detail of a marble intarsia, dated 1157. Faltona, S. Felicità. (d) Ornamental rosette for parquetry, woodcut by Dürer, published 1525. (e) and (f) Pavements, designed by Michelangelo. (e) The ornamental pavement of the Piazza del Campidoglio, Rome, designed 1546. (f) Detail of the pavement in the Biblioteca Laurenziana, designed in 1524.

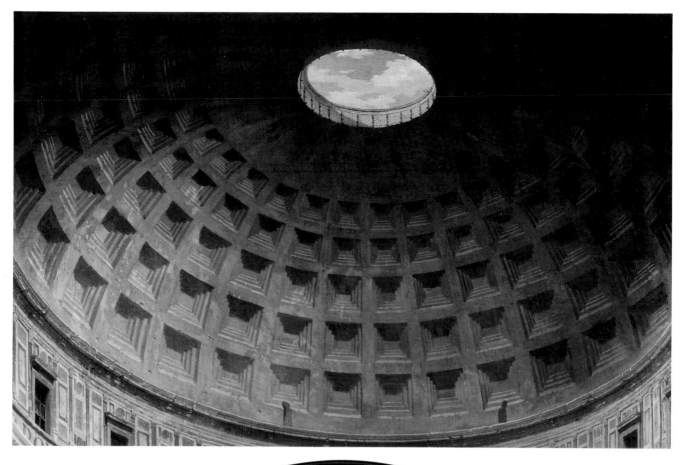

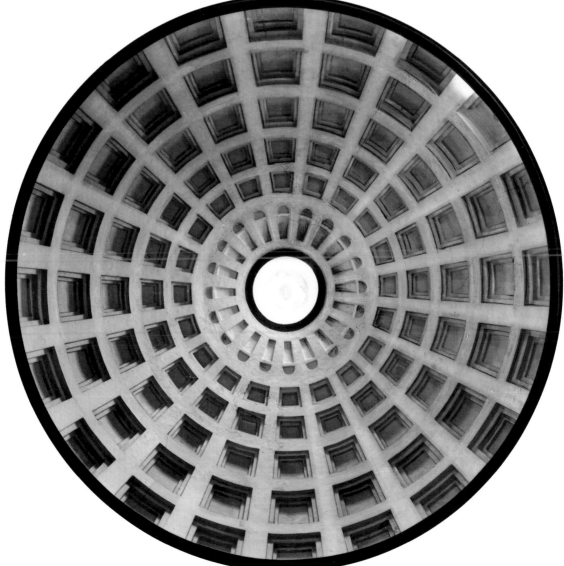

PLATE XIII. (a) Partial view of the inside of the Cupola of the Pantheon, Roman, about A.D. 110. (Detail of a painting by Paolo Pannini in the National Gallery of Art, Washington.) (b) Inside of the Cupola of the Medici Chapel, built by Michelangelo, 1523–1524.

a

b

c

d

PLATE XIV. *Masks.* (a) Shouting head above the niche of Leah, from the tomb of Julius, about 1514 (cf. Plate 234), (b) Mask on the archivolt keystone of the Porta Pia, Rome, about 1562. Detail of Plate 264.

(c) A capital in the Medici Chapel, about 1524. Detail of Plate 165. (d) A capital on the Palazzo dei Conservatori, about 1546. Detail of Plate 248.

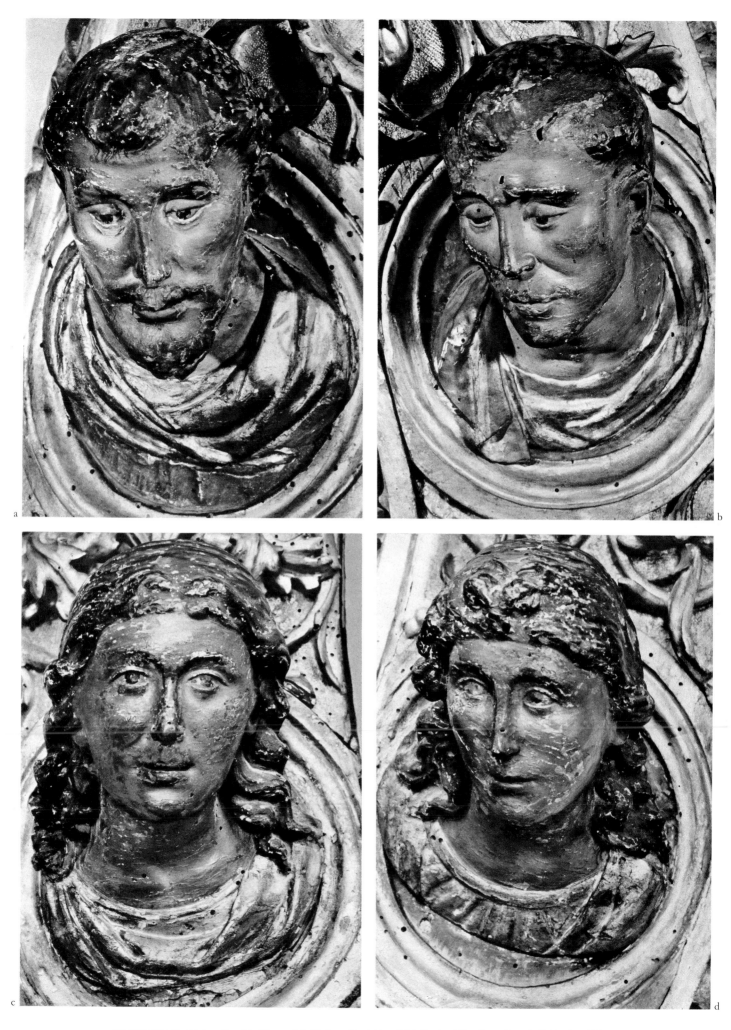

PLATE XV. *Details from the original frame of the Madonna Doni.* (a) and (b) Heads of Prophets. (c) and (d) Heads of Sibyls.

a

b

PLATE XVI. *Nicchione del Belvedere* (cf. Plate 255). (a) Pen and ink drawing, about 1560, by Giovanantonio Dosio. Florence, Uffizi. (b) Engraving by Ambrogio Brambilla, 1579. Rome, Print Room in the Palazzo Corsini.

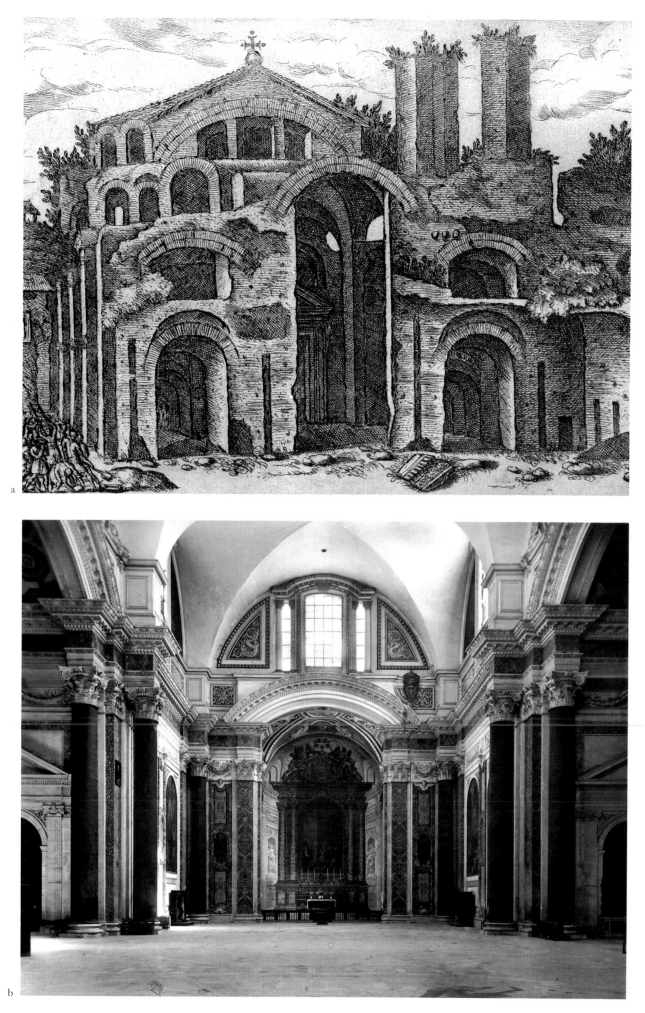

PLATE XVII. (a) The Thermae of Diocletian, converted into the Church of Santa Maria degli Angeli. Begun by Michelangelo, 1563. Between the arches on the east side of the Thermae part of the portal of the Basilica, built by Michelangelo, can be seen. Detail of an engraving by Alò Giavannoli, about 1610. (b) The transept of Santa Maria degli Angeli, Rome, in the present state, rebuilt by Vanvitelli in 1749.

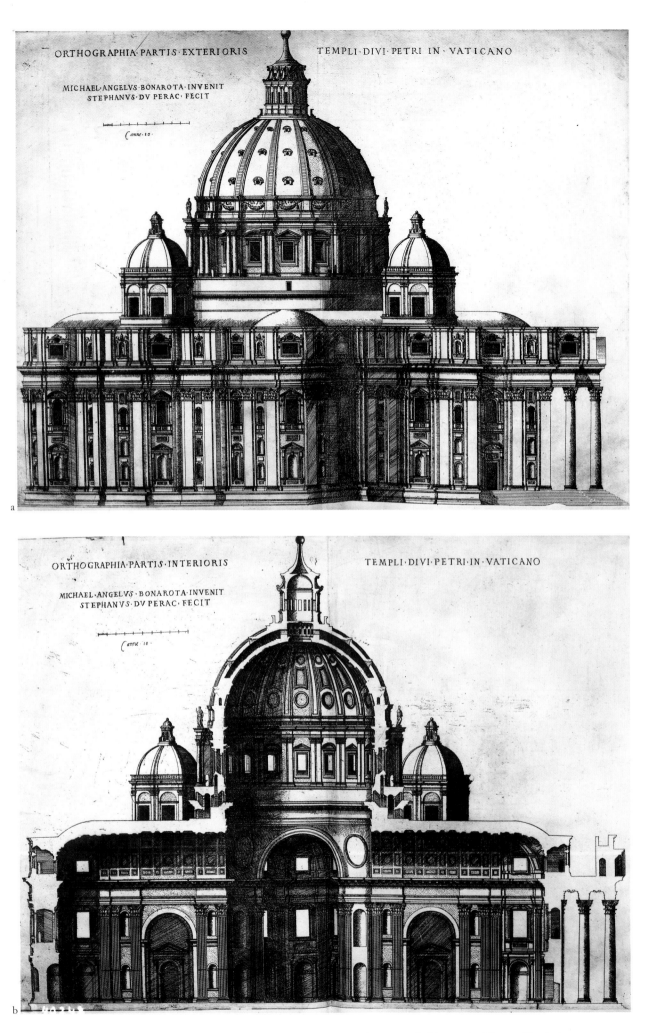

ORTHOGRAPHIA·PARTIS·EXTERIORIS TEMPLI·DIVI·PETRI·IN·VATICANO

MICHAEL·ANGELVS·BONAROTA·INVENIT
STEPHANVS·DV·PERAC·FECIT

Canne·10·

a

ORTHOGRAPHIA·PARTIS·INTERIORIS TEMPLI·DIVI·PETRI·IN·VATICANO

MICHAEL·ANGELVS·BONAROTA·INVENIT
STEPHANVS·DV·PERAC·FECIT

Canne·10·

b

PLATE XVIII. Michelangelo's designs for St. Peter's, engravings by Etienne du Pérac, 1569. (Vienna, Albertina)

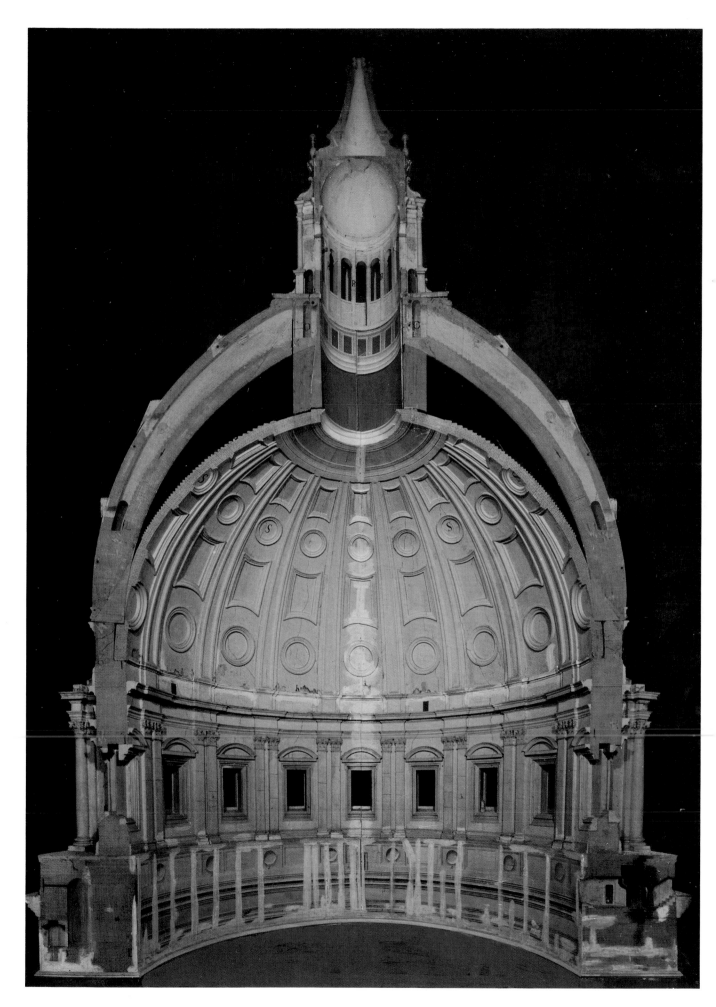

PLATE XIX. Interior of the Model for the Cupola of St. Peter's. (cf. Plate 266.)
(This large wooden model, finished by Michelangelo in 1561, was altered by Giacomo della Porta about 1576–1578.)

a

b

c

PLATE XX. (a) The tomb of Cecchino Bracci, by Francesco Urbino, from a design by Michelangelo, 1545. Rome, Santa Maria in Araceli.
(b) and (c) The Sforza Chapel in Santa Maria Maggiore, Rome, by Tiberio Calcagni, about 1559–1565, finished by Giacomo della Porta, 1573.

PLATE XXI. (a) A capital on the Palazzo dei Conservatori, about 1546. Detail from Plate 248. (b) A window in the Medici Chapel, about 1520–1523. Detail from Plate 165. (c) and (d) Windows on the Porta Pia, about 1562. Details from Plate 264.

PLATE XXII. *Lost Sculptures.* (a-c) Michelangelo's 'Sleeping Cupid'. (a) The antique model, after an engraving in Montfaucon's 'L'Antiquité expliquée, 1720. (b) Detail from Tintoretto's 'Mars and Venus', about 1545, in the Pinakothek, Munich. (c) Detail from Giulio Romano's 'The Infancy of Jupiter', about 1535. London, National Gallery. (d) Michelangelo's 'Head of a Faun'. Detail from a fresco by Ottavio Vannini in the Palazzo Pitti, Florence, about 1640. (e) The 'Giovannino'. Detail of a drawing by Michelangelo (about 1505, Louvre; cf. Plate XXV-a). (f) and (g) Sketches for lost models (Details of drawings from about 1525; British Museum, BB. 1688 and 1490), 'Hercules and Cacus' and 'Hercules and Antaeus'. (h-k) Michelangelo's lost 'Bronze David'. (h) Donatello workshop, bronze statuette of David, Berlin. (i) Bronze statuette in the Louvre (cast from a wax by Michelangelo?). (j) Detail of a Michelangelo drawing, 1502, Louvre. (k) Bronze statuette, about 1530, Amsterdam.

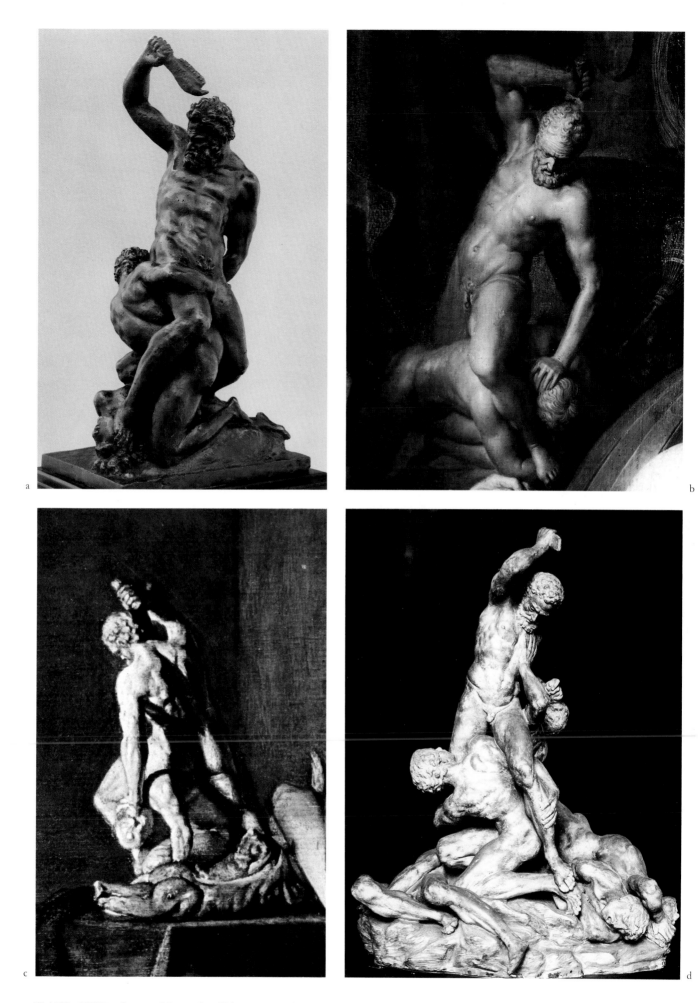

PLATE XXIII. *Samson fighting the Philistines; Hercules and Cacus.*
(a) Bronze by Pierino da Vinci after a model by Michelangelo (about 1528).
New York, Frick Collection. (b) A lost model by Michelangelo (in a Flemish
replica perhaps by Adriaen de Vries). Detail from a Self-portrait by Gerard

Dou, 1647. Dresden, Gallery. (c) A group similar to (b), Flemish replica.
Detail from *The Young Draughtsman*, by an unknown Dutch painter, about
1650. Brussels, Museum. (d) Terracotta model by Jean de Boulogne, about
1550. Tournai, Museum.

PLATE XXIV. Aristotile da Sangallo (1542): Copy after Michelangelo's cartoon for the 'Battle of Cascina'. Holkham Hall, Earl of Leicester.

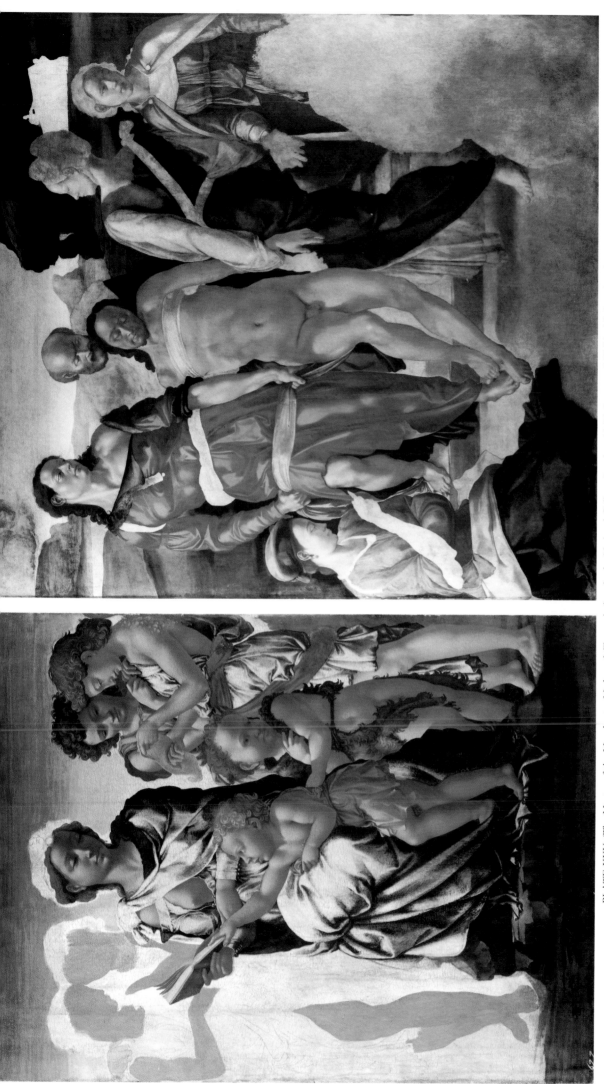

PLATE XXV. 'The Master of the Manchester Madonna': Two paintings in the National Gallery, London. (a) Madonna and Child with St. John; (b) Entombment. (Attributed to Michelangelo by Fiocco, Longhi, Toesca, Kenneth Clark, Bertini, d'Ancona; but not by Wölfflin, A. Venturi, Popp, Antal, Baumgart and Tolnay.)

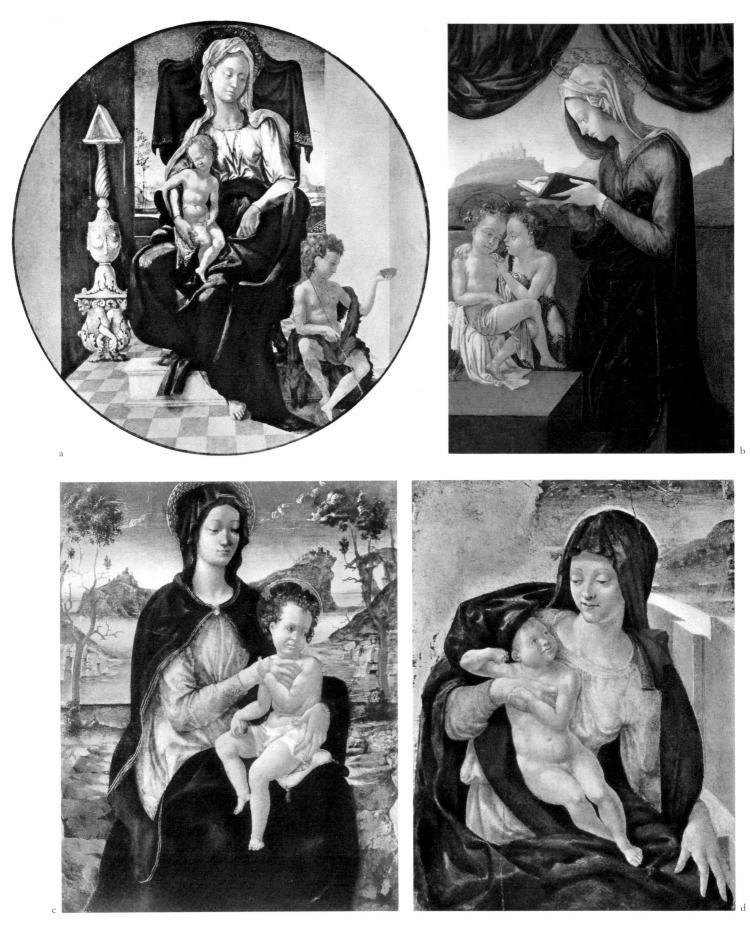

PLATE XXVI. *Four Madonnas.* (Attributed to Michelangelo by Fiocco and others.) (a) Vienna, Akademie. (b) New York, Private Collection.
(c) Baden near Zurich, Private Collection. (d) Florence, Private Collection.

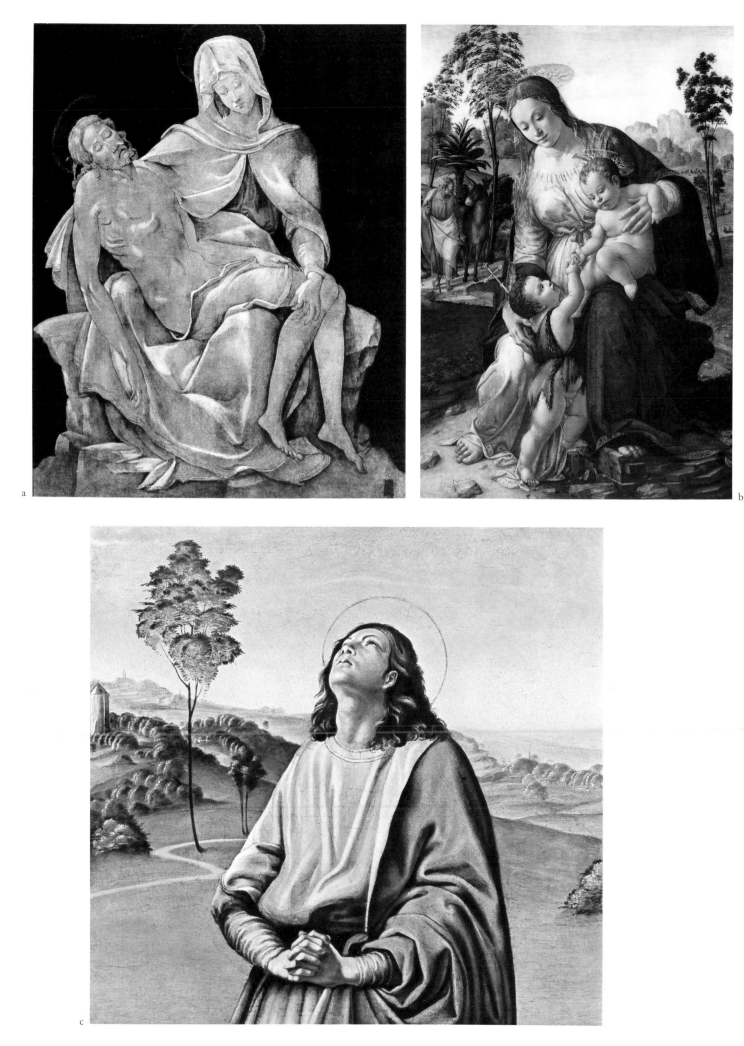

PLATE XXVII. (a) Unknown assistant of Michelangelo: Painting based on Michelangelo's Pietà of St. Peter's.
(b) The Holy Family with St. John, by Granacci (wrongly attributed to Michelangelo), National Gallery of Ireland,
Dublin. (c) St. John the Evangelist in a Landscape, Basle, Private Collection. (Attributed to Michelangelo by Longhi,
Fiocco, Nicodemi and Magugliani.)

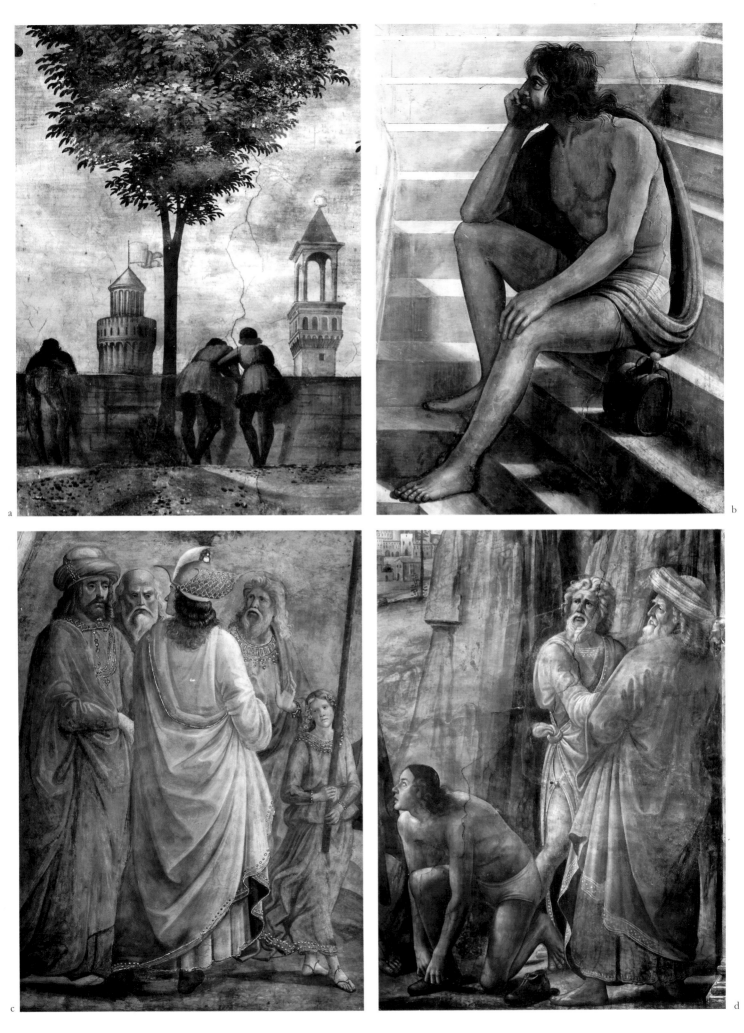

a

b

c

d

PLATE XXVIII. The youthful Michelangelo collaborating on Ghirlandaio's frescoes in Santa Maria Novella, Florence, 1488. Four examples of attributions to Michelangelo: (a) Detail from 'The Visitation of the Virgin'. (b) Detail from 'The Virgin on her way to the Temple'. (c) Detail from 'The Assumption of the Virgin'. (d) Detail from 'The Baptism of Christ'.

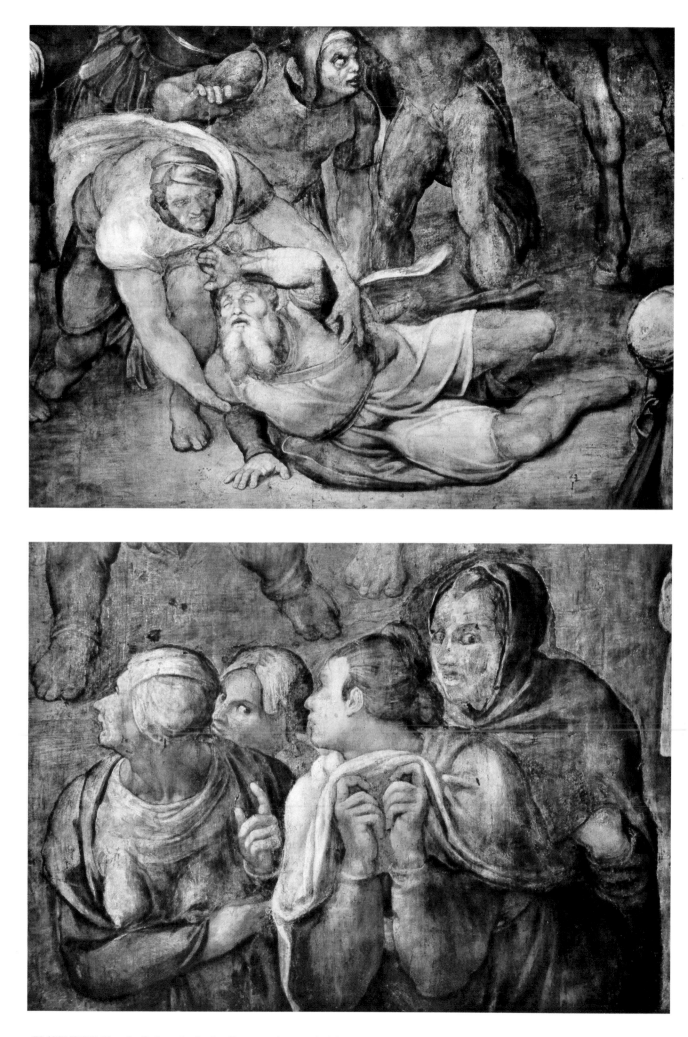

PLATE XXIX. Two details from the Paolina Frescoes; photographed during the 1933 restoration and showing the painting without any retouchings.

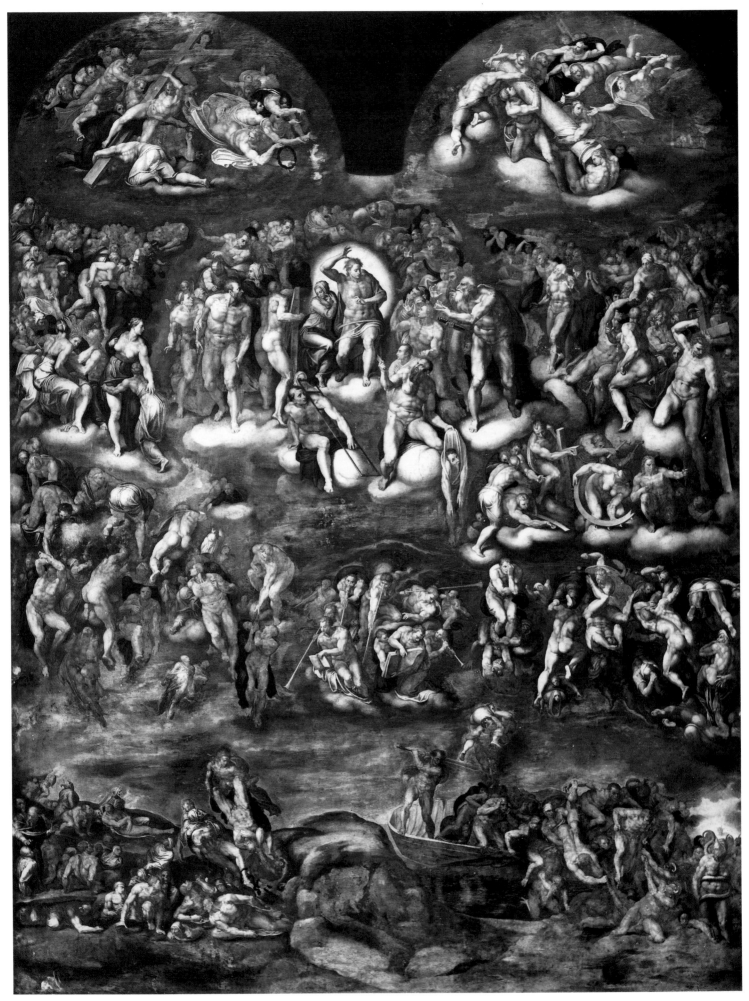

PLATE XXX. Copy after Michelangelo's 'Last Judgement', by Marcello Venusti, executed in 1549 (before Daniele da Volterra had painted over the nudes).
Naples, Capodimonte, Gallery.

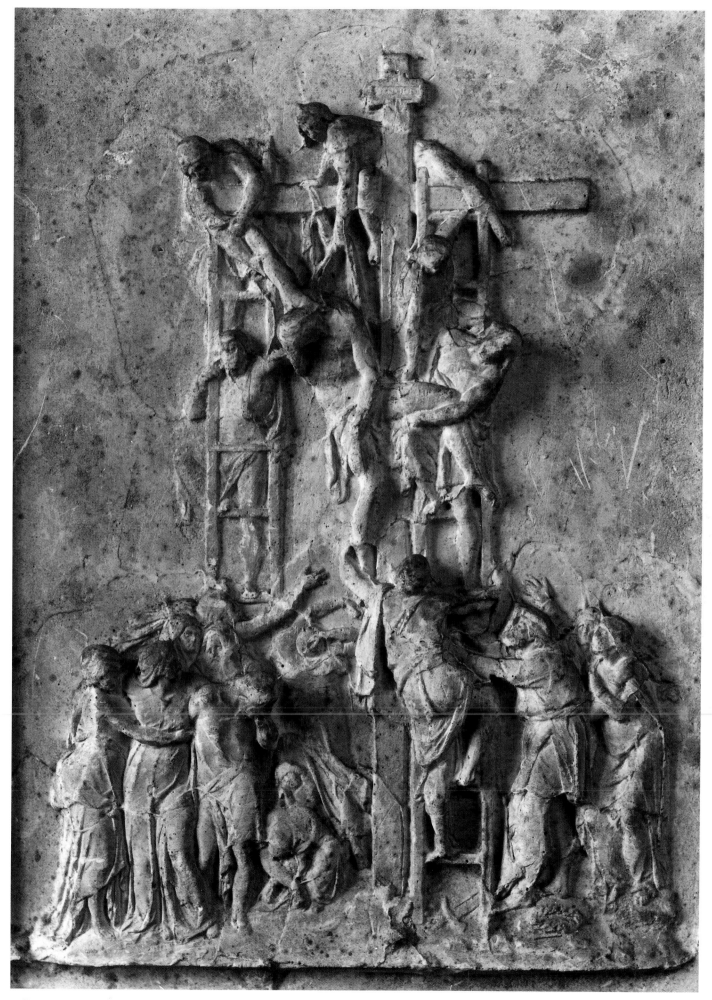

PLATE XXXI. Descent from the Cross. Plaster cast from a lost wax relief by Michelangelo, about 1540–1542. Florence, Casa Buonarroti.

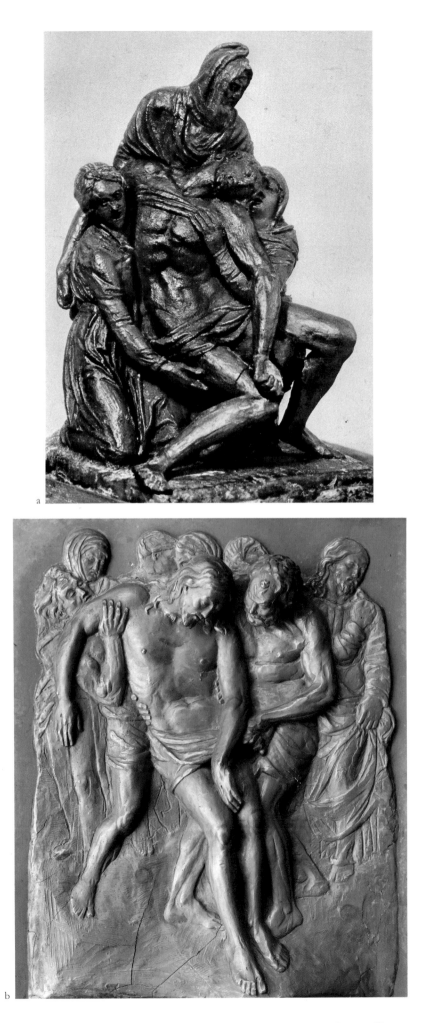

PLATE XXXII. (a) First version of Michelangelo's Pietà in the Florence Duomo. Wax. Florence, Gigli Collection. (b) Entombment, wax relief by an unknown pupil of Michelangelo (Pierino da Vinci?), about 1560, Berlin.

APPENDIX OF NOTES
MODELS IN WAX AND CLAY

Only two models appear at present to be *generally* accepted as Michelangelo's own work, both of the same period and both in clay: the large *River God* (Plate 200), and the *Victory Group* (Plate 202). A. Gottschewski was the first to recognize the River God as an original model by Michelangelo.[1] Hildebrand, Fabriczy, Schottmüller, Wölfflin and Tolnay agreed with him, but neither Frey, nor Popp, who attributed this model to Ammanati. J. Wilde has proved[2] that it is now in an incorrect position and quoted old reproductions showing how it was originally placed; in the present volume two hitherto unknown examples are added (Plate III–e, f).

The small model of a *Victory Group* (Plate 202) was accepted as genuine[3] by Bode, Fabriczy, Thode, Grünwald, Brinckmann, Wilde, Panofsky and Tolnay. This attribution went uncontradicted and we can therefore take the *Victory Group* as a starting point for the consideration of other models.

First I shall count up those models which, though not generally accepted, are of very high quality and have the opinions of great critics in their favour. (1) Wax sketch for the *Young Giant* (Plate 214) in the Victoria and Albert Museum (Plate I–b). This very fine model was accepted by Berenson (*Italian Pictures*, 1932, p. 363); also by Thode, Fabriczy, Brinckmann, and by Laux (1943). (2) Clay sketch of a *Victoria*, Casa Buonarroti (Plate I–a). Accepted by Thode, Bode, Fabriczy and Wilde; Knapp (*Michelangelo*, Munich, 1923, p. 48) compares it rightly to the *Victory Group* (Plate 202); it is of (relatively) the same size and the same material, and the technique is identical. (3) Wax sketch for a *Giant* (Plate I–e), accepted by Laux and others. Three torsos, two in the Casa Buonarroti and the other in the British Museum, formerly also in the Casa Buonarroti (Plate I–f, 222, 223), are of equal quality as the sketch for a *Giant* and I can therefore see no reason why they should be rejected.

The two wax sketches of *Nude Youths* (Plate I–c, d) offer a more complicated problem. Both statuettes are modelled in wax (see note 3), but they are not of identical technique. Neither are they connected with the marble or the bronze David, as was thought before, and Fabriczy has already suggested that the one model (Plate I–d) should be regarded as possibly a sketch for a figure of the Julius monument; the same was suggested by Thode concerning the other model (Plate I–c). However, I feel doubtful about Plate I–c, and am inclined to consider only Plate I–d an original on the assumption that the surface of the wax has suffered and has been restored. All these models have been connected with the Julius monument, while the group below consists of models for the Medici tombs. Here we have only three statuettes which are, with some authority, ascribed to the master. One of them is a slight wax sketch for *Crepuscolo* (Plate III–d), published as authentic by Sir Charles Holmes.[4] This spirited little sketch was formerly in the Casa Buonarroti. From the Casa Piccolomini in Siena came two fine large terracotta models to the collection of Dr. Alejandro Pietri in Caracas, Venezuela (Plate V). Leo Planiscig, Evelyn Sandberg-Vavalà and Odoardo Giglioli have declared them to be genuine works of Michelangelo. I believe in the authenticity of these two models. They are in baked clay, and their hard surface is better preserved than that of the other models which are in air-dried clay. The two large models in the Pietri collection make a favourable impression, particularly as the position of the limbs of the terracotta figures is not exactly the same as that of the finished marble statues, and as the models contain richer detail. In fact, old drawings, certainly done from the models and not from the statues, show the same differences.

The study of drawings by artists of the sixteenth and seventeenth centuries reproducing Michelangelo models is indeed instructive. Tintoretto owned a large number of such models, some probably originals, others only copies, and used them for studies. One set of these models was of large size, and of 'gesso', as Vasari tells us (ed. Milanesi, VII, p. 63), whereas others, which we know only from his drawings, were apparently originals.[5] The 'model' of *Giuliano* in Edinburgh is no doubt an imitation inspired by the finished statue (Plate II–d); how Michelangelo's sketch for *Giuliano* looked we learn from a Tintoretto drawing (Plate II–c). His drawing after the *Giorno* (Oxford), on the other hand, is probably after Daniele da Volterra's gesso copy – the face is as coarse and unfinished as that of the statue. There were, however, also other copies after models and also after the marbles in the Medici Chapel available to the draughtsman of that period, and quite a number have come down to us, e.g. the *Four Allegories* by Vincenzo Danti (1573, stucco; now in the Accademia, Perugia, see Plate III–a), or another set by Tribolo (terracotta; one of the figures repr. Plate III–c). Out of this set Vasari owned the *Notte*, but this is now lost. Tribolo's copies are not very large, about one Florentine ell or 2 ft. long, and that is also the usual size of other early copies, some of which have been cast in bronze. The best of these bronze replicas is the Medici Madonna in the Louvre (Plate III–b); Thiers collection No. 65; 16¼ in. high), apparently not a copy after the statue, but cast from the original small model. Thode (VI, 285) mentions a tradition that Michelangelo presented

[1] In 'Munich Yearbook', I, 1906, p. 43 f.; and in 'Rivista d'arte', IV, 1906, p. 73 f.

[2] In 'Belvedere', Vienna, 1927, p. 143.

[3] In this case it can be shown how carelessly critics have on the whole dealt with the models. Knapp (*Michelangelo*, KdK VII, 5th ed., 1924) illustrates this model on p. 166 and calls it 'stucco'; on p. 185 he calls it 'wax' and 'doubtful'. Tolnay (I, fig. 286) calls a wax statuette (our Plate I–d) 'terracotta'.

[4] Sometimes described as a model for a river god. For references to the literature on this and the following pieces, see Bibliography, section IX, p. 38 of this volume.

[5] Detlev Freiherr von Hadeln, *Zeichnungen des Giacomo Tintoretto*, Berlin, 1922. – Tietze, *The Drawings of the Venetian Painters*, New York, 1944, pp. 268–304. – W. Paesler, in 'Munich Yearbook', new series X, 1933. – Tolnay, III, 156, with references to Ridolfi and other old authors.

(273)

this bronze statuette to the Archbishop of Florence, Giovanni Salviati, and adds that it remained in the collection of the family until 1830. A bronze of the *Thief on the Cross*, which I believe to have been cast from a wax model by Michelangelo (Plate II–b), can be compared to a related drawing by an imitator of Michelangelo (Plate II–a), almost certainly drawn from such a model.[6]

One could give a long list of *lost* Michelangelo models. There were, e.g., the clay models he made for the figures of *Cosmas* and *Damian* (Plate IV–c, d), parts of which were owned by Vasari; there was a model of *Hercules and Antaeus* (cf. Plate XXII–g) which Michelangelo gave to Leone Leoni; there was a model for the left leg of *Giorno* which was in the possession of Alessandro Vittoria at Bologna (1563); there were the wax sketches Michelangelo made in 1517 for the figures on the wooden model for the Lorenzo façade; there was a small wax head, sent to Pietro Aretino in 1536, and a wax model for a bronze horse made a year later for Duke Francesco Maria of Urbino. There is mention of other models, such as two boxes full of them, which Michelangelo gave to Antonio Mini in 1531, or the four models which were stolen in 1529, when Michelangelo's Florentine studio was broken into. All those models are apparently lost, but I suspect that some of the clay models, which Mini took to France, re-appeared in Bologna and were bought by Paul von Praun (c. 1580), owned later by Prof. Haehnel in Dresden, and now in the Le Brooy collection, Montreal.

[6] Two other bronzes, wrongly attributed to Michelangelo by A. E. Popp, are not discussed any longer. The one is a life-size bronze Apollo in the Louvre, No. 681 (Popp, *Medici-Kapelle*, 1922, p. 171 f.; also J. Six, in *Gazette des Beaux-Arts*, 1921, p. 166 f.); the other a small torso in an unknown private collection (*Burlington Magazine*, vol. LXIX, November 1936, p. 202 f.).

LOST WORKS OF MICHELANGELO

I. SCULPTURE. The first work of Michelangelo's mentioned by Condivi is the *Head of a Faun*. The artist was fourteen years old when he made it. Attempts have been made to identify as this work a mask in the Museo Nazionale, Florence, but this has since been recognized as the work of a decadent seventeenth-century master. The *Faun* has disappeared, but there is perhaps a reproduction of it in a fresco in Palazzo Pitti (Plate XXII–d). The *Wooden Crucifix*, which Michelangelo made when he was about seventeen for the Prior of Santo Spirito in Florence, has also been lost; Thode believed that he had rediscovered it in a mediocre work there.[1] Likewise lost is the *Statue of Hercules* which passed from the Palazzo Strozzi into the possession of the King of France; nothing has been heard of it since 1713. Michelangelo was seventeen when he made this statue, which was a little larger than the 'Dying Captive' in the Louvre. As regards the *Giovannino*, or youthful St John, which Michelangelo made when he was twenty (formerly in the possession of Botticelli's patron, Lorenzo di Pierfrancesco de' Medici), Bode believed that he had rediscovered it, and Thode, Justi and Frey supported Bode's claim. Wickhoff, Wölfflin, Knapp and Mackowsky rightly rejected it and Grünwald thought that this marble statue (now in the Berlin Museum) is the work of the manneristic Domenico Pieratti, though his grounds for this attribution are not convincing; Wölfflin suggested the Neapolitan artist Girolamo Santacroce, and Carlo Gamba thought of Silvio Cosini, one of Michelangelo's assistants. M. Gomez-Moreno (1931) found a statue in the Salvador chapel at Ubeda which he identified and published as Michelangelo's rediscovered Giovannino; Valentiner (1938) proclaimed however that an equally indifferent statue in the Morgan Library was the Giovannino. It has rightly been suggested that the St John of the Manchester Madonna might be a reproduction of this lost statue (Plate XXII–e). Condivi mentions two *Statues of Cupid* executed by Michelangelo between his return from Bologna and the time when he was working on the Bacchus (i.e. about 1496). The first version represented a *Sleeping Cupid* and was sold by the Roman dealer Baldassare del Milanese to Cardinal Riario as a genuine antique (cf. Appendix Plate XXII–a). The statue came later into the possession of Cesare Borgia and then into that of Isabella d'Este, Margravine of Mantua. The Anonimo Morelliano mentions a Sleeping Cupid in the house of Pietro Bembo at Padua, 'different from the statue belonging to the Duchess Isabella d'Este of Mantua'. Konrad Lange believed that he had rediscovered this early work of Michelangelo's in an indifferent exhibit in the Turin museum. A more likely supposition is that there is a reproduction of this lost work in a painting by Giulio Romano, who worked at the Mantuan court from 1525, and another in a painting by Tintoretto of whom we know that he collected reproductions of Michelangelo's works (see Plate XXII–b and c; the Borghese Gallery Cupid has been lost, but there is a copy by A. Algardi in the same gallery). In 1631 the *Sleeping Cupid* is known to have passed to the collection of King Charles I of England, but all traces of it have since vanished. The other (lost) *Cupid*, sometimes also described as *Apollo*, a standing, lifesize marble figure, was made for Jacopo Galli.[2] The lifesize *bronze statue of David*, commissioned in 1502 by Pierre de Rohan, was sent to France in 1508 via Leghorn, but nothing has been heard of it for the last three hundred years. Two wax models, one in the Casa Buonarroti (Plate I–c) and another in the Victoria & Albert Museum (Catalogue 1932, plate 89–c), and a bronze statuette in Amsterdam (Plate XXII–k), have been wrongly thought to be connected with the bronze David. The only basis for

[1] This attribution was rejected by Wickhoff, Fabriczy, Tolnay and others. Tolnay thought he had found a copy of the lost Crucifix in the Sacristy of S. Spirito. In the corridor of the Monastery of S. Spirito Margrit Lisner found another Crucifix (4 ft. 6 in. high), which she regarded as the original. Ulrich Middeldorf has pointed out that the anatomy of this sculpture is quite inadequate, which disposes of the attribution.

[2] See Karl Frey, *Die Briefe des Michelangelo*, third edition, Berlin 1961, pp. 202–204, with complete bibliography. Also John Pope-Hennessy in *Burlington Magazine*, November 1956, pp. 403–411.

the reconstruction of Michelangelo's lost *bronze David* would appear to be the drawing in the Louvre (Plate XXII–j). From this drawing it is clear that Michelangelo followed Donatello (Plate XXII–h), as was stipulated in the contract, but it is probable that he also borrowed certain features from Verrocchio and Bertoldo. From the end of November 1506 to the end of February 1508 Michelangelo was in Bologna, engaged in casting the over-lifesize *bronze statue of Pope Julius II*, who had just conquered the city. The first casting was a failure, as the bronze emerged from the furnace only as far as the girdle, but on 9 July 1507 the second casting was finished; on 21 February 1508 the statue was erected. It was nearly ten feet high and weighed about seventeen tons. The Pope was shown seated, with St Peter's keys in his left hand and his right raised in benediction. The statue stood above the main portal of San Petronio for only three years and nine months, after which the populace of Bologna rose in defence of its freedom, pulled the statue down and shattered it to pieces. From the fragments Duke Alfonso of Ferrara had a mighty cannon cast, which he ironically christened 'La Giulia'. The portrait head was preserved, as the only relic of this work of Michelangelo's, in the Duke's art gallery, but has since disappeared. The destruction of the Julius statue is the most notable loss which we have to deplore among the sculptures of Michelangelo.

It is impossible to say whether the small statue of *Christ bearing the Cross*, mentioned as 'non finita' in the inventory of Michelangelo's estate[3] dated 19 February 1564, was a design for the statue in Santa Maria sopra Minerva or perhaps a reduced replica. In any case it must have been another version, for in 1564 Daniel de Volterra described it as 'similar to the Christ in the Minerva, yet differing from it'.[4] (Cf. Thode, V, 272.)

II. PAINTING. It is impossible to determine whether Michelangelo's copy after Schongauer's engraving of the *Temptation of St Anthony* was a coloured pen-drawing (Vasari, 1550), a painting on a small wood panel (Condivi, 1553), or merely the over-painting of an original engraving (Max Lehrs, in 'Prussian Yearbook', XII, p. 130 f.; cf. Thode IV, 4). According to Varchi (1564) Michelangelo made a painting of *Ghirlandaio and his assistants at work in Santa Maria Novella* (1489); according to Vasari it was only a drawing. Vasari also mentions a tempera painting of *St Francis receiving the Stigmata*, which a dilettante is said to have executed after a cartoon by Michelangelo and which then hung in the first chapel on the left in the church of San Pietro in Montorio, Rome. This cartoon and the painting have since disappeared (Thode IV, p. 50).

The greatest loss we have suffered is that of the cartoon for the *Battle of Cascina*, which Michelangelo prepared in the winter of 1504–5. This work was executed in competition with Leonardo's 'Battle of Anghiari' and was intended for the left half of a wall of the council chamber in Florence (the other half of the wall was reserved for Leonardo's battle-piece); the execution in fresco was never begun. Fragments of this cartoon were preserved until 1635, and there are numerous copies of parts of it. The oil-painting in grisaille at Holkham Hall (Plate XXIV; 30×52 in.) is supposed to be the most comprehensive copy. The tempera painting of *Leda and the Swan*, which Michelangelo painted in 1530, was given by him to his pupil Antonio Mini, who took it with him to France. Mini's friend Benedetto del Bene established a regular 'Leda factory' in Lyons; the picture seems to have been very popular and numerous copies are extant. In London, the National Gallery and the Royal Academy own examples. (Both copies are by Rosso Fiorentino.)

On the wall opposite the 'Last Judgement', that is to say over the entrance to the Sistine Chapel, Michelangelo was to paint a *Fall of the Angels*, and he made several sketches for it. One of his colour-mixers afterwards executed a fresco, which was formerly in the church of the Trinità dei Monti in Rome.

The Portal of the Sforza Chapel in Santa Maria Maggiore, Rome, designed by Michelangelo. Detail of an engraving, 1621.

[3] This Christ and a small Pietà were left to Michelangelo's servant, Antonio del Franzese. The inventory also mentions an unfinished statue of St Peter, which Thode (I, 487) is inclined to identify with the statue of Julius II for his monument, mentioned in a letter of 1508. (Cf. Jacob Hess, *Burlington Magazine* 1943, 55 f.; Tolnay IV, pp. 15 and 143.)

[4] Varchi, in his 'Funeral Oration for Michelangelo' (*Quellenschriften für Kunstgeschichte*, Vienna, 1874, VI, 119) mentions, in addition to the Minerva Christ (Plate 151), 'another Christ, completely nude, shown turning away, which he gave to the Marchesa di Pescara'.

III. ARCHITECTURE. All the models in clay and wood which Michelangelo made are lost, with the exception of the one for the cupola of St Peter's. To give two examples from the year 1559, there is no trace left of the model for the Church San Giovanni dei Fiorentini in Rome (although we know it quite well from old engravings), or of the model for the staircase of the Biblioteca Laurenziana. (See also Plate 155.)

The Church of Santa Maria degli Angeli alle Terme and the Sforza Chapel in Santa Maria Maggiore in Rome have been altered so much by later architects that they can be counted amongst Michelangelo's lost works.

The work on Santa Maria degli Angeli was started in 1563 and finished three years later. Pope Pius IV (1559–65) had commissioned Michelangelo to transform the best preserved part of the ancient Baths of Diocletian into a church. The *tepidarium* was strengthened and two large doors opened in the short side. Michelangelo had the help of Jacomo del Duca (who also assisted him in the work on the Porta Pia). The engraving (Plate XVII–a) shows the east side of the Thermae and the large Renaissance door, designed by Michelangelo as the main entrance to the Basilica. (This door is now walled up.) Plate XVII–b shows the transept of the church in the present state, as it was rebuilt by Clemente Orlandi and Luigi Vanvitelli from 1700 to 1749. Where the High Altar is now there was, in Michelangelo's time, the main entrance (see illustration on this page). About other alterations see Thode V, 184.

The Thermae of Diocletian, Tepidarium. Drawing by Giov. Antonio Dosio, about 1563. Florence, Uffizi. (Cf. Plate XVII–b).

The Sforza Chapel (Plate XX–b, c) is also very much rebuilt. The commission to Michelangelo came from Cardinal Guido Ascanio Sforza. Most of the work was done by Michelangelo's assistant Tiberio Calcagni (who also worked on the Magdalen of the Florentine Pietà and finished the 'Brutus'); after Michelangelo's death, and the death of Calcagni (1565), Giacomo della Porta finished the Chapel in 1573. The Chapel had 'a façade within the church' with a portal designed by Michelangelo (ill. p. 275), but this was removed in 1748.

ATTRIBUTIONS

I. SCULPTURE. None of the many new attributions of the last forty years has had much success. There was first the 'Head of a Cyclops' in the Bargello,[1] a discovery of Adolfo Venturi (L'Arte, 1922, p. 177 f.); and then the 'Bozzetto of a Crouching Girl' in a private collection at Munich,[2] sponsored by Kieslinger ('Prussian Yearbook' 1928, p. 50 f.); but already doubted by Hekler in 'Wiener Jahrbuch für Kunstgeschichte', VII, 1930, p. 219). Tolnay has published twice (in 'Prussian Yearbook', 1933, p. 121 f.; and 'The Youth of Michelangelo', Princeton, 1947) a relief with the coat of arms of Pope Julius II in the Museo Civico, Bologna. He suggested that this relief was originally underneath the lost bronze statue of Julius II on the façade of San Petronio. Bertini ('Michelangelo fino alla Sistina', 1945, p. 25) has already protested against this attribution. A few more unsuccessful discoveries are mentioned in the foregoing note on the Lost Works. A marble group of Venus and Cupid in the Palazzo Vecchio at Florence was attributed to Michelangelo by Matteo Marangoni (1955). In Giovanni Papini's 'Vita di Michelagniolo nella vita del suo tempo', 6th edition, Milan, 1951, a new crop of finds is illustrated and dis-

cussed. One is the 'Head of Hercules',[3] in the possession of a Polish sculptor in Paris; this head is supposed to be a fragment of Michelangelo's Hercules statue, which in the time of Henry IV was at Fontainebleau; another find is a 'Bust of a Youth' in a private collection in Rome.[4]

II. PAINTING. Papini's third attribution concerns a painting in Santa Maria at Marcialla, near Florence, a 'Pietà'. This fresco was attributed to Michelangelo already by some scholars of the early eighteenth century, but since then it has been justly forgotten.[5]

[3] Papini, p. 54. To judge from the photograph, the poor work of a provincial Roman artist, or the copy after a Hellenistic sculpture without importance. Giovanni Antonio Gori, the Florentine archeologist, thought that he possessed the small model, about 4½ in. high, for the head of Michelangelo's 'Hercules' (Thode IV, 17).

[4] Papini, opp. p. 273. This bust is a copy from Michelangelo's 'Victory' in the Palazzo Vecchio. The technique of the copyist reminds one vaguely of Raffaelo da Montelupo's 'St Damian' in the Medici Chapel, and of his 'Prophet' on the Julius Monument, but this little bust shows even stronger relations with the work of Vincenzo Danti, who, as has been assumed, has done some work on Michelangelo's 'Victory' (Plate 205).

[5] Papini, pp. 73–74, and opp. 53. Rather in the manner of Jacopo del Sellaio, but too weak to be by him. According to Stendhal (*Rome, Naples et Florence*; paragraph dated 25 October 1816), the Italians attributed at one time even the designs of their tarot cards to Michelangelo!

[1] By some unknown sculptor of the Mannerist period.
[2] Perhaps by Vincenzo Danti.

There is a group of paintings, not all of them by the same hand, which are at present by some writers considered as the earliest paintings by Michelangelo.[6] Here is a complete list (see Plates XXV–XXVII).

(1) *Pietà*. Rome, Galleria Nazionale, No. 948. (Zeri classes this painting in the same group as our Nos. 2–6, and attributes these seven pictures to Jacopo dell' Indaco. I agree with Zeri on the whole but believe that No. 7 is of a higher quality and probably by a different hand.)

(2) *Madonna with the Candelabrum*. Vienna, Academy, No. 1134. Ascribed to Michelangelo by Adolfo Venturi and Fiocco. Attributed to Antonio Mini by Anny Popp, and to Bugiardini by Berenson. (1932).

(3) *Madonna with Child and St John*. New York, private collection. (Formerly Florence, Conte Contini Bonacossi.) Fiocco's attribution.

(4) *Madonna and Child*. Private collection, Baden near Zurich. Fiocco's attribution.

(5) *Madonna and Child*. Florence, private collection. Fiocco's attribution ('Rivista . d'arte', XXVI, 1950, p. 149).

(6) *The Manchester Madonna*. London, National Gallery, No. 809 (Plate XXV–a). Attributed to Michelangelo by Toesca (1934), Kenneth Clark (1938), Fiocco and Longhi (1941), Bertini (1945) and Johannes Wilde (1951). Not by Michelangelo according to Wölfflin, Frizzoni, Adolfo Venturi, Popp, Tolnay, and Dussler. Accepted by Berenson as a workshop production.

(7) *The Entombment*. London, National Gallery, No. 790 (Plate XXV–b). Attributed to Michelangelo by Fiocco, Longhi, Clark, Wilde, Gould, Berenson, Toesca, Bertini; but not by Wölfflin, Popp, Baumgart, Tolnay, Antal and Dussler.

(8) *St John the Evangelist*. Basle, private collection. Attributed to Michelangelo by Longhi, Fiocco, Nicodemi and Magugliani (1952).

(9) *Madonna with Child and St John in a Landscape*. Dublin. National Gallery of Ireland, No. 98. Attributed to Michelangelo by Fiocco. Correctly attributed to Francesco Granacci by Mary Logan, Gronau, Berenson and Zeri; this attribution is now almost generally accepted.

Nos. 1–8 are not all by the same hand. The pictures 6 and 7 are by far the best of the whole group. There is presently a pronounced tendency to attribute them to Michelangelo himself. This is, in my opinion, wrong. The 'Master of the Manchester Madonna' was apparently a Florentine painter influenced by Granacci and Bugiardini; between 1516 and 1534 he was inspired by Michelangelo, and probably worked in his studio at Florence, not necessarily as a painter.

[6] G. Fiocco, *La data di nascita di Francesco Granacci e un'ipotesi Michelangiolesca*, in 'Rivista d'arte', serie II, anno II, 1930, p. 193 f.; anno III, 1931, p. 109 f., 385 f. *Un'altra pittura giovanile di Michelangelo*, in 'Critica d'arte', anno II, 1937, fasc. X, 172 f. – *Sull'inizio pittorico di Michelangelo*, in 'Le Arti', anno IV, 1941, p. 5 f. – *Primizio di Michelangelo*, in 'Rivista d'arte', XXVI, 1950, p. 149 f. – R. Longhi, *A proposito dell'inizio pittorico di Michelangelo*, in 'Le Arti', anno IV, 1941, p. 136. – Cf. A. E. Popp, *Garzoni*, in 'Belvedere': VII, 1925, p. 6 f. – L. Magugliani in 'Annali', I, 1952, p. 20 f. – Federico Zeri, *Il Maestro della Madonna di Manchester*, in 'Paragone', 1953, July, pp. 15–27.

NOTES ON THE APPENDIX OF PLATES

The models, Plates I–V, are discussed on pp. 273–274. Plate IV–c shows St Cosmas, the model for which, as Vasari relates, was made by Montorsoli himself, but Michelangelo reworked it extensively; clay sketches for the head and the arms of Cosmas were in Vasari's possession. The life-size model for St Damian was entirely by Michelangelo.

For Plates VI and VII see the notes on Plates 165–201 on p. 25.

Plate VI. According to Vasari, the New Sacristy was built from designs by Michelangelo. Johannes Wilde (*Michelangelo's Designs for the Medici Tombs*, in 'Journal of the Warburg and Courtauld Institutes', 1955, p. 54 f.) accepts this statement as correct; one of his proofs is a sketch by Leonardo which shows the north transept of the church without a sacristy (Manuscript L, folio 15 verso, datable 1502–03).

Leonardo da Vinci: Pen and ink sketch, The Church of San Lorenzo.
Paris, Institut de France.

The reasons for and against Wilde's theory are analysed by James S. Ackerman (*The Architecture of Michelangelo*, London, 1961, Catalogue, p. 23).

Plate VII. 'The lantern is Michelangelo's only important contribution to the exterior of the chapel' (Prof. Ackerman).

For Plates VIII and IX see the note on Plate 157 on p. 24f.

For Plates X and XI see the notes on the Tomb of Julius, p. 20.

Plate XII is a commentary, by means of illustrations, on Michelangelo's two designs for pavements, one for the

floor of the Biblioteca Laurenziana, the other, twenty years later, for the Piazza del Campidoglio – two ornamental rosettes of similar design. This design was not invented by Michelangelo, but goes back to the antique (Plate XII–a), was used in the Middle Ages (Plate XII–b and c) and later by Dürer, who gives such a rosette in woodcut No. 21 of his work 'Underweysung der messung mit dem zirckel und richtscheyt'. The rosette of the pavement of the Piazza del Campidoglio is not circular, but elliptical; it follows however the same pattern.

Plate XIII shows that the cupola of the Medici Chapel has an antique prototype.

Plate XIV shows, in four illustrations, a single strain of Michelangelo's inventiveness, the masks. See also Plates 11, 184, 189–191.

Plate XV shows details from the original frame of the Doni Madonna (cf. note 11 on p. 13). The frame was, in my opinion, designed by Michelangelo himself, or at least the five heads. Elfried Bock (*Florentinische und venezianische Bilderrahmen*, Munich 1902, p. 78 f.) believes that the frame was executed in Siena. As Michelangelo worked on the statues for the Piccolomini altar in Siena from 1501 until 1504 – the period during which he also painted the Doni Madonna – he was in close touch with Sienese craftsmen and may have entrusted one of them with the carving of the frame.

For Plate XVI see text on p. 34.

Plate XVII is discussed on p. 276.

For Plates XVIII and XIX see text on p. 35.

Plate XX–a. Cecchino Bracci, the nephew of Michelangelo's friend Luigi del Riccio, died on 8 January 1545 at the age of fifteen. Michelangelo wrote 48 four-line epitaphs and, in a sonnet, promised a tomb with the boy's portrait. He made the design, which Urbino executed to the best of his ability.

For Plates XX–b and c see text on p. 276.

For Plate XXI see the notes on Plates 165, 248, 264.

Plate XXII, which shows lost sculptures by Michelangelo, is discussed on p. 274 f.

Plate XXII–h. Leo Planiscig (*Piccoli Bronzi Italiani del Rinascimento*, Milan 1930, ill. No. 5) ascribed this statuette, a rough cast from a wax, to Donatello himself; but not the Martelli David in the Johnson collection, a life-size marble statue based on this small bronze ('Phoebus' II, 2, p. 55 f., Basle 1949).

Plate XXII–i. Thode (VI, p. 285, No. 606) accepted this bronze as a cast from a genuine Michelangelo model, 'the first sketch for the bronze David, based on Donatello'. Wilhelm Boeck (*Michelangelos Bronzedavid und die Pulszky-Statuette im Louvre* in 'Mitteilungen des Kunsthistorischen Instituts in Florenz', VIII, 1959, p. 131 f.) has given good reasons for this opinion. A slightly larger cast from the same model was formerly in the collection of Victor Koch, London, who sold it to a collector in South Africa.

Plate XXII–j. This famous Michelangelo drawing is the only trace left of the lost Bronze David.

Plate XXII–k. Thode (VI, p. 266, No. 557) called this statuette 'the final model for the Bronze David'. This opinion can hardly be defended any longer and the illustration is given here only for the reason that it cannot easily be found anywhere else.

XXIII–a. This bronze is connected with the clay sketch, Plate 202; several other bronzes of this group are extant, the two best known ones are in the Bargello, Florence; they are correctly ascribed to Pierino da Vinci (Vasari-Milanesi, VI, 128). Tintoretto owned apparently an original clay sketch of this group by Michelangelo and made numerous drawings from it (see Tietze, *The Drawings of the Venetian Painters*, 1944: Tintoretto drawings 1559, 1564, 1567, 1666, 1679, 707, 708, 733, 734 and 741).

Plate XXIV is mentioned on p. 275.

Plates XXV–XXVII are discussed on p. 277.

Plate XXVIII: As Michelangelo entered Ghirlandajo's workshop at the age of thirteen (and stayed for less than one year), most biographers have wondered on which of Ghirlandajo's frescoes he may have collaborated. Padre Fineschi (K. Frey, *Michelagniolo Buonarroti: Quellen und Forschungen*, vol. I, Berlin 1907, p. 18) thought he could recognize Michelangelo's hand in the boys leaning over the balustrade of the terrace of San Miniato (Plate XXVIII–a). Another attribution is mentioned by Raimond van Marle (*Italian Schools of Painting*, The Hague 1931, vol. XIII, p. 73), though he attributes this figure (XXVIII–b) to David Ghirlandajo. The question has been discussed fully by Giuseppe Marchini (*Burlington Magazine*, October 1953, pp. 320–331) after the recent cleaning of the frescoes

of Santa Maria Novella. Two details reproduced here (XXVIII–c and d) are examples of Marchini's attributions. Plate XXIX contains two important illustrations made from photographs taken during the restorations of 1933 when the paintings were stripped of all retouches. They leave no doubt about the bad state of preservation of the frescoes.

Plate XXX is mentioned on p. 32. According to Johannes Wilde (*Burlington Magazine*, Nov. 1959, p. 373) Venusti painted this copy 'obviously not from the fresco itself but from one of his own famous drawings after the fresco'; he took many liberties and gave St Peter the features of the Farnese Pope Paul III.

Plate XXXI. This relief ($12\frac{1}{4}$—$9\frac{1}{2}$ in.) is related to a drawing at Haarlem (Frey 330) and a number of reliefs. For a list of replicas see Thode V, p. 481 f., and Ulrich Middeldorf & Oswald Goetz, *Medals and Plaquettes from the Sigmund Morgenroth Collection (Santa Barbara, California)*, Chicago 1944, p. 43, No. 309.

For Plate XXXII–a: see Thode V, 276 and VI, 282. This wax sketch ($7\frac{5}{8}$ in. high) agrees with the engraving by Cherubino Alberti (B.23, about 1580) and reproduces the Florentine *Pietà* (Plate 256) before it was re-worked by Calcagni. Note the left leg of Christ.

Plate XXXII–b. With a faked signature; but the relief is probably based on a lost Michelangelo drawing. Frida Schottmüller (1933) attributed it, wrongly, to Vincenzo de' Rossi, but pointed out that (according to Gramberg) it is stylistically related to the Palestrina Pietà (Plate 262) and to the Pietà relief in the Vatican (Tolnay, *Michelangiolo*, Florence 1951, p. 388). Middeldorf identified this assistant with Pierino da Vinci.

The fibula on the toga of Brutus (see plate 237).

INDEX TO THE PLATES

I. ARCHITECTURE

II. PAINTINGS

III. SCULPTURES

IV. MODELS

Roman numerals refer to the Plates in the Appendix.